HERITAGE MATTERS

ARCHAEOLOGY, CULTURAL PROPERTY,
AND THE MILITARY

United Kingdom
National Commission for UNESCO

United Nations
Educational, Scientific and
Cultural Organization

HERITAGE MATTERS

ISSN 1756-4832

Series Editors
Peter G. Stone
Peter Davis
Chris Whitehead

Heritage Matters is a series of edited and single-authored volumes which addresses the whole range of issues that confront the cultural heritage sector as we face the global challenges of the twenty-first century. The series follows the ethos of the International Centre for Cultural and Heritage Studies (ICCHS) at Newcastle University, where these issues are seen as part of an integrated whole, including both cultural and natural agendas, and thus encompasses challenges faced by all types of museums, art galleries, heritage sites and the organisations and individuals that work with, and are affected by them.

Archaeology, Cultural Property, and the Military

Edited by

LAURIE RUSH

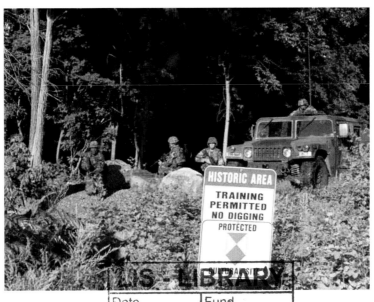

THE BOYDELL PRESS

First published 2010
The Boydell Press, Woodbridge
Reprinted in paperback and transferred to digital printing 2012

ISBN 978 1 84383 752 7

The Boydell Press is an imprint of Boydell & Brewer Ltd
PO Box 9, Woodbridge, Suffolk IP12 3DF, UK
and of Boydell & Brewer Inc.
668 Mt Hope Avenue, Rochester, NY 14620, USA
website: www.boydellandbrewer.com

A CiP catalogue record of this publication is available
from the British Library

The publisher has no responsibility for the continued existence or accuracy of URLs for
external or third-party internet websites referred to in this book, and does not
guarantee that any content on such websites is, or will remain, accurate or appropriate.

Papers used by Boydell & Brewer Ltd are natural, recyclable products
made from wood grown in sustainable forests

Typeset by Tina Ranft, Woodbridge
Printed and bound in Great Britain by
CPI Group (UK) Ltd, Croydon, CR0 4YY

Contents

List of Illustrations: Figures and Tables

TABLES

Archaeology and the Military:
An Introduction

LAURIE RUSH

The very best news about this book is that, as I write this introduction in the autumn of 2009, some of the chapters are out of date already. Even in the few weeks since the last chapters were submitted, an International Military Cultural Resources Working Group, the IMCuRWG, has been established; the US Central Command Historical/Cultural Advisory Group has developed a mission statement and charter; US Central Command has signed an environmental regulation that establishes cultural resource considerations during contingency operations, and has received $60,000 in funding for 2010 for International Cultural Resources Cooperation; more on-site trainings in Egypt are scheduled; the US Defense Language Institute has just completed translation of the Iraq Archaeological Site Atlas, including all the maps; and the list goes on and on.

So why not stop the presses? Why put the effort into publishing a volume when a trendy website could keep the interested audience up to date on these issues and accomplishments? The answer to this question goes back to learning from history and staying grounded in the law. One of the purposes of this volume is to provide a reference document for advocates of cultural property protection. It should be a resource for individuals who are interested and willing to partner with the military to achieve the goal of respect for heritage in areas of conflict and disaster. These kinds of individuals are often called upon to make a case for cultural property protection. When they are successful in making their case, they are then often asked to develop creative solutions to address situations where cultural property is in grave danger.

In order to make a case for cultural property protection and the legal requirements, Patty Gerstenblith has provided a comprehensive legal introduction. She begins with ancient Rome and continues through history to implications of the recent ratification of the 1954 *Hague Convention for the Protection of Cultural Property in the Event of Armed Conflict* by the United States Senate. Her knowledge and the detail she is able to muster provide essential information for those of us who engage in these issues on a regular basis. Gerstenblith's chapter also illustrates the essential need for this volume. Even though much of the international legal framework for cultural property protection was in place, the United States and many of its international partners should have been better prepared for the cultural property challenges that their military personnel faced in the current global conflicts. We reproduce the 1954 Hague Convention and its two Protocols as an appendix here, as these documents are a central focus of this volume.

The issue of preparation becomes even more frustrating when we consider that the United States Armed Forces has, as part of its history, outstanding accomplishments in cultural property protection. Towards the end of World War II, the US and the UK established the Monuments Officers Programme. The Monuments Officers saved untold

numbers of works of art and returned them to the European community. Less than 60 years later, the same military organisations were unprepared for operating in archaeologically sensitive areas and for anticipating looting both in the field and from collections. However, as you read Krysia Spirydowicz's account of the Monuments Officers Programme it becomes immediately clear that the US Department of Defense should be using it as an example in an attempt to rebuild the capacity of the current US Army Civil Affairs programme to address cultural property issues. She concludes with a very concise and appropriate list of lessons learned in 1941 that could be readily applied today. Corine Wegener's experience in Baghdad builds on this discussion by demonstrating the extent of Civil Affairs capability when they deploy the right person at the right time.

Paul Green follows this discussion with additional historical perspective and discusses how methods for considering cultural property have evolved and changed for the United States Department of Defense since World War II. As he brings his discussion to the present, he is far too modest. Green's Central Command GIS working group has worked on the Iraq Atlas translation, will eventually geo-rectify this document, and has added sites to the Central Command environmental planning maps for Iraq and Afghanistan: over 3000 sites for Iraq and 2000 for Afghanistan. Joris Kila sheds light on the challenges of the war zone with his account of managing conservation in situations where cultural property is attacked on purpose, as in the Balkans. The situation that he faced reflects the complexity of the issue, especially when responsible parties representing host nations choose to preserve damage as part of their legacy to their children and to the enemies of their children. He also emphasises the importance of maintaining a distinction between cultural property protection and cultural awareness training efforts among the military. At times, confusion about the nature of the two types of initiatives and their proponents have led to unwarranted criticism of military archaeologists and cultural property protection efforts.

One of the most frustrating aspects of the US damage at Babylon during the second Gulf War was the contrast between the lack of cultural property planning and training for deploying US personnel and the outstanding job that the United States Department of Defense does in caring for its own archaeological and cultural properties at home. Martin Brown gives a detailed description of a comparable domestic programme in the UK, in which cultural properties are identified and protected at the Salisbury Defence Estate. Jim Zeidler and I then offer detailed accounts of our work with the United States Department of Defense to address this disparity and to prepare deploying forces properly for future encounters with valued archaeological sites and sacred places when they serve overseas.

Darrell Pinckney, a professional archaeologist, builds on the discussion by providing a personal account of his efforts to add cultural resources management to his military responsibilities during his six-month deployment at the airbase in Kirkuk. Only individuals who have actually served in conflict zones can truly appreciate the challenges faced by even the best-intentioned cultural property professionals in such environments. Hugo Clarke also provides his combat zone account of 'Operation Heritage', the British effort to survey sites and partner with the Iraqis on meaningful heritage preservation projects. Julian Radcliffe follows with his account of the current situation in the UK and

the development of expertise within deploying UK forces, as, we hope, the UK prepares to ratify the 1954 Hague Convention. Diane Siebrandt offers a conflict zone experience from a different perspective, discussing what has been accomplished by the partnership that she established with the US military in her role as the US State Department cultural liaison in Baghdad.

The one theme that rings true in all of the chapters is that partnerships and a willingness to work together toward a vision of preservation have brought success to all of the initiatives. Just as the Monuments Officers discovered 60 years ago, flexibility and a willingness to work with what you have can result in great achievements.

The contributions from Austria (Friedrich Schipper *et al*) and Switzerland (Stephan Zellmeyer), are extremely valuable because they offer examples of what military organisations can accomplish when a well-thought-out cultural property protection programme is planned and implemented. Both nations have taken the protocols of the Hague Convention and have implemented them domestically, by identifying their most valuable properties at home, and operationally, by establishing cultural property officers and training programmes for military personnel. Larger military organisations that are just beginning to consider the Hague Convention could use both of these examples as models for establishing their own programmes.

Sarah Parcak then concludes the volume by taking us into the future and providing a glimpse of what can be accomplished when we combine the power of intellect and technology from the academic and military communities. We recognise that the challenges of working with already identified archaeological sites and teaching our military personnel to recognise and respect them is huge. However, that should not prevent us from establishing a vision of a future in which we go beyond our current limitations to discover, plan and partner for preservation.

This volume was intended to gather detailed background information to provide context for some of the best examples of partnerships, projects and experiences that have laid the foundations for all of the progress currently being made in cultural heritage preservation during armed conflict. Some of the chapters provide snapshots in time. We hope that the lessons of the past, in addition to the examples from the present, will not be forgotten.

I will conclude with personal notes. First, I would like to thank Peter Stone for his vision in suggesting this volume and his critical contributions in helping to organise the topics and author selection. I would also like to thank Catherine Todd for all of her hard work during the final editing process. As I consider this volume, and all of the accomplishments it represents, I feel extremely fortunate to have had the opportunity to be a part of this process. It has been an extraordinary honour to have had the opportunity to work on cultural property preservation issues at the international level. It is an even greater honour to call the authors represented in this volume colleagues and friends.

Laurie Rush
Fort Drum, New York State
September 2009

1

The Obligations Contained in International Treaties of Armed Forces to Protect Cultural Heritage in Times of Armed Conflict[1]

Patty Gerstenblith

In April of 2003, as the United States military took control of Baghdad during the second Gulf War, the world soon learned that the Iraq Museum, the world's largest repository of ancient Mesopotamian art and artefacts, had been looted. The United States received almost universal blame for allowing the looting to occur, with some even charging that the United States' inaction had violated international law. Furthermore, the United States military, in its role of quasi-occupier of Iraq, constructed military bases on, or in other ways utilised for military purposes, culturally and historically sensitive sites at Ur, Babylon and Samarra. During the hiatus in effective law enforcement and the political chaos in the years that followed the initial invasion, archaeological sites, particularly those of the Sumerian period (approximately third millennium BC) in the southern part of Iraq, were looted.

These actions and events pose questions concerning the obligations of a military power to avoid doing harm to cultural heritage and to actively preserve it during armed conflict and occupation. While much controversy and criticism were engendered in the cultural heritage preservation community, and the Gulf War undeniably had a significant adverse effect on Iraq's cultural heritage, it is also likely that these events provided the final impetus, directly or indirectly, for the United States, after a delay of 55 years, to ratify the first international convention to address exclusively cultural property – the 1954 *Hague Convention for the Protection of Cultural Property in the Event of Armed Conflict*.

HISTORICAL BACKGROUND

The looting and destruction of cultural heritage during and in the wake of warfare has a long history, going back even to ancient times. Cultural looting served to emphasise to the defeated the loss of their political, cultural and religious freedom, and it demonstrated the might of the conqueror in asserting its cultural dominance. The effects of cultural looting are well illustrated in the depiction on the Arch of Titus in Rome of the triumphal procession in which the Menorah and other sacred implements taken from the Second Temple in Jerusalem at the time of its destruction in AD 70 were displayed as war booty (Miles 2008, 260–63). However, some Roman authors, particularly Cicero in his prosecution in 70 BC of Gaius Verres, the Roman governor of Sicily, for greed and corruption, expressed ambivalence concerning the extent to which cultural and religious works could be plundered without offending religious or moral principles.

1 A version of this chapter was originally published in *Archaeologies* 5 (1), April 2009 (Springer).

As the European concept of a law of warfare developed in the 16th and later centuries, legal commentators were divided over whether cultural sites and objects were legitimate war booty or a distinct form of protected property. During this period, the concept of the 'just war' developed: any actions necessary to accomplish the purposes of a just war were considered legitimate, but the destruction or appropriation of cultural property was not considered necessary to achieve these purposes. For example, the Dutch jurist Hugo Grotius, who laid the basis for general international law, set out in his treatise *De jure belli ac pacis* (*On the Law of War and Peace*), published in 1625, his theories on the just war and the proper rules for conducting warfare, writing that '"those things which, if destroyed, do not weaken the enemy, nor bring gain to the one who destroys them", such as "colonnades, statues, and the like" – that is, "things of artistic value"' should not be destroyed (O'Keefe 2006, 6).

During the 18th-century Enlightenment the concept that artistic works had a distinct, protected status was fostered by the belief that educated people of all nations were united by an appreciation of and love for works of art and architecture. Although still tempered by the doctrine of necessity, this belief imposed an obligation to ensure that such works were protected. The Swiss philosopher, legal expert and jurist Emmerich de Vattel expressed this view when he wrote in *Droit des Gens* (*The Law of Nations*) in 1758:

> For whatever reason a country be ravaged, those buildings must be spared which do honour to humanity and which do not contribute to the enemy's strength, such as temples, tombs, public buildings and all works of remarkable beauty. What is to be gained by destroying them? It is the act of a sworn enemy of the human race to deprive it lightly of such monuments of the arts … (O'Keefe 2006, 11)

At the turn of the 19th century the French emperor Napoleon rejected these scruples and looted artworks and other cultural objects from throughout Europe as well as Egypt. French artists expressed ambivalence: some praised this transfer of artworks to Paris as rescuing them for the benefit of both the French and other peoples of Europe; others, particularly the architectural theorist Antoine-Chrysostôme Quatremère de Quincy, objected, arguing that cultural objects belonged and were best understood within their original contexts. Following Napoleon's defeat, the Duke of Wellington established a new modern precedent by refusing to take cultural objects from France as war booty and instead insisting that the French return to their nations of origin cultural objects taken during the Napoleonic Wars. Even so, only about half of the objects taken by Napoleon were returned, thus forming the basis for future claims by Germany against France for restitution.

The precedent set by the Duke of Wellington was followed in the first codification of a law of warfare. Francis Lieber, a Prussian soldier and classicist who had been present at the Battle of Waterloo and later became a law professor at Columbia University in New York, was asked by President Abraham Lincoln to draft a code of conduct during warfare for the United States army during the Civil War. The 1863 *Instructions for the Government of Armies of the United States in the Field* (General Order No. 100), known as the Lieber Code, set rules that explicitly acknowledged

that special treatment was warranted for charitable institutions, scientific collections and works of art. The Lieber Code classified such property, regardless of who owned it, as non-public property, in order to distinguish it from movable public property that could be used as war booty to further the war effort.

The relevant sections of the Lieber Code state:

> 31. A victorious army appropriates all public money, seizes all public movable property until further direction by its government, and sequesters for its own benefit or that of its government all the revenues of real property belonging to the hostile government or nation. The title to such real property remains in abeyance during military occupation, and until the conquest is made complete.

> 34. As a general rule, the property belonging to churches, to hospitals, or other establishments of an exclusively charitable character, to establishments of education, or foundations for the promotion of knowledge, whether public schools, universities, academies of learning or observatories, museums of the fine arts, or of a scientific character–such property is not to be considered public property in the sense of paragraph 31; but it may be taxed or used when the public service may require it.

> 35. Classical works of art, libraries, scientific collections, or precious instruments, such as astronomical telescopes, as well as hospitals, must be secured against all avoidable injury, even when they are contained in fortified places whilst besieged or bombarded.

> 36. If such works of art, libraries, collections, or instruments belonging to a hostile nation or government, can be removed without injury, the ruler of the conquering state or nation may order them to be seized and removed for the benefit of the said nation.

> The ultimate ownership is to be settled by the ensuing treaty of peace.
> In no case shall they be sold or given away, if captured by the United States, nor shall they ever be privately appropriated, or wantonly destroyed or injured.

Many of these principles were picked up in the 1899 and 1907 *Hague Conventions with Respect to the Laws and Customs of War on Land*, the first international treaties to make specific provision with respect to protecting cultural property during warfare. Articles 23, 28 and 47 of the 1899 *Convention Annex* prohibit pillage and seizure of property by invading forces. Article 56 requires armies to take all necessary steps to avoid seizure, destruction and intentional damage to 'religious, charitable, and educational institutions, and those of arts and science' as well as to 'historical monuments [and] works of art or science'.

The Regulations annexed to the 1907 *Hague Convention on Land Warfare* expanded the 1899 Convention and had two key provisions. The first, contained in Article 27, dealt with the obligation to avoid damaging particular structures.

> In sieges and bombardments all necessary steps must be taken to spare, as far as possible, buildings dedicated to religion, art, science, or charitable purposes, historic monuments, hospitals, and places where the sick and wounded are collected, provided they are not being used at the time for military purposes.

> It is the duty of the besieged to indicate the presence of such buildings or places by distinctive and visible signs, which shall be notified to the enemy beforehand.

However, one may note that this article contains three important caveats. First, the obligation to avoid causing damage to these buildings is limited by the phrase 'as far as possible', and therefore the obligation gives way to the exigencies of warfare. In addition, two obligations are imposed on the besieged: to mark the buildings with a distinctive sign (which must be communicated to the enemy in advance) and to avoid using the buildings for military purposes. If the buildings are used for military purposes, then the protection of this provision is forfeited.

The second provision is in Article 56:

> The property of municipalities, that of institutions dedicated to religion, charity and education, the arts and sciences, even when State property, shall be treated as private property.

> All seizure of, destruction or wilful damage done to institutions of this character, historic monuments, works of art and science, is forbidden, and should be made the subject of legal proceedings.

Here the obligation to protect property (both movable and immovable) belonging to institutions of a religious, charitable, educational, historic and artistic character from intentional damage is absolute. Furthermore, this complements Article 55, which emphasises that an occupying power has an obligation to preserve and safeguard the value of immovable property, including forests and agricultural lands. Another provision of the Conventions imposes a more generalised obligation on an occupying power to preserve and safeguard the value of immovable property, as well as to ensure the safety and security of the local populations in occupied territory.

These treaties were particularly important because all the major combatants during both world wars, including the United States and the European nations, were parties to them. While these treaties were unable to prevent the cultural devastation wreaked on Europe, and international conventions are routinely criticised for their apparent ineffectiveness in preventing such destruction, the Conventions serve an important role in punishing, even if after the fact, those who violate their directives. At the end of World War I Germany was required to make reparations to France, Belgium and other countries for damage caused to cultural sites and monuments. At the end of World War II some of the Nazi leadership – in particular, Alfred Rosenberg, who headed the Einsatzstab des Reichsleiter Rosenberg, the Nazi unit that engaged in systematic art looting and confiscation – were prosecuted and executed for violations of the Hague Conventions, including engagement in the organised plunder of both public and private property (United States Holocaust Memorial Museum nd). Finally, these earlier conventions were used, particularly as embodying customary international law, in prosecutions of Serbian military leaders for intentional damage to cultural property during the Balkan Wars of the 1990s. Article 3(d) of the *Statute of the International Criminal Tribunal for the former Yugoslavia* (ICTY) states that 'seizure of, destruction or wilful damage done to institutions dedicated to religion, charity and education, the

arts and sciences, historic monuments and works of art and science' are violations of the laws or customs of war (United Nations 2009). This provision was utilised in four cases brought before the ICTY, including that of Pavle Strugar, who was convicted in 2005 for the intentional attack on the Old Town of Dubrovnik, a World Heritage Site, as well as for other war crimes (UNESCO 2005, 6–7).

The tasks of protecting cultural sites during World War II and of returning cultural objects after the war fell to the Monuments, Fine Arts and Archives teams established by the United States and British militaries. These teams were composed of historians, art historians, classicists and archaeologists, and they played a significant role in preserving Europe's cultural heritage. Initial restitution efforts were carried out by government mandate, but these efforts continue today largely as the result of private initiative and lawsuits prompted by the descendants of the original owners. With the exception of the Soviet Union, none of the victorious allies deliberately attempted to retain cultural objects as war reparations from Germany, and it was the explicit policy of the United States and Great Britain to return cultural objects to their owners.

THE 1954 HAGUE CONVENTION AND ITS PROTOCOLS

Following the devastation of World War II, the international community promulgated a series of international humanitarian conventions, including the 1954 *Hague Convention for the Protection of Cultural Property in the Event of Armed Conflict*. Although it was based on the earlier Hague Conventions, the 1935 *Roerich Pact* that applied only in the Americas, and a draft convention started before World War II, the 1954 Hague Convention was the first international convention to exclusively address cultural property.

The Hague Convention begins with a Preamble asserting the universal value of cultural property whereby we are all diminished when cultural property, situated anywhere in the world, is damaged or destroyed. In setting out the justifications for the Convention, the Preamble states that the nations join the Convention:

> Being convinced that damage to cultural property belonging to any people whatsoever means damage to the cultural heritage of all mankind, since each people makes its contribution to the culture of the world;

> Considering that the preservation of the cultural heritage is of great importance for all peoples of the world and that it is important that this heritage should receive international protection[.]

The phrasing of the Preamble draws on a tradition that imposes obligations on nations to care for the cultural property within their borders during both peacetime and military conflict.

In Article 1, the Convention defines cultural property to include:

> movable or immovable property of great importance to the cultural heritage of every people, such as monuments of architecture, art or history, whether religious or secular; archaeological sites; groups of buildings which, as a whole, are of historical or artistic

interest; works of art; manuscripts, books and other objects of artistic, historical or archaeological interest; as well as scientific collections and important collections of books or archives

Also included in the definition are buildings whose purpose is to preserve or exhibit cultural property, including museums, libraries and archives, as well as refuges intended to shelter cultural property during armed conflict.

The core principles of the 1954 Hague Convention are the requirements to safeguard and to respect cultural property. Article 3 defines the safeguarding of cultural property: nations have the obligation to safeguard cultural property by preparing during peace to protect it from 'the foreseeable effects of an armed conflict'. Article 4 addresses the respect that should be shown to cultural property during armed conflict and imposes primarily negative obligations – that is, actions which a nation is required to refrain from taking. The first provision calls on nations to respect cultural property located in their own territory and in the territory of other parties to the Convention by refraining from using the cultural property 'for purposes which are likely to expose it to destruction or damage' during armed conflict and by refraining from directing any act of hostility against such property. Unfortunately, the next provision provides for a waiver of these obligations where 'military necessity imperatively requires such a waiver'. The Convention is unclear as to what is meant by military necessity. While there have been some attempts to define it, there is no universal agreement and it has been argued that this provision significantly undermines the value of these provisions as a whole.

The third paragraph of Article 4 had received virtually no commentary or interpretation until after the looting of the Iraq Museum in Baghdad in April 2003. The provision states that parties to the Convention 'undertake to prohibit, prevent and, if necessary, put a stop to any form of theft, pillage, or misappropriation of, and any acts of vandalism directed against, cultural property'. When read literally, it seems to impose an obligation on nations to prevent *any* form of theft or pillage, even if it is being carried out by the local population. However, for reasons that I have explained more fully elsewhere (Gerstenblith 2006, 308–11), this provision probably refers only to an obligation to prevent acts of theft, pillage and misappropriation carried out by members of the nation's own military. In particular, because there is no caveat stating that the obligation extends only to what is feasible or practical under the circumstances and given the post-World War II context in which the Convention was written, it seems very unlikely that the drafters intended to impose a blanket obligation during conflict. However, it is perfectly reasonable to expect nations to control the conduct of their own military and to provide for punishment of those who violate such restrictions. The final provisions of Article 4 prohibit the requisitioning of cultural property and acts of reprisal taken against cultural property.

Article 5 turns to the obligations of an occupying power. The primary obligation of an occupying power is to support the competent national authorities of the occupied territory in carrying out their obligations to preserve and safeguard its cultural property. The only affirmative obligation imposed is to take 'the most necessary measures of preservation' for cultural property damaged by military

operations and only if the competent national authorities are themselves unable to take such measures. The primary value promoted by this provision is one of non-interference – in other words, the occupying power should interfere as little as possible with the cultural heritage of the occupied territory, and only when the local authorities are unable to do so. Any actions taken by the occupying power should be done only in concert with the competent national authorities whenever and to the extent possible.

The Convention provides special protection for centres with monuments, immovable cultural property and repositories of movable cultural property (Articles 8–11), but this mechanism has rarely been used. Cultural property under special protection is immune from acts of hostility except in exceptional cases of 'unavoidable military necessity' or if the property or its surroundings are used for military purposes. Article 6 provides for the marking of cultural property with the Blue Shield symbol, as outlined in Article 17. Article 7 requires parties to the Convention to introduce into their military regulations and instructions provisions to ensure observance of the Convention and to foster a spirit of respect for the culture and cultural property of all peoples. It also requires nations to establish within their armed forces services or specialist personnel whose purpose it is to secure respect for cultural property and to cooperate with the civilian authorities responsible for safeguarding cultural property.

The First Protocol to the Convention was written contemporaneously with the Convention to address the disposition of movable cultural property. These provisions were separated from the main Convention at the request of the United States and other Western nations, which were reluctant to restrict the flow of cultural objects. The First Protocol consists of two parts; when ratifying the First Protocol, nations can opt out of one part or the other. The first part requires occupying powers to prevent the export of cultural property from occupied territory, take into their custody any cultural property in their territory that has been illegally exported from occupied territory and to return such cultural property to the competent authorities of formerly occupied territory at the end of hostilities. If such cultural property must be returned, the occupying power that had the responsibility to prevent the export from occupied territory must pay an indemnity to the holder in good faith of the cultural property. The second part of the First Protocol requires nations that take cultural objects into custody during conflict for the purpose of protecting them to return the objects at the conclusion of hostilities. The First Protocol was not popular with the major art market nations of Western Europe and the United States and has been ratified by fewer nations than the main Convention.

After four decades of experience with the Convention and, particularly, the experiences during the Balkan Wars, UNESCO undertook the writing of the Second Protocol, which was completed in 1999 and came into effect in 2004 (Boylan 1993). The Second Protocol accomplishes five primary goals: it narrows the circumstances in which the 'military necessity' waiver can apply; it requires nations to establish a criminal offence for serious violations of the Convention, including responsibility for those in higher command; it requires the avoidance or minimisation of collateral damage to cultural property; it requires that the justification for a legitimate military action that might cause damage to cultural property must be proportionate to the damage that may result, and it clarifies the 'non-interference' principle – that is, that

occupying powers should not interfere with or destroy the cultural or historical evidence of the occupied territory and should not conduct archaeological excavations, unless necessary to preserve the historical record, and that occupying powers have an obligation to prevent illegal export of cultural property from occupied territory.

At this time there are 123 High Contracting Parties to the main Convention, 100 Parties to the First Protocol and 56 Parties to the Second Protocol. The United States and the United Kingdom *signed* the main Convention in 1954 but had not *ratified* it at the time of the 2003 Gulf War. However, by signing the Convention these nations indicated their intention to ratify it. Furthermore, 'customary international law imposes an obligation on states that have expressed intent to be bound to a treaty through signature to refrain from any activity that might defeat the "object and purpose" of that treaty for the period of time ratification is pending' (Corn 2005, 35). However, a convention is not legally binding on a nation until it completes the formal process, which differs from nation to nation, by which the nation becomes a State Party. Neither the US nor the UK has signed either the First or the Second Protocol.

Despite its failure to ratify the Convention, the policy of the United States was to view as binding those provisions of the Hague Convention that the United States regarded as part of customary international law. Customary international law is general practice among nations that is accepted as law. To be a part of customary international law, a rule must be a part of State practice and there must be 'a belief that such practice is required, prohibited or allowed ... as a matter of law ...' (Henckaerts 2005, 178); because customary international law is based on a combination of State practice and rules that are generally accepted among nations, it is therefore difficult to determine its precise content. Those core provisions of the Hague Convention that are accepted as customary international law include the primary responsibility of nations to protect the cultural property located within their own territory, the obligation to avoid targeting cultural sites, subject to the military necessity waiver, and the obligation to prevent members of the military from engaging in theft, pillage and misappropriation of cultural property. Beyond these core principles, however, it is difficult to determine what other provisions of the main Convention and the two Protocols are part of customary international law.

In addition to the Hague Convention and its Protocols, other international instruments are available to protect cultural property. For example, Article 53 of *Additional Protocol I* of the *1977 Protocols to the 1949 Geneva Conventions* states that it is prohibited '(a) to commit any acts of hostility directed against the historic monuments, works of art or places of worship which constitute the cultural or spiritual heritage of peoples; (b) to use such objects in support of the military effort; (c) to make such objects the objects of reprisals'. Similar provisions appear in *Protocol II to the Geneva Conventions*, but these are focused more explicitly on conflicts of a non-international character. Finally, article 8 of the Rome *Statute of the International Criminal Court* includes among its serious violations 'intentionally directing attacks against buildings dedicated to religion, education, art, science or charitable purposes [and] historic monuments ... provided they are non-military objectives'.

RECENT DEVELOPMENTS

The situation with respect to ratification and implementation of the Hague Convention is in the process of radical change. In 2004, on the Convention's 50th anniversary, the United Kingdom announced its intention to ratify the Convention. Following the release of a Consultation Paper and opportunity for public comment, the United Kingdom introduced draft legislation for implementation of the Convention and both Protocols in January 2008. This legislation is notable for establishing, in line with the requirements of the Second Protocol, a criminal offence for serious breaches of the Convention and of the Second Protocol, including liability for those in command. The legislation also implements the First Protocol by establishing a criminal offence for a person who deals 'in cultural property illegally exported from occupied territory knowing or having reason to suspect that it has been unlawfully exported'. This legislation has, however, become bogged down in discussion over certain aspects of implementation and the UK has not moved further towards ratification. New Zealand also introduced implementing legislation for all three instruments in Parliament at the beginning of September 2008, but has so far ratified only the main Convention.

Although the United States signed the Convention in 1954 it took no further action throughout the Cold War because of objections from the military. With the collapse of the Soviet Union, the US military withdrew its objections. President Clinton transmitted the Convention and First Protocol to the Senate Foreign Relations Committee in 1999, but no action was taken until the State Department placed them on its treaty priority list in early 2007. The Senate Foreign Relations Committee held hearings in April 2008, and the Senate gave its advice and consent to ratification of the Convention in September 2008. The United States deposited its instrument of ratification on 13 March 2009 and immediately became a party under Article 33, which allows ratification to be given immediate effect for nations currently engaged in armed conflict. Although President Clinton transmitted the First Protocol in 1999 along with the main Convention, and it was placed by the State Department on its treaty priority list, the Senate Foreign Relations Committee did not consider it, and it was not voted on by the Senate.

United States ratification of the Convention was subject to four understandings and one declaration. The First Understanding states that the level of protection accorded to property under special protection is one that is consistent with existing customary international law; the Second Understanding states that the action of any military commander or other military personnel is to be judged based on the information that was reasonably available at the time an action was taken; the Third Understanding states that the rules of the Convention apply only to conventional weapons and do not affect other international law concerning other types of weapons, such as nuclear weapons; and the Fourth Understanding states that the provisions of Article 4(1) requiring Parties 'to respect cultural property situated within their own territory ...' means that the 'primary responsibility for the protection of cultural objects rests with the Party controlling that property, to ensure that it is properly identified and that it is not used for an unlawful purpose'. The Declaration states that

the Convention is self-executing, meaning that it operates 'of its own force as domestically enforceable federal law', without requiring any implementing legislation, but the Declaration also notes that the Convention does not confer any private rights enforceable in US courts (Senate Foreign Relations Committee 2008).

While US policy has been to follow the principles of the Convention, ratification brings additional advantages. It will increase awareness of the importance of protecting cultural heritage during conflict, including the incorporation of heritage preservation into all phases of military planning, and it will clarify the United States' obligations and encourage both the training of military personnel in cultural heritage preservation and the recruitment of cultural heritage professionals into the military. The area where ratification of the Hague Convention could have the greatest impact is in preventing unintentional damage resulting from ignorance rather than intentional actions, as the possibility of unintentional damage is reduced through the educational efforts required by the Convention. A military that is better informed about the value of cultural heritage and the specifics of the cultural heritage of an occupied territory (such as the location of sites and monuments) will be less likely to cause unintended harm. Perhaps most importantly, ratification sends a clear signal to other nations that the United States respects their cultural heritage and will cooperate with its allies and Coalition partners in achieving more effective preservation efforts in areas of armed conflict.

CONCLUSION

While the 2003 Gulf War caused devastating losses to Iraq's cultural heritage, far beyond those sustained in the looting of the Iraq Museum, the war also seems to have provided the necessary impetus for several of the major military powers to take action to ratify and implement the 1954 Hague Convention. Unlike the United Kingdom, which is attempting to address all three instruments at the same time, the United States has not moved on either of the two Protocols. Such action must await review by the appropriate executive agencies. However, the same motivations for ratification of the main Convention apply to ratification of the two Protocols. In particular, the United States may be left in a situation in which its closest military allies will be subject to differing legal requirements with regard to the protection of cultural heritage during armed conflict and occupation. It is to be hoped that the United States will soon consider the two Protocols so that it can continue to demonstrate its commitment to preserving the world's cultural heritage.

BIBLIOGRAPHY AND REFERENCES

Boylan, P J, 1993 *Review of the Convention for the Protection of Cultural Property in the Event of Armed Conflict (The Hague Convention of 1954)*, UNESCO Doc Ref CLT-93/WS/12 101

Corn, G S, 2005 Snipers in the Minaret – What is the Rule? The Law of War and the Protection of Cultural Property: A Complex Equation, *The Army Lawyer* 386, 28–40

Gerstenblith, P, 2006 From Bamiyan to Baghdad: Warfare and the Preservation of Cultural Heritage at the Beginning of the 21st Century, *Georgetown Journal of International Law* 37, 245–351

Henckaerts, J-M, 2005 Study on Customary International Humanitarian Law: A Contribution to the Understanding and Respect for the Rule of Law in Armed Conflict, *International Review of the Red Cross* 87 (857), 175–212

Miles, M M, 2008 *Art as Plunder: The Ancient Origins of Debate about Cultural Property*, Cambridge University Press, New York

Miles, M M, forthcoming Still in the Aftermath of Waterloo (provisional title), in *Cultural Heritage, Ethics, and the Military* (ed P G Stone), The Boydell Press, Woodbridge

O'Keefe, R, 2006 *The Protection of Cultural Property in Armed Conflict*, Cambridge University Press, New York

Senate Foreign Relations Committee, 2008 *The Hague Cultural Property Convention: 110th Congressional 2d Session Executive Report 110–26*, available from

http://frwebgate.access.gpo.gov/cgi-bin/getdoc.cgi?dbname=110_cong_reports&docid=f:er026.pdf [accessed 6 October 2009]

UNESCO, 2005 *Report on the Implementation of the 1954 Hague Convention for the Protection of Cultural Property in the Event of Armed Conflict and its two 1954 and 1999 Protocols*, UNESCO Doc Ref CLT-2005/WS/6

United Nations, 2009 *Updated Statute of the International Criminal Tribunal for the Former Yugoslavia*, available from

http://www.icty.org/x/file/Legal%20Library/Statute/statute_sept09_en.pdf

[accessed 6 October 2009]

United States Holocaust Memorial Museum, nd Alfred Rosenberg, *Holocaust Encyclopedia*, available from http://www.ushmm.org/wlc/article.php?lang=en&ModuleId=10007123 [accessed 6 October 2009]

Rescuing Europe's Cultural Heritage: The Role of the Allied Monuments Officers in World War II

KRYSIA SPIRYDOWICZ

INTRODUCTION

Throughout history the looting of enemy property in times of war has been an accepted practice. Monuments, works of art and culturally significant objects have always been favoured targets. Not until the 20th century did a more enlightened attitude finally emerge. The most successful large-scale action to rescue and protect cultural property in the 20th century occurred during World War II. British and American fine art advisers were attached to fighting units in the Allied forces in Europe with the express objective of preserving what remained of Europe's great architectural and artistic traditions. This chapter will focus on the history and accomplishments of this extraordinary group of men and women.

INITIAL RESPONSE

In the early 1940s the occupation of Western Europe by Nazi forces led to growing concern, both in Britain and in America, over the protection of works of art and monuments located in the war zones. In the USA, numerous civilian groups were formed at centres of learning. The most prominent of these included a special committee of the American Council of Learned Societies and the American Defense–Harvard Group, which consisted of concerned faculty from Harvard University in combination with local citizenry (Smyth 1988). In response to a request from the War Department, both groups began to prepare lists of art objects and monuments requiring protection in occupied territories or in possible theatres of war.

A four-part report was produced which consisted of lists of monuments and artworks organised by country and included an explanation of the significance of the material, a brief historical outline and a short bibliography. Also included was a brief 'first aid' manual outlining principles and practices of safeguarding and preserving cultural material in the field as well as lists of military and civilian personnel experienced in handling cultural material (Perry 1943). This comprehensive document, which included lists for virtually all enemy-occupied countries, was all the more remarkable for the fact that it was completed within eight months by busy museum professionals and academics.

Lobbying of the US government by the Harvard Group and the American Council of Learned Societies, combined with the efforts of prominent individuals such as Francis Henry Taylor, Director of the Metropolitan Museum of Art, and William

Dinsmoor, President of the Archaeological Institute of America, eventually led to the formation in August 1943 of the American Commission for the Protection and Salvage of Artistic and Historic Monuments in Europe. Chaired by Supreme Court Justice Owen J Roberts, this body quickly became known as the Roberts Commission. Its extensive responsibilities included the protection and conservation of works of art and historical records in Europe as well as the eventual salvage and restitution to the lawful owners of objects appropriated by the Axis powers (American Commission 1946).

The efforts of the Roberts Commission led to the creation of the Monuments, Fine Arts and Archives Section (MFA&A), which was officially attached to the G-5 Division of the Supreme Headquarters Allied Expeditionary Force (SHAEF). Because of the joint nature of operations, both British and American officers were involved. The original prospectus called for a large operation headed by a lieutenant colonel to be assisted by two majors and a sizeable field staff. Owing to a lack of resources, this ambitious plan had to be scaled back significantly.

British participation in the MFA&A was organised by Sir Leonard Woolley. This well-known British archaeologist was appointed Archaeological Adviser to the Director of Civil Affairs in November 1943 (Woolley 1944). Because of his elevated status in the British Army, Colonel Woolley was able to appoint Geoffrey Webb, Slade Professor of Fine Art at Cambridge, as Director of MFA&A operations for the Allied Forces. Soon after, British experts from similar academic and museum backgrounds to their American counterparts were seconded to the MFA&A.

The organisers wished to avoid the problems that had developed during the earlier invasion of Italy by Allied forces. Owing to military secrecy and lack of coordination the protection of monuments in Italy first took place on a rather *ad hoc* basis. Firstly, MFA&A officers were assigned to specific zones that could not be entered until taken in their entirety by the invasion forces. And even after reaching their assigned locations, officers were often hampered in their movements by a lack of transportation. The Supreme Commander of the Allied Forces, General Dwight Eisenhower, was initially lukewarm to any preservation concerns in Italy. He felt that the rescue and restoration of cultural property was a civilian, rather than a military responsibility. The British reacted in horror to the prospect of a combined civilian–military operation in the field. Eventually, Churchill's government prevailed upon President Roosevelt to abandon the idea. British political pressure was also responsible for an inquiry into complaints of looting by American forces during the occupation of Naples and ultimately, for Eisenhower's first order concerning the protection of monuments in Italy which admonished higher commanders to determine the location of historical monuments and to avoid destruction of famous buildings whenever possible. After this, the lot of the MFA&A officers improved considerably. They were allowed to travel with combat units so that they arrived on the scene in a more timely fashion. Access to information was also improved, with the distribution of small booklets listing monuments in each region rather than the lengthy lists originally compiled by the Harvard Group.

MFA&A personnel, known informally as Monuments Officers, consisted of young, talented men and women who in civilian life had been architects, art

professors, museum curators, conservators and artists. Many had already enlisted and been recommended for transfer from other tasks by the Roberts Commission. Among the first Americans in the group were Bancel LaFarge, a New York architect, George Stout, head of conservation at the Fogg Art Museum at Harvard, Deane Keller, Professor of Fine Art at Yale, and James Rorimer, Curator at the Cloisters, Metropolitan Museum of Art. British participants included Edward Croft-Murray, Assistant Keeper of Prints and Drawings at the British Museum, architect J E Dixon-Spain and Douglas Cooper, art historian and art critic.

D-Day Invasion

Prior to D-Day, much careful planning took place to ensure that the disasters that had taken place in Italy were not repeated. A more flexible assignment system was created and operations were generally streamlined. The chief responsibilities of a MFA&A officer were defined – that is, to protect monuments from unnecessary damage or misuse, during and after combat; to arrange for emergency repairs to damaged monuments; to record thefts of works of art by the enemy; and to collect any evidence which might lead to their eventual recovery (American Commission 1946).

By the date of the D-Day invasion the entire MFA&A complement consisted of 17 men. George Stout, by now a Lieutenant in the US Navy, was transferred to the ranks of the MFA&A. The first Monuments Officer to arrive in France after D-Day was Bancel LaFarge, who was soon joined by Stout. Together with a British colleague from the RAF, Squadron Leader J E Dixon-Spain, they began the near impossible task of inspecting and protecting what remained of Europe's cultural heritage. Initially they received little support and had to resort to travelling by liberated bicycle or hitch-hiking. Their reports were often composed on borrowed typewriters.

The MFA&A in Normandy

LaFarge and Stout began their work in Bayeux, a cathedral town that had survived the fighting virtually intact. As they moved on to Caen, they discovered that Allied bombing missions had destroyed almost 70 per cent of the city. Unfortunately, the latter situation tended to be the norm in many of the towns and cities that they visited in Normandy in the ensuing weeks. Although Allied bomber pilots had been instructed to avoid destroying historic monuments wherever possible, many of the great cathedrals and abbeys in Normandy were badly damaged. Intact as well as partially destroyed buildings frequently contained mines or other lethal booby traps. Occasionally, Monuments Officers used this to their advantage. Stout and others were able to protect the shattered remnants of some historic monuments from complete demolition by Army engineers by roping off areas with white tape, signalling the presence of unexploded mines.

In northern France Monuments Officers reported on damage resulting from German air attacks at the beginning of the war in 1940 as well as damage caused by Allied aerial bombardment in the spring and summer of 1944. In areas such as the Somme, where fighting had occurred during World War I, numerous monuments still

bore the scars of that terrible conflict. Some repairs had been made to damaged buildings by local officials during the Nazi occupation. Owing to the enormity of the task, Monuments Officers preferred to assist local officials whenever possible rather than assuming direct responsibility for protecting damaged monuments.

In October 1944 the British MFA&A officer, Major Lord Methuen, described repair work that was in progress. He reported that, owing to the lack of supplies of new roof tiles, old tiles were being stripped from non-essential buildings so that the roofs of essential buildings, including historic monuments, could be repaired prior to the onset of winter (Methuen 1952). Other emergency work included the sorting of damaged masonry, the temporary roofing of damaged churches, the capping of exposed stone walls with concrete and the erecting of tubular scaffolding to support weakened masonry structures.

Monuments Officers also began the struggle to prevent souvenir hunting and/or looting by idle occupation forces. Particularly during the final frigid winter of the war, the billeting of large numbers of soldiers in historic homes and palaces was a major issue. Unoccupied chateaux in France and later in Belgium provided attractive housing solutions for many commanders. It was the task of the billeting officers under the guidance of the MFA&A to warn against damaging property of artistic value. This arrangement generally worked well; however, in the chaos of war, some units installed themselves first and consulted afterwards.

CULTURAL PROPERTY IN FRANCE

As Allied troops advanced across Europe the extent of looting of artworks by Nazi forces gradually became apparent. The situation in France differed somewhat from the rest of Europe because of the division of the country into occupied and unoccupied zones. Shortly before the outbreak of war, most institutional collections had been sent for safety to repositories in remote areas of western and southern France and, throughout the war, French museum personnel remained on guard in these locations. Although the Nazis regularly inspected many of the repositories, they did not disturb the valuable contents, believing that they could easily be claimed at the end of the war (Ross 1946). French museum officials, including M Jacques Jaujard, Director of the Louvre, successfully used the tactic of bureaucratic delay to prevent some of the greatest masterpieces from being shipped to Germany.

Private art collections did not fare as well as French institutional collections. Jewish property was ruthlessly plundered by the notorious Nazi unit, headed by Alfred Rosenberg, that was known as the Einsatzstab Reichsleiter Rosenberg (ERR) or Task Force Rosenberg. Initially charged by Hitler with the task of transporting valuable cultural goods to Germany for safeguarding, this unit eventually descended to the stripping of any useful goods, including furniture, bed linen and clothing, from Jewish houses in Paris and the Occupied Western Territories. Less than two weeks after the capitulation of the French government, the confiscation of the property of wealthy Jewish families began. This included the contents of chateaux and fine residences as well as the remaining stocks of artworks belonging to the leading Jewish art dealers in Paris.

In spite of the looting and destruction of artworks that characterized Nazi regimes throughout Europe, it should be noted that the Nazis had their own counterpart of the MFA&A, known as the Kunstschutz, an organisation that was originally set up during World War I as a fine art protection service (Clemen 1919). Revived in May 1940, the Kunstschutz was responsible for the protection of monuments, works of art and other cultural material in the Occupied Territories. In France, this organisation was headed by Count Wolff-Metternich, a respected art historian who did not belong to the Nazi party. During the initial weeks of the Nazi occupation of France, Count Metternich was instrumental in preventing the removal of artworks from the main French repositories, an act which he considered to be a contravention of Article 46 of the Hague Convention.

The Kunstschutz dealt with many of the same problems that were later encountered by the MFA&A. Preventing or controlling the billeting of troops was a major concern. Instructions issued to Kunstschutz officers regarding the protection of important chateaux included recommendations about fire prevention, with special warnings to place gasoline and ammunition dumps well away from any structures. There was also the recognition that, if destruction of buildings occurred, the Kunstschutz would be held liable. Valuable paintings and furniture were to be locked up and libraries and archives were to be placed off limits.

Kunstschutz officials were also responsible for the care of monuments. Under their supervision, considerable restoration work took place at Versailles and other important chateaux. Even as Allied forces advanced into Normandy, their organisation continued to safeguard monuments damaged by Allied aerial bombardment. Nevertheless, the Kunstschutz had a dark side. The organisation maintained links with the Task Force Rosenberg and with art dealers working for Nazi party leaders. Numerous references to artworks, books and manuscripts that were to be returned to Germany once peace negotiations were completed revealed the ultimately sinister objectives of this organisation (Ross 1946).

ENTERING THE RHINELAND

After the liberation of Paris the Allied armies swept on through Alsace to Belgium and Holland. George Stout and his companions experienced continual difficulties because of the unusual nature of their mission. As a Naval officer, Stout received little assistance from Army officials, but he finally managed to solve his billeting difficulties by attaching himself to the Twelfth Army. His transportation problems were eased by the chance find of a barely functioning Volkswagen, formerly the property of the German Army. On 17 September 1944, he was ordered to Maastricht in Holland, where he inspected the first of many art repositories that the Monuments Officers were to encounter. With Nazi approval, the Dutch government had stored over 800 paintings for the duration of the war in the limestone tunnels close to town. Finding the paintings to be in good shape, Stout recommended that the collection remain *in situ* for the time being.

Walter Hancock and George Stout were the first Monuments Officers to observe the state of German cities after months of bombing. They were shocked by the terrible

devastation. When Walter Hancock entered Aachen, once the glorious capital of Charlemagne's empire, he found the city completely abandoned with only the shells of buildings still standing. At considerable personal risk, he dodged German shells in order to inspect the Cathedral. To his surprise, he found the medieval building relatively intact and the shell-shocked vicar still in residence. Because of the continued danger of fire from German shelling, the vicar urged Hancock to reassemble the fireguard. This group of six teenage boys belonging to the Hitler Youth had already saved the Cathedral several times from blazes started by incendiary bombs. After clearance from the US Military Governor, Hancock and Stout were able to reinstate the youthful, eager guards (Hancock 1946). This was the first of many similar situations to be faced by the Monuments Officers: how to distinguish between Nazi and non-Nazi elements in the local population and how to delegate responsibility effectively in a society completely shattered by war.

While inspecting the Seurmondt Museum in Aachen, George Stout made an important discovery in the debris: an annotated copy of the museum's catalogue that indicated that part of the collection had been moved from Meissen to Siegen. It seemed likely that only the most precious objects would make such a perilous journey; therefore Stout expected to find a repository there containing objects of great importance. SHAEF Headquarters was informed of the possibility that a valuable cache of artworks would soon come to light.

DISCOVERY OF THE UNDERGROUND REPOSITORIES

Realising that Nazi rule was about to end, German citizens began to volunteer information. When questioned by Walter Hancock, a German architect confirmed Stout's surmise that important works of art were to be found at Siegen, in the copper mine under the old town. Within a few days, Hancock learned of the existence of 230 repositories through information provided by museum and university officials. Instructions were issued to Allied combat units that, as soon as repositories were found, military guards were to be posted, along with 'off limits' signs.

In early April Stout and Hancock entered the mine at Siegen, where they found over 400 paintings, including canvases by Rembrandt, Rubens, Van Dyck, Van Gogh, Gaugin and Cranach, as well as stacks of crates from the museums in Bonn, Cologne, Essen and Munster. Cases containing the treasures of Aachen Cathedral, including the relics of Charlemagne and the robe of the Virgin Mary, were found with their packing seals intact (Hancock 1946).

All of the artworks were at risk from conditions in the mine. The Nazis had installed a heating system to reduce the naturally high humidity levels. This had been operated from a nearby factory that had been destroyed in the recent bombing. Hancock noted that water had dripped from the ceiling and that many of the paintings and polychrome statues were covered with mould. A German restorer estimated that ten years would be required to remedy all of the damage.

An even more spectacular discovery was made only four days later. The salt mine at Merkers in Thuringia was found to contain the entire gold reserves of the Reichsbank as well as a portion of the gold reserves of Belgium. Army sources also

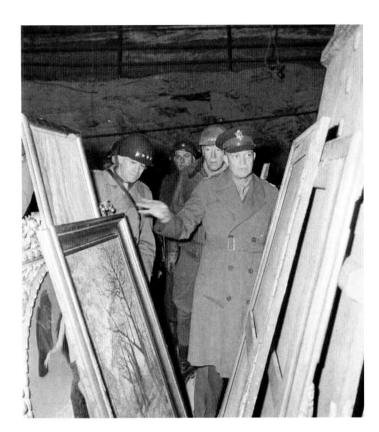

FIG 2.1.
GENERAL DWIGHT
EISENHOWER IN 1945
INSPECTING ART LOOTED
BY THE GERMANS AND
STORED IN THE MERKERS
SALT MINE DURING
WORLD WAR II (BEHIND
HIM ARE GENERAL
BRADLEY, LEFT, AND LT.
GENERAL PATTON,
RIGHT).

mentioned that 'some art' had been found. When Monuments Officers were allowed to inspect the cache, they found an incredible treasure trove including the polychrome head of Queen Nefertiti and the most valuable paintings from the collections of 15 Berlin state museums (American Commission 1946). The find was so astonishing that all of the top US generals came to visit – Eisenhower, Bradley, Eddy and Patton. The resulting publicity eventually eased the lot of the Monuments Officers, who began to receive a greater degree of cooperation from military officials. Suddenly, finding art had become a glamorous activity.

Just before the end of the war, the largest art cache of all was discovered in the Austrian Alps near Salzburg. Over 6000 paintings as well as innumerable pieces of sculpture and other objects had been hidden in the giant salt mine at Alt Aussee. Here was found the great Hitler Collection destined for the museum that the Führer had planned to build at Linz, Austria. Also present was the art stolen from Italy by the Hermann Goering Division in 1944 and most of the artworks plundered from private collections in France, Belgium and the Netherlands by the Task Force Rosenberg. Among the greatest masterpieces sequestered here were the Van Eyck altarpiece from Ghent, the Czernin Vermeer and Michelangelo's sculpture of the Madonna and Child stolen, in the last days of the war, from the Cathedral at Bruges.

When Allied victory appeared to be inevitable, the local Gauleiter ordered the destruction of the mine by planting giant bombs at each of the entrances. The explosives were housed in wooden crates marked 'Care–Marble–Do Not Upset'. Fortunately, Dr Pöchmüller, the chief mining engineer, and others who were concerned for the safety of the artworks learned of this sinister development. In the final chaotic days of the war, the assistance of the salt miners was enlisted to remove the bombs and seal off the mine interior by blowing up the entrance tunnels. This heroic gesture of the miners was in fact driven not by any particular love of art but by their fear that a giant explosion would ruin the mine and take their livelihood along with it (Pöchmüller 1945).

Over 600 repositories of varying sizes were found in Germany and Austria, both above and below ground. With the cessation of hostilities, the Monuments Officers were faced with a series of enormous tasks: to remove the looted artworks from the repositories, to find safe and secure interim storage, to assess damage and provide emergency repairs, to identify and catalogue stolen works and, finally, to assist in the restitution of works to the appropriate European governments.

REMOVAL OF LOOTED ART

To remove artworks to safety, the Monuments Officers used whatever packing materials were at hand. Nazi military stores yielded many useful items, including rubber boots that could be cut into wedges to provide padding between paintings. Gas-proof capes were used as waterproof wrapping (Hancock 1946). George Stout commandeered a stock of sheepskin coats originally destined for Nazi use at the Russian front. Many important works, including Michelangelo's Madonna and Child, were brought out of the mine at Alt Aussee wrapped in the thick sheepskins. The difficulties of working deep underground were numerous. Power failures necessitated time-consuming searches for generators and the fuel to power them (Hancock 1946), and most of the machinery in the mines had been disabled, so that many artworks had to be hoisted manually to the surface.

For labour, the Monuments Officers were left to their own devices, as none could be spared by the military. Generally, they were forced to use groups of Displaced Persons or DPs – that is, individuals of many nationalities brought to Germany to provide slave labour for Nazi projects. Weakened by deprivation, some DPs could barely carry a painting. Thus, the provision of adequate rations became a priority. In cases of extreme need, local jails had to be emptied to provide the necessary manpower (Stout 1945). There were few problems with security in such situations, as most individuals were more than willing to assist the conquering forces after years of suffering under Nazi cruelty.

Transportation for the rescued artworks was another major problem. Truck convoys were often diverted to other tasks at the last minute. When truck drivers did appear, there were frequent additional problems such as providing them with lodging and adequate rations. Even after convoys reached their destinations safely there was sometimes little or no help forthcoming from the occupying military units. When Walter Hancock arrived in the ruined city of Cologne on a weekend with the first load

of looted artworks from the mine at Siegen, local military officials told him 'to come back on Monday'. Monuments Officers were forced to use their own ingenuity in such situations, sometimes contravening military regulations to ensure the safety of their precious cargoes.

Establishing the Collecting Points

As early as 1944 officials at SHAEF Headquarters predicted that storage depots would be necessary for the temporary housing of artworks and cultural materials looted by the Nazis (Smyth 1988). At the war's end, Major Bancel LaFarge, chief of the MFA&A for US military forces in Europe, requested that collecting points be set up in occupied Germany for purposes of protection and custody. A directive to this effect was issued by SHAEF on 20 May 1945.

Four collecting points were established in the US Zone of Occupation at Munich, Marburg, Wiesbaden and Offenbach. The largest and most operationally complex of these was that at Munich, which was housed in the former national headquarters of the Nazi party. Two enormous buildings, the Verwaltungsbau and the Führerbau, were chosen because they were among the largest and least damaged structures in the city. The Collecting Points at Wiesbaden and Marburg, set up in former museum buildings, housed mainly displaced national treasures of German origin. The fourth Collecting Point at Offenbach was used to store printed materials looted from libraries and archives in Eastern and Western Europe (Howe nd).

Craig Hugh Smyth, a young American art historian and Naval lieutenant, was assigned the formidable task of setting up the Collecting Point at Munich. Given few instructions, Smyth had to work out the details for himself, much as Walter Hancock had done earlier when he created a depot at Marburg for the art rescued from the mines at Siegen and Bernterode (Hancock 1946). There were a number of frustrating delays: US troops billeted in one of the buildings had to be removed, and both buildings had to be cleared of sensitive materials that included Nazi party records and Nazi art. Owing to the efforts of Smyth and his fellow officers, surviving Nazi party files were brought to the attention of Army Intelligence and salvaged for later use (Smyth 1988).

The partially gutted Verwaltungsbau had to be repaired, cleaned, staffed and guarded in the face of innumerable difficulties. Glass and roofing materials were somehow procured so that the building could be weatherproofed. Engineers and electricians were needed to restore light and heat to the building. Barbed wire barriers were erected and a network of underground passageways was blocked. US Third Army provided a permanent security detail. Eventually properly screened civilians replaced military personnel as internal security, thus relieving some of the demand on Third Army resources.

Staffing of the Collecting Point, both permanent and casual, was problematic. Because the Army had no spare manpower, German civilians were employed. Applicants had to be checked for their political affiliations against the so-called 'white lists' of non-Nazis as well as for their art historical qualifications. Three months after Smyth procured the building, the staff consisted of 107 civilian employees, 114

temporary construction workers and the military guard. Because of the ravaged condition of the city and the lack of supplies, Smyth also had to assume responsibility for billeting and feeding the permanent military guard as well as the truck drivers for the convoys and their military escort.

Once it became fully operational, the Munich Collecting Point began to resemble a large museum. Strict security measures were enforced and fire precautions were instituted, including the equipping of the building with carbon dioxide extinguishers. Doors were provided with locks and access to keys was restricted. An efficient system was worked out for unloading, cataloguing and storing the truckloads of art that had begun to arrive on an almost daily basis. At first there were no storage racks, so that paintings had to be stacked against the walls, sculptures were crowded into empty rooms and crates were left unopened. This unsatisfactory situation was soon rectified by the construction of wooden shelving units. Daily inspections of the storage areas were carried out and temperature and relative humidity readings were taken in several representative locations.

One of the principal duties of the curatorial staff was the maintenance of a complete record of the holdings at the Collecting Point. To this end an elaborate filing system was set up, consisting of five separate sets of cross-referenced files. Photography was essential for the purposes of inventorying and identifying art objects, so the services of a trustworthy photographer were engaged. A working art library was set up using the books of the Pinakothek and the Bavarian National Museum. A conservator from the staff of the Alte Pinakothek was retained on call to provide first aid treatment to objects in fragile condition. An Art Documents Centre was also created to house the records pertaining to looted art; these included documents collected in Germany and Austria as well as the detailed records of the Task Force Rosenberg, which were found near Munich at the castle of Neuschwanstein.

Once the war was over, the restitution of looted art became a major priority. An Art Looting Investigation Unit was set up under the supervision of the Office of Strategic Services (War Department 1946). Three Naval officers, Theodore Rousseau of the National Gallery, James Plaut of the Institute of Modern Art in Boston and Lane Faison, Professor of Art at Williams College, formed a roving secret service. They were assisted by Lieutenant Walter Horn, a US Monuments Officer and former German citizen who had emigrated to America years before to escape Nazi oppression. The intelligence-gathering activities of this group were essential for the purposes of establishing the rightful ownership of looted artworks. Some of the information was later used to charge high-ranking Nazi war criminals, including Goering and Rosenberg, at the Nuremberg trials.

RESTITUTION OF ARTWORKS

The issues of restitution and reparation had been discussed throughout the war by various Allied, British and American groups. From mid-1944 onwards the Roberts Commission, in cooperation with representatives of the Allied and occupied nations, had been working on the formulation of a restitution policy. Finally, agreement was

reached that readily identifiable artworks would be returned to the governments of the countries from which they came, rather than to individual owners. Although this policy was never officially adopted by the Allied governments, President Truman set the process in motion by decreeing a policy of unilateral restitution from the US Zone in July of 1945. Several directives from SHAEF headquarters followed, making it clear that artworks were to be returned 'in bulk' to their owner-nations (Nicholas 1995). This action prevented the Allied Military Government from becoming involved in disputes about ownership and more difficult issues of restitution, some of which have yet to be resolved.

The Collecting Points were viewed as the logical clearing houses for this operation and so it was that the Monuments Officers faced their final challenge. The process began with several well-publicised restitutions designed to demonstrate the goodwill of the Allied Military Government. Among the most spectacular of these was the return, by special plane, of the Van Eyck altarpiece to Brussels. Some works were important enough to require a special escort. The Czernin Vermeer was personally carried back to Vienna from Munich by Andrew Ritchie, chief of the MFA&A for Austria, who locked himself in a compartment of the train for the duration of the journey.

Operations at the Munich Collecting Point soon settled into a routine. Among the first priorities were the removal and transportation of the contents of the large art repositories at Alt Aussee and Neuschwanstein. For the first time at Neuschwanstein the MFA&A began to deal with foreign representatives, usually art experts, who were invited to Munich to set up offices in the Collecting Point. Each representative was provided with a German curatorial assistant. For clearly identifiable works a set procedure of examination, documentation and confirmation was developed. Eventually the objects were returned by truck, train or plane to their rightful owners.

The officers of the MFA&A who were stationed at the Collecting Points began to realise that they could play a positive role in the reconstruction of German cultural life. To this end, public exhibitions of works from local museum collections were organised. During the autumn of 1945 the staff at the Munich Collecting Point began to envision the building as a future art institute. The key elements – including a functioning art library, space for seminars and a weatherproof building – were already in place. The Zentralinstitut für Kunstgeschichte was thus established while the Collecting Point was still functioning. As the operations of the Collecting Point dwindled over the years that followed, the Zentralinstitut expanded until it took over the entire building, which remains its home today.

Conclusion

Although the concept of fine art advisers attached to invading armies can be traced back to the Napoleonic era, the motives of such groups were far from altruistic. The rescue of European cultural property by the Allied Monuments Officers represented an entirely new development in the history of warfare. For the first time, no distinctions were made between the cultural materials of the victors and the vanquished. Unlike the Nazis, who attempted to obliterate entire cultures through

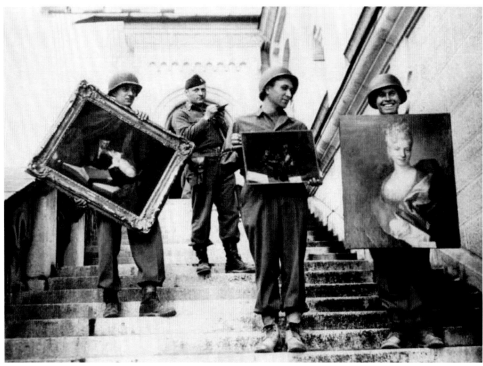

FIG 2.2
MONUMENTS, FINE ARTS, AND ARCHIVES OFFICER JAMES RORIMER (REAR CENTRE) SUPERVISES US
SOLDIERS RECOVERING PAINTINGS FROM NEUSCHWANSTEIN CASTLE IN GERMANY. MFAA TEAMS WERE
PART OF AN EFFECTIVE MILITARY EFFORT TO PROTECT AND RECOVER CULTURAL PROPERTY DURING
WARTIME. (PRIOR TO THE WAR, RORIMER WAS A CURATOR AT THE METROPOLITAN MUSEUM OF ART IN
NEW YORK; HE WENT ON TO BECOME ITS DIRECTOR.)

wholesale destruction and looting, the Allied Forces as represented by the MFA&A
sought to preserve cultural materials of all types in all areas ravaged by war.

The most important lessons learned from the MFA&A experience include the
following: to be adaptable in unpredictable situations; to use available resources, no
matter how meagre, effectively; to respond quickly in front-line situations; to
maintain a wide rather than a narrow focus; to delegate responsibility whenever
possible; and, where theft and looting of artworks and other cultural property was an
issue, to restore in bulk rather than piecemeal.

The policies and procedures established during World War II have been adapted
and refined by military forces in a number of countries, including Austria, Switzerland
and the USA. The Arts, Monuments and Archives unit of the US Army Civil Affairs
Command is perhaps the closest contemporary successor to the MFA&A. To
enumerate the goals of this unit – protection, preservation, rehabilitation and
restitution of cultural property – is to hear a powerful echo from the past.

BIBLIOGRAPHY AND REFERENCES

American Commission for the Protection and Salvage of Artistic and Historic Monuments in War Areas, 1946 *Report of the American Commission for the Protection and Salvage of Artistic and Historic Monuments in War Areas*, US Government Printing Office, Washington, DC, available from: http://www.questia.com/PM.qst?a=o&d=55065074 [accessed 17 September 2009]

Clemen, P (ed), 1919 *Kunstschutz im Kriege*, Seeman, Leipzig

Dear, I C B, and Foot, M R D, 1995 *The Oxford Companion to World War II*, Oxford University Press, Oxford

De Jaeger, C, 1981 *The Linz File: Hitler's Plunder of Europe's Art*, Wiley, Toronto

Farmer, W I, 2000 *The Safekeepers: A Memoir of the Arts at the End of World War II*, Walter de Gruyter, Berlin

Feliciano, H, 1997 *The Lost Museum: The Nazi Conspiracy To Steal The World's Greatest Works Of Art*, Basic Books, New York

Flanner, J, 1947 Annals of Crime III: Monuments Men, *The New Yorker*, 8 March, 38–55

Hammett, R W, 1946 Comzone and the Protection of Monuments in Northwest Europe, *College Art Journal* 5 (2), 123–6

Hancock, W, 1946 Experiences of a Monuments Officer in Germany, *College Art Journal* 5 (4), 271–311

Harclerode, P, and Pittaway, B, 1999 *The Lost Masters: The Looting of Europe's Treasurehouses*, Gollancz, London

Harris, C R S, 1957 *Allied Military Administration of Italy, 1943–1945*, Her Majesty's Stationery Office, London

Howe, T C, nd *Collecting Points*, unpublished typescript in papers of Thomas Carr Howe, Archives of American Art, Washington, DC

LaFarge, B, 1946 *Lost Treasures of Europe*, Pantheon, London

Methuen, P A (Lord), 1952 *Normandy Diary*, Robert Hale Ltd, London

Nicholas, L, 1995 *The Rape of Europa*, Vintage Books, New York

Perry, R B, 1943 American Defense, Harvard Group, *Report of Activities to November 1943*, unpublished typescript in papers of W G Constable, Archives of American Art, Washington, DC

Pöchmüller, E, 1945 *Das Schicksal der Kulturgutbergung in den österreichischen Salinen im Weltkrieg 1939–1945*, unpublished manuscript, Archives of American Art, Washington, DC

Ross, M C, 1946 The Kunstschutz in Occupied France, *College Art Journal* 5 (4), 336–52

Simpson, E, 1997 *The Spoils of War*, Harry Abrams Inc, New York

Smyth, C H, 1988 *Repatriation of Art from the Collecting Point in Munich after World War II*, Gary Schwartz/SDU Publishers, Maarssen/The Hague

Stout, G, 1945 *Diaries*, unpublished manuscript in the papers of George Stout, Archives of American Art, Washington, DC

War Department, 1946 *Art Looting Investigation Unit Final Report*, unpublished typescript in papers of Otto Wittmann, Getty Research Institute, Los Angeles

Woolley, L, 1944 *Letter to Dr Dinsmoor* (2 March 1944), unpublished typescript in papers of W G Constable, Archives of American Art, Washington, DC

Woolley, L, 1947 *A Record of the Work Done by Military Authorities for the Protection of the Treasures of Art and History in War Areas*, His Majesty's Stationery Office, London

The UK's Training and Awareness Programme[1]

JULIAN RADCLIFFE

It is ironic that the USA and the UK, who have led many of the military interventions of the last decade, have had the least capacity for the protection of cultural property in countries for which they would become responsible. They have lagged far behind The Netherlands, Italy and Austria, all of whom developed specialist units and military staffs for this work. While the USA and UK might have been able to rely on their NATO allies for some expertise in Cold War operations in Europe, they have not been able to do so on expeditionary operations elsewhere when these countries were not deployed. Even more critically, these countries, with their capabilities, were not involved in the planning of the operations when the input could have been the most constructive and would have helped to avoid many of the later calamities.

There are several reasons for this extraordinary omission. One was the incompatibility of a nuclear power signing up to protect cultural property if there was any use of such weapons. Another was a mistaken belief by the US military that war fighting was an end in itself and peace-making was not their task, and a reluctance to take on more responsibility than they could easily fulfil. The long tradition in the Anglo-Saxon countries of emphasising the private ownership of and freedom to trade in cultural assets has led, in government and in the national psyche, to the involvement of the State assuming a weak position in cultural matters: hence the absence of a Ministry of Culture in the USA and the rather weak and comparatively recent culture Ministry (currently known as the Department for Culture Media and Sport) in the UK. There has therefore been no focus in the government for these concerns.

There was some suspicion that the USA and UK Governments were lobbied by the strong art trades in both countries, who did not want any restrictions on their activity which might have resulted from either country ratifying the 1954 *Hague Convention on the Protection of Cultural Property in the Event of Armed Conflict*. These groups had certainly pressurised the State Department, the Foreign Office and the Attorney Generals in both the USA and UK not to recognise the laws of those countries trying to stop exports of cultural property. Even if there was no direct opposition, there was certainly an absence of positive support or interest.

Although the UK has not, as yet, ratified the 1954 Hague Convention, it has trained its forces to some degree in the requirements of the Geneva Conventions in relation to the protection of cultural property, although it has not developed any expertise in the armed forces to discharge these responsibilities beyond the most basic.

As Krysia Spirydowicz illustrates in Chapter 2, during World War II, when the great majority of the male population were engaged in the war effort, it was

1 The views expressed are those of the author and do not reflect necessarily those of the Ministry of Defence or Her Majesty's Government.

comparatively easy to find individuals in the armed forces with backgrounds in relevant cultural fields. Therefore, expertise such as that required when the Allied Armies had to restitute the art seized by the Nazis could be found by individuals with museum backgrounds contacting their friends who were already in the armed forces, who could be redeployed as hostilities wound down (Nicholas 1995). In parallel but stark contrast, the Russians had trophy brigades to 'collect' art from Germany; indeed, a photograph exists of Irina Antonova, the future curator of the Pushkin Museum in Moscow, unloading looted pictures from a Russian army lorry in 1945.

At the beginning of the 21st century, with very small UK professional armed forces in a semi-permanent state of overstretch, there has been no spare capacity for the inclusion of expertise outside that considered essential in all military operations. Furthermore, the initial planning for the Iraq and Afghanistan campaigns did not place sufficient emphasis on the post-conflict reconstruction phases. In any regard, if it had been assembled, all the civilian/military capability required for such a reconstruction phase would have included as only a small part expertise for the protection of cultural property.

The British Army has considered the importance of an understanding of the wider cultural aspects of countries where UK forces are deployed by reviewing the possibility of deploying cultural advisers (ie those with knowledge of, for example, religious, social and economic matters) to the relevant headquarters in much the same way as there is normally a political adviser and a financial controller. However, this initiative has not been connected to the concept of protecting cultural property directly.

In recent years, the situation in the UK has not been helped by an absence of coordination between the Department for International Development (DFID) (under a Minister opposed to the Iraq war) and the Ministry of Defence and Foreign and Commonwealth Office. There was then a misplaced doctrine on the need to separate military operations from aid, which, it was argued, must be a strictly civilian operation (and thereby more neutral), in the hope that it would not be tainted by association with combat operations but welcomed by friend and foe alike.

In the event, in both Iraq and Afghanistan, the environment was too dangerous for the deployment of non-military personnel at the time when the need to protect the cultural inheritance was greatest and when the most good might have been done. The same debate which led archaeologists to question whether any of their number should be involved in working with the military (see, for example, Gerstenblith 2009; Hamilakis 2009; Stone 2009) was mirrored in the departments of government where, rather than resigning immediately, the DFID Minister failed to cooperate. This has received much attention from the Iraq Inquiry set up in the UK under Sir John Chilcot to consider the period from the summer of 2001 to the end of July 2009, embracing the run-up to the conflict in Iraq, the military action and its aftermath. The failure of government departments to cooperate is likely to be strongly criticised.

There may be some regular members of the UK armed forces who are keen amateur archaeologists or have some of the other types of skills necessary to protect cultural property from the civilian world. In reality, however, most regular members of the armed forces will already be deployed on other tasks. There is a clear need for dedicated, specialised personnel with influence in the command chain and the ability

to operate on the ground. However, any such expertise will not be effective unless it can operate in the wider context of a stable civilian administration; the running of museums and restoration of artefacts cannot be carried out in isolation or without the support of both the military chain of command and the local population. It is vitally important to recognise the views of the latter – for example, attitudes to their buildings and possessions, attitudes to foreigners and the prevailing religious context.

There has been a long history of using Reservists to supplement regular forces in specialist areas, particularly where civilian skills are required; examples of this are medical support (more practice is available in civilian hospitals as a result of road accidents than in the military in peacetime), specialist engineering and logistics (for example, running a port or railway, which the military do not do routinely). In the UK this reliance on voluntary civilian support extends to law and order; the Metropolitan Police (New Scotland Yard) have recruited, under the so-called 'ArtBeat' scheme, 12 Special Constables who work normally in the museum or art worlds to provide additional resources in numbers and expertise to the Arts and Antiques Unit, which is currently staffed by only three uniformed officers and two civilians. The Special Constables are released by their employers to undertake 4 weeks' basic training and then carry out their police duties on one day per fortnight. They have the same powers as a full-time officer and have to be able to perform the same duties as any other Special Constable – patrolling, making arrests and so on – as well as providing their own skills to counter art crime. This integration of the civilian and the uniformed also brings the advantages that it engages civil society and is part of the democratic principle that the community must participate in what it requires of its forces.

The use of civilians also recognises that it is more difficult to train a policeman or soldier to be a curator than it is to train a curator to have sufficient military skills to survive on the battlefield and be able to operate effectively in a hostile environment. The use of civilians, and their comparatively small numbers, presents another difficulty, however. When budgets are tight the regular forces will favour their own and question those resources devoted to Reserve components or capabilities which are not a high priority for the most demanding wars of national survival or so-called 'force on force' (that is, for example, industrialised countries fighting conventionally or even with weapons of mass destruction). There is a natural tendency for the military to focus on these aspects of high intensity war fighting requiring sophisticated air support, armoured manoeuvre and carrier task forces: so budgets, promotion and glory have led that way. The less glamorous so-called 'enablers' of linguists, lawyers, experts in civilian government, fishing or agriculture have come a poor second in terms of finance, organisation and influence; or they have been considered simply another department's problem.

As the UK and USA have faced up to the critical importance of the 'hearts and minds' aspects of insurgency they have rewritten their military doctrine and re-addressed the need to be able to project soft power, to reconstruct and stabilise. Part of this requirement is to be able to deploy highly trained individuals (with extensive language skills and experience of the countries in question) in task-organised formations. These formations will vary depending on the particular country, the level of threat and the task to be performed. They will require a wide variety or

combination of types of employment and deployment: either in uniform or as civilians, as employees of the UK Government, the United Nations or another multinational organisation, or of a charity or a contractor paid by one of the multinationals. This flexibility is essential to keep down the cost; contractors or charities are in general cheaper than civil servants or soldiers but are able, advantageously, to mutate between them. The Italian Carabinieri have demonstrated the advantage of being able to deploy as police or soldiers (see Zottin 2008). The range of expertise that might be required to deal with the differing economic, social, cultural and governmental systems encountered is impossible to forecast accurately. The emphasis must be on the ability to add capabilities which were not previously contemplated at very short notice with the minimum of bureaucracy.

The numbers and capability in terms of self-sustainment (logistic, medical) must be similar to those of an expeditionary armed force. Recently the Conservative Party has started to speak of the deployment of a brigade-size formation to provide the stabilisation capability. This is radical thinking by current standards and would need to recognise that each situation will require a different mix of capabilities and means of delivery if the recipient of the aid is to accept it without feeling the same resentment which may be shown to military occupation. This is the context in which the protection of cultural property must be developed. It cannot be successful unless the other essentials of law and order and economic and social cohesion are present or are provided; it must be integrated with and contribute to them.

Although there will always be a need for overall general cultural protection expertise, the detailed requirements of any one theatre of operations may be very specialised. Assuming that there is popular support for the intervention, how can the necessary specialists be recruited and, if necessary, deployed in a military environment? Clearly there would be enormous advantages in having those archaeologists who have excavated in the area return to it, or experts in manuscripts visit the location where they may be held to advise on their restoration: the removal of material culture might well be unacceptable politically or technically.

In the British Army there is a system for taking any expert required in a theatre and giving them sufficient basic training and rank (sadly very necessary in an organisation so driven by, and deferential to, rank) to provide the capability. In World War I the chaos of the rail system supporting the British Army in France had to be reorganised by a senior executive from a rail company, who was given the rank of a Major General. There is a pressing need to use this facility, which is currently aimed at specialised engineer or logistic personnel, much more widely.

Another proposal is to ask all Reservists to provide details of their civilian skills, from which those who have expertise in any field which might be required, including (for cultural property protection) architecture, archaeology, curation, restoration and museum administration, can be identified. Many Reservists join the Volunteer Reserves in order to get away from their normal career activity and there was some concern that they might not wish to be dragooned back into their 'day jobs' or that their employers might resent the use of their employees in roles which might conflict with the employer's interests: for example, the employer may have been hoping to provide the skills to the Ministry of Defence under a profitable contract. The intention

would be to use the individual's civilian skills only if they and the employer were in agreement, and on many occasions both may benefit from the employee having the opportunity to put his civilian skills into practice on operations.

There will be some operations in which the protection of cultural property is not required or is undertaken by allies and so it would be difficult to justify providing Reserve personnel for this task alone. The idea then would be to have them 'double hatted' – they would remain in their existing role as, for example, infantry soldiers, and take on protection of cultural property as an additional task.

There would a be small cadre of Reservist staff officers who would be permanently assigned to the MoD for policy development under a Reserve Colonel, to the operational planning and exercise/training staff under a Lt Colonel, and with a Major deployed in theatre as the adviser to the local commander. Depending on the intensity of the requirement there would then be a team in each brigade who could operate on the ground and who would be supplemented when necessary by specialists who, if not available in the armed forces from the civilian skills database, would be recruited specifically as outlined above.

All of these individuals would receive additional training time in order to keep up-to-date with International Conventions, lessons learnt from operations, relevant civilian expertise and so on. They would supervise the material provided for the individual training of all members of the armed forces on the Geneva and Hague Conventions and provide the exercise input to train operational and logistic staff on the need to consider cultural property protection in all aspects of warfare and peacekeeping operations. This will include the mapping of physical sites, measures for their protection, and a deeper understanding of cultural aspects of the host nation.

One of the great advantages of giving higher priority to the cultural aspects of the nations where conflict is a threat is to encourage a more intelligent and sensitive understanding of the local population. It was ironic that the speech by Col Tim Collins, a British Commanding Officer, to his troops on the eve of the invasion of Iraq, which highlighted the need to revere the historic nature of the country, and was widely praised by President Bush among others, was not matched by the planning for protection thereafter (Collins 2003).

In future a large aspect of the political and military intelligence effort should be devoted to the cultural aspects of an operation – understanding what makes a country tick, what the 'centres of gravity' are – a common military expression to explain what will unhinge an enemy force, but equally applicable as a concept to the hearts and minds of a nation or tribe. In military affairs we speak of the physical aspects of force and the moral ones, in which culture is a major determinant.

The UK is starting its efforts far behind other nations and will benefit enormously from studying the work of other armies and other countries. We will never rival the Carabinieri Stolen Art Squad, or the Netherlands government's expertise in helping overseas museums, but we do have the advantage of easy access to a great concentration of expertise in world-class universities and the London art market. The latter has been considered a mixed blessing if not an evil force by many archaeologists, who see the market, particularly in antiquities, as driving by demand the illegal excavation and looting of sites which invariably increases after wars. There is no

doubt, however, that some of those in the art trade are very sensitive to the need to protect the local patrimony and could provide invaluable expertise, as they did in the restitution teams of World War II. Cultural property covers such a wide ambit, from local government records to national costumes, all of which may be threatened by ethnic cleansing, that the museum community alone will not be able to cover the ground.

Prior to operations and in addition to the enormous task of mapping cultural sites, it will be necessary to have access to individuals who have expertise in all those aspects of any nation's cultural life which need protection. UNESCO has developed a limited part of this. The military teams will also have to liaise with, and provide stolen item data to, INTERPOL and organisations such as the UK Art Loss Register, in order to circulate warning notices to those who may be offered particular types of items.

There is now in the UK for the first time for many decades a proper public debate on the shape and resources of the defence budget. Although defence has not been considered a vote winner it may turn out to be an election loser for a government which did not make it a priority to provide the resources which conflict requires. High among these are the specialised and unglamorous capabilities, such as cultural property protection, often provided by the Reserves at tiny cost, the absence of which may have adverse strategic consequences. The media gave enormous coverage to the looting of the Iraq National Museum in Baghdad and the effect on opinion in the USA, UK and elsewhere was extraordinarily negative. There would be no excuse for the UK if such an event occurred on our watch.

BIBLIOGRAPHY AND REFERENCES

Collins, T, 2003 *Colonel Tim Collins' Speech*, available from http://journal.dajobe.org/journal/2003/03/collins/ [accessed 11 February 2010]

Gerstenblith, P, 2009 Archaeology in the Context of War: Legal Frameworks for Protecting Cultural Heritage during Armed Conflict, *Archaeologies* 5 (1), April, 18–31

Hamilakis, Y, 2009 The 'War on Terror' and the Military–Archaeology Complex: Iraq, Ethics, and Neo-Colonialism, *Archaeologies* 5 (1), April, 39–65

The Iraq Inquiry, available from: http://www.iraqinquiry.org.uk/ [accessed 11 February 2010]

Nicholas, L, 1995 *The Rape of Europa*, Vintage Books, New York

Stone, P, 2009 Protecting Cultural Heritage in Times of Conflict: Lessons from Iraq, *Archaeologies* 5 (1), April, 32–8

Zottin, U, 2008 Italian Carabineers and the Protection of Iraqi Cultural Heritage, in *The Destruction of Cultural Heritage in Iraq* (eds P G Stone and J Farchakh Bajjaly), Boydell & Brewer, Woodbridge

US Army Civil Affairs: Protecting Cultural Property, Past and Future

CORINE WEGENER

Tragic events such as the burning of the National Library of Bosnia in Sarajevo, the obliteration of the great Buddhas at Bamiyan and, in particular, the looting of the Iraq National Museum in 2003 have led to discussions about how military organisations around the world deal with avoiding damage to cultural property while waging an armed conflict. Much of the debate centres on whether or not cultural heritage professionals should provide information and advice regarding the protection of important cultural sites in the theatre of operations to military planners or whether providing such advice is unethical, actually making it easier to wage war.

However, this debate does not seem to acknowledge the historic role of cultural heritage professionals during wartime. In fact, during World War II, American and European cultural property professionals were inextricably involved in government and military efforts to protect cultural heritage. Through their efforts, the US Army Civil Affairs Division and several Allied nations developed a small number of teams of cultural heritage professionals within the military ranks called the Monuments, Fine Arts and Archives (MFA&A) teams. Nicknamed the 'Monuments Men', they were relatively successful in protecting, salvaging and repatriating many thousands of important cultural objects during the course of the war and beyond (see, for example, Nicholas 1995 and Spirydowicz, this volume). Many of these Monuments Men and Women went on to become important contributors to the cultural heritage profession in the post-war era: Italian Renaissance expert Frederick Hartt; Richard Davis, later director of the Minneapolis Institute of Arts; James Rorimer, later director of the Metropolitan Museum of Art; and Edith Standon, later curator of textiles at the Metropolitan Museum of Art, to name just a few. In all, there were fewer than 100 members of these special teams (Edsel 2006), but through their efforts many objects and icons of our shared cultural heritage were saved. Paintings by Da Vinci, Vermeer and Van Eyck were saved from destruction and many thousands of stolen works of art were repatriated. Towards the end of the war, as the Allies began the final push towards Berlin, they began to discover Nazi looted art in caches throughout Austria and Germany. The MFA&A teams were called upon to take over the long and difficult process of inventorying the material, moving it to central collecting points, cataloguing it and repatriating as much as possible to the countries of origin for return to the rightful owners. This process took years, lasting long after the war ended, and more than 50 years later we are still dealing with the repercussions of World War II in terms of the repatriation of looted cultural property to its rightful owners and heirs.

Unfortunately, in contrast to World War II, planning for the protection of cultural property in preparation for the invasion of Iraq was practically non-existent. In fact, as many have pointed out, planning for basic post-conflict operations in Iraq was also

non-existent (see, for example, Gordon and Trainer 2006; Ricks 2006). Admittedly, several cultural heritage professionals and organisations provided information to the US Department of Defense (DoD) regarding cultural site coordinates before the US-led invasion, information which was used by the DoD to successfully avoid Coalition bombing damage to most cultural heritage. However, dire warnings clearly voiced by archaeologists such as McGuire Gibson, a professor at the Oriental Institute of the University of Chicago, regarding probable looting of museums by the Iraqis themselves, went unheeded. The worst-case scenario unfolded on 10–12 April 2003 with the looting of more than 14,000 objects from the Iraq National Museum (see Bogdanos 2005; Rothfield 2009; Stone and Farchakh Bajjaly 2008).

While damage to and looting of cultural heritage has continued since World War II, it was not until the looting of the Iraq National Museum that many in the cultural heritage community became familiar with the story of the Monuments Men. Fewer still realised that the descendents of

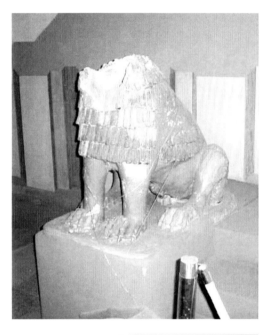

Fig 4.1
Right: Lion from Tel Harmal (an archaeological site near Baghdad) from the collection of the Iraq National Museum. The lion was damaged by looters in April 2003.

Fig 4.2
Below: Roman sculpture from al Hatra in the collection of the Iraq National Museum. Looters damaged the sculptures during the looting of the museum in April 2003.

the MFA&A teams survive, in one incarnation or another, up to the present day as part of the US Army Civil Affairs and Psychological Operations Command.

Civil Affairs is the branch of the Army that deals with issues of humanitarian assistance, refugee operations, infrastructure building and cultural property protection, among many other tasks. More than 90 per cent of Civil Affairs personnel are Army Reservists who have civilian skills that are valuable to the Civil Affairs mission. However, at present there are few cultural heritage professionals among their ranks, and they rely on advice and training from cultural heritage professionals outside the armed forces. These professionals are gathered together under the banner of the US Committee of the Blue Shield, a non-profit organisation formed after the looting of the Iraq National Museum in the spirit of the work performed by our World War II colleagues and committed to the protection of cultural property worldwide during armed conflict (see below). However, unlike the situation in World War II, where a number of cultural heritage professionals found themselves already serving in the military alongside most of the able-bodied male population, today's all-volunteer military has a mere handful of serving cultural property professionals.

This lack of expertise within the military was particularly obvious during the invasion of Iraq in 2003. In the entire 352d Civil Affairs Command, an Army Reserve unit consisting of approximately 1800 personnel during this mission, only a handful were assigned to work on a functional speciality team dedicated to cultural property issues. Only two members of that team had any cultural heritage training or expertise.[1] When I arrived in Baghdad in May 2003 to assist after the looting of the Iraq National Museum, the number of cultural heritage professionals actually went down to one, as the two existing team members were reassigned to other duties.

It soon became apparent that one of the most pressing needs at the Museum was objects conservation. More than 14,000 objects were looted, but hundreds more had been wilfully damaged or were suffering from the lack of climate control in the Museum's galleries and storage areas. The Museum's conservation staff had little training or experience, in large part because of the inability to travel abroad for education during more than a decade of sanctions, and the Museum's infrastructure suffered nearly as much from lack of basic repairs as from the looting for much the same reasons.

It soon became apparent that there was also a huge vacuum regarding international assistance or non-governmental organisations prepared to assist during a cultural property emergency in a war zone. While UNESCO visited and performed an assessment on 16 May 2003, they were not able to follow up with assistance, particularly after the bombing of the UN Headquarters in Baghdad later that summer. Even the International Committee of the Blue Shield, a relatively new organisation formed in 1996 to support the 1954 *Hague Convention for the Protection of Cultural Property in the Event of Armed Conflict*, was unable to form or deploy a response team.

When I left Iraq in March 2004 after nine months, the conservation problems at the Museum were still unresolved. It would be a few more months before conservators

1 Captain William Sumner, a landscape archaeologist, and Major Christopher Varhola, an anthropologist/archaeologist, were trained cultural professionals on the original team.

who were able to stay long enough to provide actual on-site objects conservation and training arrived from the Italian Ministry of Culture. Damage to many works of art might have been mitigated by a small, deployable team of conservation professionals or, ideally, by military personnel with conservation training and experience.

In addition to the looting of the Iraq National Museum, there have been a number of instances of damage to cultural property through various military operations in Iraq and Afghanistan. These include the well-known instance of damage to the archaeological site at Babylon by the placing of a Coalition military base on the site (Bahrani 2008; McCarthy and Kennedy 2005), damage to the minaret at Samarra (BBC News 2005), and the continuing looting of archaeological sites possibly due to the ongoing lack of stability (Breitkopf 2007; Stone and Farchakh Bajjaly 2008). In all, US credibility has suffered both in Iraq and on the international stage. However, in some ways, the looting of the Iraq National Museum has caused an immense change in the policies and structures of the US military (particularly Army Civil Affairs) and cultural heritage organisations in an effort to prevent a recurrence of similar situations in the future.

In the US Department of the Army, the new Field Manual 3–07, Stability Operations (October 2008), includes several references to cultural heritage. A pivotal document in raising stability operations to the same level of importance as kinetic, or combat, operations, the Field Manual details how to deal with civilian issues. In particular, paragraph 5–52 'Shrines and Art' states that, 'except in cases where military operations or military necessity prevents it, the force protects and preserves all historical and cultural monuments and works, religious shrines and objects of art, and any other national collections of artifacts or art' (US Department of the Army 2008, 5–9).

Army Civil Affairs has also launched several new initiatives in an effort to jump-start its long-dormant Arts, Monuments and Archives functional speciality. In 2005, it published the first basic handbook to cultural property protection in nearly two decades (US Department of the Army 2005; 2007). While the current Civil Affairs structure no longer has a specific Arts, Monuments and Archives team designation, the six remaining functional speciality areas still address cultural heritage and the unique role of Civil Affairs within the US military to perform the task of coordinating for its protection (US Department of the Army 2006).

Civil Affairs also plans to assign Additional Skill Identifiers to qualified Civil Affairs personnel based on their civilian skills and education. While still in the drafting stage, ASIs may include designations such as Archivist, Archaeologist and Curator. Plans are also underway to grant direct commissions to the rank of captain for individuals possessing master's degrees in particular cultural heritage fields, much the same as the military has traditionally done for doctors and lawyers. Civil Affairs is also redoubling its efforts to recruit and transfer cultural property professionals currently serving in other types of units, both within the Army Reserve and National Guard and in other branches of the military.

Meanwhile, recognising that the lack of cultural heritage expertise in their ranks is detrimental to their mission, the US Army Civil Affairs and Psychological Operations Command has developed a special training partnership with the US Committee of the

FIG 4.3
BLUE SHIELD TRAINING FOR AFGHANISTAN PROVINCIAL RECONSTRUCTION TEAMS, CAMP ATTERBURY,
INDIANA, JANUARY 5, 2010.

Blue Shield (USCBS). USCBS is the US branch of an international network of Blue
Shield organisations dedicated to the protection of cultural property during armed
conflict and natural disasters.[2] The Blue Shield name is derived from the 1954 *Hague
Convention for the Protection of Cultural Property in the Event of Armed Conflict*,
which specifies the blue shield as the international symbol used to mark cultural
property for protection during armed conflict. The International Committee of the
Blue Shield and its affiliated national committees work together as the cultural
equivalent of the Red Cross, providing information and assistance when cultural
property is at risk from natural or man-made disasters.

USCBS was formed in 2006 in response to the tragic looting of the Iraq National
Museum in 2003. Founding member organisations include the American Institute for
Conservation, the American Library Association, the Archaeological Institute of
America, the Association of Moving Image Archivists, the Society of American
Archivists, the US-International Council on Monuments and Sites and the

2 For more information about the US Committee of the Blue Shield see: www.uscbs.org. For more
information on the International Committee of the Blue Shield and the Association of National Committees
of the Blue Shield based in The Hague, see: www.ancbs.org.

International Council of Museums-US. As an umbrella organisation for all these cultural heritage professional organisations, USCBS has a very large network of expertise to draw upon.

For the training partnership, USCBS is called upon to train deploying Civil Affairs units. Drawing on its network of expert trainers, information is provided on the cultural heritage, archaeology and architectures of the region. Trainers have usually travelled and worked in the region and provide contacts information for their cultural heritage colleagues in the region. A professional conservator provides basic objects conservation information, and experienced military personnel provide information on military responsibilities under the 1954 Hague Convention, the historic role of Civil Affairs units in protecting cultural property and the importance of this role in terms of the greater military mission. All the training is provided free of charge by USCBS and its training partners, the Archaeological Institute of America and the American Institute for Conservation of Historic and Artistic Works, and each trainer is a volunteer. USCBS has trained more than 1000 deploying Civil Affairs personnel since 2006.

In conclusion, those in the cultural heritage professional community who argue that they should not have a role in training or advising the military on preventing and mitigating damage to cultural heritage seem not to understand the lessons of history. In World War II, when American cultural heritage professionals organised their efforts and offered their assistance to the military it was accepted gratefully and, as a result, damage to cultural property, while still great, was probably diminished in many ways. In contrast, the experience of the looting of the Iraq National Museum and other recent damage to cultural heritage seems to indicate that we as cultural heritage professionals must fulfil our responsibility to do what we can to prevent damage to cultural property whenever possible. To do otherwise leaves our colleagues to fend for themselves when their collections are at risk and abdicates our responsibility to our shared cultural heritage.

BIBLIOGRAPHY AND REFERENCES

Bahrani, Z, 2008 The Battle for Babylon, in *The Destruction of Cultural Heritage in Iraq* (eds P G Stone and J Farchakh Bajjaly), The Boydell Press, Woodbridge (Paperback 2009)

BBC News, 2005 *Ancient Minaret Damaged in Iraq*, available from http://news.bbc.co.uk/2/hi/middle_east/4401577.stm [accessed 20 September 2009]

Bogdanos, M, with Patrick, W, 2005 *Thieves of Baghdad*, Bloomsbury, New York

Breitkopf, S, 2007 Lost: The Looting of Iraq's Antiquities, *Museum News* (January/February), available from American Association of Museums website: http://www.aam-us.org/pubs/mn/MN_JF07_lost-iraq.cfm [accessed 20 September 2009]

Edsel, R, 2006 *Rescuing Da Vinci: Hitler and the Nazis Stole Europe's Art-American and Her Allies Recovered It*, Laurel Publishing, Dallas

Gordon, M R, and Trainer, General B E, 2006 *Cobra II: The Inside Story of the Invasion and Occupation of Iraq*, Pantheon Books, New York

McCarthy, R, and Kennedy, M, 2005 Babylon Wrecked by War, *The Guardian*, 15 January, available from http://www.guardian.co.uk/world/2005/jan/15/iraq.arts1 [accessed 20 September 2009]

Nicholas, L, 1995 *The Rape of Europa: the Fate of Europe's Treasures in the Third Reich and the Second World War*, Vintage Books, New York

Ricks, T E, 2006 *Fiasco: The American Military Adventure in Iraq*, Penguin Press, New York

Rothfield, L, 2009 *The Rape of Mesopotamia: Behind the Looting of the Iraq National Museum*, University of Chicago Press, Chicago

Stone, P G, and Farchakh Bajjaly, J, 2008 *The Destruction of Cultural Heritage in Iraq*, The Boydell Press, Woodbridge (Paperback 2009)

US Department of the Army, 2005 Graphic Training Aid 41–01–002, *Civil Affairs: Arts, Monuments, and Archives Guide*, available from http://www.au.af.mil/au/awc/awcgate/army/gta41–01–002_arts_monuments_and_archives.pdf [accessed 20 September 2009]

US Department of the Army, 2006 FM3–05.40 *Civil Affairs Operations* (September), available from www.fas.org/irp/doddir/army/fm3–05–40.pdf [accessed 20 September 2009]

US Department of the Army, 2007 Graphic Training Aid 41–01–002, *Civil Affairs: Arts, Monuments, and Archives Guide*

US Department of the Army, 2008 Field Manual 3–07, *Stability Operations* (October), 5–9, available from usacac.army.mil/cac2/repository/FM307/FM3–07.pdf [accessed 20 September 2009]

Cultural Property Protection in the Event of Armed Conflict: Deploying Military Experts or Can White Men Sing the Blues?

Joris D Kila

Introduction

- Why on earth should the military be involved in Cultural Property Protection (CPP)?
- Aren't they in the business of destroying cultural property?
- Is it ethical to cooperate with the military where CPP is concerned?
- Protection of culture is not a priority; saving lives and providing water and food is more important.
- Military units do not have the necessary expertise to handle artefacts.
- Should social scientists cooperate with the military at all?
- We are already doing something with culture!

The above are just a few of the questions and statements raised by the legal requirement to protect cultural property during conflict for those countries that have ratified the 1954 *Hague Convention for the Protection of Cultural Property in the Event of Armed Conflict*; and archaeologists who have worked with the military to enable the latter to fulfil these legal requirements (or, in the case of those countries that have not ratified the Hague Convention, to work within the spirit of the Convention) have been criticised by colleagues (see, for example, Hamilakis 2003; 2009).

This criticism came to a head during the sixth World Archaeological Congress (WAC-6) in Dublin in 2008 (Rothfield 2008b; and see Gerstenblith 2009; Hamilakis 2009; Stone 2009). The discussion was driven by strongly held ethical beliefs, and archaeologists who had chosen to partner with the military were labelled as 'part of the problem' and were accused of losing their impartiality. These arguments echo the debates of the 1960s, when similar allegations were made about individuals partnering in various capacities with the military. However, the situation then was completely different. At that time the majority of protestors were young intellectuals, often students, demonstrating against major powers and wars of, at least perceived, colonialism. Since then the political climate and world order have changed considerably, and the majority of conflicts are no longer 'symmetric' – the clashing of two, usually international, conventional adversaries in intense and violent battles – but tend to be 'asymmetric', in which combatants are unequally matched and therefore frequently use non-conventional methods of warfare intended to exploit their opponents' weaknesses, thereby offsetting their own quantitative or qualitative deficiencies. As a result, the mindset of military planners in relation to the tasks they have to undertake is (slowly) changing. This chapter discusses the changing military

context within which Cultural Property Protection (CPP) takes (or should take) place in the 21st century. I hope to provide those who criticise their colleagues for working with the military with an insight into new approaches and strategies within European and NATO forces aimed at countering problems concerning the implementation of CPP in times of conflict.

The Context of Conflict

> Lessons learned from the early KFOR deployment stage showed that Cultural Property very often turns out to be the ultimate backing and identity-founding symbol, the last expression of self assertion of people who lost almost everything in a perpetuated act of violence and ethnic cleansing. (Brigadier General Wolfgang Peischel 2002, 139)

Modern conflicts can be culturally motivated, related to ethnicity, education, religion, differences in perception of culture and, last but not least, national identity, as was demonstrated in the former Yugoslavia, where numerous acts of iconoclasm occurred. These elements are not only present individually but also interact between and influence the conflicting parties as well as parties attempting to resolve a conflict. While the military have a common goal – winning the conflict and restoring peace or reaching the end state in a peacekeeping or stabilisation mission – they are not used to nor yet equipped to deal with such complex non-military scenarios. The situation can be further complicated by the different cultures and sub-cultures that exist within military organisations, such as, for example, the differences between the navy and the army. This combination of military and non-military cultures, both domestic and international, contributes to the complex range of factors that influence and shape or even seriously restrain the development of a policy concerning CPP within the military.

While there is an increasing, but by no means universal, acceptance within the military of the need for CPP, anyone trying to implement an effective CPP strategy should be aware that 'tasks that are not part of the culture will not be attended to with the same energy and resources as tasks that are part of a certain culture' (Wilson 1989, 101). In other words, if the military is not used to or intrinsically inclined to tackle CPP it will give it a lower priority than other tasks that it is used to carrying out. This reluctance may, on occasion, reveal internal and inter-agency rivalries, as Rothfield noted with respect to the failure to plan for CPP in the build-up to the 2003 invasion of Iraq: 'Bureaucratic stove piping and inter-agency rivalry prevented information from reaching the appropriate decision-makers at both the top and in the field' (Rothfield 2008a; also see Kila 2008b). The issue is not confined within the military, however; some NGOs see military activities that are not related to the military core-business, including CPP, as 'false competition' and, to make their case stronger, add that they can do such things more cheaply than the military. In addition, there is the low priority argument: 'of course CPP is important but you must admit that housing and water have greater priority' is often the answer when attention is sought for CPP.

It has to be remembered that military actions are predominantly aimed at reaching their so-called mission 'end state'. For CPP to be taken seriously by the military,

commanders, especially those in the field, have to see the relevance of CPP within the context of reaching the end state of a mission as soon as is reasonably possible. This view includes fitting CPP into the military planning process as either a risk or a potential force multiplier. It is in helping mission commanders see this relevance that cultural heritage specialists can play a critical role by partnering with the military or by accepting military commissions.

It should be stressed that CPP is not only about protecting, for example, archaeological sites for archaeologists, but that it frequently has an impact on the post-conflict economy (eg tourism), national identity or ethical aspects of a conflict – preventing, for example, the profits of illicit traffic of artefacts being used to buy weapons, or belligerent attempts to deprive ethnic groups of their cultural identity by the destruction of cultural property that is not a military target, thus intensifying a conflict (Pesendorfer and Speckner 2006). From this perspective, related subjects are propaganda, manipulation of history and sociological aspects such as the urge for distinction and the creation of new, or revitalisation of old, symbols and icons.

As there appears to be widespread misunderstanding about how culture is defined within the context of armed conflict two general, linked, points need to be clarified. First, four terms are used, frequently interchangeably, by those discussing this issue: 'cultural property', 'cultural heritage', 'cultural awareness' and 'cultural resources'. The legal term for the subject discussed by this chapter, according to the 1954 Hague Convention and other treaties, is cultural property. This term refers to physical entities and is defined quite precisely in Article 1 of the Convention. It is not an ideal term, however, because the term 'property' suggests a form of ownership, and it should be noted that professionals use the term 'cultural property' *only* because it is the legal term used in the Convention. 'Cultural heritage', on the other hand, represents a wider construct and now includes aspects of human expression beyond physical objects – for example, intangible cultural heritage, although in the past the term referred only to monumental remains of cultures. 'Cultural awareness' is a different concept, and includes awareness of local traditions and customs – essential if unintentional offence is not to be given, but not of direct relevance to the protection of cultural property; nor is cultural awareness mandatory under international law. Cultural awareness training is normally provided to military personnel by experts other than CPP specialists, many of whom have no knowledge of, or experience with, cultural property protection. Last but not least there is the term 'cultural resources'. This term is already used in military contexts, especially in the United States, but currently has no explicit juridical connotations which make it more usable than the other terms. Apart from this, it is sometimes paired with 'natural resources' in military environmental guidance documents, the military mindset being receptive to the protection of 'resources'. As the terms are not interchangeable, the legal term cultural property is used in this chapter.

Second, and following from this, the distinction between programmes such as the US 'Human Terrain System' (HTS) and archaeologists and other cultural heritage specialists working to support CPP must be made clear. Part of the anger expressed towards the military and other archaeologists who spoke at WAC-6 appeared to stem from the fact that many anthropologists and archaeologists do not distinguish

between an archaeologist who is working with the military within the context of CPP and anthropologists involved with cultural awareness or human terrain teams (see, for example, Albarella 2009). Social scientists working for the US HTS teams should not be confused with cultural property experts who work with the military in accordance with the 1954 Hague Convention, and especially the 1999 Second Protocol, or other international legal instruments concerning CPP. Having made this distinction I have to acknowledge the possibility that, on occasion, military intelligence and human terrain work may touch on CPP. For example, when artefacts are looted and smuggled out of a country onto the international antiques market, the revenue generated may be used by insurgents to buy weapons. In this case, an archaeologist or art historian involved in CPP could find themselves at the very centre of a counter-insurgency operation. The distinction is still valid, however, as the key factor is that the focus of any such operation is cultural property as defined by the Hague Convention. The main factor contributing to the confusion outlined above is, as stated above, that the term cultural awareness (local customs, tribal behaviours etc) is often confused with Cultural Property Protection. Again, I reiterate that cultural awareness is not mandatory under international law, and it is implemented, and troops trained, by social scientists who are not cultural property experts.

I hope that the following discussion of new and developing military planning will raise the debate to another level. To put matters in perspective, and to illustrate the possibility that military or militarised experts can be useful in protection of cultural property, I want to use a metaphor to describe the core of the ethical problem.

Can White Men Sing the Blues?

This metaphor generates questions such as:

- Should white men sing the blues?
- Can black and white men play the blues together?
- Do all men want to sing the blues?
- Who gets the royalties?
- Can we all join in playing instrumental blues?
- Will it be slow or up-tempo blues?
- Who decides what's in tune or out of tune?

The metaphor implies that, in relation to CPP, there are problems concerning communication, composition (eg which disciplines are represented in an emergency response team), perception, status, coordination, education and competence in terms of the 'players' – in this case individuals representing the academic, cultural, bureaucratic and military worlds.

A Dissonance: Can Black and White Men Play the Blues Together?

One of the main challenges is to create a discourse where archaeology and cultural property subject matter experts can find a way to work effectively in partnership with

members of the military. As Feil explains (2008), the intrinsic community, composed of academics, cultural experts and the like who have the knowledge but lack the funds and decision-making power, has to convince the instrumental community – people such as diplomats, military, development experts and governmental institutions, who have the resources and decision-making power – to deal with CPP. The latter will consider CPP only when it is clear that it fits its strategy to achieve a safe, sustainable and secure environment in conflict areas. When the players from the intrinsic community are not in tune with each other it is more difficult to interact and negotiate with the instrumental community. In addition, the military and other members of the instrumental community to a large extent still remain to be convinced about the relevance of CPP. Negotiations can only succeed if the civil stakeholders have a *communis opinio*. In addition, if archaeologists partner with the military they are able to introduce an extra factor to the military situation that can, in fact, be an incentive for cooperation. That incentive is the fact that knowledge of, and respect for, cultural property facilitates and supports the military mission in an asymmetric conflict environment – a point to which I shall return.

While the intrinsic community debates the sensibilities of working in CPP, and while the instrumental community remains to be convinced about its relevance, it must be stressed that CPP, as already mentioned, is actually required under International Humanitarian Law (IHL) (and see Gerstenblith, this volume). In other words, regardless of whether it sees its value or not, the instrumental community is compelled to take CPP seriously as soon as its government ratifies the relevant IHL. The argument that archaeologists working for or with the military could misuse their position is not valid since they are restricted by IHL that provides the legal context for their work in the first place. It should also be emphasised that, while there are no explicit references in any of the international conventions, as a general rule and where they exist, military cultural experts are not allowed to carry out relevant tasks when civil experts are still available in the area, and nor are they allowed to continue their activities when civil experts are able to return and take full responsibility. In addition, excavations in conflict areas, other than emergency excavations, are not permitted.

There are also, obviously, economic benefits for assonance both in cultural heritage experts and the military working together in CPP and in musicians playing the blues well together. There is no question that intact cultural property can contribute to economic benefits when a conflict is over; there are hundreds of examples of tourism based around cultural property forming a basis for economic – and in turn political – stability post-conflict. In the following case study of the Orthodox Monastery of Matejce I identify a number of key issues concerning CPP operations that were important in this particular case but that are also of general value. Of course, there are other issues relating to CPP in times of conflict not discussed here; these include civil/military cooperation, cultural property officers, handover procedures for CPP activities to succeeding military or civil experts, further legal obligations and implications concerning military law, such as the principles of military necessity and proportionality, economical implications, military incentives for implementing CPP, looting, illicit traffic and the link to military intelligence and security, financing of CPP activities, training and education of military and other

stakeholders (see many of the other contributions to this book), clashing cultures and iconoclasm. I have discussed a number of these elements in other publications using different cases (Kila 2008a; 2008b; forthcoming). The Matejce case study focuses on the aspect of cultural identity and its manipulation within the context of CPP. This illustrates the complexity of the challenge when a multidimensional set of stakeholders becomes involved. NATO involvement offers an opportunity to discuss its role and the challenges to international cooperation when developing more broad-based solutions for the challenges of CPP using IHL as a framework.

Iconoclasm in the Orthodox Monastery of Matejce in Macedonia

The 'creative' use of damaged CP

The monastery of St Bogorodica Matejce is situated near the village of Matejce, approximately 40 kilometres north of the Macedonian capital, Skopje. The monastery was founded by the Serbian Emperor Dusan and completed in 1355 by Empress Jelena and her son, the Serbian Emperor Uros. Forming part of the monastery is the Church of St Bogorodica. Armed conflict in the Republic of Macedonia commenced at the beginning of 2001 and the monastery was occupied by the Ushtria Çlirimtare Kombëtare (UCK – National Liberation Army), who operated in the Republic of Macedonia in 2000 and 2001, who used it as their headquarters and arsenal. The Macedonian civil and religious authorities feared that the monastery had suffered damage. Early action to assess and possibly restore the suspected damage was financially supported by the Dutch Embassy in Skopje. The first report (6–7 July 2001) included a photographic record of the Church of St Bogorodica provided by staff of the EU Monitoring Mission. The pictures indicated damage to the roof and UCK graffiti on some of the church mural paintings, but not on the fresco paintings. The report recommended that no one be permitted to touch or remove the graffiti from the mural paintings since that would cause more extensive and irreparable damage to the 14th-century Byzantine murals. The report also recommended that any treatments should be undertaken only by Macedonian and international experts. Later it became apparent that the frescos had in fact suffered damage. A fact-finding mission by experts from the Republic's Institute for The Protection of Cultural Monuments, undertaken in September 2001, when members of the UCK were still *in situ* (Nicolik-Novakovic 2004), discovered not only that damage had been inflicted on the mural paintings, but that owing to 'cleaning' work being carried out, contrary to the earlier recommendations, some paintings had been destroyed. The report of this second mission also noted the urgent need for the temporary repair of the damaged roof in the south-eastern corner to prevent further damage to the interior, which contained valuable 14th-century mural paintings, and, as a high priority, the cleaning of the church and the repair of damaged mural paintings.[1]

[1] When reading the ICOMOS Macedonian Committee report one gets the distinct impression that matters were considerably delayed by the highly bureaucratic procedures followed. Numerous institutions were involved, such as ICBS, ICOMOS, UNESCO and the State Institute for the Protection of Cultural Monuments (RZZSK).

FIG 5.1
DAMAGED MURAL IN MATEJCE.

One of the first projects to be undertaken by the newly formed Cultural Affairs functional specialists' network from CIMIC (Civil Military Cooperation) Group North (CGN) was an assessment mission to Macedonia, where the Dutch army led the NATO operation 'Amber Fox'. CGN is a dedicated CIMIC capability based in The Netherlands affiliated to NATO and consisting of a framework of six participating nations: the Czech Republic, Denmark, Germany, Norway and Poland. It contributes CIMIC support units and, where possible, functional specialists to be active in the areas of Civil Administration, Humanitarian Aid, Civil Infrastructure, Economy and Commerce and Cultural Affairs. As CGN's network manager for cultural affairs, I went to Matejce in the last week of August 2002 as part of this assessment mission. I arrived at the monastery accompanied by two Macedonian colleagues from the National Museum in Skopje. The monastery and surroundings were apparently not yet completely cleared of mines and the complex was still in use by the UCK, which presented some difficulties, but we found several instances of damage as described above. I saw murals completely destroyed because someone had tried to remove the graffiti using steel wool scouring pads impregnated with soap normally used for cleaning dishes.

On closer inspection of the graffiti, we saw that some murals had been sprayed with green paint, whereas others had been drawn upon with what looked like a black felt-tip marker. I took samples of very tiny fragments lying on the floor which came from parts of the mural-free wall. Undecorated areas of the wall had also been

FIG 5.2
DAMAGED ST PETER MURAL, MATEJCE.

sprayed and written upon, so I was able to take samples of this wall surface covered with the green paint and black ink. The paint in most readily available spray cans is based on two types of binding agents, acrylics and alkyd. Subsequent laboratory tests revealed that by using acetone and wadding it was easy to remove the paint, implying that acrylic paint had been used for the green graffiti in Matejce. After testing the samples of the black marker ink, as used on the painting of St Peter, we discovered that we had to be careful here: the difference between the green paint and the black marker ink is that the black ink used colour pigments that directly dissolved in the basic acetone liquid. Therefore, their application was more deeply intrusive. In addition to the challenge of dissolved pigments, other chemical processes could take place during attempts at removal, such as the chromatographic reaction that causes the separation of colour pigments. Tests showed that alcohol was not effective in removing the ink. However, acetone and ethyl acetate did the job, at least in the laboratory. It was therefore decided that the best way to operate would probably be to use a gel instead of a liquid to prevent the cleaning agents from damaging additional layers.

Carved and scratched murals such as the painting of Georgios Okrites (see Fig 5.3) are best treated by carefully filling and retouching them. Following the laboratory tests, CIMIC Group North's specialists offered to restore the damaged mural of St Peter by removing the graffiti and applying a non-intrusive protective layer that would facilitate the removal of future graffiti should it be targeted again. However, to our surprise, the party responsible for the mural saw its defaced state as excellent public relations and asked us not to restore it until a peace agreement was signed. For the moment they were quite happy with their 'treated' mural, which made a powerful statement. Later, the whole project involving the specialists of CIMIC Group North was stopped by the Dutch MoD owing to the withdrawal of Dutch troops.

Fig 5.3
GEORGIOS OKRITES, PROBABLY AN ARCHBISHOP OR ST GEORGE: DAMAGED MURAL IN THE MATEJCE MONASTERY.

This Macedonian example raises a question over how situations like these should be interpreted. Is this example a misuse of damaged cultural property as propaganda? Is someone trying to create a win–win situation? Of course, art historians, politicians and all the concerned parties should consider these issues. However, in the meantime, it remains a rather confusing matter for the military, who have to distinguish between CP and damaged CP. By means of comparison, one can consider what the difference is between the damaged St Peter (the Maradona) and a conceptual piece of art like Marcel Duchamp's L.H.O.O.Q.?[2] To an outsider they both look like vandalised paintings; however, Duchamp's picture is actually in itself a creation of Marcel Duchamp, rather than Da Vinci's Mona Lisa, damaged. His aim was to attack the eternal values of Western culture. Note the fact that the UCK members, who were unlikely to be trained in art, used graffiti symbols derived from Western mass culture such as Ray Ban sunglasses, soccer trophies and Diego Maradona, while at the same time attacking Christianity, which they perceived as equivalent to Western culture. How, therefore, can the military recognise cultural objects, and damage to them, and ask for advice on the basis of a basic iconographic description to be judged by so-called 'reach-back capabilities' (scholars, research institutes etc) who are not present and may be thousands of miles away? What is damage in this context: is it the destruction of art or of identity, and who is the vandal?

A number of key issues and dilemmas can be identified, including:

- The military perspective on conflict: changing military approaches to current types of conflict and changing military attitudes toward issues such as cultural property
- The role of parties involved, such as functional specialists and NATO; international cooperation
- Legal obligations, international humanitarian law
- Status and definition of CP as perceived by the military
- Changing aspects such as the international political environment
- CP as a means of identity and distinction
- CP and propaganda, manipulation of CP
- Religion
- Who is the vandal?

There is insufficient space to deal with all of these issues in this chapter. Rather, it should be noted that they all exist and that the immediate task is to open a discussion with military planners as to how to best address them.

THE MILITARY CONTEXT

The aim of a military operation is to reach the so-called 'end state'. In most cases this means the establishment of a sustainably safe and secure environment. It is reasonable to expect that at the beginning of this process a conflict's root causes are addressed.

2 L.H.O.O.Q.: a cheap postcard-sized reproduction of the Mona Lisa, upon which Duchamp drew a moustache and a goatee. This 'readymade' (1919) is one of the most well-known acts of degrading a famous work of art. The title, when pronounced in French, is a pun on the phrase 'elle a chaud au cul', which translates colloquially as 'she has a hot ass'.

FIG 5.4
L.H.O.O.Q FROM BOX IN A VALISE (BOÎTE-EN-VALISE) BY OR OF MARCEL DUCHAMP OR RROSE SÉLAVY (DE OU PAR MARCEL DUCHAMP OU RROSE SÉLAVY). MARCEL DUCHAMP, AMERICAN (BORN FRANCE), 1887–1968

In such an environment, indispensable elements such as the economic system, a juridical system (including a police force) and other relevant aspects of civil infrastructure are re-installed and set up to function in an independent manner so that the foreign military can go home. To save and protect CP, as part of this process, there are basic requirements. The military must have CP experts and civil reach-back capabilities at their disposal throughout all of the phases of a conflict, including the planning and assessment phases.

CONFLICT

The International Committee of the Red Cross (ICRC 2008) identifies two types of conflict: 'international armed conflict', involving two or more States, and 'non-international armed conflict', between governmental forces and non-governmental armed groups, or between the latter groups only. IHL also makes a distinction between non-international armed conflicts in the meaning of common Article 3 of the Geneva Conventions of 1949 ('Armed conflict not of an international character occurring in the territory of one of the High Contracting Parties') and non-international armed conflicts falling within the definition provided in Article 1 of Additional Protocol II ('armed conflicts in which peoples are fighting against colonial domination and alien occupation and against racist regimes in the exercise of their right of self-determination, as enshrined in the Charter of the United Nations and the Declaration on Principles of International Law concerning Friendly Relations and Co-operation among States in accordance with the Charter of the United Nations'). Legally speaking, no other type of armed conflict exists. One type of armed conflict can evolve into another type.

CHANGING MILITARY MINDSETS AND ATTITUDES

Continuing changes and developments concerning the character of conflicts, and related strategies to end these conflicts, reveal that today's military operate in an increasingly complex setting: that of asymmetric conflict, as noted above. In this regard the military has had to learn to adapt to new situations; and the increasing complexity of war creates situations that are especially challenging for activities involving Civil Affairs and Civil Military Coordination (CIMIC) units trying to work with and engage the local population during missions. From this perspective CPP is one of the many 'new' specialities required by the military, taking its place alongside other forms of expertise such as civil administration, economic development, humanitarian affairs and civil infrastructure. The armed forces did not traditionally have these now essential capabilities within their organisation, so reacted by outsourcing some tasks to contractors and introducing so-called 'functional specialists' or 'reservist special tasks' – individuals who have expertise, including archaeology and art history, unavailable in the standing army and who normally work in civil society, who were 'painted green' – the European military expression for being temporarily militarised or, after training, enlisted as a reservist to be called into active duty when needed. The deployment of these reserve officers created tensions:

commissioning functional specialists caused practical problems such as issues of rank, difficulties over operating in the field with professional soldiers who were better trained, and a lack of understanding of, and experience with, military customs and traditions. These challenges call for additional research on CPP, not only from a theoretical but also from a practical perspective, to gain knowledge that can serve as a basis for the improvement and adaptation of current practices. For cultural experts, including archaeologists and art historians, it is difficult to grasp the military mindset, just as it is difficult for some academics to 'cross the bridge' and work with the military or militarised cultural experts. By the same token, many military professionals find it challenging to work with academics.

PARTIES INVOLVED IN THE CASE

Though Matejce is a unique case, the range of parties involved gives an indication of the complexity implicit in the implementation of CPP and the frequent involvement of many different stakeholders in CPP activities. All of the following took some part in, or had a view on, the Matejce case study:

- Military: CIMIC Group North, Functional Specialists, Netherlands Armed Forces
- Militant armed forces from the UCK
- International organisations: NATO, UNESCO, ICBS, ICOMOS
- Religious institutions in Macedonia
- Governmental institutions: Macedonia: Institute for the Protection of Cultural Monuments of the Republic of Macedonia, Ministry of Culture Macedonia, National Museum Macedonia. Netherlands: Royal Netherlands Embassy in Skopje, Instituut Collectie Nederland Amsterdam. MoD The Netherlands
- Individual art historians and restorers

INTERNATIONAL COOPERATION – NATO POSITION REGARDING CPP AND A POSSIBLE WAY AHEAD

In the Matejce case, for the most part, implementation of CPP was through CIMIC, with some participation from the wider Netherlands Armed Forces. Had the US been involved, their implementation might have been through Army Civil Affairs. The former NATO Secretary General has summed up the challenge involved in factoring in the international organisations:

> For NATO a comprehensive approach is one that fosters cooperation and coordination between international organisations, individual states, agencies and NGOs, as well as the private sector. Developing such a culture of cooperation is not going to be easy. We are all attached to our own ways. (NATO Secretary General de Hoop Scheffer, 2007)

Even though the Secretary General was not referring specifically to CPP, but to interagency coordination, when he made this statement, most would agree that his concern about developing a culture of cooperation would apply to CPP. In this regard I will first introduce what is called the Comprehensive Approach and then explain the

link with CPP. In addition, it is useful to outline how cooperation at the NATO level could work to implement powerful CPP programmes while defining the obstacles that would need to be addressed.

THE 'COMPREHENSIVE APPROACH'

Since the origins of conflicts are of a non-military nature, the use of different, non-military agencies and powers to end conflict is necessary. As development and security are strongly interconnected it is necessary to approach safety, reconstruction and good governance in a comprehensive manner – hence the 'Comprehensive Approach'. In this approach, development cooperation and military and diplomatic activities should be integrated. This means that the military contribution to crisis management operations must be combined with diplomatic efforts and development cooperation – the so-called '3D strategy': Development, Defence and Diplomacy. The Dutch armed forces are currently using a second generation of this 3D concept, based on four areas of concern: security, politics, and social and economic well-being. CPP fits into this concept as it is positive for the public image of a country, internationally as well as nationally. By actively demonstrating a CPP policy and at the same time meeting treaties and obligations mandatory under IHL, the support from a country's inhabitants for national and international military operations can be strengthened.

As a practical example of this strategy, Coalition forces in Afghanistan and Iraq have developed Provincial Reconstruction Teams (PRTs) that are designed to help improve stability by increasing the host nation's capacity to govern; enhancing economic viability; and strengthening local government's ability to deliver public services such as security and health care. Staffed by military, militarised and civilian experts, PRTs are a means of coordinating interagency diplomatic, economic, reconstruction and counter-insurgency efforts among various agencies in Afghanistan and Iraq. PRTs are intended to be interim structures; after a PRT has achieved its goal of improving stability, it will be dismantled to allow traditional development efforts to occur (http://www.gao.gov/new.items/d0986r.pdf (accessed 25 April 2010)). The Dutch Joint Doctrine Bulletin on PRTs states that the essence of a comprehensive approach is the fact that conflicts cannot be solved by military means only.

In addition to the PRT strategy, discussions are turning to the possibilities of multinational cooperation with organisations such as NATO, which potentially has capabilities for Civil Emergency Planning. I have argued elsewhere (Kila 2008a) that, in theory, NATO would be the ideal organisation to house and support a militarised cultural emergency team. This task would fall naturally to the department of Civil Emergency Planning (CEP), and in particular to the Senior Civil Emergency Planning Committee (SCEPC). Of course, there is also a related military intelligence element, especially in the case of the illicit traffic of artefacts. In addition, NATO's Allied Command Transformation (ACT), which includes in its mission statement the goals of 'improv[ing] military effectiveness and interoperability' and 'support[ing] Alliance operations', should include cultural heritage protection in its programme. CPP could also be taught at NATO's educational institutions. Since many countries are members of NATO, the possibility of locating and recruiting militarised experts is potentially significant.

However, at present, responsibility for providing advice on cultural heritage issues to military planners and commanders of NATO forces lies not with CEP but with CIMIC/Civil Affairs. This situation complicates matters for, while the NATO CIMIC AJP-9 doctrine seems designed to enhance the implementation of, in this case, CPP, different NATO member countries have very different concepts and perceptions of CIMIC generally. For example, whereas NATO as an organisation considers CIMIC as 'observation, interposition, and transition assistance', the UK perceives CIMIC as 'direct assistance by conventional troops' and the US recognises it as 'force protection, liaison, and limited direct support' (Celik 2005). The EU's definition of CIMIC in EU-led crisis-management operations is similar to NATO's: 'the coordination and cooperation, in support of the mission, between military components and civil actors which are external to the EU, including national populations and local authorities, as well as international, national, and non-governmental organisations and agencies'. Canada has two definitions, one for the domestic environment and one for international environments.

Consequently, it is not easy at present to use CEP as perceived by NATO for a cultural (property) emergency planning strategy. Apart from the conditional political intention, or political will, needed to create a multinational cultural emergency capability (CERC), a number of other issues are raised: does NATO have the same obligations as State Parties that ratified the Hague Convention? If so, how does this relate in practice to the support of the Commander's mission doctrine? Can a CERC act only when military forces are called upon by a civil authority to conduct a particular mission? In the case of a natural disaster the military has a finite mission for a finite time period. Can they operate under civil direction throughout? Articulating the legal obligations that would drive these efforts would provide guidelines for addressing these questions, complications and obstacles.

As a further complication, within NATO itself, the so-called STANAGs (NATO Standardization Agreements for procedures and systems and equipment components) are developed and promulgated by the NATO Standardization Agency in conjunction with the Conference of National Armaments Directors and other related authorities. According to NATO's STANAG 7141 EP, CPP falls under environmental issues, being the handling of natural and cultural resources. NATO members' defence ministries normally follow such STANAGs by issuing national directives or orders. A number of countries, as well as NATO, have Environmental Policy Working groups that provide an opportunity to incorporate expertise on cultural resources including CPP.

THE (CHANGING) STATUS AND DEFINITION OF CULTURAL HERITAGE OR PROPERTY

Different viewpoints and arguments exist among experts and scholars over the question of whether cultural property should be protected at all or in all circumstances. I leave this discussion to others and assume that it is important to protect cultural property in the event of armed conflict, touching subsequently on the notion of protecting and saving cultural property in the event of natural disasters. Furthermore, over the course of time, the definition of cultural property has changed. For example, statues of Lenin and Stalin from the Soviet period were not considered to be cultural property in the

immediate aftermath of the disintegration of the Soviet Union. In addition, a geographical location or an associated regime can influence the appreciation of, or status awarded to, cultural property. For example, the Taliban considers all pre-Islamic cultural property as pagan and therefore saw that it was perfectly within their rights to destroy it – resulting in the loss of the Bamiyan Buddhas. In the same way, certain property within a country, as, for example, in Iraq, can be seen as important Islamic heritage (eg the Golden Mosque), whereas other property (eg Babylon, Ur) in the same country is seen as less important Christian biblical heritage.

The Link with Religion

Religion has always been, and still remains, one of the elements that can cause and drive conflicts, and the deliberate destruction of cultural property has been a recurring thread throughout history. For example, a religious conflict between Calvinists and Catholics which took place in the Netherlands in 1566, the so-called 'Beeldenstorm', led to the damage and destruction of churches, monasteries and their contents, including paintings, murals and books. This targeting of religious buildings was echoed in the conflict in the former Yugoslavia, where churches and mosques were specifically targeted by the warring factions. In another example, the link between religion and cultural property was made explicit by the actions of the (then) Israeli opposition leader, Ariel Sharon, who, together with a Likud party delegation surrounded by riot police, visited the Temple Mount compound, widely considered the third holiest site in Islam, on 28 September 2000. The purpose of the visit was to demonstrate that under a Likud government the Temple Mount would remain under Israeli sovereignty. His visit was condemned by the Palestinians as provocation and an incursion, particularly given the presence of his armed bodyguards, who arrived with him. Critics claim that Sharon knew that the visit could trigger violence; it is widely credited with leading to the second Palestine Intifada.

In May 2003, just after the American invasion of Iraq had begun, Abdulamir Hamdani, the archaeology inspector of Dhi Qar province in southern Iraq, called on the Grand Ayatollah Ali al-Sistani with an urgent request. 'We needed his help to stop the pillage', Hamdani recalled. His province covers much of what was once the land of Sumer. In the third millennium BC it was a fertile plain incorporating the cities of Ur, Lagash, Girsu, Larsa and Umma; today, the shifting course of the Euphrates and Saddam's campaign to drain the marshes have for the most part turned it into an impoverished wasteland. After Saddam's fall, many poor locals – often backed by armed militia – turned to archaeological looting. As a result, the black market trade in antiquities became a major part of the local economy. Al-Sistani honoured Hamdani's request to announce a fatwa. He proclaimed that digging for antiquities is illegal; that both Islamic and pre-Islamic artefacts are part of Iraqi heritage; and that people with antiquities in their possession should return them to the museum in Baghdad or Nasiriyah. Copies of the fatwa were distributed widely in the south, and published in the Iraqi press. As a result some of the looters stopped, because they tend to obey the Grand Ayatollah. The fatwa was a small victory for Hamdani in his struggle to save cultural property.

CONCLUSIONS

Cultural property protection is an obligation under international humanitarian law. There seems to be no compelling reason why CPP should or could only be implemented at the expense of humanitarian aid; CPP and humanitarian aid are separate issues implemented by separate institutions and experts. Moreover, aid budgets can be, and usually are, allocated separately and independently of cultural funds. In addition, CPP and cultural awareness are separate issues with different motives and are handled by different experts.

Awareness and appreciation of the value of CPP must be increased in order to change the current situation in which policy planners, government officials and military commanders seem to be reluctant to take effective action, mainly as many are not familiar with the subject. The creation of national, dedicated departments for CPP which benefit all services (navy, air force and army) will contribute to an effective and lasting solution. Under such an arrangement, the CPP officers can slowly integrate and earn an accepted position within the armed forces. Professional deployment is not an unusual outcome, as this happened in the past with medical and juridical personnel who are now fully integrated. Another challenge within the military is the new dual role of warrior and peacekeeper, which requires at least an adaptation of the military mindset, as is also the case for the dual role of culture destroyer and culture protector. If members of the military can adapt to being both warrior and peacekeeper at the same time they must be able to do the same in relation to CPP.

Military involvement in Cultural Property Protection is seriously restricted by people who invent and introduce irrelevant ethical issues around cooperation between civil experts and the military. If all parties adhere to the legal framework provided by the Hague Convention then there should be no ethical problems. It could even be argued that ignoring the resolutions and suggested cooperation as outlined by International Humanitarian Law is in itself unethical.

EPILOGUE

- Should white men sing the blues?

 Yes, if civilian experts provide them with the expertise they need to meet the legal requirements of the 1954 *Hague Convention for the Protection of Cultural Property in the Event of Armed Conflict.*

- Can black and white men play the blues together?

 Absolutely: as I write this article, archaeologists are working successfully in Egypt with an international team to teach archaeology awareness to American and British military personnel. Additional examples include the United States Central Command, which has established a Historical/Cultural Advisory Group and the new International Military Cultural Resources Working Group. Both of these groups include subject matter experts and military officers working together.

- Do all men want to sing the blues?

 Many archaeologists and cultural property experts have strong personal commitments to international archaeological stewardship. Others also recognise their obligations under international law as citizens of countries that have signed the 1954 Hague Convention. Members of both groups have discovered that a very effective way to meet this commitment is to work as partners with the military. The subject matter experts who have chosen to sing the blues have had a tremendous positive response from their military colleagues. The answer is YES!

- Who gets the royalties?

 When we save cultural property, all citizens of the world benefit.

- Can we all join in playing instrumental blues?

 We are already playing the intro.

- Will it be slow or up-tempo blues?

 As you are reading this article, the tempo is increasing.

- Who decides what's in tune or out of tune?

 History…

Everybody gets the blues, from the White House to the poor house, and singing the blues, playing the blues, or even listening to others sing and play the blues always helps you feel better. (Poet 2008)

Can white men sing the blues? Probably not, but they can do a mighty fine instrumental blues instead.

BIBLIOGRAPHY AND REFERENCES

Celik, M, 2005 Comparison of the British and Canadian CIMIC and the U.S. CMO doctrines to the NATO CIMIC doctrine, thesis, Naval Postgraduate School, Monterey

CIMIC Group North Civil Assessment Team Iraq Al Muthanna, 2003 Hoofdstuk 4 Cultuur (eds L Col R Schuurman, L Col J Kila), Internal Report, Netherlands MOD

Feil, S, 2008 Engaging Interagency Processes to Protect Cultural Sites: Communities, Authorities, and Capabilities, in *Antiquities under Siege: Cultural Heritage Protection after the Iraq War* (ed L Rothfield), Altamira Press, New York, 219–34

Gerstenblith, P, 2009 Archaeology in the Context of War: Legal Frameworks for Protecting Cultural Heritage during Armed Conflict, *Archaeologies* 5 (1), April, 18–31

Hamilakis, Y, 2003 Iraq, Stewardship and 'The Record': An Ethical Crisis for Archaeology, *Public Archaeology* 3, 104–11

Hamilakis, Y, 2009 The 'War on Terror' and the Military–Archaeology Complex: Iraq, Ethics, and Neo-Colonialism, *Archaeologies* 5 (1), April, 39–65

de Hoop Scheffer, J, 2007 Speech by NATO Secretary General at the Microsoft-BBC-NATO – Defence Leaders Forum, 23 April, Noordwijk aan zee, available from http://www.nato.int/docu/speech/2007/s070423a.html [accessed 16 November 2009]

ICRC, 2008 How is the Term 'Armed Conflict' Defined in International Humanitarian Law? ICRC Opinion Paper, March, available from http://www.icrc.org/web/eng/siteeng0.nsf/htmlall/armed-conflict-article-170308/$file/Opinion-paper-armed-conflict.pdf [accessed 14 October 2009]

Kila, J D, 2008a Utilizing Military Cultural Experts in Times of War and Peace: An Introduction – Cultural Property Protection within the Military, Experiences in Theatre, Different Perceptions of Culture and Practical Problems, in *Culture and International Law* (ed P Meerts), Hague Academic Press/Asser Press, The Hague

Kila, J, 2008b The Role of NATO and Civil Military Affairs, in *Antiquities Under Siege: Cultural Heritage Protection after the Iraq War* (ed L Rothfield), Rowman & Littlefield Publishers, New York

Kila, J, forthcoming Cultural Property Protection in the Context of Military Operations – The Case of Uruk, in *Cultural Emergency in Conflict and Disaster* (eds B Klein Goldewijk and G Frerks), Routledge

Nicolik-Novakovic, J, 2004 Institute for the Protection of Cultural Monuments of the Republic of Macedonia, in *Cultural Heritage at Risk in the Event of Armed Conflicts: Proceedings of Macedonian National Committee of ICOMOS*, Skopje

Peischel, W, 2002 Protection of Cultural Property within the Framework of Civil/Military Cooperation, in *Protection of Cultural Property in the Event of Armed Conflict – a Challenge in Peace Support Operations* (eds E R Micewski and G Sladek), Austrian Bundesheer, Vienna

Pesendorfer, M, and Speckner, H, 2006 International Workshop on the Protection of Cultural Property in Peace Support Operations, Bregenz, 19–23 June, available from http://www.vorarlberg.at/vlb/vlbveranstaltungen/2006/pdfs/Workshop%20program.pdf [accessed 16 September 2009]

Poet, J, 2008 Review of Willie Nelson & Wynton Marsalis' 'Two Men with the Blues', Crawdaddy!, Issue 2.10, 23 July, available from http://crawdaddy.wolfgangsvault.com/Review/Willie-Nelson-Wynton-Marsalis-Two-Men-With-the-Blues.html [accessed 28 September 2009]

Rothfield, L, 2008a What Went Wrong: Learning the Lessons of Iraq for Cultural Heritage Protection in Time of War, paper presented at the *Protecting Cultural Heritage in Times of Armed Conflict* conference, 7 February, Tallinn

Rothfield, L, 2008b First Thoughts on the World Archaeological Congress Resolution, *The Punching Bag*, 9 July, available from http://larryrothfield.blogspot.com/2008/07/first-thoughts-on-world-archaeological.html [accessed 16 September 2009]

Stone, P, 2009 Protecting Cultural Heritage in Times of Conflict: Lessons from Iraq, *Archaeologies* 5 (1), April, 32–8

Wilson, J Q, 1989 *Bureaucracy: What Government Agencies Do and Why They Do It*, Basic Books, New York

Good Training and Good Practice: Protection of the Cultural Heritage on the UK Defence Training Estate

Martin Brown FSA MIFA

The impetus to effectively train soldiers has been recognised for thousands of years. Writing in AD 390, the Roman military theorist Vegetius set out his belief that:

> Victory in war does not depend entirely upon numbers or mere courage; only skill and discipline will insure it. We find that the Romans owed the conquest of the world to no other cause than continual military training, exact observance of discipline in their camps and unwearied cultivation of the other arts of war (Vegetius 1767, I: 1).

> The courage of a soldier is heightened by his knowledge of his profession, and he only wants an opportunity to execute what he is convinced he has been perfectly taught. A handful of men, inured to war, proceed to certain victory, while on the contrary numerous armies of raw and undisciplined troops are but multitudes of men dragged to slaughter (*op cit*, I: 2).

Over the centuries military authorities have taken these precepts to heart and today professional military forces seek to ensure that training is both relevant and as authentic as possible. As a result, the British military has a variety of landscape and terrain available to it both in the UK and further afield, which provides the environment for all aspects of training, from basic fieldcraft for new recruits through trade training such as engineering or gunnery to full mission rehearsal ahead of operational deployment.

Defining the Resource

The Defence Training Estate (DTE) is part of Defence Estates (DE). DE is a government agency responsible for the administration of land held and used by the Ministry of Defence (MoD). The Estate includes some 130 training areas and ranges in England, Scotland and Wales (Parliament 2007) which range from the large landscape areas, such as Salisbury Plain (28,000 hectares) and Otterburn (23,000 hectares), to individual sites such as the disued World War II munitions store at Yardley Chase (186 hectares). Many of these sites include ground taken into military use prior to World War II and, as such, represent rural areas that have not experienced the levels of development and agricultural intensification seen elsewhere in western Europe following World War II and notably, in the agricultural sector, the industrialisation of farming under the aegis of the European Union. In Britain,

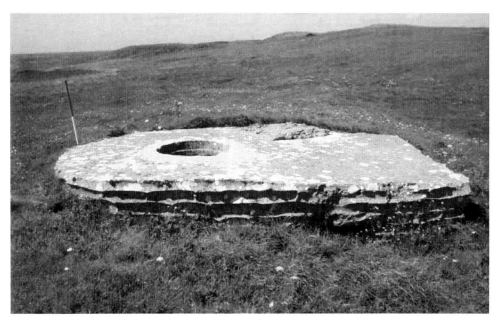

FIG 6.1
A GERMAN-STYLE RINGSTAND OR TOBRUK SHELTER BUILT AS PART OF A TRAINING LANDSCAPE TO
PREPARE TROOPS FOR THE ALLIED INVASION OF EUROPE IN 1944.

ploughing has long been seen as a major threat to the archaeological heritage, being
responsible for damage to significant numbers of sites and their historic landscape
settings (Trow 2004, 37–8; Hinchcliffe and Schadla-Hall 1980; Oxford Archaeology
2002, 2). However, as much of the DTE is used for military manoeuvres or gunnery it
is, by and large, unsuitable for widespread cultivation. As a result the remains of cultural
heritage survive well, as do elements of the natural environment (MoD 2009a).

The Defence Estate includes over 700 Scheduled Archaeological Monuments
protected within the terms of the 1979 *Ancient Monuments and Archaeological Areas
Act* (as amended 1984), including Iron Age hillforts, Roman rural settlements,
medieval moated sites and Cold War testing sites. There are also in the region of 800
Listed Buildings, which are also protected by legislation (MoD 2009a, 3). In addition,
MoD land includes many other archaeological sites without designation, ranging from
prehistoric flint scatters and medieval field systems to concrete blockhouses. There is
also the archaeological evidence left by the military themselves. In recent years the
growing recognition of 20th-century military heritage has seen the designation of a
range of monuments, including practice trenches from the Great War, such as those at
Bovington, Otterburn or Penally (Brown 2008), and sections of anti-tank wall and
Tobruk shelters (*Ringstand*) copied from German beach defences and used in training
for the Allied invasion of Europe on D-Day (1944) from Hankley, Shoeburyness and
Castlemartin. These sites add an extra layer of the military's own heritage to the
landscape, in addition to the more traditional archaeology found here and elsewhere

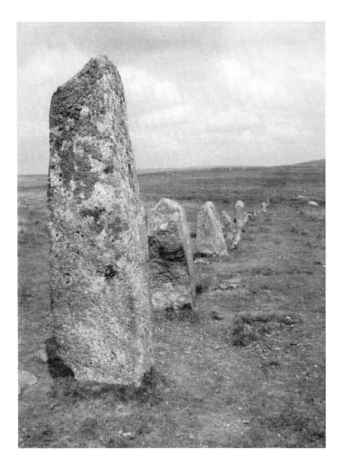

FIG 6.2
A PREHISTORIC STONE ROW ON
THE DARTMOOR TRAINING
AREA. STAR SIGNS ARE NOT
CONSIDERED APPROPRIATE IN
THIS OPEN LANDSCAPE, WHICH IS
PART OF NATIONAL PARK, SO
PROTECTION IS EMBEDDED IN
STANDING ORDERS, WHILE
MONUMENTS ARE MARKED ON
TRAINING AREA MAPS TO ALERT
TROOPS TO THEIR PRESENCE AND
SIGNIFICANCE.

in the countryside. A number of sites, such as Lulworth and Sennybridge, also include abandoned dwellings and settlements of more recent date. These sites were evacuated for training during World War II and have become part of the cultural heritage of DTE and of their local areas, contrasting with other nearby sites where development has continued. Moreover, the remarkable state of preservation of landscape within DTE means that cultural heritage assets may be seen in the context of a historic landscape, rather than as isolated fragments within a wider agricultural landscape. Perhaps the best-known example of this phenomenon is Salisbury Plain, where English Heritage has undertaken extensive survey of the training area that shows the high degree of survival of remains (McOmish *et al* 2002). Similar studies undertaken for DE on the Dartmoor Training Area, also by English Heritage, and at Sennybridge by the Clwyd-Powys Archaeological Trust, have shown that Salisbury Plain is by no means unique in the extent of survival and the quality of preservation. Nevertheless, a number of activities undertaken by the military users of DTE could be singularly destructive to the cultural heritage. As a result, a small Historic Environment Team (HET) is employed to advise Heads of Establishment and their estate managers on the

appropriate management of heritage assets. HET also provides liaison with statutory bodies such as local government archaeologists, English Heritage, Cadw and Historic Scotland, as well as providing a link with other heritage stakeholders such as the Council for British Archaeology or voluntary archaeological societies.

COMMITTED TO CONSERVATION

> The stated purpose of DTE is: 'To provide and develop a safe and sustainable training estate and facilities to meet the training requirements of Defence'. (Defence Estates 2006, 2)

The key issue is to provide well-trained service personnel who are properly equipped for the defence of the realm. However, as the then Secretary of State for Defence, the Rt Hon Geoff Hoon, wrote in the foreword to the Estate Strategy:

> We are very conscious that we hold our estate in trust and on trust for the nation. We have a responsibility to demonstrate that we are managing it in a sustainable way ... We have to balance our primary activities with proper stewardship of this part of the nation's heritage, recognising the interests of stakeholders beyond the Department. (MoD 2000, 2)

This statement reflects the fact that UK government has made a number of commitments to the preservation and protection of the historic environment in its direct care. For example, the 2003 'Protocol for the Care of the Government Estate' (DCMS 2003) sets out government commitments in respect of the historic environment; these have been adopted by the MoD and are implemented by DE. These commitments have been developed within MoD through chapter six of the *Defence Lands Handbook* (DE 2000, 6.1–6.16). This document establishes that 'It is the responsibility of the Commanding Officer/Head of Establishment to exercise controls on land, not let on full agricultural terms, to ensure any activity is not detrimental to any archaeology on the estate' (*ibid*, 6.6). The document then lists examples of hazards, including military training, farming, forestry and natural threats such as burrowing animals. It goes on to recommend the provision of signage on sensitive remains to prevent damage such as digging into or the driving of vehicles onto areas where these activities could be detrimental, or even illegal under the heritage protection legislation (*ibid*). Effectiveness of stewardship is monitored through a number of targets, including the condition of all archaeological monuments and historic buildings on the estate that are protected by heritage legislation. During the reporting year 2008/9, for example, 47 per cent of 737 monuments were deemed to be in good condition, 32 per cent in fair condition, and 20 per cent in poor condition (MoD 2009a, 7). While some of these condition assessments are undertaken by in-house specialists others are carried out by contractors, but all use the same methodology and recording forms to ensure consistency. The commitments to appropriate stewardship of the estate do, however, go beyond the documentation of the condition of designated heritage assets, as liaison with stakeholders from the

heritage sector, including governmental heritage bodies, may result in management recommendations and action. These statutory bodies also monitor MoD performance and could potentially criticise stewardship, causing not only embarrassment but, in a worst-case scenario, prosecutions for damage and significant restrictions on military activity within a given area.

The commitment to stewardship of cultural heritage is implemented at the level of the individual site through the Integrated Rural Management Plan (IRMP). All the major sites within DTE have an IRMP and there is a commitment to extend this coverage across all training areas. The IRMP includes components written by internal stakeholders including the military (whose priorities, as far as possible, drive the document), as well as estate managers and other professionals, such as members of the HET. Each component will include management aspirations that are deconflicted, agreed and prioritised before inclusion in the final IRMP document. In addition, many sites have a Conservation Group, which serves to draw together local experts in ecology and heritage who can advise the Head of Establishment in respect of conservation matters. As most specialist group members will be external to DE they will be able to provide independent support but also independent criticism of a site and its managers, as necessary. In many cases, these group members are very familiar with the site and have deep local knowledge, which means that they can offer a different perspective from the DE archaeologist who visits less regularly but who is, perhaps, more aware of issues within the organisation, as well as national trends.

HERITAGE UNDER FIRE?

The cultural heritage on DTE is open to a number of threats. These may be military, civilian or natural. However, it is the military threat and its mitigation that will be considered here.

Soldiers have trained on some parts of DTE since the 18th century, when the smooth-bore musket and cannon were the height of technology available to the military. In those days and for the following century the most significant threat to the landscape and to the archaeology within it came from the boots of Tommy Atkins (the nickname for British infantrymen), the hooves of his horses and the wheels of his wagons and cannon. However, as warfare has become increasingly industrial and mechanised, the threats have multiplied. The basic trench, dug to position a weapon or to shelter from incoming fire, can cause the same damage to a cultural heritage asset it always has, but explosives and the wheels and tracks of vehicles are more destructive than in days gone by. A site used today as a training area may have its origins in the 19th century, when the destructive power of ordnance was a fraction of that available to today's military and when vehicles such as the armoured personnel carrier existed, quite literally, only in the realms of fantasy. As such, it is essential to recognise the potential of the men and *materiel* to damage sites: for confirmation of this one need only look at the historic damage to archaeological monuments on the estate. On Salisbury Plain, the Snail Down Bronze Age barrow group exhibits damage from inter-war tank training (McOmish *et al* 2002, fig 2.27), while recent scrub clearance of monuments revealed another barrow at Bulford Ranges, also Salisbury Plain, that had

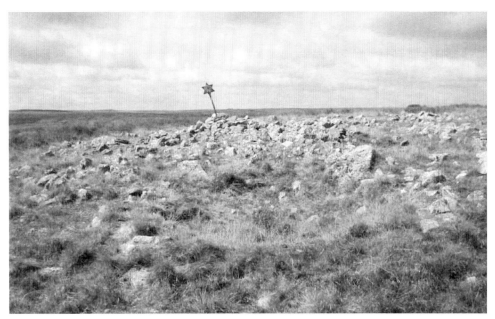

FIG 6.3
A BRONZE AGE CAIRN ON THE SENNYBRIDGE TRAINING AREA. THIS MONUMENT EXHIBITS HISTORIC
DAMAGE FROM ITS FORMER USE AS A TARGET WHEN THE LAND WAS USED AS AN ARTILLERY RANGE. THE
CAIRN IS NOW MARKED WITH A STAR SIGN AND HAS BEEN INCLUDED ON RANGE MAPS IN ORDER TO
PREVENT FURTHER DAMAGE. CONDITION INSPECTION HAS SHOWN THAT DAMAGE HAS CEASED, EVEN
THOUGH MORTARS ARE STILL USED IN THIS AREA.

been incorporated into a Great War trench system. The damage sustained during this
operation suggested that a dug-out or shelter had been cut into the mound as part of
the wider entrenching. Elsewhere, some barrows – which tend to occupy prominent
locations with excellent lines of site across the landscape – have suffered historic
damage as a result of troops creating observation posts or machine-gun positions,
while others have been used as targets for artillery because they are visible to both
trainees and instructors from a safe distance (*ibid*, fig 2.4; RCAHMW 1997, 102).
Meanwhile, the abandoned villages of Imber and Tyneham and the 19th-century fort
at Scraesdon were all fought through during military exercises. However, as the MoD
and the military began to assume the mantle of good stewards of the landscape, moves
began to ensure that the historic damage cited above did not continue and to protect
cultural heritage without impeding training. What may have been acceptable in times
of total war would not be accepted by either public or statutory bodies in periods of
less immediate danger. Today, DTE works in partnership with other parts of DE and
with external specialists to ensure that the commitments discussed above are met and
that cultural heritage is not compromised by military training (Brown 2005).

In the first instance the documentation and mapping of cultural heritage assets is
essential. Such information provides a knowledge base for the assessment of

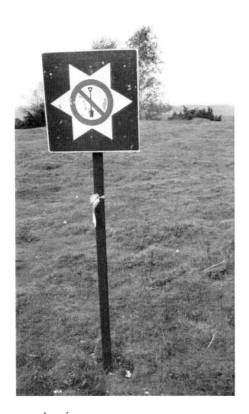

FIG 6.4
THE 'NO DIGGING' STAR SIGN. THE STAR SYMBOL
AND THE VISUAL REINFORCEMENT, BASED ON A
ROAD SIGN, ARE DESIGNED TO BE UNDERSTOOD BY
TROOPS EVEN IF THEY DO NOT SPEAK ENGLISH.

significance, condition monitoring and protective measures, where necessary, against potential damage. In 2000 a baseline condition assessment of DTE was undertaken. This included the gathering of data from historic environment records and the undertaking of field survey to verify results and to report on condition and the state of active protection, if any. This data forms the basis of the DE heritage database and is regularly revisited to ensure an up-to-date resource. Asset mapping is also carried through to the main DE estate information systems so that data on Scheduled Monuments and Listed Buildings are available to all users. Mapping may also include archaeological site groups, which have been grouped together for management purposes or to set a dispersed group of Scheduled Monuments within a landscape context. Meanwhile, maps of individual training areas are marked with symbols that indicate archaeological monuments, often deeming them 'out of bounds'. While these are usually the designated assets, such as Scheduled Monuments, this is not exclusively the case, as some significant sites may not have legal protection. Training area maps are used in the planning and execution of exercises by military users and should as such provide a guide to areas that should be avoided. The maps will, in turn, be backed up by standing orders for each site that underline the importance of sites and that, where shown as being off-limits, they should actually be avoided. Should such instructions be ignored and damage occur, the relevant soldiers will be required to repair damage, among other sanctions.

On the ground significant monuments are likely to have protective signs erected around them; the most common form is the silver six-pointed star on a post. Although other forms of signage have been introduced in the past, this star sign is felt to remain the most effective, as it is an easily remembered visual symbol. Signs with wording such as 'Archaeological Monument – No Digging' are considered less successful, partly because of the range of nationalities, including Iraqis, Afghans, Poles, Dutch and Turks, who may be found using DTE sites and who may not speak or read English. In order to reinforce messages, the star may be enhanced by stickers based on road signs which indicate that digging should not take place (a red circle with a line

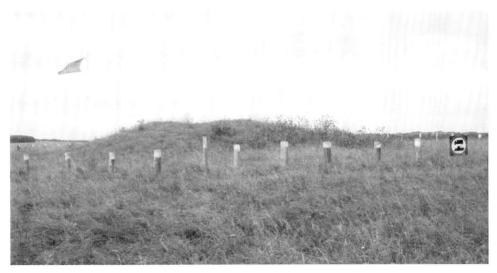

FIG 6.5
A BRONZE AGE BOWL BARROW ON THE SALISBURY PLAIN TRAINING AREA SHOWING PALISADES AND NO
DIGGING SIGNS. THE RED FLAG INDICATES THAT THE RANGES ARE LIVE AND PUBLIC ACCESS IS PROHIBITED.
THE WOODEN STAKES ARE INTENDED TO WARN TROOPS OF THE PRESENCE OF ARCHAEOLOGY AND TO
PREVENT VEHICULAR ACCESS BUT TO ALLOW GRAZING ANIMALS AND TROOPS ON FOOT ACROSS THE
MONUMENT.

through a shovel), nor should vehicles drive over the site (a red circle with a line
through a stylised vehicle). In addition, extra protection may be afforded by the
erection of a palisade around an asset: fence posts driven into the ground around the
boundaries of a monument at sufficiently close intervals to impede vehicular access
but far enough apart to allow access by both dismounted troops and any stock used
to graze the training area. Some of the posts may also be painted with reflective paint
to enhance their visibility at night. The palisade will also act as a final alert to the
driver of a vehicle that he has crossed into an out-of-bounds area. For larger sites,
such as a deserted medieval village, an area may be fenced off and used as a penning
for animals grazing, also providing a means of keeping the livestock out of harm's way
during periods of intense military activity. This serves to protect both stock and
monument, as the animals will graze over the heritage asset and its fence will exclude
potentially hazardous activities. Nevertheless, as has been stated above, DTE exists to
train service personnel and these protective measures could be seen as a restriction on
the estate's primary function. However, there are moves to integrate some
archaeological sites more closely into training. During normal usage by troops there
are perceived to be few complaints about restrictions arising from heritage or
environmental designations, but during major exercises such as the Mission Rehearsal
Exercise (or MRX) troops may be on a final tranche of training ahead of operational
deployment to a conflict. Accordingly, any restriction needs to have sufficient
justification and archaeological sites have, in the past, been marked on exercise maps
as minefields, chemically contaminated areas or refugee camps. However, following

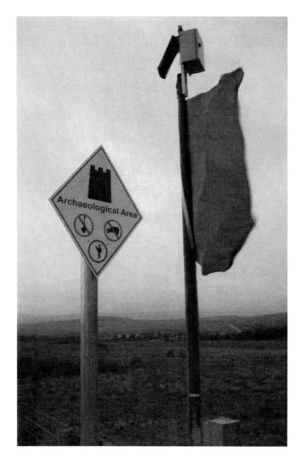

FIG 6.6
A SIGN ALERTING TROOPS TO THE
PRESENCE OF ARCHAEOLOGY AND WHAT
THEY MAY AND MAY NOT DO ON THE
GROUND. THIS STYLE OF SIGN IS USED
ON THE OTTERBURN TRAINING AREA.

both the invasion of Iraq and the looting of the National Museum in Baghdad, as well as the destruction of the Bamiyan Buddhas in Afghanistan, all of which show the renewed importance of cultural property in war (Bogdanos 2005), there are now moves to mark some sites as 'Cultural Heritage' that should be respected within the terms of the 1954 Hague Convention (UNESCO 1954). As such, troops can be seen not only to be learning valuable lessons that will serve in the conflict zone, but also to be protecting domestic heritage as part of the learning experience.

Meanwhile, the message about active protection is reinforced in a number of ways when troops are not in the field. Some sites, such as Salisbury Plain, will show all troops an introductory video which describes the cultural and environmental heritage assets and sets them in the context of military training. Other communication tools may include poster displays or small museums, as at DTE Dartmoor's headquarters. Here the posters have been placed above the urinals in the latrine blocks because 'it's the only place you can be sure they'll read them' (Lt Col Tony Clarke, *pers comm*), while the museum forms the backdrop to pre-exercise planning meetings. Different media have been targeted at different audiences with different amounts of time available for their education. Another success in broadcasting conservation and safety messages to troops has been the 'Green Pack', a set of playing cards that was introduced in 2005. They are issued to troops exercising on Salisbury Plain. Each suit of cards has a theme covering ecology, archaeology, safety and best practice to minimise damage to the Plain by exercising troops. A set is issued to each eight-man section, which is the basic unit of the British Army. As spare time is wiled away playing cards, the positive messages flash in front of the soldiers time and again.

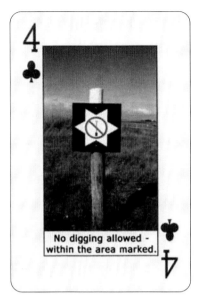

'No Digging' sign

Great War practice trenches

Barrow damaged during inter-war
tank training and reinforcing the
message about preservation

The cartoon draws on the proximity
of Stonehenge to the Salisbury Plain
Training Area to reinforce messages
about stewardship

FIG 6.7 EXAMPLES OF THE GREEN PACK CARDS

Playing cards and palisades may seem to represent a low-tech approach to maintenance of the estate, but this can be coupled with the inspections of sites by HET staff and the range wardens and by the regular condition assessment exercises. However, there are more technological options available in some situations and these are being explored. During Tactical Engagement Simulation exercises (TESEX) troops and vehicles are equipped with sensors that are, in essence, an advanced laser-tag system with an attached display screen, something like a pager. As fired weapons and 'hits' are registered by sensors worn on the uniform, the wearer may find a buzzer and on-screen message alerting them to an injury or even death, so that they must withdraw or be evacuated, simulating real casualties and adding a level of authenticity for the commanders. For vehicles, the same effect can result in temporary disablement. In addition, each sensor array, whether on an individual or vehicle, can be tracked across the training area. Although this is a tactical evaluation tool, enabling instructors to remotely assess performance, it effectively also allows an individual responsible for damage to a heritage or environmental asset to be identified. However, the TES equipment may also be used to alert wearers to the close proximity of heritage assets and could, theoretically, disable a vehicle that was about to cross the palisades into an archaeological monument. While TES equipment is not widely used, there are opportunities to afford last-line protection through such technology (Lt Col Fellowes, *pers comm*), particularly since TESEX tend to be highly fluid exercises with 'free play', during which the participants are not working to a defined script and must react to situations as they develop, which increases opportunities for accidental disturbance to the landscape.

Despite, or perhaps because of, the more intensive use of some training areas, some damage is not accidental and must be mitigated. Since 2001 the British military has been engaged in operations in Afghanistan and Iraq. As the balance of operations has shifted from traditional war-fighting to internal security and counter-insurgency operations, DTE has been required to provide realistic training facilities, such as the Afghan village recently opened on the Stanford Training Area (Norfolk, UK), which has been described as 'the best equipped training site in the UK' (Daily Telegraph 2009). The building of such a complex – or any of the other developments associated with current operations on DTE – has great potential to cause damage to remains. However, use of the heritage database, liaison with local government archaeologists involved in the planning process and the implementation of programmes of archaeological investigation serve to mitigate the effects of development by identifying heritage issues that prompt appropriate action, whether that be the identification of either alternative locations or construction types for development or prior works to ensure archaeological recording, ensuring preservation, where possible, or appropriate recording prior to unavoidable destruction. While in line with UK practice over the historic environment and development (eg PPG16), the approach again shows commitment to active protection of the heritage, as it was introduced during a period when MoD had exemption from the civil planning system.

CONCLUSIONS

The Defence Training Estate is an historical asset. Its acquisition over some 200 years has removed land from the stresses of modern development and intensive agriculture attendant upon most of the rest of the UK countryside. As a result the estate includes some very fine cultural heritage assets, many of which are deemed to be of national importance. In addition, the wider landscape setting of the individual assets may also be seen as a cultural asset. The MoD has recognised the cultural heritage value of its estate and implemented policies to ensure that there is stewardship of the land held. This has been transferred, at individual sites, into a series of measures to quantify and assess the heritage, protect assets and raise awareness of the resource on the part of users. These may be practical protective measures or educational initiatives designed to influence user behaviour. In some cases this behaviour may be seen as a positive part of training, engendering a respect for cultural property that may be useful when operationally deployed. The protection of cultural assets on DTE is assisted and monitored by heritage professionals working within DE who are supporting training by ensuring that the estate is in good order for its continued military use. However, in ensuring a sustainable estate, in line with government commitments for the training of service personnel, DE continues to act as a significant cultural heritage resource; defence of the heritage and defence of the realm are not incompatible and can, in fact, be complementary.

BIBLIOGRAPHY AND REFERENCES

Bogdanos, M, with Patrick, W, 2005 *Thieves of Baghdad*, Bloomsbury, New York

Brown, M, 2005 Archaeology and Heathland on the Defence Estate, in *Heathland – Past, Present, Future* (ed H D V Prendergast), East Sussex County Council, Lewes

Brown, M, 2008 Reflections of War, *Britain at War Magazine* 19, 61–7

Daily Telegraph, 2009 *MoD builds Afghan village in Norfolk*, available from http://www.telegraph.co.uk/news/newstopics/onthefrontline/5256219/MoD-builds-Afghan-village-in-Norfolk.html [accessed 19 August 2009]

DCMS, 2003 *Protocol for the Care of the Government Historic Estate*, DCMS, London, available from http://www.culture.gov.uk/images/publications/BCRprotocol.pdf [accessed 21 September 2009]

Defence Estates, 2000 *Defence Lands Handbook*, Ministry of Defence, London

Defence Estates, 2006 *Defence Training Estate Annual Report 2005/6*, Defence Estates, Warminster

Department for Communities and Local Government, 1990 *Planning Policy Guidance 16: Archaeology and Planning*, available from http://www.communities.gov.uk/documents/planningandbuilding/pdf/156777.pdf [accessed 18 August 2009]

Hinchcliffe, J, and Schadla-Hall, R T (eds), 1980 *The Past Under the Plough*, Department of the Environment, London

McOmish, D, Field, D, and Brown, G, 2002 *The Field Archaeology of the Salisbury Plain Training Area*, English Heritage, Swindon

MOD, 2000 *In Trust and On Trust: The Strategy for the Defence Estate*, Ministry of Defence, London

MOD, 2009a *Ministry of Defence Biennial Heritage Conservation Report 2007–2009*, Ministry of Defence, London

MOD, 2009b *Biodiversity on the Defence Estate*, available from http://www.defence-estates.mod.uk/conservation/2_biodiversity.php [accessed 12 August 2009]

MOD, 2009c *Archaeology: Introduction*, available from http://www.defence-estates.mod.uk/conservation/4_archaeology.php [accessed 12 August 2009]

Oxford Archaeology, 2002 *The Management of Archaeological Sites in Arable Cultivation: Appendix Dii*, Oxford Archaeology, Oxford

Parliament, 2007 *Select Committee on Defence: Fifteenth Report*, available from http://www.publications.parliament.uk/pa/cm200607/cmselect/cmdfence/535/53509.htm [accessed 12 August 2009]

RCAHMW (Royal Commission on Ancient and Historic Monuments in Wales), 1997 *An Inventory of the Ancient Monuments in Brecknock (Brycheiniog)*, Sutton, Stroud

Trow, S, 2004 Saving Sites from the Plough, *Institue of Field Archaeologists Yearbook and Directory 2004*, IFA, Reading

UNESCO, 1954 *Hague Convention for the Protection of Cultural Property in the Event of Armed Conflict*, available from http://unesdoc.unesco.org/images/0008/000824/082464mb.pdf [accessed 8 October 2009]

Vegetius, 1767 [390], *De Re Militari*, available from http://www.pvv.ntnu.no/~madsb/home/war/vegetius/dere03.php [accessed 12 August 2009]

In-Theatre Soldier Training through Cultural Heritage Playing Cards: A US Department of Defense Example[1]

JAMES ZEIDLER AND LAURIE RUSH

INTRODUCTION

Cultural heritage protection has been a long-standing challenge for the US military during deployments to Afghanistan and Iraq, one perhaps typified by the well-publicised military damage to the site of Babylon and the equally notorious looting of the Iraq National Museum, both of which occurred at the start of the conflict in Iraq. These and many other transgressions have been explored in considerable detail in recent edited volumes which together provide a 'lessons learned' guide to what went wrong and what might have been done better (Rothfield 1988; Stone and Farchakh Bajjaly 2008; see also Cogbill 2008). Some would place blame for these incidents on an intentionally callous disregard for the cultural heritage of other nations by the US military, while others (eg Armstead 2008; Cogbill 2008) place blame squarely on the lack of pre-war planning for heritage protection. While we agree that adequate pre-war planning is key, we argue that the overriding culprit in this instance is a lack of formal pre-deployment awareness training – at *all levels* of the military hierarchy – on issues related to cultural property protection in foreign theatres of operation. Without a basic awareness of the issue, it is unlikely to be made a priority in pre-war planning efforts.

This situation is somewhat paradoxical and counter-intuitive when considering the large measure of success that the Department of Defense has had with its compliance and stewardship responsibilities for cultural heritage resources on its own military installations throughout the United States. Unfortunately, those very responsibilities were never translated to in-theatre operations by war planners at the outset of the conflicts in Afghanistan and Iraq and no thought was given to international or host country law in this regard. Even the current awareness training project discussed in this chapter originated at the installation level (Fort Drum, NY) as a proof-of-concept project awarded by the Department of Defense Legacy Resource Management Program through a competitive proposal process. Now in its fourth year of funding, the project has met with considerable success and it is hoped that many of the gains that have been made in raising DoD awareness of cultural property protection in foreign operations can be institutionalised in a more permanent manner (Rush and Bogdanos 2009).

1 The views and opinions expressed here are solely those of the authors and do not necessarily represent the views, opinions or policies of the US Department of Defense, the US Army or Fort Drum.

Product	Type
Fort Drum CRM Program	Group-orientated, formal
Training Scenarios (MSELs)	
Hardened Historic Sites	
'Mock' Training Assets	
CEMML, Colorado St. Univ.	
CB Training Module	
Self-Guided PPT Show	
Country-Specific Websites	
Soldier Pocket Cards	
Playing Cards	Individualised, informal

TABLE 7.1
LIST OF IN-THEATRE
CULTURAL HERITAGE
AWARENESS PRODUCTS
ARRAYED ALONG
SLIDING SCALE OF
TRAINING/LEARNING
FORMAT

From the outset, our challenge was to develop a range of educational products that would raise awareness on cultural property protection issues at all levels of the military hierarchy, and that could be applied in a wide variety of training settings as well as in-theatre operational contexts (Table 7.1). Ideally, these settings would range from informal, individualised contexts to more formal, group-orientated training scenarios. In general, we followed established guidelines and procedures for communication campaigns commonly followed in the conservation professions (see, for example, Jacobson 1999), but tailored, of course, to meet our specific needs and target audiences. As Table 7.1 demonstrates, the more group-orientated and formalised products were developed by the Cultural Resources Management Program at Fort Drum for implementation in pre-deployment training exercises. These included (a) the development of Mission Scenario Event Lists (MSELs) that explicitly included cultural property protection issues in the training scenarios, (b) the hardening and reinforcing of 19th-century historic building foundations for their adaptive reuse in actual training exercises, and (c) the creation of 'mock' archaeological sites that simulate those found in the Middle East so that the aforementioned MSELs can be executed in more realistic surroundings. Many of these ideas and training assets have now been implemented at other training installations.

Moving toward more individualised and informal contexts for awareness training, the Center for Environmental Management of Military Lands (CEMML), Colorado State University, assisted in the development of several products aimed at self-guided learning. These included: (a) a comprehensive web-based training module for individual or classroom training; (b) a self-guided PowerPoint presentation on underwater heritage resource issues, suitable for both individual review or classroom training contexts; (c) comprehensive country-specific websites for Iraq and Afghanistan that provide considerable detail on cultural property protection issues in

those countries as well as summaries of legal mechanisms and enforcement procedures for cultural property protection; (d) small (6 in × 4 in), double-sided, waterproof Soldier Pocket Cards with very basic information on in-theatre heritage preservation issues that can be conveniently carried in the battle dress uniform (BDU) for ready reference; and (e) the cultural heritage playing cards, occupying the extreme end of the 'individualised, informal learning' spectrum. It is this last product to which we now turn our attention. Their intent was relatively straightforward. As one journalist put it: 'the cards get on with the business at hand: to alert average, card-playing GIs to the sacred terrain around them and their responsibility to it' (Kaylan 2007).

WHY PLAYING CARDS? WHY NOW?

The history of playing cards is fairly well known, having their origin in China as far back as the 9th century AD, then spreading through the Middle East and India, and on to Europe by the late 1300s, where their popularity exploded as a result of woodcut printing in the early 15th century (Wikipedia (Anon) 2007a; Hargrave 1966; Needham 2004; Parlett 1977; Tilley 1973; Wilkinson 1895; and Wowk 1983, among others). The four suits now used in most of the world (spades, clubs, hearts and diamonds) were developed in France in the late 1400s. But, along the way, playing cards have long had roles far beyond their recreational use – as informational and educational tools (Decker 2001). Their value in this respect lies in their compact size, maximal portability and frequent use both by individuals and by larger groups. Hence, the medium ideally ensures broad distribution of the message, with 52 opportunities to convey pieces of that message.

In a military context, the famous 'spotter cards' of World War II that showed silhouettes of enemy aircraft and naval ships immediately come to mind as a means of raising troop awareness (US Games Systems 2003). More recent examples are the infamous 'Most Wanted Iraqis' cards (aka the Saddam Cards) developed by the Defense Intelligence Agency. Lesser known military playing cards that actually served as the inspiration for our cultural heritage playing cards are the Integrated Training Area Management (ITAM) playing cards developed by the US Army to raise awareness of a wide variety of environmental issues and concerns on military training lands. For our purposes (Fig 7.1), we wanted to develop a deck of informational playing cards that would provide all levels of the US military with a basic awareness of the cultural heritage preservation issues encountered in the Iraq and Afghanistan operations. In so doing we attempted to create a balanced mixture of messages, many devoted to conveying basic information on Mesopotamian and Afghanistan prehistory and history, and several others devoted to fundamental 'Dos and Don'ts' for military personnel in the field.

As for the 'Why Now?' question: several critics have asked what took so long, the implication being that it is 'too little, too late'. Why are these training products appearing in DoD circles long after the initiation of deployments in Afghanistan and Iraq? The answer to that question is that the impetus for this awareness training came from the bottom up, so to speak – from a cultural resources program manager at one Army installation – and following the development of the idea there was a long

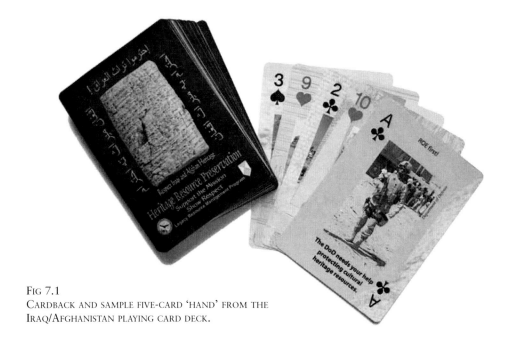

Fig 7.1
Cardback and sample five-card 'hand' from the
Iraq/Afghanistan playing card deck.

process of proposal writing and competition leading to the initial funding. Rather than complain about the length of time it has taken to get where we are, we prefer to take the long view and look towards establishing cultural heritage awareness training as a mainstay of DoD training doctrine, so that US military personnel are sensitised to the issue no matter where in the world they are deployed and no matter what their purpose.

Conceptual Design

With respect to the design of the playing cards, a contributing journalist to a major US newspaper characterised them in the following terms:

> It's hard not to let out an involuntary chuckle when you first see the cards: They're so literal and well-intentioned, so perky and bright and functional, that they defy all cynicism. Like the Saddam 'Most Wanted' cards, they achieve instant pop-culture status, but without knowingness or sly postmodern winking at the cultural mirror. They hark back to the early, unself-conscious time of pop artifacts, when chewing gum wrappers and pin-up posters were merely, effectively, themselves. (Kaylan 2007)

While we make no claims to having 'pop-culture status' as our ultimate goal, we *were* very concerned with developing a product that was both attractive and informative, one that would be used frequently by troops in the field, as well as by military trainers and planners.

Playing card content and design were guided by several considerations (Fig 7.2). First, we attempted to have each card suit represent a certain kind of message:

Playing Card Content and Design

Message by Suits:
- Hearts–winning hearts and minds.
- Diamonds–saving precious artifacts.
- Spades–cautioning against digging and site destruction.
- Clubs–raising awareness on heritage preservation.

Imagery + Captions:
- Educational…importance of Mesopotamia as cradle of civilization and Afghanistan as historical hub of trade.
- Informational…do's and don'ts for U.S. soldiers with respect to site protection, looting, and antiquities trafficking.
- Keep the messages simple.
- A little redundancy is good.

A Simple Overarching Metaphor:
- "Remember! When artifacts are looted and ruins are destroyed, valuable pieces of the cultural puzzle disappear forever…"
- Background images can be formed into four puzzle shapes, one for each suit, as shown on the wild card. The solution to each puzzle is an image from that suit.

FIG 7.2
ESSENTIAL COMPONENTS
OF PLAYING CARD
CONTENT AND DESIGN.

- <u>Hearts</u> for 'winning hearts and minds' (admittedly a long shot …);
- <u>Diamonds</u> for 'saving precious artefacts';
- <u>Spades</u> for 'cautioning against digging and site destruction';
- <u>Clubs</u> for 'raising awareness on heritage preservation issues'.

In the end, there was some overlap in these messages but overall the groupings hold together reasonably well.

The real work took place with respect to the selection of imagery and captioning. We were aiming for several messages that were simply educational in nature, conveying in layman's terms the importance of Mesopotamia as a cradle of civilisation and Afghanistan as an historical hub of long-distance trade. The two cards displayed in the upper left of Fig 7.2 provide good examples:

- 8 of Hearts: Mesopotamian civilisation originated in the Fertile Crescent between the Tigris and Euphrates Rivers where agricultural settlements were established over 8000 years ago.
- Jack of Clubs: Ancient cultural artefacts and objects of art are heritage resources that must be protected.

However, the cards also had to bear a rather heavy informational load as well by providing US military personnel with important Dos and Don'ts with respect to

cultural property protection, illicit looting and antiquities trafficking. The two cards displayed on the left centre of Fig 7.2 are representative examples:

- 4 of Diamonds: Report to your OIC (Officer in Charge) any looting activity or attempts to sell ancient artefacts.
- 10 of Spades: Heavy excavation equipment can do great harm to archaeological sites: be aware and prepare to stop.

Messages were purposely kept simple, a task that was aided by the space limitations on the cards themselves. Imagery was generally in colour although a few older black-and-white images of ancient sites and artefacts were also used for effect. While a wide variety of messages was desirable, the 52 cards also allowed room for some redundancy and some of the basic messages can be found on more than one card.

The final selection of imagery and associated captioning was anything but straightforward. The authors, along with the CEMML graphic designer Tracy Wager, formed a small committee for final card layout and design decisions. But, prior to that, an overwhelming number of potential images had to be vetted for overall attractiveness and suitability, for accuracy of captioning, for potential copyright infringements and for suitable image resolution (300 dpi or greater). These often conflicting requirements resulted in a somewhat tedious but necessary vetting process. The Mesopotamian and Afghanistan imagery and captioning were reviewed by several Middle Eastern scholars including Dr Samuel Paley (SUNY, Buffalo), Dr Roger Ulrich (Dartmouth College), Col Matthew Bogdanos (US Marine Corps Reserve), Dr John Russell (Massachusetts College of Art) and various scholars affiliated with the Oriental Institute of the University of Chicago. The Oriental Institute Museum deserves special credit for providing several images of Mesopotamian sites and artefacts free of charge. Military-related imagery and captioning were reviewed by Hillori Schenker of the DoD Legacy Resource Management Program and Brian Lione, former Deputy Historic Preservation Officer for the Department of Defense. A final 'reality check' was provided by several military personnel deployed in Iraq and Afghanistan, as well as US-based personnel.

One of the more distinctive features of the cultural heritage playing cards was the inclusion of a background puzzle that can be found in each of the four card suits. It is a half-tone image from one of the cards of that suit, blown up so that when the 13 cards of that suit are arranged in a particular fashion, the entire image is revealed. These puzzles are meant to remind the card user of a simple overriding metaphor: that 'when artefacts are looted and ruins are destroyed, valuable pieces of the cultural puzzle disappear forever'. In addition to providing an alternative to the usual game of solitaire, the card puzzles hopefully offer a thought-provoking link to the issue at hand: *protecting cultural property as a means of preserving history*.

Table 2 shows the final breakdown of themes within the 52-card deck. As this breakdown demonstrates, educational messages on the two countries in question (including ancient sites, representative artefacts, and a map) make up some 24 of the messages, followed by 18 messages dealing specifically with Dos and Don'ts for military personnel. These are by no means magic numbers, but reflect what we felt was an appropriate balance in the 52 messages.

Topics	#
US military in-theatre (do's and don'ts)	18
Iraq/Afghanistan cultural heritage sites	13
Iraq/Afghanistan cultural artefacts	10
US military at US installations	4
Generic heritage issues	4
Iraqi people	2
Map (Fertile Crescent)	1

TABLE 7.2
TOPICAL BREAKDOWN OF MESSAGES
ON THE 52 PLAYING CARDS.

When developing educational products such as these, one of the first issues to be addressed is the educational level that is appropriate for the messages. This, of course, depends on the targeted audience. There is an often-used rule of thumb for educational and interpretive exhibit design that text should be developed at the 6th Grade level, or a notional reading age of 12, to make it maximally accessible and understandable by a broad range of the viewing public (Belcher 1991, 17). However, since our targeted audience was meant to be restricted to US military personnel aged 18 years and above – 'the average card-playing GIs', as one journalist put it – we opted for a slightly higher educational level. Realising that many individuals of our targeted audience might not have college-level education, and that in many places in the United States World History is not taught in the later years of high school, we have opted for a 9th Grade educational level exemplified by recent World History texts such as Ramirez, Stearns, and Wineburg's volume entitled *Human Legacy* (Ramirez *et al* 2007). Thus the educational messages on Iraq and Afghanistan history and prehistory do not assume prior knowledge of these areas beyond the level of detail found in these textbooks, at least for the cultural heritage playing cards. For more in-depth treatment of these topics, US military personnel are referred to the two websites we have produced on cultural heritage preservation in Iraq and Afghanistan, developed in collaboration with the non-governmental organisation (NGO) *Saving Antiquities for Everyone* (Kunkel 2008a; 2008b).[2]

In terms of the playing cards themselves, the card back (Fig 7.3) received special attention because of its iconic role in representing the entire deck. We selected a cuneiform tablet, also depicted on the 10 of Diamonds, as the emblem to represent the card deck and the project in general. It is from the site of Nippur, Iraq, and was acquired by the University of Pennsylvania Museum through scientific excavations in the early part of the 20th century. The basic message of the card back is that US military personnel should strive to 'respect Iraqi and Afghan heritage'. This phrase

2 These websites are now available on the CEMML parent website at the following URLs:
Iraq: http://www.cemml.colostate.edu/cultural/indexiraq.html;
Afghanistan: http://www.cemml.colostate.edu/cultural/indexafgh.html.

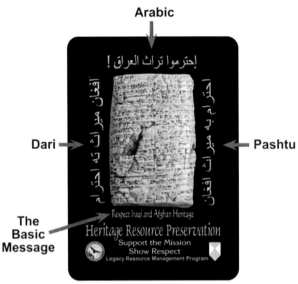

Arabic

Dari

Pashtu

The Basic Message

FIG 7.3
LEFT: BASIC MESSAGE AND
PERTINENT TRANSLATIONS ON THE
CARDBACK.

FIG 7.4
BELOW: THE PLAYING CARDS OF
THE CLUBS SUIT ARRAYED IN
'PUZZLE' FORMAT SHOWING THE
MINARET AT SAMARRA.

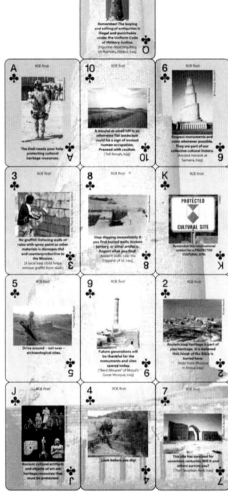

was then translated into Arabic, Dari and Pashtu, so that citizens of the host nations would have a clear understanding of the intent of the card decks. Symbols include the logo of the Legacy Resource Management Program along with the Blue Shield, the international symbol for a protected cultural property.

Some 120,000 of these decks were printed in several production runs by the US Playing Card Company (Cincinnati, OH) and almost all of them have now been distributed to US military personnel in pre-deployment training contexts here in the US and/or in-theatre in Iraq and Afghanistan.

Other related training products include two promotional posters, one representing the card back and the other displaying all of the cards arrayed in their respective puzzles by suit. (Fig 7.4 depicts the Clubs suit and its associated puzzle to provide a general idea of the imagery and captioning.) These have been sent in smaller numbers to the same entities

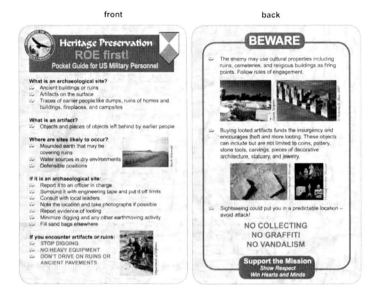

Fig 7.5

FRONT AND BACK OF THE
HERITAGE PRESERVATION
'SOLDIER POCKET CARD'.

receiving the card decks as a means of advertising their availability and promoting their use. The Soldier Pocket Card (Fig 7.5), mentioned previously, was designed for distribution in tandem with the playing card decks. It contains condensed information on heritage preservation issues, along with some of the imagery that also appears on the playing cards. Some 110,000 of these cards have been printed in Fort Collins, CO, and sent along with the card decks to US military personnel in pre-deployment training contexts here in the US or in-theatre in Iraq and Afghanistan. The design and development of these diverse products were by no means isolated undertakings. The Iraq and Afghanistan websites, the Soldier Pocket Card, the two promotional posters and the playing card decks themselves were consciously conceived as mutually reinforcing sets of awareness training products on cultural property protection issues.

GETTING THE WORD OUT

Apart from the DoD promotion of the cultural heritage playing cards and related products (eg Eugene 2008), we have also attempted to publicise their existence through a variety of media, including major newspaper articles, short news items in popular archaeology magazines such as *Archaeology* and *British Archaeology* (Pitts 2008; Schlesinger 2007), and radio interviews in Britain (BBC), the United States (National Public Radio, Colorado Public Radio) and Canada. We have also presented papers at an annual meeting of the Society for American Archaeology (Wager *et al* 2008), as well as two professional CRM conferences hosted by the Department of Defense (Zeidler 2007; Zeidler and Rush 2008).

More recently, the playing cards and Soldier Pocket Card have been featured in the University of Chicago Oriental Institute's recent exhibit entitled *Catastrophe: The*

Looting and Destruction of Iraq's Past (April 2008). We have even achieved the dubious honour of having our own Wikipedia entry, entered anonymously sometime in the late autumn of 2007 (Wikipedia (Anon) 2007b).

While all of this media coverage and popular exposure is helpful and gratifying, we are also pleased to report considerable positive feedback from US military personnel deployed in Iraq and Afghanistan. As one example among many, we mention a team of combat surgeons from Camp Adder, located not far from the ancient site of Ur. Here, one of the surgeons happened to be an alumnus of Colorado State University and upon hearing about the cards immediately contacted the senior author to inquire about getting several decks for his medical unit. The entire group had shown a keen interest in local archaeology and had been conducting *ad hoc* and unsanctioned 'tours' at the ziggurat of Ur. The playing cards, as well as the Iraq/Afghanistan websites, had the desired effect of raising their awareness of cultural heritage preservation issues and alerted them to the potential damage that they themselves could unwittingly inflict through unsupervised touring.

THE WAY FORWARD

We conclude by highlighting four current initiatives and activities resulting from the initial round of playing card distribution. These include:

- Assessment of the effectiveness and utility of the Iraq/Afghanistan playing cards by means of a formal, yet simple, questionnaire (see Appendix) following procedures and guidelines for program evaluation found in conservation and museum literature (eg Jacobson 1999; Diamond 1999) [in progress]
- The translation of the Soldier Pocket Card into Arabic, Dutch and German for distribution to NATO allies in production runs of 1000 cards each [completed]
- The production of a new bilingual (Arabic–English) deck of informational playing cards on Egyptian cultural heritage resources for Operation Bright Star training exercises [completed]
- The development of a new website devoted to Egyptian cultural heritage resources as a companion to the Iraq and Afghanistan websites [in progress]

Our ultimate goal with these educational products and other project-related initiatives is to ensure the permanent incorporation of cultural heritage protection awareness in DoD and NATO training doctrine, so that it *always* becomes a part of operational military planning.

BIBLIOGRAPHY AND REFERENCES

Armstead Jr, J H, 2008 The Chain of Command, in *Antiquities under Siege: Cultural Heritage Protection after the Iraq War* (ed L Rothfield), AltaMira Press, Walnut Creek, CA, 117–24

Belcher, M, 1991 *Exhibitions in Museums*, Smithsonian Institution Press, Washington, DC

Bogdanos, M, with Patrick, W, 2005 *Thieves of Baghdad*, Bloomsbury Publishing, New York

Cogbill, J B, 2008 Protection of Arts and Antiquities during Wartime: Examining the Past and Preparing for the Future, *Military Review* (January–February 2008), 30–36

Decker, R, 2001 Promotional Playing Cards: From Sultans to Salesmen, 1300–1900, in *Art as Image: Prints and Promotion in Cincinnati, Ohio* (ed A M Cornell), Ohio University Press in association with the University of Cincinnati Digital Press, Athens, Ohio, 108–30

Diamond, J, 1999 *Practical Evaluation Guide: Tools for Museums and Other Informal Educational Settings*, Altamira Press, Walnut Creek, CA

Eugene, T, 2008 Army Project Teaches Cultural Awareness to Deployed Troops, *Army* (March 2008), 53–8

Hargrave, C P, 1966 *History of Playing Cards and a Bibliography of Cards and Gaming*, Dover Publications, New York and London

Jacobson, S K, 1999 *Communication Skills for Conservation Professionals*, Island Press, Washington, DC

Kaylan, M, 2007 Play Cards, Protect a Culture, *The Wall Street Journal* (online edition) 4 October, available from http://www.opinionjournal.com/la/?id=110010688 [accessed 21 September 2009]

Kunkel, P, 2008a DoD *Cultural Heritage Training: Iraq* (website), available from http://www.cemml.colostate.edu/cultural/indexiraq.html [accessed 21 September 2009]

Kunkel, P, 2008b DoD *Cultural Heritage Training: Afghanistan* (website), available from http://www.cemml.colostate.edu/cultural/09476/indexafghenl.html [accessed 21 September 2009]

Needham, J, 2004 *Science and Civilisation in China* vol IV, part 1, Cambridge University Press, Cambridge

Parlett, D S, 1977 *Original Card Games*, Gage Educational Publishing Company, Toronto

Pitts, M, 2008 Spoilheap: British Archaeology Collects the Finds You may have Missed, *British Archaeology* 98 (January/February), 39

Polk, M, and Schuster, A M H (eds), 2005 *The Looting of the Iraq Museum, Baghdad: The Lost Legacy of Ancient Mesopotamia*, Harry N Abrams Inc Publishers, New York

Ramirez, S E, Stearns, P, and Wineburg, S, 2007 *Human Legacy*, Holt, Rinehart and Winston, New York

Rothfield, L (ed), 2008 *Antiquities under Siege: Cultural Heritage Protection after the Iraq War*, AltaMira Press, Walnut Creek, CA

Rush, L W, and Bogdanos, M, 2009 The Strategic Value of Heritage Training: Protecting the Past to Secure the Future, *Joint Forces Quarterly* issue 53, 2nd quarter, 126–7

Schlesinger, V, 2007 Desert Solitaire, *Archaeology* 60 (4), July/August, available from http://www.archaeology.org/0707/trenches/solitaire.html [accessed 20 October 2009]

Stone, P G, and Farchakh Bajjaly, J (eds), 2008 *The Destruction of Cultural Heritage in Iraq*, The Boydell Press, Rochester, New York

Tilley, R, 1973 *A History of Playing Cards*, C N Potter, New York

US Games Systems, 2003 *Spotter Playing Cards: Naval and Airplane Double Deck Set*, US Games Systems

Wager, T, Zeidler, J A, and Rush, L W, 2008 Solving the Preservation Puzzle: The Development of Cultural Heritage Playing Cards for In-Theatre Soldier Training, paper presented at *Consideration for Archaeological Property During Military Conflict*, symposium organised by Laurie W Rush at the 73rd Annual Meeting of the Society for American Archaeology, 26–30 March, Vancouver

Wikipedia, 2007a *Playing Card*, available from http://en.wikipedia.org/wiki/Playing_cards (modified 2 August 2007)

Wikipedia, 2007b *Archaeology Awareness Playing Cards*, available from http://en.wikipedia.org/wiki/Archaeology_awareness_playing_cards (modified 17 December 2007)

Wilkinson, W H, 1895 Chinese Origin of Playing Cards, *American Anthropologist* 8, 61–78

Wowk, K, 1983 *Playing Cards of the World: A Collector's Guide*, Lutterworth Press, Guildford

Zeidler, J A, 2007 Update on the Cultural Heritage Playing Cards and Soldier Pocket Card, paper presented at 'Train the Trainer: In-Theatre Cultural Heritage Considerations' workshop organised by Laurie W Rush at the *Sustaining Military Readiness through Conservation, Compatible Land Use Planning, and Encroachment Mitigation* conference, 30 July, Orlando, FL

Zeidler, J A, and Rush, L W, 2008 In-Theatre Cultural Heritage Preservation Training for the DoD: An Overview of Current Initiatives, *United States Air Force Cultural Resources Management Workshop*, April 22–24, Eglin AFB, FL

Questionnaire on the In-Theatre Cultural Heritage Preservation Playing Cards

NAME (optional):
AFFILIATION:
LOCATION:

Question 1:
The cards were attractive, unique, and stirred my interest in the topic of cultural heritage preservation.

Strongly Disagree		No Opinion		Strongly Agree
1	2	3	4	5

Question 2:
The cards provided useful background information on Iraq and Afghanistan history and archaeology.

Strongly Disagree		No Opinion		Strongly Agree
1	2	3	4	5

Question 3:
The cards provided useful 'DOs' and 'DON'Ts' with respect to the potential impacts of military activities on heritage resources.

Strongly Disagree		No Opinion		Strongly Agree
1	2	3	4	5

Question 4:
The background puzzles for the four suits were effective at conveying the importance of leaving cultural heritage resources intact.

Strongly Disagree		No Opinion		Strongly Agree
1	2	3	4	5

Question 5:
Overall, the cards were successful at promoting greater awareness and discussion of in-theatre cultural heritage preservation issues.

Strongly Disagree		No Opinion		Strongly Agree
1	2	3	4	5

GENERAL COMMENTS:

RETURN TO:
James A. Zeidler
CEMML, Campus Delivery 1490
Colorado State University
Fort Collins, CO 80523-1490
OR
james.zeidler@colostate.edu

Dealing the Heritage Hand: Establishing a United States Department of Defense Cultural Property Protection Program for Global Operations

LAURIE RUSH

The United States Department of Defense (DoD) has one of the most robust and proactive cultural resources programmes in the world. Archaeologists working for all branches of the services have inventoried hundreds of thousands of acres, have discovered tens of thousands of archaeological sites, have set aside thousands of sites for preservation, and have made many significant archaeological discoveries on the North American continent and Hawaii. It is difficult to imagine a group of professionals who could have been more dismayed than US military archaeologists when the news of damage done to Babylon hit the global media. Since military archaeologists work for an organisation whose mantras include 'we train as we fight', it was difficult to understand how the US could have failed during global operations to implement the outstanding heritage ethics and practices routinely followed at home.

Ironically, domestic stewardship practices contributed in part to the lack of US preparation for successfully taking archaeological sites into consideration when operating abroad. Traditionally, in the US, the most important archaeological properties on military lands are put off-limits to military personnel as a preservation measure. As we continue to learn, we discovered that this approach limits opportunities to teach about the issue.

To address the problem of inadvertent damage to archaeological sites in-theatre, a group of military archaeologists realised that they would need to design and institute heritage awareness for personnel training to deploy. A second critical role that military archaeologists recognised they could play would be to help archaeologists who were subject matter experts on the affected sites and areas approach the Department of Defense to address the issue more effectively. A team composed of a military and an Old World archaeologist approached the Office of the Secretary of Defense (OSD) Legacy Resource Management Program to fund an 'In-Theater Heritage Training Project'. Over the past three years, this project has successfully established an In-Theater Heritage Planning and Training Program. The ongoing project goal is to move toward a permanent office within the DoD that would have responsibility for planning and training for heritage issues related to any global operation. It is important to note that this project has focused on planning and awareness related to archaeological sites, historic structures and sacred places in the landscape.

THE IN-THEATER HERITAGE TRAINING PROJECT: A CHRONOLOGY

2003: Invasion of Iraq, looting of the National Museum
Major Corine Wegener is mobilised as the first serving US Civil Affairs Monuments Officer since World War II; US Marine Corps Colonel Matthew Bogdanos responds to the looting by leading an inter-service task force into Baghdad to investigate the looting and to implement a plan to recover stolen objects.

2004: US Marine Corps damage at Babylon makes global headlines.
Dr Rush, military archaeologist based at Fort Drum NY, and Professor Roger Ulrich, Chair of the Dartmouth College Department of Classics, agree to work together to develop solutions and write a funding proposal.

2005: Legacy Proposal to support In-Theater Heritage Training is submitted for 2006 funding.
Dr Paul Green's Legacy project demonstrates efficacy of using public sources for developing DoD Archaeology GIS (see Chapter 10, this volume). The Archaeological Institute of America (AIA) establishes a project where archaeology subject matter experts travel to training installations to educate soldiers (Rose 2007).

2006: The OSD Legacy Program awards funds for playing cards, training materials and replica sites for field training. This funding continues for two additional years. Dr Rush is invited to brief the Joint Staff at the Pentagon. Dartmouth University publicity results in offers of help from a distinguished group of academic subject matter experts. Professor Ulrich also approaches subject matter experts for information and opinions on what to teach and how best to teach US military deploying personnel about archaeology and heritage. The funding enables Dr James Zeidler and the Colorado State University Center for Environmental Management of Military Lands team to join the effort. The first field training sites are built and utilised, and playing card development begins. Dr Rush brings Colonel Matthew Bogdanos on board. US Committee for the Blue Shield is formed.

2007: The DoD identifies heritage issues as one of the top five environmental issues challenging US forces during global operations. Dr Rush is invited to brief the plenary session of the Joint Staff Pentagon workshop on Environmental Issues during Global Operations. Central Command adds archaeological planning to the Bright Star War Games. The cards are featured in *Archaeology* Magazine, resulting in excellent media coverage. Saving Antiquities for Everyone – SAFE – is tasked with providing reference information and develops the DoD Iraq and Afghanistan Heritage Reference websites. The DoD hosts a day-long symposium at the Defense Conservation Conference that brings key academic representatives to meet with military trainers and archaeologists.

2008: A round-table discussion at the AIA meetings in Philadelphia brings together high-ranking DoD staff with academic archaeology subject matter experts. The goal is set to continue to raise awareness for the issue at the highest levels of the DoD. The Central Command Historical/Cultural Advisory Group is formed and a productive

liaison is established between the US Military and the State Department in Iraq. Army and Air Force Central Commands add archaeological information to their environmental GIS databases. Central Command adds the heritage issue to the environmental focus group at the Eagle Resolve Coalition Exercises hosted by the United Arab Emirates. The DoD sponsors a symposium at the Sixth World Archaeological Congress (WAC-6) on working with the military for the preservation of cultural property, and an international working group is formed and meets for the first time. The United States Senate ratifies the 1954 *Hague Convention for the Protection of Cultural Property in the Event of Armed Conflict*. Project efforts indirectly result in the saving of Site Tell Arba'a Kabir during expansion of a US Army patrol base south of Baghdad. Central Command secures funding to support the Historical/Cultural Advisory Group and consideration of cultural property issues during the 2009 Eagle Resolve and Bright Star Exercises.

2009: AIA and DoD host a working group partnership day at the AIA annual meeting. The working groups develop a plan for a permanent heritage office within DoD, and the international group that was established at WAC-6 has an opportunity to meet for a second time. Dr Rush and Col Bogdanos author an article that appears in Joint Forces Quarterly calling for a permanent DoD Heritage Office. Central Command begins to incorporate historical/cultural issues into its environmental regulations for contingency operations.

The DoD/AIA Partnership

'What we have here is a failure to communicate…'

In thinking about the origins of the US DoD project, the first big challenge was to establish contact between members of the archaeological academic communities who work in the Old World and the military archaeologists who work on US installations in North America and Hawaii. In spite of continuing efforts to publish, present at scientific meetings and sponsor numerous creative outreach programs, the DoD archaeology program continues to be one of the best-kept secrets in the United States military. As we began to introduce ourselves to our Mesopotamian colleagues, each conversation began with a comment like, 'I didn't know DoD had archaeologists'.

There is even a term for one of the collegial challenges: it is called 'The Great Divide'. For the most part, archaeologists whose speciality areas are in the Old World trained first as scholars in ancient history, the classics or art history. Archaeologists who specialise in the New World, both North and South America, generally begin as anthropologists. The preferred academic society for the Old World is the AIA; for the New World it is the Society for American Archaeology (SAA). As a result, with some exceptions, these two sets of scholars, who have much in common, never trained together as graduate students, do not read each others' journals, and do not attend each others' scientific meetings.

So the first big challenge was how to get members of these two groups introduced and talking to each other. It was made even more difficult by the fact that many of the

Mesopotamian specialists had been frustrated in their efforts to contact the DoD prior to the 2003 US invasion of Iraq. Dr McGuire Gibson of the Oriental Institute in Chicago provided detailed data on archaeological sites and cultural properties to the Defense Intelligence Agency prior to the First Gulf War and again in 2003. He also warned repeatedly about the potential for looting at the Baghdad Museum. To his immense frustration, even though his data was used most effectively to create and implement a 'no-strike' list for the Air Force, the same information never made it to personnel on the ground. Owing to the complicated organisation of the DoD, Dr Gibson and his concerned colleagues discovered much too late that sharing site information with one programme within the DoD was not sufficient to ensure that the necessary information would reach every military agency that needed it. Unbeknown to the concerned subject matter experts, heritage issues such as protection of archaeological sites fall under the DoD Environmental Program rather than under Military Intelligence or Combat Operations.

The key to opening a more productive dialogue between Mesopotamian subject matter specialists and the Department of Defense turned out to be the renewal of a friendship at a high school reunion between Dr Laurie Rush and Professor Roger Ulrich, Chair of the Classics Department at Dartmouth College. Dr Rush had been frustrated in her initial attempts to approach Mesopotamian subject matter specialists to help her prepare a better Environmental Compliance Officer Training Class. The two archaeologists agreed that a DoD-wide heritage training programme was badly needed and that they would work on it together. Dr Rush approached the OSD Legacy Resource Management Program for funding, and the 'In-Theater Heritage Training Project for Deploying Personnel' began, as outlined above.

From that beginning, the network continued to grow in very productive ways. The DoD archaeologists became aware of the AIA initiative for Soldier lectures and archaeologist participation in the Navy Post Graduate School Culture Awareness Training. The military archaeologists had also previously been unaware of the contributions of Dr McGuire Gibson and the Oriental Institute in the creation of the Defense Intelligence Agency and Air Combat Command no-strike list. Once acquainted, the scholars and military archaeologists were able to form the core of a network that has expanded since that time. As Dr Sam Paley eloquently pointed out when he addressed the DoD Conservation Conference symposium, it is critical that members of both professional communities continue to talk to each other and work together until a solid network between the two is established. The greatest step forward in terms of partnership formation was a round-table discussion that brought together representatives of both communities at the AIA conference in January 2008. In addition to the concerned academic subject matter experts, military participation included the Deputy Preservation Officer for the Department of Defense, the Director of Army Civil Affairs Training, the Deputy Director of the Marine Corps Center for Lessons Learned, the Cultural Resources Manager for Air Combat Command, the Army Historic Preservation Officer and the Project Director for In-Theater Heritage Training. The resulting partnerships have helped all aspects of the project to move forward. One of the most significant outcomes of the round-table meeting was the creation of the Central Command Historical/Cultural Advisory Group.

In addition to the creation of an effective network of professionals, which is now working to address these issues, the Legacy-funded project has successfully developed a series of tools that are being used to educate deploying personnel about the significance of the archaeology, historic structures and sacred places that they will encounter in the landscape and to help these individuals understand that showing respect for these features may become a critical aspect of a successful military mission.

'TRAIN AS WE FIGHT': THE FIELD TRAINING ASSETS

One of our first project ideas was to construct replica archaeological sites in the midst of field training areas. These sites were designed to provide realistic opportunities to incorporate heritage issues into military training scenarios. The team used images of Mesopotamian archaeological properties and Muslim cemeteries to help in the design of inexpensive and easily built sites. The first prototype was erected at Fort Drum at the Adirondack Aerial Gunnery Range 48. It was built in time to be used by the Air National Guard Squadron based in Syracuse, New York, to train for their deployment. The replica sites were placed in juxtaposition with the intended targets so that the pilots could practise minimising potential collateral damage to a heritage property that might lie in the immediate vicinity of a military target. A replica cemetery with Middle Eastern-style markers was also included. After a series of flyovers, pilots who were between deployments reported that the replica avoidance targets were a good facsimile of site profiles they had seen from the air in-theatre. It is important to note that these avoidance assets provided the first 'no-strike' training opportunity for aerial gunnery in the DoD. As soon as the Range 48 replica sites were in place, and their success was clear, Fort Drum Range Training requested that similar assets be built as quickly as possible for the benefit of training infantry brigade combat teams.

It may come as a surprise to many that funding for an initiative of this type is limited, even within an organisation as well-funded as the US DoD. As a result, the project team developed a strategy for finding the most streamlined and cost-effective methods for acquiring materials and implementing construction. At the time of the project, a government credit card limit for purchase was US$2500; as a result, each replica site was constructed for just under that amount. We even used concrete testing tubes that were free to build a replica stone cone mosaic tower.

The need for training realism, as expressed by the combat commanders and trainers, pushed the project participants to design and construct assets based upon photographs from the internet as well some images provided by interested subject matter experts. There was not sufficient time to review the designs with additional academic volunteers or to request additional imagery. As a result, the replica site designs still require critical review and modification. Soldiers between deployments are informing us that our cemetery design does not allow for regional variation, so we have collected new images and plan to rebuild accordingly. However, the current assets have been used to successfully implement complex training scenarios. For example, Tenth Mountain Division Light Fighters were able to secure a weapons cache hidden within a replica cemetery under simulated fire without any damage to the cultural property.

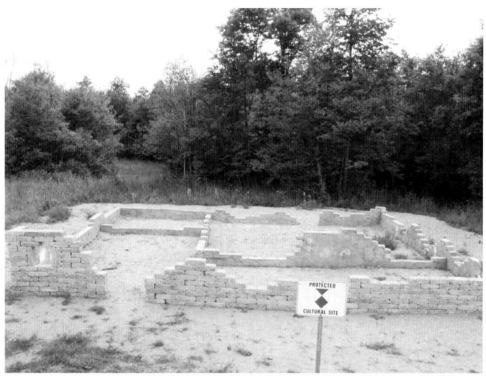

FIG 8.1
WITH LEGACY FUNDING, FORT DRUM BUILT REPLICA MIDDLE EASTERN STYLE 'ARCHAEOLOGICAL SITES'
AND SIGNED THEM WITH THE BLUE SHIELD. AS SOON AS THESE SITES APPEARED IN THE TRAINING AREA,
COMMAND REQUESTED ADDITIONAL ONES. SOLDIERS INCLUDE THEM IN SCENARIOS BASED ON THEIR
EXPERIENCES, OFTEN WIRING THEM FOR TRAINING ON IMPROVISED EXPLOSIVE DEVICES (IEDs).

The success of the replica sites reinforced the idea that training installations needed to more directly address archaeological issues in preparation for deploying personnel. It makes little sense to put archaeology at home off limits to personnel who may be directly encountering World Heritage properties when they deploy for global operations. Therefore, the next logical step was to select an actual archaeological property to stabilise and open for real training. At Fort Drum, the historic village of Sterlingville was a logical choice for three reasons. First, it was located at a crossroads near the cantonment, so the area was constantly requested for training, especially for traffic control and check point scenarios. Second, during a tour of the village with senior citizens who had lost their homes there in 1941, they pointed out to us that they had given up their homes for military training, not historic preservation. Some of the individuals on the tour were less than pleased to see 'off limits' signs in their lost community. Third, treating the village as off limits was not a good choice for preservation management. The extreme weather conditions in northern New York combined with extensive vegetation growth were degrading the features that remained from the original village landscape and structures such as poured concrete foundations and stone walls.

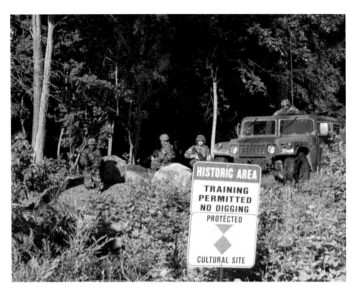

FIG 8.2
SOLDIERS TRAIN IN THE
HARDENED
ARCHAEOLOGICAL SITE OF
STERLINGVILLE, ON FORT
DRUM, A 19TH CENTURY
'COMPANY TOWN' WHERE PIG
IRON WAS MANUFACTURED.
SINCE THE AREA WAS
REOPENED FOR TRAINING,
OVER 5000 DEPLOYING
SOLDIERS HAVE HAD THE
OPPORTUNITY TO PRACTICE
OPERATING IN A REAL
ARCHAEOLOGICAL SITE,
MINIMISING IMPACTS. THEY
ARE ALSO EXPOSED TO THE
BLUE SHIELD AS THE
INTERNATIONAL SYMBOL FOR
A PROTECTED CULTURAL SITE.

The Army has a programme called Integrated Training Area Management (ITAM), which was created to develop and implement techniques to maintain training land environments in good condition. Part of ITAM's mandate is to stabilise and protect archaeological sites. As a result, ITAM was the ideal partner in the stabilisation of historic Sterlingville. Cultural Resource and ITAM crews documented features, laid geo-textiles, sandbagged vulnerable structural elements, added layers of fill, and even built reinforcing wooden structures for masonry. When the work was done, historic Sterlingville re-opened to soldiers as an historic training area. The restrictions on digging and limited use of paint bullets reinforce the concept that in some situations military personnel must attempt to minimise their impact on the environment. When Sterlingville re-opened, Fort Drum became the first US military training installation to offer deploying personnel the opportunity to train in an actual archaeological site. Dugway Proving Ground followed not long after, with outstanding use of an historic mining area that replicates conditions in Afghanistan.

PLAYING CARDS

The military has used playing cards as a training aid since at least World War II. The archaeology playing cards were in fact modelled on a deck of environmental playing cards issued by the Army Integrated Training Area Management Program and not, as is often assumed, on the famous Saddam cards. The planning team included Dr Rush, Professor Ulrich, Dr Zeidler and Tracy Wager, the designer. We decided to organise the messages by suit. Clubs contained messages about heritage preservation, spades were related to digging and avoiding damage to sites, diamonds were artefact orientated, and hearts covered 'hearts and minds' issues. Ms Wager offered the idea of adding a

watermark to each card that would make it a puzzle piece. When each suit is assembled, the cards form the image found on one of the cards in that suit. For example, when the spades are assembled, they form the image of the minaret at Samarra. Over one-third of the cards contain messages that apply to any potential theatre of operation. As a result, the card decks can be easily modified to apply to additional regions of the world. Active duty personnel in-theatre have been enthusiastic and appreciative of the cards. Messages include recognition that saving heritage is an issue in which American forces and the Iraqi people can immediately find common ground (see Zeidler and Rush, this volume, for a more detailed account of card development).

IMPLEMENTATION OF GLOBAL OPERATIONS: ENVIRONMENTAL GUIDELINES

In the world of military bureaucracy, heritage preservation falls under the Environmental Annex of the Military Operations Plan. However, in terms of strategy, it also falls into the rapidly growing area of cultural awareness for deploying personnel. Substantive cooperative accomplishment between these two worlds requires patience and a willingness to spend immense amounts of time working at bureaucratic issues behind the scenes. To complicate matters even further, no combat commander goes to battle in the 21st century without a lawyer, and treatment of cultural property also falls under the Combat Operations Law of War Analysis. During the summer of 2007 members of the Joint Staff, Department of Defense professionals who support the Joint Chiefs of Staff, organised a workshop with the purpose of addressing environmental issues that arise during the course of global operations. To demonstrate the priority that has been assigned to the issue at the Pentagon level, one of the plenary sessions at this workshop was devoted to heritage preservation. Compelling questions asked by the Joint Staff formed the basis for a root cause analysis of the failure to implement the Pentagon's own environmental guidance for heritage preservation at Babylon. DoD personnel, with the assistance of academic partners, have been identifying the challenges and developing solutions ever since.

One initiative was to assign an archaeologist to participate in the planning process for the Bright Star War Games. Bright Star is a coalition exercise created by the Camp David Accords which takes place in the Western Desert of Egypt every two years. The Joint Staff viewed Bright Star as an opportunity to examine the process for the dissemination and implementation of the environmental annexes to the operations plans. The archaeologist provided an awareness briefing at the planning conference and analysed the battle plans with support from Egyptologist subject matter experts. The goal was to compare the proposed exercise plans with archaeological site locations with the intention of shifting the exercises if necessary to ensure site avoidance. One lesson learned is that underwater operations need also to be considered, and the Navy divers exemplified archaeological cooperation in exercise planning. They demonstrated commitment to the preservation process, provided detailed location information for review with a clear intention of moving proposed exercise activities, such as underwater demolition operations, if there were to be a

potential archaeological impact. The archaeologist subject matter expert partners provided their review within two days, so there was no mission delay. In fact, the divers expressed appreciation, and were enthusiastic about learning more about the history of the area where they were operating.

One of the outcomes of the 2007 Bright Star participation was funding for an Egypt-specific deck of archaeology awareness playing cards that would be distributed during the 2009 Bright Star. Beginning with the cards, the Bright Star planners also considered incorporation of cultural elements into the scenarios. For example, one of the scenarios included Coalition forces encountering looters at an archaeological site, and another replicated disturbance of archaeological property during installation of communications equipment. In addition to incorporating archaeological and cultural issues into Bright Star, Central Command also brought the heritage issue to the table at the 2008 Eagle Resolve Coalition Exercises hosted by the United Arab Emirates. If Central Command continues to be a model for the US DoD on this issue, the United States has the potential to emerge as a world leader in cultural property protection during armed conflict and stability operations.

It became clear that the Bright Star model could, with the cooperation of Central Command and encouragement from concerned subject matter experts, be applied to contingency operations in Iraq. In the US Department of Defense, actions and activities must be associated with the proper legal drivers and documentation. The first step, for successful implementation of archaeological planning for Bright Star, was to draft the archaeological specifications in Annex L, the Environmental Annex to the operations plan. The next step was to draft a Historical/Cultural chapter for the new environmental regulations document that would govern environmental compliance by US forces in Iraq and Afghanistan. This process was completed in the fall of 2009.

Another critical set of documents includes guidelines for completing environmental baseline documentation for forward operating bases. The Environmental Annex of the operations requires that cultural property be taken into consideration during the course of operations planning. We discovered that most of these documents were vague and, as a result, were not considered seriously. The military archaeologists, in conjunction with exercise planners, began to draft Annex language that would provide specific guidelines to be followed and added cultural property to the lists of environmental features that required inspection and documentation.

In-Theatre Cultural Resources Management

There is no question that, as important as the documents are, it is equally important and more exciting to work through the issues on the ground. The Historical/Cultural Advisory Group had the good fortune to have contact with a professional archaeologist who had deployed with the Air National Guard to Kirkuk. Darrell Pinckney was willing to help evaluate the archaeological challenges associated with infrastructural improvements at Warrior Base Kirkuk. Warrior Base was an Iraqi Army base that was occupied by the Americans. The base is adjacent

to a tell and also includes burials and third-millennium occupation areas. Some of the burials were of Iraqi military personnel. Air Force personnel were encountering various forms of cultural material during the construction of drainage ditches and utility corridors. Faced with the challenges of completing projects while minimising damage to archaeological material, Pinckney joined the Advisory Group in order to provide insight into what types of materials would be the most useful to military personnel trying to avoid impacts in demanding situations. The result was an illustrated construction checklist with instructions for working with the State Department that serves as a liaison with the Iraq State Board of Antiquities. This method has begun to work, and a version for Afghanistan has been requested by the Army Corps of Engineers.

TELL ARBA'A KABIR

Media coverage surrounding the cards has proved to be the single most important contributing factor for establishing a strong network of professionals who are now working together on an international basis to address cultural property issues. The appearance of the cards in the popular press enabled a number of military archaeologists and DoD environmental personnel who were working on the issue from a variety of perspectives and programmes to find each other. These connections also extended to representatives of other government agencies, including INTERPOL and the State Department, in addition to academics and representatives of non-governmental agencies. An absolutely critical connection that was made in this way was that between the military and Diane Siebrandt, the State Department Liaison with the Ministry of Culture in Baghdad. Siebrandt joined the Central Command Historical/Cultural Advisory Group, and as a result was able to integrate her work with military efforts to improve their approach to heritage issues.

In the autumn of 2008, a US Army unit in Iraq needed to expand their patrol base. A social scientist assigned to the unit noticed pottery, mud-brick debris and other evidence of archaeological material within the perimeter of the proposed project area. He mentioned his observations online, leading Dr Sam Paley to contact the author, who put him in touch with the State Department Liaison with the Ministry of Culture. Diane Siebrandt contacted the Iraqi archaeological inspectors for the area and arranged a meeting at the expanding patrol base location, where representatives of the military and Iraqi archaeologists could all meet together. This on-site meeting gave rise to an alternative expansion plan that resulted in the site, Tell Arba'a Kabir, being saved from damage or destruction. All of the networking that made this process possible was an indirect result of the In-Theater Project and the media coverage of the playing cards. Tell Arba'a Kabir is also important because the positive result that followed the process illustrates that when the right people do have the right information at the right time, and when they know who to contact, good decisions are made without any negative impacts on, or delays to, the military mission.

GIS

The damage to Bala Hissar and the ultimate relocation of the Afghan Defense Intelligence Headquarters in Kabul illustrated the costs of failing to offer archaeological expertise during the course of project planning in-theatre. One of the Heritage Training project mottos is 'to provide the right information to the right people at the right time'. This requirement means that the military has to have archaeological site information readily available for any global operation, both during stability as well as kinetic operations. This task involves a multiple step process. First, an academic subject matter expert has to be willing to offer site inventory information to the military planning GIS databases. The data need to be geo-rectified with sufficient reliability for acceptance into a military system. They must then be modified to fit the Department of Defense standard GIS data structure. Rules for access to these data must be determined so that site avoidance materials are not hijacked to become guides for looters. Over the course of time, all of the Command GIS systems need to be provided with heritage information for any possible global operation.

Maintenance of site data is also complicated by its strategic significance. When insurgents choose to use cultural properties as fighting positions, these locations take on operational importance. In situations where the nature of the battle is based in ethnic or religious differences, cultural properties are often symbolic, and the no-strike list immediately transforms into the 'strike first' list. The DoD must recognise these concerns if cultural data is to be used wisely and appropriately. Classifying the data is not the solution, because secret classifications prevent many of the deploying personnel who need the information the most from gaining access to it. In addition, the vast majority of cultural data is available in the public domain. Paul Green, in his OSD Legacy funded project, demonstrated that public source information could be easily used to establish cultural property GIS information for both the Central American and Balkan regions (and see Green, this volume).

INTERNATIONAL INITIATIVES

The United States is not alone in addressing the issue of protection of cultural property during times of armed conflict. The Netherlands, Austria, the United Kingdom, Italy, Estonia and Switzerland all either have programmes in place or are in the process of establishing programmes to address these issues. The UK MoD is developing a system that will establish cultural property officers at the equivalent of the US brigade level (see Radcliffe, this volume). The Austrians and the Dutch have cultural property officers already serving in their militaries, and the Italians have the distinguished Carabinieri. These special personnel served with distinction in Iraq, where they rappelled out of helicopters to surprise looters stealing from important Iraqi archaeological sites. Representatives of all of these countries are willing to share materials, programmes and ideas for the maximum benefit of all.

SUMMARY

After four years of work on this project, it has been exciting to see the progress that has been made and daunting to consider how much work has yet to be done. Ratification of the Hague Convention now makes protection of cultural property during times of armed conflict United States Federal law. The success of the heritage project has helped to position DoD to meet the letter and the spirit of the treaty. At this point in time, effective DoD partnerships are going to be critical to success – not just with subject matter experts and their professional organisations but also with Ministries of Defence from all over the world.

BIBLIOGRAPHY AND REFERENCE

Rose, B, 2007 Talking to the Troops about the Archaeology of Iraq and Afghanistan, in *The Acquisition and Exhibition of Classical Antiquities*, Notre Dame University Press, 139–54; abridged version reprinted in the *Berlin Journal* 15, (2007) 38–41

Teaching Cultural Property Protection in the Middle East: The Central Command Historical/Cultural Advisory Group and International Efforts

Laurie Rush

A relatively well-known business training video used in the US portrays a very eager team attempting to construct an aeroplane in flight. The narrator discusses quality control as workers attempt to construct a cabin around wind-blown passengers. The metaphor applies to a host of government and business undertakings and, to be perfectly honest, it also applies to aspects of US military attempts to develop a heritage training and planning programme[1] concurrently with US forces being actively engaged in some of the most archaeologically rich areas of the world. As the US Central Command (CENTCOM) Historical Cultural Advisory Group (CCHCAG or CENTCOM HCAG) begins to plan and implement training for cultural property protection, deployed personnel approach members of the group with on-the-ground and immediate archaeological and heritage landscape challenges. As the US pursues full spectrum operations in Iraq and Afghanistan, the immediate archaeological issues can range from soldiers taking a pot shot at an archaeological site surveillance tower to inadvertent destruction of an ancient Afghan water system, affecting multiple villages. All of the advisory group members recognise that both the immediate needs and the long-term goals are critical. Forward personnel require and deserve all of the reach-back expertise they request. However, establishment within the United States Department of Defense of a permanent cultural property programme that provides maps, information, education, training and guidelines for behaviour should dramatically decrease the number of heritage challenges that are encountered unexpectedly.

THE ADVISORY GROUP

The CENTCOM HCAG began when military archaeologists came together for the first time at the Archaeological Institute of America (AIA) Annual Meeting in Chicago in January 2008. In this setting, professional archaeologists had the opportunity to meet with Department of Defense (DoD) personnel to articulate their concerns and suggest solutions. Group members now include the lead environmental officer for CENTCOM, the Deputy Federal Historic Preservation Officer for the DoD,

1 For the purposes of this paper, the term heritage or heritage landscape refers to archaeological sites, historic structures and sacred places.

environmental officers and GIS professionals for Army and Air Force Central Commands, the Air Combat Command Cultural Resources Manager, the Deputy Preservation Officer for the Air Force, the Director of the Legacy In-Theater Heritage Training Program, the Director of Cultural Resources for Colorado State University Center for Environmental Management of Military Lands, the Cultural Heritage Liaison for the US Embassy in Baghdad, and a professional archaeologist who served as a volunteer Cultural Resources Manager while serving as an airman in Kirkuk. Any forward personnel who are encountering heritage landscape issues are encouraged to call into the CENTCOM HCAG meetings.

The US military has a series of Combat Commands (COCOMs) that cover all areas of the world. The Central Command Area of Responsibility includes the Middle East and Egypt. Other COCOMs include Pacific Command, Africa Command, Europe Command, Southern Command and Northern Command. The other COCOMs are expressing interest in the activities and accomplishments of the CENTCOM HCAG, so there is potential to expand these efforts to other, and hopefully all, regions of the world.

TRANSITION AT UR

One of the first issues to appear on the horizon for the advisory group was stewardship for the ancient city of Ur. In response to looting in the south of Iraq, the US extended the perimeter fence at the Ali/Adder Air Base to incorporate the ruins of Ur into a protected zone. This action completely prevented looting, but it also made the site accessible for US military personnel, who were fascinated and began to organise tours. Unfortunately, Abdulamir Hamdani, the Iraqi Site Inspector for the Nasiriyah District, was unable to gain access to the restricted installation perimeter, and watched with frustration through the fence as US personnel climbed the ziggurat and visited the ancient remains. The then Commander of US Forces in Iraq, General David Petraeus, temporarily solved the problem by putting the ancient city off limits to US personnel.

As part of the solution, the US State Department Cultural Heritage Liaison stepped in (see Siebrandt, this volume). She developed and arranged to fund a project that supported participation by the University of Pennsylvania to develop a long-term site management plan for Ur. She also funded participation by a military liaison in order to expedite transition of responsibility for the ancient city from the US military back to the Iraqi State Board of Antiquities and its Nasiriyah Provincial District Inspector. Ironically, reconstruction of the perimeter fence and development of a new visitor control check point for the adjacent US military base also raised the challenge of disturbance of archaeological deposits related to outlying districts of Ur. The State Department, with the cooperation of the US Army Tenth Mountain Division, supported travel of the President of the Archaeological Institute of America and a military liaison to Ali/Adder military base in order to inspect potential damage at the visitor centre site, to complete field reconnaissance for future site planning and to meet with Garrison leadership. A successful transition ceremony was completed on 13 May 2009, and the Iraqis are now caring for the site and planning for its future.

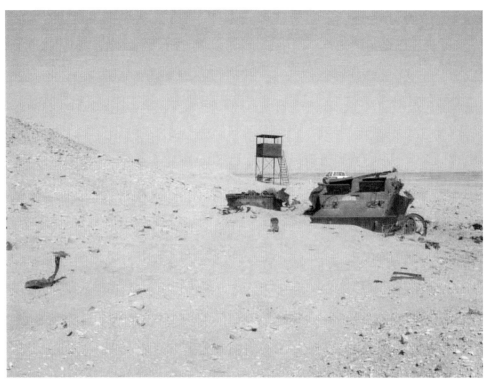

FIG 9.1
IRAQI MILITARY VEHICLE EMBEDDED IN THE SANDS OF ERIDU. EVIDENCE OF IRAQI MILITARY TRAINING
UNDER SADDAM CAN BE FOUND ACROSS THE SITE.

During the trip to Ur, the delegation, including Abdulamir Hamdani, completed field reconnaissance for five additional archaeological sites: Eridu, Ghanmi, Larsa, Ubaid and Uruk. Of the five, only Ghanmi showed signs of very serious looting. According to site guards, Larsa experienced episodes of looting when Saddam was in power, but much of the site remains in good condition. Unfortunately, the site guards also reported US personnel shooting at the guard tower. They even reported the exact day and time dating back to July 2006. The recounting of what, to some, might appear to be a relatively minor incident in the midst of a war illustrates how much these issues can matter to members of a host nation population. The experience in Larsa reiterates the strategic value of educating military personnel about the value of cultural property.

In contrast, Eridu and Ubaid both showed evidence of impacts incurred during Iraqi military occupation of the region prior to 2003. Figs 9.1 and 9.2 show, respectively, an Iraqi military vehicle buried in the sands of Eridu and vehicle fighting positions excavated into ruins at Ubaid. In the midst of discussions of damage at Babylon there has been no mention of previous damage to archaeological resources in Iraq during the Saddam period. In contrast, a very positive example of what can be

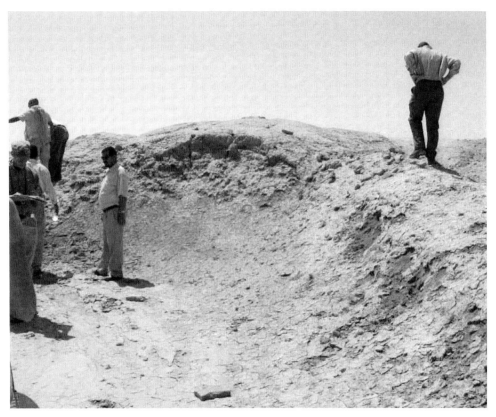

FIG 9.2
SADDAM'S FORCES DAMAGED CENTRAL FEATURES OF UBAID WHEN THEY EXCAVATED VEHICLE FIGHTING
POSITIONS.

accomplished when there is partnership with the military for stewardship is provided
by Uruk. When sites in Nasiriyah and Muthanna provinces were being looted, a
cultural property officer from the Netherlands, Lieutenant Colonel Joris Kila, went to
Uruk and arranged for payment to Bedouin guards to protect the ancient city. As a
result, Uruk has been successfully preserved for future generations. The delegation
found no evidence at all of looting. Unfortunately, there is some damage at Uruk, but
this is due to weathering and erosion of features that were exposed by archaeologists
during the early 20th century. The good news is that site protection at Uruk may
extend into the next generation.

As another aspect of cooperation for Iraq archaeological site planning, the US
Defense Language Institute is currently translating the Iraq archaeological site
inventory, a document that is somewhat analogous to the US National Register of
Historic Places, from Arabic to English. This document, with its corresponding maps,
will be a valuable tool in extending the partnership potential for stewardship in
Mesopotamia.

FIG 9.3
BEDOUIN FAMILY MEMBERS
- PERHAPS THE NEXT
GENERATION OF
CARETAKERS FOR THE
ANCIENT CITY OF URUK.

MIDDLE EASTERN MILITARY EXERCISES AND THE OPPORTUNITY TO TEACH; BRIGHT STAR WAR GAMES, EGYPT

The 2007 Bright Star War Games offered an opportunity to consider methods of teaching members of the US military about archaeology and heritage issues on site in the Middle East. Egypt archaeology playing cards have been developed as one of the training assets. These cards are similar to the cards developed and distributed for Iraq and Afghanistan. One difference is that all of the captions are in English and Arabic, so that Middle Eastern counterparts can see what the Americans are attempting to teach their personnel. The Egyptian cards also come with a fold-out timeline of Egyptian history. Bright Star occurs every two years, so it offers the possibility to build a meaningful programme over time. Educational goals for US personnel during 2009 Bright Star included the possibility of incorporating cultural property scenarios into the actual military exercises, opportunities to brief military personnel at the exercise

planning conferences and the opportunity to teach about archaeology on actual archaeological sites (see Appendix). Military exercises that take place outside of the United States have three components: a planning conference, the field portions of the exercise, and an executive seminar at the conclusion of the field portion. All three offer potential teaching opportunities.

The 2009 Bright Star experience has offered a series of accomplishments as well as lessons learned. During preliminary planning meetings, when US military representatives approached Egyptian military leadership about the fact that the US was interested in teaching about heritage and archaeology, the response was negative. In essence, the Egyptians pointed out that, from their point of view, the people who were responsible for the 'destruction' of Babylon should not be teaching anyone about heritage preservation. As a result, the Americans limited their teaching efforts to US personnel only. In addition, members of the CCHCAG approached Lieutenant Colonel Kila and requested his assistance in working with Egyptian Antiquities officials to help arrange educational opportunities for the Americans. Owing to his efforts, four members of the CCHCAG had the privilege of meeting Dr Zahi Hawass, Secretary General of the Egyptian Supreme Council of Antiquities. Dr Hawass arranged for admission to Saqqara for US military personnel, a special tour guide at the site and access to tombs that are not ordinarily open to visitors. Even though participation in this US military educational opportunity was voluntary, the bus was filled and interest in the issue extended all the way up to the highest ranking US General responsible for the exercise.

FIG 9.4
US MILITARY PERSONNEL PARTICIPATE IN THE FIRST EVER US ON SITE ARCHAEOLOGICAL AWARENESS TRAINING IN THE MIDDLE EAST, SAQQARA EGYPT, JUNE 2009. LTC JORIS KILA FROM THE NETHERLANDS WORKED WITH DR ZAWI HAWASS TO ARRANGE FOR ACCESS TO THE SITE AND A SPECIAL GUIDE.

The educational goals for the site visit were for the participants to understand the following points that were briefed at the site and also provided in a handout about Saqqara:

HERITAGE IS IMPORTANT
- The Egyptians have mentioned the US Air Force helicopter pilot who was recently convicted of smuggling stolen museum artefacts out of Egypt using a US military helicopter.
- Damage to the ancient ruins of Babylon and looting of the Iraq National Museum during the US invasion of Iraq left a negative impression around the world, possibly greater than we appreciate.
- Inadvertent damage to an ancient Afghan water system or karez at FOB Wolverine jeopardised the US mission there.

SITUATIONAL AWARENESS
- Even if an archaeological site offers few clues at the surface, perhaps only bits of rubble – it can be as significant as a World Heritage Site, important to the local population, and possibly sacred.
- Do not move or remove building blocks, other architectural objects, or artefacts – if you lose the historic context of a site, it makes it much harder to interpret, map, or rebuild.
- Pay attention to the inadvertent effects of occupation and traffic across a site, especially erosion and damage to features.
- No photos of images not ordinarily exposed to light or touching of carvings and pigments, as this will degrade colour and contrast.
- Never remove artefacts from an archaeological site or purchase them.
- Note the positive effect of tourism to heritage properties on the local economy (stability operations).

LEGAL AND STRATEGIC DRIVERS
- *Hague Convention for the Protection of Cultural Property in the Event of Armed Conflict* (ratified by US 2008).
- Looting and smuggling of artefacts funds the black market, terrorism, and insurgencies.
- Damage to Cultural Property encourages ethnic hatred and can damage the identity of a nation or a people.
- Military orders and International Law forbid removal of any object of antiquity from a host nation to the US.

There was sufficient interest in the on-site training that planners for Bright Star have requested that members of the advisory group return to Egypt during the actual exercise in order to offer additional educational opportunities.

An additional goal generated by Bright Star lessons learned is to assist US military leadership in developing a sophisticated understanding of the importance of the Egyptian response that included the reference to damage at Babylon. It is clear that

this heritage issue has compromised the reputation of the US military in a serious way in the Middle East, a loss that could have strategic implications.

Eagle Resolve Exercises, Persian Gulf

Every year the United States participates along with Gulf State Coalition partners in a military exercise called Eagle Resolve. The host nation changes from year to year. In 2008 the United Arab Emirates hosted the exercise in Abu Dhabi and in 2009 Qatar hosted the exercise. Owing to the efforts of the lead CENTCOM Environmental Engineer, an Environmental Focus group was added to the executive seminar that is held at the conclusion of the field portion of the Eagle Resolve exercise. In 2008, the US introduced heritage and cultural property training to the focus group as their lead environmental issue. However, the Middle Eastern delegates selected alternative environmental issues to discuss at that point. In 2009, the US brought the subject back to the discussion, and on that occasion there was definitely more interest among the delegates. The Qatar military has recently established an environmental programme. Representatives of this effort were interested in learning more about adding archaeological issues to the portfolio of a military environmental programme. Jordanian delegates expressed interest as well.

The Jordanian Environmental Conference

Defense Environmental International Cooperation Funds have supported two environmental conferences in Amman as a partnership project between the US and Jordanian militaries. In 2009, members of the CENTCOM HCAG attended this conference and presented an account of the US military domestic cultural resources programme and US efforts to teach deploying personnel about archaeology. The presentation featured bilingual slides in English and Arabic. The response from Jordanian military officers was very positive and encouraging. Many expressed genuine interest and support for expanding discussions of this topic at future conferences. There are indications that high-ranking Jordanian military personnel may be interested in learning more about cultural property considerations, both during training and deployment. In addition, a leading Jordanian archaeologist has been working toward developing a heritage awareness educational opportunity for military personnel in Jordan, preferably to be held at Petra, with both an international faculty and international participation. Other good news is that at least one additional Middle Eastern country has expressed an interest in holding a military conference focusing on cultural property protection.

The IMCuRWG

As Lieutenant Colonel Kila demonstrated in Egypt, and with renewed interest in international training to be held in Jordan, it is becoming increasingly clear that working internationally is critical for success in addressing military education with respect to cultural property training. At the US Sustaining Military Readiness

Conference in Phoenix in 2009, the International Military Cultural Resources Working Group (IMCuRWG) was established. The mission of this group as stated is:

> IMCuRWG comprises cultural heritage professionals working in the military context in order to:
> - Enhance military capacity to implement cultural property[2] protection across the full range of operations
> - Provide a forum for international cooperation and networking for those working within the military context
> - Identify areas of common interest
> - Share best practice and lessons learnt
> - Raise awareness and publicise military commitment to the protection of cultural property and cultural heritage, both tangible and intangible

The IMCuRWG also has an advisory group of non-military preservation professionals.

THE FUTURE

The CENTCOM HCAG continues its work while pursuing the goal of establishing a permanent programme for heritage protection within the United States Department of Defense. It is hoped that recent US ratification of the Hague Convention will provide a catalyst in this respect. Interest from environmental personnel within the other combat commands is also encouraging. Clearly, the establishment of the IMCuRWG will enable members to continue to work at an international level and to build on each other's accomplishments for the benefit of archaeological stewardship on a global level – in the Middle East and beyond.

2 The term cultural property as defined in the Hague Convention for the Protection of Cultural Property in the Event of Armed Conflict.

UNCLASSIFIED

EVENT: Bright Star 09/10

THEME: IMPACTS TO CULTURAL PROPERTY

TRAINING OBJECTIVES / BATTLE DRILL: Minimize Impacts to Cultural Property

SUBJECT: Proposed Desert Bed Down Site is an Archeological Property

DESCRIPTION: When unit begins to improve a bed down site they discover pieces of pottery, objects that include statuary, and old coins. They begin to notice that mud bricks are laid in linear patterns and may be parts of walls.

EXPECTED ACTION:
1. Unit needs to select alternative position.
2. If unit must bed down in the archeological site, the following precautions must be taken:
 a. Unit should attempt to obtain reach back information concerning site perimeter and potential feature locations.
 b. Least important parts of the site would be locations for any necessary excavation.
 c. All perimeter improvements should be accomplished using sterile fill and HESKO type barriers.

LEARNING POINT: Damage to archeological properties offers potential PR advantage to the enemy.

POC INFORMATION:
1. Dr. Laurie Rush
 Cultural Resources Manager
 US Army – Fort Drum, NY
 DSN: 312.772.4165
 E-mail: laurie.rush@us.army.mil
2. LTC Daniel R. Brewer
 U.S. Central Command – Environmental Engineer
 US CENTCOM – MacDill AFB, LF
 DSN: 312.651.6607
 E-mail: brewerdr@centcom.mil

UNCLASSIFIED

Cultural Resources Data for Heritage Protection in Contingency Operations[1]

PAUL R GREEN

INTRODUCTION

As a key instrument of US foreign policy, the Department of Defense's (DoD) global reach since World War II has served to help maintain international peace, provide humanitarian and disaster assistance, improve infrastructure capacity in other nations and curb the spread of illegal international narcotics trafficking. In many such activities, military engineers and embedded teams of technical experts are often at the forefront of planning and initial placement of US personnel and material. Traditionally, few professional cultural resource specialists have been included in these efforts. In addition, information as to the presence and character of local heritage resources was absent from mission planning for the most part. This gap extended from the basic data itself to a general lack of standards and processes for employing the data in military planning for contingencies. In this chapter some past and current efforts by the US military to deal sensitively with cultural heritage during contingency operations are reviewed and potential improvements by the international community considered. The ultimate goal is to ensure that, for heritage or cultural property protection, the right data is available to the right people at the right time, before, during and after combat situations.

WORLD WAR II AND THE COLD WAR ERA

During World War II, the concerns of the US military and its allies with cultural heritage focused on art, architecture, museums and monuments. Well-known examples include the successful recovery of art looted by the Axis powers and the preservation of the architectural treasures of Paris and Rome from destruction by retreating forces (and see Spirydowicz, this volume). Less fortunate was the attempt to forestall the destruction of the glass and sculptural treasures of the Monte Cassino monastery during the Italian campaign, despite a long and hard look by the Allies at the direction of General Eisenhower.

In the succeeding Cold War era (1945–1991) US forces were stationed at bases around the world, implementing a policy of strategic containment of the Communist bloc. No formal guidelines existed at that time for the protection of cultural heritage sites by US personnel on these installations. Although the US had helped foster the

1 This is a revised version of a paper originally presented at the Sixth World Archaeological Congress, Dublin, Ireland, 30 June 2008. The opinions and conclusions in this paper are the author's alone and do not necessarily reflect those of the United States Department of Defense, the United States Air Force, Air Combat Command or the Federal Government of the United States.

creation of the 1954 *Hague Convention for the Protection of Cultural Property in the Event of Armed Conflict*, Cold War era concerns by the Pentagon forestalled its adoption by the US Senate. Consideration of host nation heritage resources on DoD's overseas installations was sporadic during the Cold War.

Mainstream consideration for the identification and protection of heritage or cultural resources did not come into being in the US military until the 1960s, with the passage of laws such as the *National Historic Preservation Act* (NHPA) and the *National Environmental Policy Act*. Even then, substantial and recurring funding for the inventory and management of cultural resources on US installations did not occur until the 1980s, following a series of high profile environmental compliance cases. Cultural resources efforts were incorporated into the DoD 'Conservation' programme along with natural resources. Other environmental programmes included regulatory compliance (focused on hazardous waste and air and water quality) and hazardous contamination restoration or clean-up.

From the late 1980s, this system facilitated not only the hiring of several hundred government cultural resources professionals, primarily archaeologists, but also the systematic cultural resources inventory of hundreds of thousands of acres of DoD lands in the US. These government archaeologists were situated primarily in engineering and environmental organisations dedicated to supporting installation missions in the US. Few had any overt connection to operational forces that deployed in contingencies. A serious gap developed in DoD between the organic professional heritage expertise available in the US and assets available to assist in planning and executing contingency operations, as well as follow-on sustainment. The latter was primarily an *ad hoc* circumstance, when deploying reservists and National Guardsmen with professional expertise might through happy circumstance be available to help guide actions appropriately, within the constraints of their primary military mission.

Post-Cold War Era

Owing largely to these kinds of fortuitous situations, during the First Gulf War in 1991 Coalition forces were aware of important archaeological sites in lower Mesopotamia and took steps to avoid them during the aerial campaign and the subsequent armoured thrusts into Kuwait and Iraq. The 'no-strike' list included some of the most well-known archaeological sites and heritage locations. However, as this fact became known to the opposition such sites were employed to hide combat assets, such as fighter aircraft, for later retrieval, contrary to the Law of Armed Conflict. In addition, relatively straightforward issues such as symbols used on maps could and did complicate operations in the past. During the Balkan conflicts of the 1990s, the contending forces encountered historic bridges and ruined battlements; some of the latter were indicated on operational terrain maps as 'fortifications' and subject to potential attack.

The 9–11 Era

Following the attacks of 11 September 2001, US forces began a worldwide campaign against terrorist organisations and governments supporting them. An invasion of

Afghanistan in the autumn of 2001 removed the Taliban government from that country and forced al-Qaeda terrorists to seek refuge in mountainous areas along the border with Pakistan. Given this intense but short-lived military operation, impacts on Afghan archaeological sites and other heritage properties were probably minimal. Collections from the Afghan National Museum began a long process of reconstitution from various places of safekeeping, inside and outside the country.

In the months leading up to the invasion of Iraq by US and Coalition forces in March 2003, military planners in the US and UK received information from academic archaeologists concerning the location of sensitive Iraqi heritage and archaeological sites, with the intention of protecting them from damage or destruction as a result of military operations. This was largely a successful effort, as heritage sites for the most part escaped damage from aerial bombing and strafing and were bypassed by ground operations. However, few plans had been made to protect Iraqi heritage assets in the post-conflict phase, and recent publications (Bogdanos with Patrick 2005; Rothfield 2008; Stone and Farchakh Bajjaly 2008) have documented damage to sites as a result of looting by vandals and thieves or military operations: these included the Iraq National Museum in Baghdad, archaeological sites of world renown such as Ur and Babylon, and hundreds of others less well-known but scientifically, historically and culturally important sites. Such stories helped to spur Coalition militaries and their governments into action. The latter are working with the Iraqi government to improve the overall security situation, re-establish Iraqi governance over historic sites and monuments, rebuild damaged museums and collections and train museum personnel (see Department of State 2009). The *Status of Forces Agreement* (SOFA) executed in 2008 between the governments of Iraq and the US includes provisions concerning the protection of heritage properties; thus, 'upon the discovery of any historical or cultural site or finding any strategic resource in agreed facilities and areas, all works of construction, upgrading, or modification shall cease immediately and the Iraqi representatives at the Joint Committee shall be notified to determine appropriate steps in that regard' (Department of State 2008, Article 5, Part 5).

CULTURAL HERITAGE PROTECTION IN CONTINGENCY OPERATIONS

Historic preservation laws in the US which govern daily operations at military installations in that country do not apply to Federal actions overseas, with one important exception. Passed into law with the NHPA Amendments of 1980, but not actually part of the Act itself, Section 402 requires that:

> Prior to the approval of any Federal undertaking outside the United States which may directly and adversely affect a property which is on the World Heritage List or on the applicable country's equivalent of the National Register, the head of a Federal agency having direct or indirect jurisdiction over such undertaking shall take into account the effect of the undertaking on such property for purposes of avoiding or mitigating any adverse effects. (Title 16, US Code, Chapter 470a-2)

In effect, this provision echoes that in Section 106 of the Act requiring review of Federal actions within the US. However, implementing regulations for this provision have never been enacted and neither DoD nor other US agencies have sought its active implementation. Recently, this statutory requirement was successfully cited in litigation against the DoD concerning a proposed military project in Okinawa and its effects on an animal, the dugong, with significant traditional importance to the Japanese people (King 2006).

As noted earlier, the Hague Convention was not ratified by the Senate in the 1950s. However, following the circumstances attending the Iraq invasion in 2003, particularly the looting of the Iraq National Museum and increased damage to archaeological sites there, opinion shifted and the Senate did ratify the basic Convention on 25 September 2008. The later protocols of the Convention remain to be approved by the US government. Eventually, we expect the provisions of the Convention will be incorporated into DoD policy guidance.

Current guidance on cultural resources protection for DoD activities on installations in foreign nations during peacetime is contained in Chapter 12 of the *Overseas Environmental Baseline Guidance Document* (OEBGD) (Department of Defense 2007a). In many nations where US forces are stationed, Final Governing Standards (FGS) are developed between the host government and the US in accordance with their respective SOFAs. The FGS takes precedence over the OEBGD where it exists. A recent study by the RAND Corporation provided a comprehensive overview of US joint military guidance regarding environmental matters, including archaeology and historic properties, during contingencies, and found that 'environmental issues can have a significant impact on operations', faulting the Army for its lack of a 'comprehensive approach to environmental considerations in contingencies, especially in the post-conflict phase' (Mosher *et al* 2008, xvii).

In general, contingency operations are those actions undertaken by US military personnel at the direction of the President and the Secretary of Defense, as per Title 10 of US Code or other authorities. Through the Afghan and Iraq invasions, contingency operations were divided into four phases. In Phases 1 and 2, military forces geared up for deployment and moved to the area of responsibility (AOR). Phase 3 saw decisive combat and Phase 4 the post-conflict period and redeployment of forces. As a consequence of lessons learned in Iraq DoD has added a Phase 0 (pre-contingency planning) and divided Phase 4 into two parts: 'stabilization' and 'enable civilian authorities' (Mosher *et al* 2008, 19).

The RAND study covered a broad range of environmental issues related to Army contingency deployments in all phases. One area speaks to the subject of the present discussion: data. The authors noted that 'information for commanders about local environmental conditions and infrastructures is often insufficient, not readily available, or not accessed by the decision makers when it is available, in stark contrast to the quantity and quality of information available at US installations' (Mosher *et al* 2008, 106). It clearly is important that military planners have access to, ideally, authoritative data on overseas cultural properties in order to plan and execute their actions to avoid adverse effects in all phases, if possible.

CULTURAL HERITAGE DATA MANAGEMENT FOR CONTINGENCY OPERATIONS

The US Air Force Air Combat Command (ACC), headquartered at Langley Air Force Base, Virginia, provides trained and equipped combat air forces and support personnel to Combatant Commands (COCOMs). For example, under ACC, Air Forces Central (AFCENT) and Ninth Air Force, headquartered at Shaw AFB, South Carolina, provides this capability to Central Command (CENTCOM), the COCOM for the Iraq and Afghanistan AORs. In 2005, ACC received funding from the DoD Legacy Resource Management Program to conduct a feasibility study on developing a cultural heritage resource data layer for use in planning Outside the Continental US (OCONUS) (Van West and Mathers 2007). Its goals were to develop and partially populate a database and a GIS (geographic information system) data layer for OCONUS regions; to assess the depth, breadth and availability of needed cultural heritage resource information; and to make recommendations for future efforts. The two regions selected for the study were Central America and the Balkans. The investigators did background research on the heritage laws and resources for the nations in each region, identified existing open-source information on cultural heritage sites for these areas, organised a sample of this data in a prototype cultural resources database and displayed the data on geo-referenced imagery.

The data search included internet sources (eg UNESCO's World Heritage List, ICOMOS, World Monument Fund, World Bank and the Electronic Cultural Atlas Initiative), university monographs, journals, maps, travel literature and consultation with US academics with professional expertise in the areas of interest. After location information was obtained, the sites were plotted and ARC-GIS data files produced for each country data layer. The study concluded (Van West and Mathers 2007, 73–4) that:

- Developing an OCONUS cultural heritage site data layer is technically feasible
- Site data are highly variable from nation to nation, and are:
 - usually held in high regard by the government and/or people
 - often protected by international agreements and national laws
 - typically maintained by the nation's Ministry of Culture
- Language and orthography differences present formidable barriers to data collection
- Working with host nation experts is essential for efficient and effective data collection

The investigators recommended that DoD improve its guidance in this area, comply with Section 402 of the NHPA and cooperate with other nations in safeguarding their heritage properties by, for example, adhering to the covenants of the 1954 Hague Convention.

The results of this study were presented at an OCONUS cultural heritage session of the 2007 Sustaining Military Readiness Conference (SMRC) in Orlando, Florida (Department of Defense 2007b). Dr Laurie Rush, archaeologist and Cultural Resources Manager at Fort Drum, New York, helped to organise this session. This event marked an initial international gathering of military and non-military experts in archaeology and heritage preservation to discuss problems of protecting heritage resources during conflict. One outcome was the development of cultural heritage training by Dr Brian Rose of the Archaeological Institute of America (AIA) for

deploying military personnel. In January 2008, largely through the efforts of Dr Rose, the Orlando group met with several dozen invited archaeologists and preservation experts at the AIA annual meeting in Chicago. Their goal was to discuss what could be done quickly to address problems of adverse impacts to archaeological resources from military operations in Iraq and to open a dialogue on larger issues such as site looting and the antiquities trade on the black market.

As a result of the Chicago meeting, DoD facilitated the beginning of a dialogue between ACC and AFCENT on protecting cultural resources in-theatre. Through AFCENT and CENTCOM, ACC provides military, civilian and contractor engineers and environmental experts to develop and sustain air bases, such as those at Kirkuk and Tallil (Ur) in Iraq, and temporary forward operating locations. Air Force guidance for the inclusion of cultural resources information during contingency operations like those in the CENTCOM AOR is contained in AF Handbook 10–222, Volume 4 (Department of the Air Force 2007).

This dialogue led in February 2008 to the formation of a CENTCOM-sponsored Iraq Antiquities Working Group and eventually that summer to the CENTCOM Historical/Cultural Advisory Group (CCHCAG). The group is composed of about two dozen members from DoD, the State Department and other organisations meeting regularly via teleconference. Some of its accomplishments to date include: updating or developing CENTCOM guidance for troops in the field concerning the protection of historic, cultural and heritage properties; identifying Iraqi and Afghan heritage officials with whom base officials can work on site protection; and developing archaeological and heritage site data for use by military and government officials in planning and executing construction or other activities. Through a geo-spatial data committee, CCHCAG members are working with Iraqi and Afghan officials to provide military commanders, planners and engineers with lists of cultural sites and contact information for Iraqi antiquities officials in each region of the country. This information is drawn from various sources, such as host nation site registers, archaeologists' personal and institutional data files, and open source literature.

However, this initial 'list' includes only a fraction of the total number of sites in the country. Few countries can claim to maintain a comprehensive list of their identified archaeological, historic and cultural sites. No such list exists in the United States, for despite its National Register of Historic Places actual data on hundreds of thousands of sites is scattered among the various federal and state agencies and hundreds of academic and contract organisations engaged in archaeological and historical research. Rapidly expanding economies such as China and India face the same problem, with ever-increasing amounts of archaeological site data and no geo-spatial and business standards to apply in maintaining and sharing them. To help establish a minimum set of authoritative data for Iraq and Afghanistan, CENTCOM is soliciting data from expert archaeologists with long-held research interests in those areas. Some of this data in the form of GIS shape files is now being provided for several hundred sites. One difficulty is that the research archaeologists possess large amounts of site data, but lack detailed imagery upon which to display it for most areas. The military usually has detailed imagery which is not available to the public. As an interim solution, academics are plotting their sites on declassified DoD imagery

from the Cold War era. However, although such files can be used in a rough comparative way by base personnel on an interim basis, for such things as identifying and avoiding site boundaries, they ideally need to be incorporated into approved DoD data models and databases. Only in that manner can the data be properly maintained and shared across DoD units.

At the Orlando SMRC in 2007, DoD initiated a project to begin defining the various processes used by the services in managing cultural resources. This is being done in concert with a transformation of the Spatial Data Standards for Facilities, Infrastructure and Environment (SDSFIE) to better align DoD's 'Installation and Environment' lines of business (to include Cultural Resources) with its net-centric enterprise data-sharing strategies and Business Enterprise Architecture (Department of Defense 2009). An initial phase, supported by Legacy funds, defined DoD cultural resources work processes and required geo-spatial data elements (Crane 2008a). Business data description will be part of the second phase, which builds on a core set of processes and data elements described in an earlier Legacy-funded project (Crane 2008b).

In January 2009, the AIA again sponsored discussions relating to how archaeologists can constructively engage with military planners for heritage preservation before, during and after conflict. In addition to its plenary, the conference held a day-long session with working panels on broad topics such as training for military personnel, preventing illicit antiquities trade, DoD organisational issues and planning (AIA 2009). Since this conference, CENTCOM approved the dispatch to Afghanistan of environmental teams to assess conditions at forward operating locations prior to the build-up of US forces. These assessments included consideration of cultural heritage resources and will help guide construction, operation and eventual dismantlement of the bases when they are no longer required.

Problems stand in the way of having an effective international cultural site database available for use by contingency planners, however. There is a need for some consensus in the international community as to a minimum level of heritage site information that can be maintained and made available to authorised users for effective planning and conservation. Alternative means of hosting such data need to be explored, such as maintaining data in a controlled-access computer warehouse at a 'neutral' third party or Non-Governmental Organisation, or having each nation maintain its own data and sharing it under standard rule sets through the internet. Alternatively, military organisations will have to rely on data assembled from all sources and stored only in their restricted access databases. This makes the process of revising and improving data quality more difficult, as academic experts have little or no access to the information.

Open-source information lacks the comprehensive coverage, granularity and validation needed for local efforts such as building a tent city, enlarging a roadway or locating the best route for a communications or power conduit. However, it would still be useful in the initial planning stages of large contingencies, helping the military to avoid sites not only during combat but also in the much longer sustainment and/or departure phases. The development of geo-databases with cultural site information has spread worldwide, although the coverage is uneven. Some nations, such as Egypt

(EAIS 2009), have mature GIS implementations with substantial amounts of cultural site data, while others, such as Iraq, rely primarily on paper copies of information that are managed by hand. Even in the former case, however, US and other foreign military and diplomatic personnel, cultural resource managers, archaeologists and others must be aware of and sensitive to the often delicate, if not absent, relationships among a given country's military and heritage communities.

Continued dialogue among archaeologists, other preservation professionals and military officials is essential to develop procedures for ensuring the best possible information is available in a timely manner to allow on-site military commanders, engineers, and planners to protect global heritage resources during all phases of contingency operations.

BIBLIOGRAPHY AND REFERENCES

Archaeological Institute of America (AIA), 2009 Archaeology in Wartime: A Roundtable about Cultural Resources Preservation in War Zones, *2009 Annual AIA Meeting*, 9 January, Philadelphia. http://www.archaeological.org/webinfo.php?page=10175&saia=1 [accessed 26 May 2009]

Bogdanos, M, with Patrick, W, 2005 *Thieves of Baghdad*, Bloomsbury Publishing, New York

Crane, B, 2008a *DoD Cultural Resources Data Management Needs Assessment Summary Report*, Department of Defense Legacy Resources Management Program, Project Number 07–369, May 2008

Crane, B, 2008b *DoD Cultural Resources Business Data Standards Summary Report*, Department of Defense Legacy Resources Management Program, Project Number 08–369, December 2008

Department of Air Force, 2007 *Environmental Guide for Contingency Operations Overseas*, AFH 10–222, Volume 4, 1 March 2007

Department of Defense, 2007a *Overseas Environmental Baseline Guidance Document*, DOD 4715.05-G, Office of the Undersecretary of Defense, Washington, DC, 1 May 2007

Department of Defense, 2007b *Sustaining Military Readiness Conference*, http://www.sustainingmilitaryreadiness2007.com/index.cfm [accessed 26 May 2009]

Department of Defense, 2009 *Spatial Data Standards for Facilities, Infrastructure, and Environment*, http://www.sdsfie.org/ [accessed 26 May 2009]

Department of State, 2008 *Agreement Between the United States of America and the Republic of Iraq On the Withdrawal of United States Forces from Iraq and the Organization of Their Activities during Their Temporary Presence in Iraq*, 17 November, available from http://www.mnf-iraq.com/images/CGs_Messages/security_agreement.pdf [accessed 22 September 2009]

Department of State, 2009 *Iraq Cultural Heritage Project*, http://exchanges.state.gov/chc/ichp.html [accessed 26 May 2009]

Egyptian Antiquities Information System (EAIS), 2009, http://www.eais.org.eg/index.pl/home [accessed 26 May 2009]

King, T F, 2006 Creatures and Culture: Some Implications of 'Dugong v Rumsfeld', *International Journal of Cultural Property* 13, 235–40

Mosher, D E, Lachman, B E, Greenberg, MD, Nichols, T, Rosen, B, and Willis, H H, 2008 *Green Warriors: Army Environmental Considerations for Contingency Operations from Planning through Post-Conflict*, RAND Corporation, Santa Monica, CA

Rothfield, L (ed), 2008 *Antiquities Under Siege: Cultural Heritage Protection After the Iraq War*, AltaMira Press, Lanham, MD

Stone, P G, and Farchakh Bajjaly, J (eds), 2008 *The Destruction of Cultural Heritage in Iraq*, The Boydell Press, Woodbridge

Van West, C R, and Mathers, C, 2007 *OCONUS Data Layer for Cultural Resources*, Department of Defense Legacy Resources Management Program, Project Number 05–266

Time not on my Side: Cultural Resource Management in Kirkuk, Iraq

DARRELL C PINCKNEY

EDITOR'S NOTE

Airman First Sergeant Darrell Pinckney, a professional archaeologist, was mobilised for deployment to Iraq and assigned to the US Regional Airbase at Kirkuk (KRAB). Kirkuk is an installation that was first established by Saddam Hussein and is not the only Iraqi military installation to have been constructed in an archaeologically sensitive property during the Hussein regime. When First Sergeant Pinckney arrived, archaeological challenges at Kirkuk had been outlined in *Archaeology* Magazine (April/May 2006) and additional infrastructure projects were continuing to unearth pottery, raising concerns about archaeological features. At this point in time Central Command had organised a Historical/Cultural Advisory Group, the members of which had added the challenges at Kirkuk to their agenda. Airman Pinckney graciously agreed to serve as a forward advisory group member. Not only did he add cultural resources management activities to his assigned duties as First Sergeant, but he also agreed to correspond regularly with the advisory group members in order to help them develop an appreciation of the challenges of attempting to implement US cultural resources ethics and methods in a war zone. Airman Pinckney's careful documentation of the sites he found at Kirkuk Regional Air Base provided the baseline map for later State Department evaluation of the installation's heritage assets prior to US draw down and transition to Iraqi control.

Until First Sergeant Pinckney's deployment, even though some of the advisory group members had experience in war zones, no one on the advisory group had any experience of attempting to work on archaeological issues in the combat or contingency operation setting. First Sergeant Pinckney's willingness to work with us was invaluable in terms of moving the In-Theater project forward. Lessons learned ranged from the logistical challenges of sending equipment to a war zone to the diplomacy required to establish collegial relationships between serving military members in stressful situations and academic subject matter experts who were providing reach-back expertise from home. Most importantly, First Sergeant Pinckney provided the advisory group members with the perspective from the front line. His correspondence and recommendations have helped the advisory group focus in a realistic way on projects that can genuinely make a difference in the forward setting. His work provides a critical reminder that anyone who is concerned about stewardship issues in conflict areas must have a clear understanding of the military mission and the challenges facing the men and women tasked with carrying out that mission under life-threatening conditions. Airman Pinckney's recommendations at the

conclusion of his article are very important and have been guiding the In-Theater project during the course of the year since he returned.

Airman Pinckney's observations and experiences raise critical issues for the future of the US approach to cultural property protection during armed conflict. The concerns of his superior officer remind us that the cultural property officers serving during World War II had cultural property issues as their primary mission. The ability of archaeologists to serve on active duty within their professional capacity would provide an immediate solution to this challenge. Physicians and lawyers currently serve on active duty within the military both in reserve and career capacities, and this model of service could be readily applied to archaeologists and other cultural property professionals.

INTRODUCTION

Over time, Kirkuk, Iraq, has been home to Assyrians, Babylonians, Arabs and Turkomen. As a result, it is reasonable to expect the archaeological properties at Kirkuk Regional Air Base to date back at least 5000 years. Kirkuk is located in close proximity to the ancient Mesopotamian city of Nuzi, located about 10 miles south of the current base, now known as Yorgun Tepe. The Nuzi site was formally excavated in the late 1920s under the direction of archaeologists from Harvard University, and an archive of over 4000 clay tablets, inscribed with Akkadian cuneiform that described the ancient culture, were discovered. In addition, one of the world's earliest stone maps – believed to be over 5000 years old – was encountered there. To the east of the base lies Jarmo, long considered to be the world's first agricultural community, dating back as far as 7000 BC. The population of Kirkuk today is composed of various ethnic groups: Kurds (43 per cent), Arabs (35 per cent), Turkomen (20 per cent) and Assyrians (2 per cent). Members of all of these groups take pride in their ties to the ancient archaeological sites of the region.

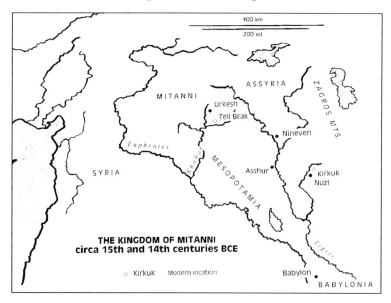

FIG 11.1
THE KINGDOM OF
MITANNI

FIG 11.2
A CIVILIAN
CONTRACTOR
EXAMINING A
TELL-LIKE
FEATURE,
KIRKUK

ARCHAEOLOGICAL ENCOUNTERS BY THE MILITARY

At the locations of digging activities on two different tell-like structures on the Kirkuk Regional Airbase, two sites with bone and pottery fragments were discovered; these were estimated by local authorities to be approximately 3000 years old. The faunal material was later determined to be of porcine (pig) origin by faunal experts. I identified the location of this site and placed this on the base engineer map as Site 8, Tell 3. The first of these digging activities related to the placement of a mobile air traffic radar installation on the top of the tell. This feature is the highest point on the installation. KRAB leadership consulted with local elders prior to installing the radar, and the actual installation required minimal ground disturbance. However, during the course of installing additional security fencing around the radar installation at the base of the tell, artefacts began spilling out of the hillside. Digging was ordered to be stopped, and Air Force personnel consulted with local authorities. The resulting negotiations culminated in a mitigation plan in which the Air Force cooperated to translate the unearthed objects to a local museum. The Air Force also offered to support curation efforts at this institution. The archaeological issues delayed the ability of the Air Force to make the radar operational. The Air Force also had to cease digging in 2007 at an additional infrastructure project location owing to discoveries of pottery.

CONDITIONS IN 2008

Artefacts such as pottery sherds, bones and tools are ubiquitous on Kirkuk Regional Air Base. A simple walk along the edge of a trench or the foot of a hill will almost always guarantee an encounter with cultural material. Although General Order 1A, a

Military Order, prohibits possession, removal, disturbance or destruction of archaeological resources, there is always the possibility that the presence of cultural material at the KRAB will be ignored by personnel, either because they are intimidated by the type of repercussions that could result from their collection of the materials, or because they simply did not recognise the objects as material significant to Iraq's past. In addition, not all potsherds and other artefacts were easily recognisable to military personnel who did not have archaeological experience. The soil at KRAB was always covered with dust, so that all objects on the surface, whether they were ancient artefacts or modern gravel, had a tendency to blend together visually. While General Order 1A was extremely well intentioned, it may have had the unintended effect of making the process of reporting cultural material through the military chain of command cumbersome. When I arrived in January 2008 there was very little information available to military personnel regarding reporting a find, as while General Order 1A was aimed at preventing damage to, or theft of, cultural material, it failed to provide any guidance for the reporting of finds. I reported this situation to the Historical/Cultural Advisory Group during one of my first conference call meetings with them from Iraq.

Why is Construction Required?

It is very reasonable for archaeologists and other concerned people, who were not on the scene, to ask why further construction was needed at Kirkuk and why Americans continued to disturb cultural material, even when their mission was delayed by discoveries of pottery in 2004. Ongoing construction at KRAB was essential in order to improve drainage as well as to make repairs to existing sanitary utilities and electrical lines. Elements of the infrastructure of this installation were insufficient when US forces took possession, and in order to repatriate an existing military installation to the new Iraqi government, the current operational facilities had to be kept up to date and repairs made. By maintaining existing utilities in a serviceable condition, the airmen and women at Kirkuk were hoping to contribute to the US effort of fostering a new alliance and enabling the Iraqis' future ability to defend themselves from their enemies.

The Inventory

During my record gathering, documentation process and interviews with contractors I was able to compile a list of known sites, their locations on base and a brief description of each site using the Trimble (Geo XT) GPS and a digital camera.

The Sites

1. Site 1 – Memorial 1: a memorial erected by Coalition forces to Iraqi soldiers who were killed in a firefight during the battle of Kirkuk Air Base. Below the monument is a bunker which was destroyed by artillery. Because access to the remains of the Iraqi soldiers was not permitted, an Islamic marker was erected on top of the bunker to serve as a memorial to the fallen Iraqi soldiers.

FIG 11.3
THIS MONUMENT WAS ERECTED AFTER THE BATTLE AND SERVES AS A MEMORIAL TO FALLEN IRAQI
SOLDIERS.

2. Site 2 – Gate 5 Cemetery: a relatively small cemetery of Islamic origin. There is currently no signage designating the cemetery and its spiritual significance.

3. Site 3 – Open Field: cultural material was encountered here in 2004 during a construction and grading project by the base contractor, Readiness Management Systems. Artefacts encountered consisted primarily of pottery. Informants believe the site to be a buried village.

4. Site 4 – unnamed cemetery: an Islamic cemetery. The oldest burials located in this cemetery could not be determined and require further investigation by Islamic Cultural Resource Managers.

5. Site 5 – a possible tell: excavation in 2004 at this site led to a quick shut down as cultural material was encountered. Artefacts (some stone tools and pottery fragments) can easily be collected where erosion and the elements have exposed the objects.

6. Site 6 – human remains encountered by civilian contractors: the remains (according to the contractors) were wearing Iraqi helmets and are believed to be from the Persian Gulf War (during the first conflict with President George H Bush). Although they (the contractors) are not forensic experts, the location was noted and mapped to prevent future impacts on this site.

7. Site 7 – EMEDS (Expeditionary Medical Systems) Helicopter Landing Pad: View outside of EMEDS and is believed by the contractor to cover a large area. Huge urns and large pottery vessels were encountered. According to the contractor, vessels in the cache were covered with animal hair. It is currently believed that the site may run under the entire structure of both the landing pad and the EMEDS Hospital.

8. Site 8 – Tell 3: pottery was found here.

9. Site 9 – Mud brick structure located outside the wire (base boundaries): the site appears to be composed mainly of mud brick and a majority of the structure remains concealed by earth. A possible ziggurat.

Fig 11.4
A structure at the KRAB which many believe is a ziggurat

10. Site 10 – classified; a possible tell (or mound): the site is littered with pottery fragments with some pottery protruding from the mound. Perched atop the mound is US Air Force Tactical gear.

11. Site 11 – Air Force Village: pottery sherds were encountered on the surface in front of Air Force Village around the flag poles where retreat and revile are conducted.

12. Site 12 – Large Cemetery: this the largest of Islamic cemeteries located at KRAB. It is presently protected under General Order 1B, which prohibits all non-Muslims from entering an Islamic site.

FIG 11.5
THIS IS THE
LARGEST CEMETERY
LOCATED AT
KIRKUK REGIONAL
AIR BASE. OTHER
CEMETERIES AND
BURIAL GROUNDS
LOCATED AT THE
KRAB ARE NOT AS
EASILY
IDENTIFIABLE AS
THIS ONE.

13. Radar Site: Tell 5, pottery.

14. Tell 1: pottery.

15. Tell 4: pottery.

16. Isolated deposit: pottery sherds encountered approximately 2.5 m below the surface; located inside the Air Force Village.

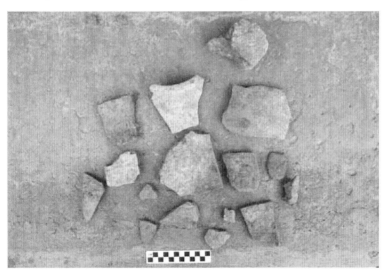

FIG 11.6
POTTERY
FRAGMENTS THAT
SOME SCHOLARS
SUGGEST ARE
GREY WARE FROM
THE 3RD
MILLENNIUM BC

17. Site Locations from satellite image. Image removed for security reasons.

Challenges of Cultural Resources Management During Contingency Operations

My superiors responded to my site documentation efforts with mixed emotions. My immediate supervisor believed that my attempts to document the sites and participate in the teleconferences with the Central Command Historical/Cultural Advisory Group would interfere with my duties. When I described my involvement, he responded with 'What?! I need a First Sergeant working for me, not a First Archaeologist'. I declared that my involvement with the said endeavour was minimal, would not interfere with my day-to-day activities, and would be beneficial to the development of stronger ties between the US and Iraqi people. The need to wade through the bureaucratic quagmire was difficult at first, but not unexpected; thankfully, a majority of the command structure was receptive to my suggestions regarding the importance of saving sites. To complicate my efforts, however, military mail confused the mail between the Army and Air Force Warrior bases, so none of the archaeological equipment that the Historical/Cultural Advisory Group attempted to provide ever made it to me at KRAB.

In addition to the challenges posed by the chain of command, the realities of working in a war zone complicate efforts to implement responsible approaches to cultural resources management. In Kirkuk, these realities included hostile action. The insurgents continued to fire on personnel and to send incoming rounds into the Air Base, putting everyone at risk. Monitoring excavations could be especially dangerous. Some of these rounds, and also rounds perhaps remaining from the earlier Iraqi occupation, had not exploded. Whether excavation is archaeological or construction in nature, exposure of unexploded ordnance results in huge logistical and safety challenges. When such an encounter occurs, all excavation ceases until a complete assessment and removal of the unexploded weapon can be accomplished by members of the Explosive Ordinance Disposal team. Such weapons can include a variety of devices, such as 57 mm, 80 mm and 107 mm rockets. Many are crude in their construction and will often contain improvised launch mechanisms such as washing machine timers.

The challenges in Iraq also included environmental ones such as extreme weather, heat and pests. Sandstorms could occur, and precipitation turned the soil surfaces into a slurry of mud and sand; on one occasion during my tenure in-country it even rained mud, when rain mixed with the fine dust in the air. In desert environments scorpions, arachnids such as camel spiders, reptiles such as poisonous snakes and mammals such as rodents, foxes and coyotes are attracted to rubble. All are hazardous and vectors for disease outbreaks. Archaeological features offer shade, air spaces and habitat, so efforts to work on them increase the odds of an individual having a close encounter of the dangerous kind.

There were also archaeological challenges. When the mail failed, it took weeks for the packages to return to their senders and for us to determine the problem. The mailing problem meant that my supplies for handling and storing cultural material were minimal. My education is based on the archaeology of eastern United States. It turned out to be difficult to convey our 'on the ground' archaeological challenges to the reach-back Mesopotamian experts who were willing to help me but who were based at universities in the US. As of the winter of 2008, there were no established

military guidelines for how to handle cultural material or how to act when cultural material is encountered during military construction at a forward base. There were also no procedures for documenting and reporting these discoveries and the subsequent actions taken. Cultural property finds at Kirkuk were also complicated by the fact that multiple populations have ancestral ties to this area. In addition, there is disagreement between national and regional governments in Iraq over management of archaeological properties. Any effort to contact local elders or subject matter experts would be complicated by the need to ascertain the politics involved beforehand. As a cultural resource professional, I found that I was able to assist installation personnel in developing a working plan to aid in this process.

Another unfortunate reality in a war zone characterised by insurgency is that members of the local community who might be willing to work in partnership with US personnel, even on a stewardship issue, could be putting their lives in danger. I suspect that is why local subject matter experts did not respond in person to our requests for them to come to the air base and provide advice for avoidance and mitigation.

Where Do We Go From Here? A Military Member's Opinion

In terms of the bigger picture, my recommendations for the way forward include:

- Brief and gain support from US military leadership
- Provide step-by-step CRM guidance for in-theatre operations
- Educate the Chain of Command regarding the treatment of cultural resources
- Provide a vision of Cultural Advocacy and site conservation
- Have a clear understanding of the military mission in-theatres when making cultural property stewardship recommendations

Specific Cultural Resource Management guidance for forward personnel should include:

- Easy-to-read flowcharts and instructions
- Maps and GPS capability to document sites
- The ability to develop site avoidance plans for construction projects
- Guidelines for field reconnaissance, walk-over surveys and photo documentation
- Advice and contact information for the development of a network of Points of Contact, including personnel from the State Department, host nation Ministries of Culture, local museum curators and archaeological inspectors, and academic subject matter experts for specific regions and site types

As of my departure from Kirkuk in the spring of 2008, the sites were protected from the curious and from some of the elements. The majority of the sites were covered by earth, which in some cases was topped with a layer of gravel applied by the US. Other sites, such as cemeteries and war monuments, are recognisable, and can be seen by passers-by from the Outer Perimeter Road. Any attempt to loot these sites would result in immediate cessation and action taken by security forces. It is my hope that my efforts to record the site locations and my attempts to ensure their recognition by both the military and civilian personnel as historic sites will contribute to their future preservation.

US Military Support of Cultural Heritage Awareness and Preservation in Post-Conflict Iraq

DIANE C SIEBRANDT

INTRODUCTION

When people picture the United States armed forces in Iraq, the image most likely to come to mind is one of armed conflict. However, there is another side not so widely known – the role the military has in cultural heritage awareness. One may stop to ponder this statement, reaching back in particular to April 2003, when the US military did not stop the looting of the Iraq National Museum. Bogdanos (2008) provides an excellent account of why a tank company was unable to leave their post and confront the looters. It was not a matter of not wanting to do anything, but rather one of the soldiers taking enemy fire and not having enough backup to enter the Museum (Bogdanos 2008). One might ponder further why the Department of Defense (DoD) did not seem to act sooner on a statement put out in January 2003 by the Archaeological Institute of America warning that military conflicts put cultural heritage at risk (AIA 2003); or why a military base was built on the ruins of ancient Babylon, resulting in the US colonel in charge having to offer an apology for damages caused to the site (Cornwell 2006).

Much has changed in the last five years, and while this chapter does not ask for the exoneration of the military's past mistakes in not doing more to protect Iraq's cultural heritage sites, it does highlight the efforts now being made to support programmes aimed at preserving and protecting vulnerable sites. America's armed forces, working with the Cultural Affairs Office at US Embassy Baghdad, have been proactively engaging in cultural heritage issues ranging from site preservation to site protection and overall awareness. Military units serving in-theatre have taken the initiative in understanding the historical value of Ancient Mesopotamia and in supporting efforts to save archaeological and historical sites throughout Iraq.

The removal of modern buildings from the ancient city of Kish and supporting site surveys conducted by the Iraqi State Board of Antiquities and Heritage and the US Department of State subject matter experts are two examples of US military involvement. America's armed forces are also fully engaging in multi-agency working groups aimed at supporting and promoting cultural heritage awareness initiatives throughout Iraq. This work moves toward building strong relationships and providing the means to preserve the remains of one of the world's most important chapters of human civilisation.

BACKGROUND

I was hired by the US Department of State and arrived in Iraq as the Cultural Heritage Liaison Officer for the Cultural Affairs Office at US Embassy Baghdad in December 2006. At the time, rockets and mortars were being lobbed inside the International Zone, home of the US and Coalition Embassies and several Government of Iraq offices, and the country was in a general state of unrest. Owing to the volatile conditions it was impossible to travel safely, and work on cultural heritage issues was slow to progress; the US military was concentrating on a troop surge to help stabilise the country. The Iraqi Ministry of Culture, the Iraqi Ministry of State for Tourism and Antiquities and the Iraqi State Board of Antiquities and Heritage (SBAH) were experiencing staff changes that caused difficulties in maintaining regular communication. In addition, there had not been a US-sponsored position in the field of cultural heritage since March 2005. The country experienced peaks and ebbs in violence throughout 2007 and it was difficult to implement any real plan.

However, despite the situation, we began to get the word out about cultural heritage. I was able to brief incoming military and contractor personnel on the importance of cultural heritage awareness via PowerPoint presentations highlighting the need for sensitivity to archaeological sites and adherence to antiquities laws. In cooperation with the US Department of Defense's (DoD) Legacy Resource Management Program, our office was able to distribute the DoD Archaeology Awareness Playing Cards. Each card in the deck displays an artefact or site and gives a tip on how to avoid causing damage to historic and archaeological sites (Schlesinger 2007; Zeidler and Rush, this volume). The cards were distributed to American and Coalition forces serving in Iraq and generated interest from the troops, who sought more information about the history of the country (Fig 12.1). In addition to the playing cards, awareness posters from the Legacy Resource Management Program were distributed to military units for display on their bases. The cards and posters helped to implement an outreach programme between the US Department of State and the US military.

In addition to the playing cards, we distributed the Emergency Red List of Iraqi Antiquities at Risk brochures. These colourful brochures are developed and published by the International Council of Museums (ICOM), with support from the US Department of State's Bureau of Educational and Cultural Affairs. They display images of cultural objects that could originate from Iraq and are often targeted by the illegal antiquities markets (International Council of Museums: Red Lists, 2003). Our office supplies the brochures to the US Department of Homeland Security agents, who work in tandem with Iraqi Police and Iraqi and US military units at border crossings. While the brochures are by no means intended to make a lay person an expert in identifying antiquities, they serve as a guideline and promote awareness.

Army Post Offices (APOs) are located on bases throughout Iraq, so we also sent the brochures to them. A poster designed to hang in the APOs featured images of artefacts with text reading 'It's illegal to collect, buy or transport Iraqi Artifacts', and citing General Order 1A (g), the 2008 US import restrictions on archaeological and ethnological material from Iraq and Iraqi Antiquities Law No. 55 of 2002, Article 17.

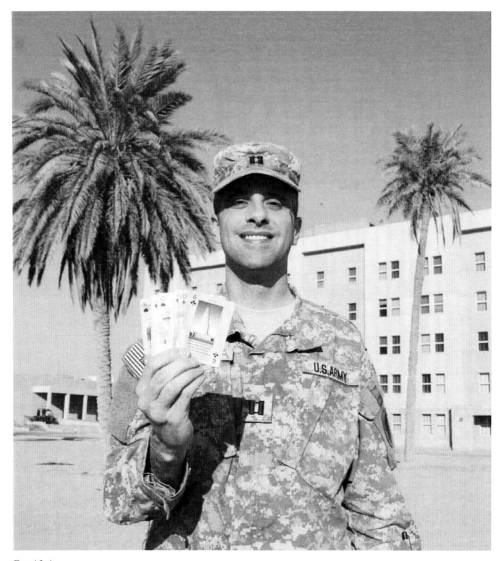

FIG 12.1
ARCHAEOLOGY AWARENESS PLAYING CARDS MADE POSSIBLE BY THE DEPARTMENT OF DEFENSE'S LEGACY
RESOURCE MANAGEMENT PROGRAM.

With the assistance of Armed Forces Network (AFN) personnel in Baghdad, our office filmed a one-minute commercial emphasising the importance of cultural heritage awareness for the military in-theatre. The commercial has been airing since June 2008 on various AFN channels. I am often recognised by military personnel who have seen the commercial and comment on their interest in the subject, proving that our message is reaching the right people.

Lastly, numerous emails were sent out and many visits were conducted to let military officers know that my job was to spread cultural heritage awareness to military personnel and that I should be contacted to answer any questions. Knowledge of my position at the Embassy was spreading by word-of-mouth and military personnel began contacting me with questions about cultural heritage in Iraq. The briefings, playing cards, posters, commercial – and simply getting the word out that a section of the Embassy was devoted to cultural heritage issues – began to pay off.

An important point to note is that three distinguished Cultural Advisers served in Iraq between September 2003 and March 2005, laying the ground work for today's successes. Each adviser spent between three and nine months in-country during difficult times. I will be starting my third year and this longevity has resulted in strong interpersonal relationships with the Iraqi authorities and American and Coalition partners. It took several phone calls and numerous lengthy meetings with various agencies to establish mutual understanding of a genuine concern by civilian and military personnel for the cultural heritage of the country. To date, there have been many instances of the US military establishing contact with our office with regard to cultural heritage sites. While space does not permit me to relate every incident, I have included several of the major cooperative actions in this chapter.

THE 3RD SQUADRON/73RD CAVALRY REGIMENT

Results of the awareness strategy were seen in September 2007, when the 3rd Squadron/73rd Cavalry Regiment, based at Convoy Support Company, Scania, contacted me regarding the ancient site of Kish (modern Tell al-Ukhaiymir), located in the Babil Province, which falls within its area of operations. The site consists of more than 40 tells (dirt hills) spread over an area of 24 sq km, and includes the remains of an Early Dynastic temple dating back about 4500 years (Roux 1992). The 3rd Squadron/73rd Cavalry Regiment was tasked with relocating an Iraqi Army outpost that was situated on the ruins, and requested an on-site archaeological assessment of the area prior to the move to ensure that culturally and historically sensitive areas were minimally disturbed by moving equipment.

As Iraq was experiencing some instability during this time, it still remained difficult for a civilian to travel long distances. I had to make my way south to the Babil Province from my base in Baghdad. While the journey of about 85 km would take only two hours in a vehicle, that mean of transport was not an option owing to safety concerns. With permission from the SBAH, and armed with stacks of the Archaeology Awareness Playing Cards and associated posters to give as hand-outs, I flew with the military on a Blackhawk helicopter to the US Regional Embassy Office in Al-Hillah, where the 3/73 met me in their armoured convoy and transported me to Kish. Journeys in humvees (High Mobility Multipurpose Wheeled Vehicles) are not the most comfortable, and having to wear an armour-plated body vest and helmet, referred to as PPE (Personal Protective Equipment), makes them even less so. I was not one to complain, however, and knew that the men and women in the regiment did this every day for hours on end with little rest. It was nevertheless an odd experience for an archaeologist to conduct a site visit decked out in heavy, bulky armour.

As I walked the site and inspected the area, I was surrounded by vigilant soldiers whose job it was to make sure I stayed safe. The men and women of the regiment were also interested in the history of the ancient mud-brick structures, however, and understood the danger that the ruins were in from the modern human habitation on the site. I pointed out the importance of avoiding the delicate Neo-Babylonian temple ruins during the forthcoming move, and the need to remove the concrete wall barriers and portable trailers that were causing weight pressure damage to the subterranean structures.

The camaraderie that the commander and senior officers had with the local Iraqi Army unit was impressive; it was evident that they had been forging their friendly relationship over a long period of time. A plan was devised with the Iraqi Army unit and the 3/73 senior officers to limit heavy moving equipment to the already impacted areas of the site and to remove the majority of the structures by hand (Siebrandt 2007). The removal of all modern structures from the site was successfully completed between 8 and 15 November 2007, with no visible damage to the ruins. A follow-up assessment was completed on 17 February 2008, again with the support of the 3/73, which showed that the site had not been disturbed since the removal of the Iraqi Army unit, and there was no evidence of looting or recent human activity throughout the site. Modern debris in the form of sandbags and plastic water bottles was later cleared from the site by local workers, who were overseen by the 3/73 and paid with a small grant from the Regional Embassy Office in Al-Hillah. The site is vigilantly watched over in case of intruders by the SBAH site guard who lives near the ruins.

The site assessments would not have been possible without the logistical support, transportation and protection of the 3/73. The foresight of the regiment in establishing contact and supporting the assessments is an excellent example of proactive situational awareness resulting in the preservation of an important archaeological site in Iraq. Another result of the positive interaction with the 3/73 was their increasing interest in and awareness of other archaeological sites in their area of operations. Regular patrols often take them past sites where they interact with local leaders and site guards. This interaction, in addition to the cultural awareness material provided to them, led the regiment to understand the needs of the deteriorating sites.

On 12 June 2008 logistical support was again provided by the regiment for a visit to two archaeological sites in order to conduct brief assessments to determine overall conditions and needs. Travelling over dusty roads in the regiment's humvees, we made our way to Nippur (modern Afak) and Tell Dlehim, both located in the Al Qadisyah Province of Iraq. The regiment's presence was welcomed by the site guards at Nippur, with whom they had been interacting over the course of their tour. An assessment of Nippur concluded that, while it is guarded by the local Facility Protection Services guards (FPS) and looting was not evident, the site does suffer from environmental weathering and a general lack of conservation maintenance (Siebrandt 2008b). The 3/73 offered their support to interested members of the local and international archaeological community to conduct an in-depth site survey and conservation plan. This plan is still in progress. The next stop was Tell Dlehim, which consists of two tells in an unguarded and unfenced agricultural area. The larger of the two was relatively undisturbed, but the smaller tell showed evidence of past looting (Siebrandt

Fig 12.2
A solider from 3/73 CAV takes photos of pottery sherds and old looter holes to assist in future situational awareness of recognising culturally sensitive areas

2008b). The men and women of the regiment readily recognised that the disturbed ground littered with pottery sherds and modern debris was evidence of illegal activity. Although Tell Dlehim does not look like an archaeological site to the layman, with no monumental features clearly visible, the regiment understood that the presence of the large hills in an otherwise flat landscape and broken pottery pieces indicated the possible existence of an archaeological site.

My travelling with the regiment, and our exploring a site with minimal distinguishable features, equipped the men and women with the knowledge to identify future culturally sensitive sites and practise avoidance tactics (Fig 12.2). It would not have been possible to visit any of these sites and conduct important assessments without the support of the 3/73; their genuine interest in and awareness of cultural heritage issues are to be commended. Although they have completed their tour, they passed on their enthusiasm for cultural heritage awareness to their replacements. Taking the first step by contacting US Embassy Baghdad for advice is a testament to the success of the cultural heritage awareness campaign working in Iraq.

THE 3RD ARMORED CAVALRY REGIMENT

Since January 2007 hundreds of decks of the playing cards have been distributed to troops throughout Iraq and posters have been sent to several of the State Department's outlying Provincial Reconstruction Teams (PRT) and military Forward Operations

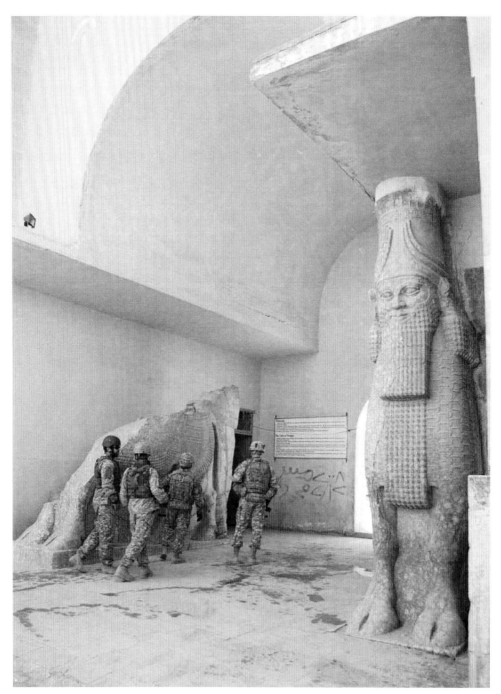

FIG 12.3
SOLDIERS FROM THE 3RD ARMORED CAVALRY REGIMENT GAIN A BETTER UNDERSTANDING OF DAMAGE
DONE TO ARCHAEOLOGICAL SITES, SUCH AS AT NINEVEH

Bases (FOB). These efforts, coupled with the knowledge of our programme via word-of-mouth, led to our beginning to receive daily enquiries about cultural heritage sites in different units' areas of operation. Thus for two weeks in mid-May 2008, the 3rd Armored Cavalry Regiment based in the Nineveh Province provided support to make archaeological site assessments in the province possible. Working with key members of PRT Mosul, and the Director General of Excavations from the SBAH, we conducted a week-long assessment of sites in the area. Our main goals were to determine whether looting was currently an issue, what environmental conditions were affecting the sites and what level of security was present (Fig 12.3).

Transportation and security were generously provided by the regiment for visits to the Assyrian sites of Dur Sharrukin (Khorsabad), Nimrud and Nineveh, as well as the Parthian site of Hatra, a UNESCO World Heritage Site. Once again, the soldiers were interested in the history of each site, asking questions about how old things were and who built the structures. Walking in full body armour and carrying their arsenal of weaponry in temperatures soaring over 30°C, the men and women of the regiment diligently protected our team so we could conduct our assessments. An overall assessment of the sites concluded that they all suffered from conservation maintenance neglect and environmental damage but that looting was not evident, mainly owing to the fact that guards are posted at each site (Siebrandt 2008a). Having the soldiers on hand was an opportunity to explain the importance of preservation and awareness. Without the support of the 3rd Armored Cavalry Regiment it would not have been possible to document vital information on these important sites. Their enthusiasm and professionalism was displayed throughout the week, and they came away with a better understanding of the critical needs facing cultural heritage sites.

THE 2ND BRIGADE COMBAT TEAM/1ST ARMORED DIVISION

In late August 2008 the 2nd Brigade Combat Team/1st Armored Division contacted our office for advice on determining whether a suspected archaeological site near their patrol base, located in Baghdad's Al-Mada'in district, was an archaeologically sensitive area. The patrol base was in the process of expanding its living area into an open field when pottery sherds were discovered on the proposed site. The Information Officer from the brigade and their embedded Human Terrain Specialist contacted our office and requested an assessment. Travelling with two appointed SBAH archaeologists, we arrived at the site and met with the officers in charge to conduct the assessment.

The site had previously been occupied by an Iraqi Army unit that had used the area as a shooting range. While visible disturbances from the Iraqi Army usage include shovel marks in the soil caused by a bulldozer and a modern footpath across the site, the US brigade had taken the necessary precaution of not conducting any work until they determined whether the location was culturally sensitive. The majority of the disturbances were caused by the local population, who use the site as a graveyard. With the exception of the few pottery sherds littering the ground, there were no archaeological features visible. The site was identified by the SBAH subject matter experts as Tell Arba'a Kabir, which dates to the Sassanid Empire (AD 226–651). The

brigade was advised not to expand their living and working quarters onto the site because of its archaeological significance and the presence of modern human burials (Siebrandt 2008c); the latter were circled by modern bricks and would not have been identified as burials without the assistance of the Iraqi subject matter experts the military brought in for the assessment, emphasising the importance of being able to recognise local grave markers.

In observing and complying with Iraq Antiquities and Heritage Law No. 55 of 2002 Chapter 2, Articles 13 and 15, and the 1954 *Hague Convention for the Protection of Cultural Property in the Event of Armed Conflict*, which the United States Senate ratified on 25 September 2008, the 2nd Brigade Combat Team/1st Armored Division complied with local laws and demonstrated foresight in contacting the proper authorities and providing support to conduct the assessment. Once again, through this assessment, the men and women of the military and their embedded civilians increased their ability to recognise culturally sensitive sites and practise avoidance.

CHARLIE COMPANY 1/244TH ATTACK HELICOPTER BRIGADE

Conducting site assessments from the ground is the best way to gain a comprehensive understanding of site conditions. However, it is difficult to visit more than two sites in one day. It takes considerable time to travel to each respective FOB to meet my military colleagues, and then more time to drive to sites that are often several kilometres away. While vehicles remain my main means of transportation, it is also possible to assess sites from the air. However, it is much more complicated to secure a helicopter for the sole purpose of flying over archaeological sites, as indeed it should be, as their main purpose is to provide air support for soldiers.

In July 2008 the Department of State's Special Coordinator for Iraqi Cultural Heritage, based in Washington, DC, was in Iraq to assist with site assessments. We were able to engage Charlie Company 1/244th Attack Helicopter Brigade to fly us over archaeological sites in the northern Dhi Qar Province. The helicopters and flight crew were assigned to us for the entire day and our goal was to get aerial images of 41 sites. The men and women on the flight crew were intrigued by our undertaking and proceeded to tell us they had seen several archaeological sites from the air during the course of their different flights. After explaining our need to photograph each site from as many different angles as possible, and providing the crew chief with site coordinates, we were told that we could pass over each site as long as they were in non-hostile areas. Equipped with our digital cameras and log books, we strategically seated ourselves as close to the open windows as the seatbelt harnesses would allow. We set off on our mission hoping to hit as many sites as possible.

As we flew over the desert landscape the hot desert air whipped around us; as anyone who has had the privilege of flying in such a helicopter will know, the 'tornado seat' is situated on the right side of the aircraft at the extreme rear. Our visitor drew the short straw, as I occupied the seat closest to the door gunner. The pilot slowed down and banked to the right as we approached each site, allowing us to capture clear images and assess conditions from the air. The 1/244th did a phenomenal job of

finding every site on our list and keeping us informed via headsets about which coordinates we were approaching. As the day progressed, the flight crew easily identified the sites and gained an understanding of what is and what is not an archaeological site.

We circled every coordinate on our map, with the exception of only a few sites, and were able to capture the multiple images from the various angles we needed for proper documentation. Our air assessment showed that evidence of past looting was visible at most of the sites, but freshly disturbed dirt was spotted at only a few locations. The findings of the survey are still being studied and will be released in a separate report. Being able to see 41 sites in one day was possible only with the support of the flight crew. Their diligence in getting us to every location we requested and their keen interest in our work is another fine example of the support of cultural heritage issues by the armed forces. The exercise also provided the flight crew with the ability to recognise potential sites, again increasing cultural heritage awareness.

Central Command Historical/Cultural Advisory Group

The majority of my work with the US military is done face-to-face in Iraq. From meetings and briefings to site visits, I interact with personnel from the Army, Navy, Air Force and Marines. Every meeting and mission is a productive step toward mutual understanding and the establishment of lasting contacts. Even though the military units deploy home after their tours, everyone I work with introduces me to their replacements. In this way I am able to maintain dialogue with the units in the area and have the opportunity to reach even more individuals, helping to spread cultural heritage awareness to a wider audience.

However, interaction does not have to be in person to be successful. As a result of pottery sherds being found at Kirkuk Air Base (Kimmons 2004; Tiernan 2007), the Central Command Historical/Cultural Advisory Group was formed. This advisory group includes participants from environmental and cultural resource offices from United States Central Command (CENTCOM), United States Air Forces Central (CENTAF), United States Army Central (ARCENT), Air Force Center for Engineering and the Environment (AFCEE), Air Combat Command (ACC), Multi-National Corps – Iraq (MNC-I), US Department of Defense (DoD), Colorado State University's Center for Environmental Management of Military Lands and, of course, the Cultural Affairs Office at US Embassy Baghdad. We hold teleconferences at least once a month to discuss ongoing and forthcoming cultural heritage issues. Our focus is on teaching military personnel about archaeological and heritage issues and the procedures to follow when they recognise that a proposed project may be affecting an archaeological site.

Just one example of the output of this group is an Archaeological Construction Checklist for military use on and near archaeological sites. This handy printout contains informative text accompanied by photographic images of actual sites, and instructs soldiers to check maps and references and walk potential construction sites for any archaeologically sensitive areas. The checklist also provides instructions on how to contact the proper authorities to request a professional assessment if

something is spotted. The Archaeological Construction Checklist has been distributed to units deployed throughout Iraq to assist them in avoiding culturally sensitive sites.

In Iraq the American-led Multi National Security Transition Command – Iraq (MNSTC-I) team used the Archaeological Construction Checklist to recommend similar procedures to Iraq's Ministry of Interior, which is in the process of implementing a Construction Guidance for Sensitive Sites document. Their planning guidance sets out the Ministry of Interior's policy on how archaeological remains and discoveries should be handled during planning stages and throughout proposed construction processes. The guidance is aimed at avoiding culturally sensitive sites and ensuring that the proper authorities are contacted prior to and during any ground-disturbing projects. The use of the checklist as a guideline by other agencies illustrates the effectiveness of the advisory group and its desired outcome of assisting agencies working to promote awareness of culturally sensitive sites.

CONCLUSION

The awareness campaign waged by the Cultural Affairs Office at US Embassy Baghdad, in cooperation with multi-agency supporters, has assisted the US military in being proactive when it comes to cultural heritage issues. For the most part people are fascinated by history, since it is, after all, what has shaped us all as humans. It was not hard to generate interest in cultural heritage issues on the part of our military colleagues – it was merely a matter of directing that interest in the proper direction. Our office has been proactive in raising awareness on several levels and our US military colleagues continue to express a vested interest in assisting in these endeavours.

The end of 2008 brought changes to America's footprint in Iraq. The Strategic Framework Agreement (SFA) cites a stronger support role, which we have been building on for the past two years (The White House 2008). As US military presence decreases, the next chapter in the history of protecting cultural heritage in Iraq will emerge. This offers new challenges in an unknown direction, which we will enthusiastically embrace. As long as an American presence remains in Iraq, our office will coordinate with the US military to continue supporting cultural heritage efforts with our Iraqi colleagues.

Raising cultural heritage awareness is an important aspect of bringing an often neglected subject to light. Iraq's archaeological and historical sites and museums are still vulnerable. They are in need of maintenance, conservation and protection. The men and women of today's armed forces are displaying awareness of cultural heritage issues and assisting in addressing these needs. Through the hard work and cooperation of military units both in-theatre and state-side our office has been successful in developing a programme that continues to generate positive results and helps save Iraq's history for future generations.

BIBLIOGRAPHY AND REFERENCES

Archaeological Institute of America, 2003 *Open Declaration on Cultural Heritage at Risk in Iraq*, available from http://www.archaeological.org/webinfo.php?page=10210 [accessed 23 November 2008]

Bogdanos, M, 2008 Thieves of Baghdad, in *The Destruction of Cultural Heritage in Iraq* (eds P G Stone and J Farchakh Bajjaly), The Boydell Press, Woodbridge, 109–34

Cornwell, R, 2006 US colonel Offers Iraq an Apology of Sorts for Devastation of Babylon, *The Independent*, 15 April, available from http://www.independent.co.uk/news/world/middle-east/us-colonel-offers-iraq-an-apology-of-sorts-for-devastation-of-babylon-474205.html [accessed 23 November 2008]

International Council of Museums: Red Lists, 2003 *Emergency Red List of Iraqi Antiquities at Risk*, available from http://icom.museum/redlist/irak/en/index.html [accessed 22 November 2008]

Kimmons, S, 2004 Soldiers Help Preserve Archeological Sites, *Defend America: US Department of Defense War on Terrorism*, 7 June, available from http://www.defendamerica.gov/articles/jun2004/a060704a.html [accessed 1 October 2008]

Roux, G, 1992 *Ancient Iraq*, 3rd edn, Penguin Books, London

Schlesinger, V, 2007 Desert Solitaire, *Archaeology* 60 (4), July/August, available from http://www.archaeology.org/0707/trenches/solitaire.html [accessed 22 November 2008]

Siebrandt, D, 2007 *Site Assessment of the Ancient City of Kish (Tell al-Ukhaimir)*, Report for the Cultural Affairs Office, US Embassy Baghdad and the 3rd Squadron 73rd Cavalry Regiment

Siebrandt, D, 2008a *Site Assessment of Archaeological Sites in Ninewa Province*, Report for the Cultural Affairs Office, US Embassy Baghdad

Siebrandt, D, 2008b *Site Assessment of Nippur and Tell Delhim*, Report for the Cultural Affairs Office, US Embassy Baghdad

Siebrandt, D, 2008c *Site Assessment of Tell Arba'ah Al-Kabir*, Report for the Cultural Affairs Office, US Embassy Baghdad and the 2nd Brigade Combat Team/1st Armored Division

Tiernan, T, 2007 Deployed Airmen Find Ancient Artifacts at Iraqi Air Base, *US Air Forces Central*, 31 December, available from http://www.centaf.af.mil/news/story.asp?id=123080814 [accessed 1 October 2008]

The White House, 2008 *In Focus: Iraq*, 4 December, available from http://www.whitehouse.gov/infocus/iraq/ [accessed 10 December 2008]

13

Operation Heritage

HUGO CLARKE

The culture of Iraq has always been of the utmost importance to its people and to the international community. Following the 2003 invasion of Iraq (and notwithstanding the priority requirements of life support, medical facilities and infrastructure repair that the Iraqi people required) it was important that cultural issues – issues that underpinned the historical identity of Iraq – were addressed, and to that end it was deemed appropriate that a cultural initiative be originated and developed with a long-term view to the future.

Before taking command of British troops in Multi-National Division (South East) (MND(SE)) in February 2008, Major General Barney White-Spunner, General Officer Commanding 3rd (United Kingdom) Division, met with Dr Neil MacGregor, Director of the British Museum, to discuss the feasibility of the British Army and the British Museum working jointly to assist the Iraqi Ministry of State for Antiquities and Tourism in developing a cultural heritage project in southern Iraq. From these discussions *Operation Heritage* was born. From the outset, its aim was to identify key heritage sites and museums in southern Iraq, assess the state that they were in and, in coordination with the Iraqi authorities and the British Museum, implement a plan to safeguard these sites and museums.

In my role as Military Assistant to Major General White-Spunner in Basra I was identified, jointly with Dr John Curtis, Keeper of the Middle Eastern Department of the British Museum, as the project manager for this initiative, and in meetings held at the British Museum and Bulford, home to the Headquarters of the 3rd (United Kingdom) Division, we drew up a plan for the project with the following nine initial objectives:

- to seek approval from the Government of Iraq for the project
- to establish key liaison routes between the British Museum, the British Army and the Iraqi Ministry of State for Antiquities and Tourism
- to secure funding for the different aspects of the project
- to nominate the important cultural heritage sites in southern Iraq and carry out assessments with a team of experts
- to establish training courses for museum curators at the British Museum
- to assess security at key heritage sites
- to assist with and help to coordinate infrastructure repair as required
- to liaise with Government of Iraq Ministries and other Coalition partners to ensure that there is a coordinated approach on heritage issues pan-Iraq
- to gain international awareness and support for this important initiative by promoting media coverage

It was decided at this stage to split Operation Heritage into two parts: *Operation Sumeria*, which aimed to identify key heritage sites in southern Iraq and assess their condition; and, second, *Operation Bell*, which aimed to establish the location of, and then fund and refurbish, a Museum for Basra. Both of these projects are covered in detail below.

OPERATION SUMERIA

As 'the cradle of civilisation', Mesopotamia contained many sites of great significance. The British Museum identified a number of the more important sites and then, with the assistance of the military, prioritised these further by studying the availability of access to them and the time frame available to visit them, particularly when utilising a military helicopter, which would have to be freed up for a short duration from other important tasks.

The 3rd (United Kingdom) Division took over command of MND(SE) in February 2008 and planning was taken forward for the site visits. John Curtis visited Basra in April and during this time visits were organised to Ur and Eridu. Owing to time constraints further sites could not be visited, but Uruk was overflown and photographed. The film footage and photography taken by the British Army's Combat Camera Team proved invaluable and was shown at an Iraqi Heritage Working Group organised at the British Museum. Planning for a larger expedition in June to carry out more detailed assessments took place during this visit; the aspiration was to visit Ur, Eridu, Uruk, Kissiga, Larsa, Lagash, Tell El Oeili and Ubaid.

Significant time and effort went into the detailed planning of the June trip. All locations had to be confirmed, a process assisted by the acquisition of satellite imagery of these sites. Additionally, we were fortunate to have Professor Elizabeth Stone from the State University of New York with the team, as she had an excellent knowledge of the exact locations of the majority of the sites, having studied satellite imagery of them for a number of years. It was planned to 'forward base' the team to the west of Basra, in Tallil, where the United States Army would accommodate it for three days. Tallil, next door to Ur, is closer than Basra to the sites to be visited and, by accommodating the team here, time spent at each site could be increased. In the event this proved to be eminently sensible as, owing to deteriorating weather during the course of each day, the team were forced to start at 0300 hrs in the morning to complete its day's assessments by the time the weather closed in at around 0930 hrs. The team were fortunate to be allocated a Merlin helicopter and crew for three days. Time was well spent beforehand with John Curtis and his archaeological team informing the crew of what needed to be achieved, the different types of aerial imagery required and the best landing sites for the helicopter so as not to damage any of the heritage sites. Authority for the site visits was granted by the Ministry of State for Antiquities and Tourism. Security and communications requirements were assessed beforehand in Basra and the relevant personnel and equipment were attached to the team for the duration of the trip.

The team, with the helicopter crew, was 25 strong. The archaeological experts were coordinated by John Curtis and included Dr Paul Collins from the British Museum, Dr Margarete van Ess from the German Institute of Archaeology in Berlin,

Elizabeth Stone from the State University of New York; and, from the Iraqi State Board of Antiquities and Tourism, Mr Qais Hussein Raheed, Director of Investigations and Excavations, Mr Mehsin Ali, Deputy Director of Iraq Museums and Mr Abdulamir Hamdani, the Inspector of Antiquities for Nasiriyah Province. Without the permissions, authority, advice and guidance of our Iraqi colleagues we could not have achieved what we did during this trip. The military side of the team was coordinated by the author and included Major Rupert Burridge, Royal Engineers, a five-man helicopter crew, a seven-man protection force, two signallers, a medic and a two-person combat camera team. Altogether some 800 photographs were taken, and among them are some of the best photographs ever taken of the sites in question. These images, together with film footage, were passed to the British Museum for further use.

At each site the team were looking for evidence of looting and when it might have occurred, for evidence of military activity, whether before or after March 2003, and for evidence of damage deriving from nearly 30 years of neglect.

At Eridu, there was no evidence of looting or of recent visits to the site. Car tracks were visible near a neighbouring canal and the site fence. Surface scraping, evident close to the fence, was presumed to be the result of field irrigation. Two site guards, who were not present during the inspection, were based at a village some distance from the mound.

Until recently there was unrestricted access to the archaeological site of Ur for Coalition troops based at Tallil, and it is suspected that large numbers of troops wandering around the site at will did some damage. Now, however, the site is out of bounds and special permission is needed to visit it.

At Uruk the major problem appeared to be erosion. The expedition house remained in a good condition, although termites had attacked wooden shelving in a work room. The fence surrounding the site was renewed with Japanese funding in 2006. There was no evidence of looting at the site, which was protected by 15 Iraqi Special Protection Force (SPF) personnel (who are trained and work for the Ministry of the Interior), one of whom arrived to check on the presence of the inspection team, and an on-site guard (for whom the German institutional system is able to maintain constant payments).

The tell at Ubaid was extensively damaged by military installations when it was established as an Iraqi command post in early 2003. There were no obvious signs of looting. The site was fenced, but the fence had been broken in at least two places. A number of vehicle tracks crossed the site. There were no designated guards for Ubaid, but guards from Ur, along with SPF personnel, protected the site.

Tell El Oeili was looted in 2003 and there were extensive remains of looter pits, now filled with sand, visible across much of the mound. There was no evidence of recent looting. The site had no fence, guard tower or designated guard. There was a surface scatter of Ubaid-period sherds, sickles and obsidian blades.

Larsa was extensively looted in 2003; at the end of that year a guard tower was erected and the presence of a guard deterred further looting. The tower had not been visited for some time, however, as demonstrated by a nest with a young grumpy hawk within the observation platform. There were at least five designated guards for the

site, based at Nasiriyah, but none was present during the inspection visit. There was no clear evidence of recent looting and large areas of the unfenced site were covered with sand and eroded brick.

The archaeological remains of Lagash were in a good state of preservation. The site, which was unfenced, was under the strong protection of the Beni Said tribe and had seven guards from two villages: Ali Khan and Rebaih. The team was met by the local guard and villagers, who reported that there had been some small-scale looting in 2003 by people from the town of Fajr but none since that date.

The south-western side of Kissiga and the summit of the mound were covered by looter holes, many filled with silt. The site had been badly damaged by military activity and the remains of tank emplacements and other military installations scarred the large gully. These military features (at least some of which were visible in photographs of the site dating to 1992) were filled with silt. The appearance of the puddled mud in the bottom of the looters' holes was similar to that in the bottom of the military installations, suggesting that the looters' holes were not recent and probably dated from 2003. The presence of US forces at Kissiga was demonstrated by numerous military food packages scattered on the surface. The site was unfenced. A large number of SPF personnel arrived in three vehicles after the team had been at the site for an hour.

In conclusion, the team found that the conditions were different at each site, making it difficult (and dangerous) to generalise. The main purpose of the mission was to assess damage at the sites, and the damage observed can be categorised under four headings:

- *Damage resulting from turning the sites into military defensive positions*: this was observed both at Kissiga and Ubaid. It is believed that these defensive works were created by the Iraq army in the period leading up to the Coalition invasion of 2003.
- *Damage to sites resulting from Coalition activities*: apart from Ur, the presence of Coalition troops, attested by discarded American food wrappers, was noted only at Kissiga.
- *Damage from looting*: there were clear indications of looting holes at Larsa, Tell El Oeili, Kissiga and Lagash, and at Eridu inscribed bricks were looted from the collapsed dig-house.
- *Damage from neglect*: it is well known that for more than 25 years (since the beginning of the Iran–Iraq War) there has been under-investment in the Iraqi cultural heritage, with the result that many sites and monuments are now suffering from neglect. This is a process that has accelerated since March 2003.

Although this survey seems to indicate that there has been no looting during the last few years, it should be noted that the team visited only eight sites, all of which are in the southern part of Iraq. It should be remembered that the sites visited may not even be typical for the southern region. A full report on all of these locations has been compiled by the British Museum.[1]

1 See: http://www.britishmuseum.org/the_museum/museum_in_the_world/middle_east_programme/iraq_project.aspx.

OPERATION BELL

The other main aim of this project was to identify museums in southern Iraq with a view to restoring them (Operation Bell). One such important museum is located in Basra.[2] As a result of the unrest there has been damage to many of the beautiful and significant buildings in old Basra; these will, over time, and given a good security situation, be redeveloped. The Ministry of State for Antiquities and Tourism has regained control of the Antiquities Museum in Basra but security in the area, though improved, is still a concern. Additionally, there is infrastructural damage to the building that requires significant work. To this end, and in liaison with the Ministry of State for Antiquities and Tourism, an alternative location was sought. It was understood that this location should have the required security for work to take place unhindered, as well as being a building of significance in the eyes of the Basrawi people. The Lakeside Palace, built for Saddam Hussein, has been established as a suitable location. Mr Qahtan Abd Ali Al-Mayahi, the Director of the Basra Museum, has fully engaged with the project and has been key in coordinating local and national Ministry figures in driving this project forward.[3] He is currently on a three-month course sponsored by the Department of Culture Media and Sport at the British Museum, which is offering bespoke curatorial training to key Iraqis who will be involved with running the Museum.

During the visit of John Curtis and his team in June a meeting was set up at the Lakeside Palace to discuss the ways in which this project could be taken forward. Present at the meeting were John Curtis, Paul Collins, Margarete van Ess, Elizabeth Stone and, from the Iraqi State Board of Antiquities and Tourism, Qais Hussein Raheed, Mehsin Ali, Mr Qasim Abdel Hameed Al-Basri (Director of Cultural Relations), Mr Mohammed Hasuni Nasir (Inspector of Basra Antiquities), Mr Qahtan Abd Ali Al-Mayahi (Director of Basra Museum) and Mrs Azhar Jaffar Hashim (Engineering and Maintenance Manager for Basra). Also present were Mr Sadiq Sultan, Prime Minister Maliki's representative for palaces; Fiona Gibb, Deputy Consul General FCO; Lt Col Neil Page, Royal Engineers; Major Rupert Burridge, Royal Engineers; the author; and two members of the Combat Camera team. It was a valuable meeting in which all parties discussed the achievements to date, next steps, funding, work required for the refurbishment of the palace as a museum and the imperative for Iraqi lead and British support. It was agreed that the Ministry of State for Antiquities and Tourism would set up a committee to drive the project forward and seek approval for the re-use of the palace from Prime Minister Al-Maliki. As agreed, the committee submitted its proposal for the use of the palace to Prime

2 There were three museums based in Basra: an Antiquities Museum, a Natural History Museum and a Museum dedicated to the Iran-Iraq War.
3 Report and findings of Basra Museum Committee submitted by Dr Ameera Aiydan Althahab, the Chairman's office of the State Board of Tourism and Antiquities to the Ministry of Culture. Report agreed in letter from Amil Mihsin Finjan, Director Minister's Office, the State Board of Tourism and Antiquities. Letter sent by Dr Ameera Aiydan Althahab to Sadiq Sultan, representative to the Prime Minister for Palaces, requesting permission for use of the Lakeside Palace for the Museum and stating that permission had been gained previously for this from the Council of Ministers Secretariat through the Basra Provincial Council.

Minister Al-Maliki's office. Soon afterwards Prime Minister Al-Maliki stated that it was his aspiration that Saddam's palaces should be turned into cultural centres.

From the outset of Operation Bell, staff of the Ministry of State for Antiquities and Tourism have taken the lead in driving this project forward. After the positive response from Prime Minister Al-Maliki to their proposal for the re-use of the palace as a museum, further discussions have taken place between the Ministry of State for Antiquities and Tourism, the British Museum and the British Army. The British Museum has offered advice on how the palace could be made into a modern museum and Rupert Burridge and his team of Royal Engineers from the British Army have provided a detailed survey of the building, including detailed floor plans, which has been submitted to the Ministry of State for Antiquities and Tourism.

Major General White-Spunner and Neil MacGregor discussed the plans with the Rt Hon Andrew Burnham, Secretary of State for Culture, Media and Sport, at the British Museum Working Group in London, and he expressed genuine interest in the project. Funding is now being discussed, with formal permission having been granted by Prime Minister Al-Maliki for the re-use of this particular palace. It is envisaged that funding streams will be investigated nationally, regionally and internationally. All funding initiatives will be Iraqi-led. The tender for the construction of the museum will also be Iraqi-led and will be put out to local companies, although some of the museum equipment will have to be internationally sourced. The Ministry of State for Antiquities and Tourism will coordinate the transfer of artefacts to the museum once it is completed.

As Basra is the second most important city in Iraq, which in itself contains some of the most important heritage sites in the world, it is only right that such a building should be utilised to put this heritage on display, not only to the local and national community but to the international community as well. The wealth of heritage in Iraq is of great interest to many and, as in the past, will in the future be a huge attraction for tourists. There is already significant media interest in this project, which will continue to grow as the initiative grows. The opening of such a museum in Basra would act as a springboard to further investment in other cultural attractions, such as a library and arts centre, which would in turn attract further economic growth, training and employment for the area. All of those involved with this initiative firmly believe that this worthwhile project will, in time, become a jewel in the Iraqi crown for the region and will attract considerable external interest and substantial opportunities for the Basrawi and Iraqi people.

CONCLUSIONS

The objectives for Operation Sumeria are close to being met but further work will continue, including further site visits, to provide assessments and greater security to the sites. Operation Bell has been taken a considerable way forward, especially now that permission from Prime Minister Al-Maliki has been granted for the use of the Lakeside Palace. It is essential that funds are now raised swiftly. The British Army and the British Museum had the opportunity to start the ball rolling on this project and will continue to push it on, with support from the FCO, as they can, but it is

essential that it becomes an Iraqi-led initiative, owned and controlled by them, if momentum is to be maintained.

It is imperative that projects such as Operation Heritage are indigenously led and advice must be sought at every juncture. The plans that the country in question has for the future preservation of its heritage, the departments that control the sites and museums, and the specific areas that require assistance must all be fully understood. The British Museum and British Army are purely supporting elements. Strong relationships within the relevant departments are essential; in this case, relationships with the Director of the Basra Museum and key members of the Ministry of State for Tourism and Archaeology have been invaluable. Additionally, a combined Coalition effort on cultural projects would magnify the effect on the ground and demonstrate the importance of the country's heritage to others.

Owing to the relatively short length of British Army tours it is important that the groundwork for projects which are worked on by the military and academia is established at an early stage to ensure that the maximum is achieved during the tour. Additionally, cultural projects should not be solely owned by a specific unit on tour but should be taken forward, as other development projects are, by those that come after.

Cultural Property Protection in the Event of Armed Conflict – Austrian Experiences

FRIEDRICH SCHIPPER,[a, b, c] FRANZ SCHULLER,[a, b, d]
KARL VON HABSBURG-LOTHRINGEN,[a, e, d]
HOLGER EICHBERGER,[a, b, d, f] ERICH FRANK, [a, b, d]
AND NORBERT FÜRSTENHOFER, [a, d]

THE ORIGIN OF MILITARY CPP IN AUSTRIA

The current Austrian situation concerning the standard and level of implementation of the 1954 *Hague Convention for the Protection of Cultural Property in the Event of Armed Conflict*, especially within the Austrian Armed Forces (AAF), is not the product of concentrated and well-organised activity; it is rather the result of a number of individuals' efforts while working in a variety of positions at the right time. A long time passed between Austria's 1964 ratification of the 1954 Hague Convention and its implementation and dissemination within the AAF.

The first Austrian 'military mission' in which cultural property protection (CPP) played a minor, although unofficial role, occurred in 1968 in the context of the 'Prague Spring'. The Austrian government and military leaders expected Soviet troops to cross Austrian territory on their way to Prague, violating the country's sovereignty and neutrality. Knowing that the Soviet troops could not be stopped by military force, Austria prepared for invasion. On the initiative of the Federal Bureau for Monuments and Sites (FBMS), and under the supervision of its provincial departments, hundreds of copies of the Blue Shield, the emblem of the 1954 Hague Convention, were distributed in several districts of eastern and northern Austria and, through the active participation of gendarmerie and army officers, these were attached to historical or cultural monuments along the predicted Soviet route through Austria. It was greatly feared that Soviet troops would not respect the country's rich cultural heritage, which had already suffered so badly during World War II – at this time the traces of this damage and destruction were still visible at many cultural sites. The idea was that this time the enemy would at least be made aware of the fact that with every single destructive step they took they were likely to be violating international law. This form

a Austrian Society for the Protection of Cultural Property
b Austrian National Committee of the Blue Shield
c University of Vienna
d Austrian Armed Forces
e Association of National Committees of the Blue Shield
f UMIT Health and Life Sciences University Hall

of resistance without force at the climax of the Cold War signalled the birth of a kind of 'Blue Shield Movement' in Austria which finally resulted in the foundation of the Austrian Society for the Protection of Cultural Property in 1980. This civil organisation is still characterised by many regular and militia army officers among its membership, who are entrusted with most of the positions on its steering board. The Society also played an initial and decisive role in setting up the Austrian National Committee of the Blue Shield in 2008. Therefore, both organisations – forming an interface between civil and military expertise as well as providing an unrivalled pool of experts within Austria – consequently have an interest and high competence in all issues of military CPP.

Meanwhile, the Hague Convention corpora developed into one of Austria's 'favourite aspects' of international law and the Austrian government demonstrates serious effort in, and commitment to, this special field. At the international level, this is manifest in Austria's contribution to the development of the Second Protocol to the 1954 Convention. Austria was not only host to one of the revision conferences but it took a decisive role in the revision of the original document. Austria entered this diplomatic arena at the right point in time.

CIVIL EFFORTS: IDENTIFICATION AND REGISTRATION OF CP

In response to the conflicts that have occurred since the early 1990s, a new discussion arose about the application and effectiveness of CPP during armed conflicts, especially concerning the value and effectiveness of the 1954 Hague Convention.

Critique or renaissance of the 1954 Hague Convention

International organisations such as UNESCO came under pressure from the media and public opinion during events such as the conflicts in Croatia (and in particular the siege of Dubrovnik); Bosnia-Herzegovina and Kosovo; the war in Iraq (in particular the looting of the National Museum in Baghdad and archaeological sites throughout the country); the attacks on the Bamiyan Buddha statues in Afghanistan; and in Lebanon (in particular, the destruction of cultural urban heritage in the southern part of the country). The problem, though, was that UNESCO – although being the 'international guardian' for the 1954 Hague Convention – had, and has, no proactive operations branch and no means to actively protect cultural property. It also lacks any form of special political authority.

As the issue is considered more closely, it soon becomes obvious that many national states, even those which are party to the 1954 Convention, have not really implemented the Convention and adopted it into their national law and regulations in a considered manner, if at all. A large number of member states have a horizontal national dissemination on a governmental level without any deeper vertical adoption and implementation. The main problem preventing most experts from dealing more intensively with the military aspect of CPP is the problem of selection and designation of cultural property to be protected under the 1954 Convention. This challenge is not even purely military, but rather a social and public problem.

In working with the 1954 Convention in the past, two scenarios were generally faced: national defence and international operations. In a comparison of the position – or role – of cultural property in armed conflicts over the last 50 years, an increasing readiness to involve such property directly in conflict can be recognised, especially in recent times. In today's world we face new challenges from threats such as so-called asymmetric conflicts, supra-national inter-ethnic and inter-religious wars, but also from the menaces of terrorism and extortion. Cultural property's position has changed dramatically, into that of a deliberate target, rather than a victim of collateral damage.

Destruction of cultural property in World War II mostly occurred by chance or as collateral damage. Even the bombings of Dresden or Monte Cassino, which caused vast destruction of cultural property, were not directed at the property itself, and there was no intention or ambition to destroy and extinguish it forever. In contrast, in recent ethnic conflicts and confrontations we find that the intention to destroy cultural property is a primary goal: the banishment of people is followed by damage to or the destruction of their cultural heritage.

For international peace-supporting and peace-keeping forces these changes represent a drastically new challenge and task. It must be remembered that many people have very strong bonds to their cultural heritage, especially when combined with or related to religion and religious symbols, and military actions against cultural property represent an attack on the *emotions* directly. In these kinds of situations military leaders are put in the position of having social responsibilities that are as important as their military commands: so what can be done and how should military planners and their civilian advisers prepare?

The civil sector of implementation

There are two main sectors for the implementation and adoption of the 1954 Hague Convention: the civil and the military. Cooperation between the civil and military communities can be somewhat difficult and sometimes even fractious. A good and respectful climate of inter-ministerial discussion is essential. Regardless of the different functions of civil and military directorates, the main focus and common goal has to be to preserve, keep and secure cultural heritage.

In Austria the civil sector falls into:

- the Federal Ministry of Education, Art and Culture (MoE) (Following legal adoption, the Ministry will generally be the administrator/guardian of the 1954 Convention) and
- the FBMS (Ensuing from Article 3 of the 1954 Convention and Article 5 of the Second Protocol ['designation of competent authorities responsible for the safeguarding of cultural property'])

The first and principal task of these authorities in implementing the 1954 Convention and its Protocols is the selection and designation of cultural property to be protected under the Convention and its Second Protocol. Owing to differing interests and opinions (both public and private) and the fact that various authorities and organisations (eg

other ministries, economic entities, companies, societies and organisations) are concerned parties, selection and designation can be, and in fact is, one of the most difficult procedures. The establishment of an inter-ministerial platform (committee) is helpful (with at least MoD, Ministry of Justice and Ministry of Foreign Affairs, national UNESCO Commission and Red Cross/Crescent representatives, as well as representatives of the territorial bodies involved).

Other countries have also addressed this challenge. A good example is the Islamic Republic of Iran. In 1989 a National Advisory Committee (with legal, technical and educational subcommittees) consisting of the MoD, the Ministry of Foreign Affairs, the Iranian National Commission for UNESCO and the Iranian Cultural Heritage Organization was formed. Madagascar also adopted a similar approach. Following Austria's experiences when implementing the 1954 Convention in the past, the Austrian authorities were likely to support such models and solutions. When implementing the Second Protocol, Austria originally considered creating such a committee. However, in the end all preparatory work was done by the FBMS alone and cooperation in the form of the above-mentioned committees was limited to the regional/provincial level (eg territorial military command).

For countries involved in the implementation phase of the Second Protocol, an independent Non-Governmental Organisation (NGO) similar to the ones that exist already in Switzerland, Austria, Italy, Romania and Germany ('Swiss/Austrian/Italian/Romanian/German Society for the Protection of Cultural Property') or in the form of national committees of the Blue Shield could also be very helpful. NGOs function as opinion leaders in cooperation with the media. They offer their expertise and support if necessary. They are willing to undertake controversial but correct and important long-term measures on behalf of the governments' interests. NGOs try to be a link between the various sectors of the government and, above all, can be a good advocate of the cultural heritage.

IMPLEMENTATION OF THE 1954 HAGUE CONVENTION

In the civil sector (operative structure)

After implementing the 1954 Hague Convention as federal law, a special office, the '1954 Hague Convention Office', was created in the FBMS. A highly experienced civil servant was designated head of the office in order to comply with the requirements of the 1954 Convention. Together with a number of colleagues, also from the military sector, they started their work. The first and most difficult step, as already mentioned, was the selection of the cultural property to be protected from the list of national monuments. Based on the results of a meeting of UNESCO experts in Switzerland in 1956, four levels (A–D) of cultural property were created (international/world heritage, national, regional and local). From today's perspective this task of identifying several thousand monuments and sites was far too complex and detailed and therefore not practicable. The following sections explain and demonstrate the importance of the above-mentioned committees in national cooperation, as well as the necessity of exchanging experiences at an international level.

The FBMS: responsibilities and activities

Upon ratification of the 1954 Hague Convention by Austria (Federal Law Gazette no 58/1964), the MoE entrusted the FBMS with the responsibility of implementing the Convention. Under its current statutes, the FBMS continues to be responsible for this implementation. It has taken, and continues to take, essential measures within the framework of the 1954 Convention concerning the selection and identification of cultural property under protection (eg by compiling lists and maps of such cultural property).

Since 1 January 2000 the FBMS has been entrusted directly with the implementation of the 1954 Convention by the *Monument Protection Act*. The FBMS has already compiled an extensive array of lists and maps of cultural property to be protected, as well as an emergency databank. As noted above, cultural property has so far been categorised within four categories, namely 'A, B, C, D', where 'D' refers to objects of local significance. This categorisation is in compliance with the recommendations adopted at a UNESCO experts meeting in Switzerland in 1956. Austria has approximately 50,000 monuments and sites listed, which is an unusually high number in comparison to other signatory states, which did not implement the experts' recommendations. However, since international conventions have to be interpreted in line with international customs, there is a need for Austria to adjust its practice to bring it into line with the internationally applied standards for assessing the significance of cultural property. The definition of cultural property in Article 1 of the 1954 Convention merely talks of property that is 'of great importance to the cultural heritage of every people', but it does not provide a more detailed definition of this qualitative term. Since Austria is the only country to observe the above-mentioned UNESCO experts' recommendations, it has become necessary to establish new lists of cultural property based on internationally customary principles of evaluation. This adjustment will result in a drastic reduction in the number of objects to be protected according to the 1954 Convention. Thus, Austria has been, and still is, confronted with two essential problems: defining the number of monuments and sites subject to the 1954 Convention, and defining the responsibilities and obligations of the individual under the 1954 Convention. The necessary regulations have now been incorporated in the *Amendment to the Monument Protection Act* that became operative on 1 January 2000. Section 13 of the Act now includes the following provisions:

1. Immovable monuments (including their components and accessories), as well as movable monuments, as defined by Article 1 of the UNESCO Convention for the Protection of Cultural Property in the Event of Armed Conflict (Hague Convention) and promulgated in Federal Law Gazette no 58/1964, which are of great importance to the cultural heritage of every people shall be inscribed on a list to be established by the FBMS. This list shall also contain objects which serve to preserve, exhibit or shelter cultural property and thus come under the protection of the convention within the meaning of the aforementioned article.

2. A pre-condition for inclusion in the list pursuant to paragraph 1 shall be that the monuments in question are of utmost significance for Austria's stock of monuments.

Decisions on their inclusion shall be guided by the internationally customary interpretation of the 1954 Hague Convention concerning the requisite importance of a property.

3. Monuments to be included in the list shall either be classified monuments or, if they are not, shall enjoy immediate institution of classification proceedings.

4. The MoD, the respective provincial governors, mayors and owners may object to inscription on the list by contesting the property's Hague Convention standard for protection, and may apply for its non-inclusion in or deletion from the list. Such an application can be rejected by decree only. The FBMS may delete objects from the list if the pre-conditions for their inclusion have changed.

5. Reference to inclusion in the list shall, if possible, be made by placing distinctive signs on the monuments according to the 1954 HC [...] The FBMS shall be entitled to instruct the owner, or any other party authorized to dispose of the property, by decree on how and to what extent the objects are to be marked [...]

6. Disregard of such a decreed instruction for marking according to the Hague Convention shall be forbidden, and so shall be any abusive kind of marking. Marking shall also be deemed abusive whenever it is of such a nature that it may lead to the erroneous assumption that it represents the distinctive emblem of the 1954 Hague Convention.

7. The existing lists and maps of cultural property under protection, certificates and entitlements to affix the 1954 Hague Convention emblems shall become invalid by 31 December 2009 at the latest [...]

8. Detailed regulations on how to proceed in the compilation of lists, etc. [...] shall be defined by the MoE (in agreement with the MoD) by decree.

The explanatory notes accompanying the *Amendment to the Monument Protection Act* discuss in greater detail a number of important issues and problems, such as:

a) Any cultural property having the requisite great importance is to be included in the list even though this may – eg for military reasons – be undesirable.

b) Also local peculiarities can, in exceptional cases, be of greatest importance to Austria's overall stock of monuments and therefore warrant their inscription on the list.

c) Cultural property deemed as subject to the provisions of the 1954 Hague Convention must in future be classified as monument or immediately become classified as such. It is thus not within the discretion of the FBMS to deem cultural property of great importance and include it in the 1954 Hague Convention list on the one hand, and not put it under preservation order on the other. Such an approach would be a contradiction in terms. However, there is no need to classify any listed objects as monuments under preservation order which, by themselves, are not monuments worthy of protection within the meaning of the *Monument Protection Act*, but which are used to preserve movable cultural property under protection (such as insignificant

buildings that house important museum collections or archives), or merely constitute the setting for the actually valuable objects (as in historic centres).

d) The deadline for completing the change-over to the new lists is 31 December 2009. Since this conversion requires extensive administrative measures, it would have been unrealistic to establish any earlier date.

As far as the decree mentioned in section 13 is concerned, *The Monument Protection Act* says that the detailed provisions on how to proceed in the compilation of lists, etc, will be defined by the MoE by decree. Any such decree will thus have to respond to the needs arising for a particular site in conjunction with the compilation of new lists and will take into account international standards regarding the compilation of lists and drawing of maps of cultural property under protection. This means that before any monument is added to the list there will be in-depth discussions between the ministries involved, in particular the MoD and the MoE, to define the requirements and solutions in compliance with practical needs.

Historically, lists of cultural property relating to the 1954 Hague Convention were developed for each federal province. These lists were compiled, partly edited into catalogues and then handed over to the MoD, where they immediately became the main working documents for the army and Cultural Property Protection Officers (CPPOs). Parallel to the selection of monuments, rules for the use of the Blue Shield emblem were drawn up. Monuments rated as Category A–C received the emblem automatically while monuments rated as Category D had to apply to use it. More recently, the production of special cultural property maps for each region has been important. At the same time special leaflets concerning measures for the protection of cultural property by civilians and public institutions, especially private owners and corporate owners such as churches and religious communities, were produced.

MILITARY EFFORTS: TRAINING AND RESPONSIBILITY OF THE AAF

General considerations

CPP is a task that has to be fulfilled in times of peace. Starting CPP measures once armed conflict has begun is too late, since other problems then have higher priority. The protection of cultural property in the event of armed conflict has to be a part of the military doctrine drafted by political authorities. It can then be transferred into military 'rules of engagement'. On the basis of these 'rules of engagement', orders can be developed and carried out. CPP has to be implemented into general military training as well as into the planning and execution of military missions, and to enable this to happen CPPOs have to be deployed in all branches of the armed forces. Therefore, in Austria military CPP is based on the assignment of CPPOs.

Military service in Austria

In Austria military service is obligatory for every male citizen when they reach 18 years of age, and there is an annual general draft split into four enlistment points

per year. Women are not conscripted but may volunteer. Over and above this obligatory service, all citizens having finished 12 grades of school (usually at the age of 18) are free to volunteer for a career as Army or Army Militia Officer. However, unlike the armed forces of many other countries, AAF officers have to undertake complete basic training and service as a basic recruit for half a year and as a Private and Corporal for a further six months. Aspiring officers finish their first year of training as a Sergeant, followed by another three years of training and service as Officer Cadets – either full-time at the military academy or part-time in the militia. On completion of their training they are given the rank of Lieutenant and are transferred to regular regimental service, where they continue their career. Officers may start a higher military specialist career – eg as CPPOs – only after having been promoted to Captain, which takes at least 14 complete years of service in the AAF. That means that officers such as CPPOs usually have a good record and extensive experience as regular army officers in either the infantry, artillery, tank or pioneer (engineer) regiments before they start their scientific education.

The organisation of CPP in the AAF

In compliance with Article 7 (Military Measures) and Article 25 (Dissemination) of the 1954 Hague Convention and Second Protocol, Article 30/2 and 3 (Dissemination), the AAF select appropriate personnel and organise a programme of training for CPPOs. Only militia (reserve) officers are trained as CPPOs; no regular officers are trained for this role. Staff selected are usually high-achieving personnel with experience in education and teaching, frequently with a knowledge of history, (especially international) law, art and cultural affairs. However, those with specialist skills such as structural engineering are also identified. Crucially, all potential CPPOs must have an aptitude for tact and diplomacy in their dealings with other people – especially colleagues in other ministries and organisations.

Functions

In 1981 the MoD issued, for the first time, a special directive concerning the 1954 Hague Convention for the AAF ('Richtlinien für den Kulturgüterschutz') which was replaced by a new and more detailed directive in 1993. Referring to Articles 7 and 25 of the 1954 Convention, it focused on three main functions/tasks of a CPPO:

- Securing and keeping respect for cultural property as assistants/advisers and specialists of their command and commanders (eg to give information about property in the area, distance of troops and weapons from cultural property etc)

- Providing for and delivering training and instruction programmes for troops and their commanders

- Maintaining contact with civilian authorities (such as the Department for Monuments, churches, monasteries, province and district authorities etc) and with various individual persons

Training and career of a CPPO

After at least 14 years of service with the AAF and having attained the rank of Captain, an officer selected to become a CPPO will undertake a basic one-week CPP course. During subsequent years of service a CPPO will complete an annual one-week course as part of their continuing CPP education and training. After at least four years of service as a CPPO and, finally, after having completed a five-week staff course, a CPPO will be promoted to the rank of Major. A CPPO must then pursue a specialised military academic curriculum in a relevant discipline and write a thesis. On completing the curriculum and thesis and after at least ten further years of service a CPPO is promoted to Colonel. While pursuing their career CPPOs will hold training seminars for civil experts and soldiers and develop expertise in special functions (eg languages). The highest ranked CPPO in the AAF is a Brigadier General in the MoD. In other words, it takes at least 14 years to become a CPPO Major, 24 years to become a Lt Colonel, and 28 years' service to become a Colonel.

Since 1995, and running parallel to the above national training programmes for CPPOs, a number of international training seminars have taken place in cooperation with the NATO-PfP (Partnership for Peace) programme. Austrian CPPOs and civil experts from relevant NGOs (Austrian Society for the Protection of Cultural Property and Austrian National Committee of the Blue Shield) have joined international seminars of ICRC and UNESCO around the globe as special CPP advisers.

Organisation

Since 1981 the MoD has assigned two CPPOs to each territorial/provincial command (one of whom is of academic level – ie Colonel) and the other at a lower rank. Beginning in 1989, a gradual process of reform and reorganisation has led to an increase in the number of CPPOs and their focus has extended to include more international activity. There were one or two CPPOs deployed at each provincial/territorial command; four CPPOs in the Austrian International Operations Command (AUTINT); two in Air Force Command; and five in MoD (Defence Staff Bureau/expert pool and Joint Command and Control Staff).

Following the implementation of the Second Protocol and the ongoing reform of the AAF (so-called 'AAF reform 2010'), a significant amount of CPP policy is still under review. It is currently planned to introduce a CPPO within each of the recently established mobile regional brigades. It is also planned to transfer the CPP conception and education unit to the National Defence Academy. These developments build on the success of the previous 20 years, which have seen the production of a number of special instructions and a manual for CPPOs.

MANUAL FOR THE CPPO

The Manual identifies the Responsibilities of a CPPO:

- The CPPO is a member of the staff at the level of a territorial command (Federal Province), division and higher.

- The CPPO is adviser to his commander in all matters relating to the respect for cultural property within a commander's responsibilities in training, preparing for and executing military actions, as well as in cases of military assistance in times of natural disasters (in conjunction with the law and constitution of the country).

- The CPPO prepares lists and information about the amount and priority of cultural property in the operational area. He contributes to the operational assessment of the military situation, which ultimately results in the production of a military report. He gives information to his commander, the liaison officers and to the district/province authorities. He drafts orders guaranteeing respect for cultural property, taking into consideration the tactical decisions of the commander. By order of his commander he controls in critical areas the tactical measures concerning respect for, and protection of, cultural property.

- The CPPO remains in contact with the Head of the Department of Monuments of the Federal Province and with his senior military colleagues.

- The CPPO is adviser and consultant for civil authorities concerning the effects and results of military operations on cultural property and he gives instructions about the possibility of safeguarding cultural property when and where civil authorities do not, or cannot, do this.

- As a member of senior staff one of the main and most important functions of the CPPO is to provide situation reports.

CPPO situation reports should include: an overview presentation of cultural property in the operational area; a short presentation of the essence of the 1954 Hague Convention and its Protocols; a short presentation of the content of the Instructions of the MoD concerning the 1954 Convention and consequences of military actions for cultural property in the operational area; suggestions and provisions for protecting cultural property during military operational planning. In order to produce such a report CPPOs have to collect special material and equipment over the years and these materials form their basic documents. CPPOs are expected to amass a set of basic material – the 'mobile office box' – including:

- Copies of the 1954 *Convention for the Protection of Cultural Property in the Event of Armed Conflict* and its Second Protocol (1999), 1972 Convention concerning the Protection of the World Cultural and Natural Heritage, GENEVA CONVENTIONS (and Additional Protocols) and International Red Cross Handbook

- guides to libraries and documentation archives, museums, private and public collections

- workbook with a collection of papers, documents and information material concerning the protection of cultural property

- set of special maps of cultural property (cultural property maps) of the area [today replaced by GIS tools]

- general map of the country [today replaced by GIS tools]

- records (address books and telephone numbers, offices and authorities name of contact persons) to secure contact (already in times of peace) with: the superior command; the territorial organisation and authorities (provincial government etc); the head of cultural departments (monument section etc) in the ministry; fire brigade, private aid organisations

- office material (typewriter/computer, paper, writing and drawing utensils)

Last but not least, the CPPO should have their own designated transport.

In summary, the main functions and tasks of the CPPO are to be an adviser and consultant for his commander, a teacher and trainer for officers and troops, and a contact person and liaison officer to civil authorities and civilians.

In accordance with the 1954 Convention, to meet the requirement for flexibility and the responsibility to provide the military command with all necessary information in the shortest time available, an EDP-supported cultural property databank was developed in the late 1980s (in the Military Command of Lower Austria/Federal Province of Austria). This model has been based on the regional code system of the Austrian Office for Statistics in conjunction with a special object code. Owing to the huge number of objects to be processed, for the initial general identification we used the district and community codes of the Office for Statistics. For exact military/operational identification, the local CPPO added the military grid code used in military maps.

RECENT DEVELOPMENTS

Civil sector

The FBMS has just completed the new registers required by the 2000 *Monument Protection Act*. After considerable discussion the number of objects in the registers was reduced dramatically. Compared with the old register, started in 1968 and finished in the 1980s, which included some 50,000 objects, the new register comprises only some 145 entries. However, this reduction in the number of objects masks a change of paradigm in the approach taken to registration: the old register was based on a single object protection system; in the new register most of the 145 objects are ensembles or areas enclosing a large number of single objects (eg the World Heritage area of the City of Vienna).

Military sector

As many years have passed since the last directive for the protection of cultural property was issued by the Austrian Federal Ministry of Defence in 1993, and since the Second Protocol to the Convention was drafted in 1999, a new military directive on cultural property protection was overdue; it was recently released in January 2010. Owing to the fact that a national system will not be very efficient in future international activities, it has been designed to be compatible within projects involving

international cooperation. Therefore, the new directive, in addition to all necessary references to the Second Protocol, also contains a chapter on CIMIC as well as on the peculiarities of peace support operations. These new horizons of internationalisation also affect personnel structure and management, as reflected by the new special term 'Liaison Officer: Military Cultural Property Protection' (officially replacing the term 'Cultural Property Protection Officer') and by the establishment of an additional expert pool as a widened personnel basis for military cultural property protection in Austria in general and for international missions in particular.

A further development is taking place with respect to CPP in the context of military disaster relief missions. Natural disaster relief has always played a special and crucial role for the AAF since the draft of the National Defence Law 1920, and this aspect of AAF's duties was also stressed when the AAF was being re-established after World War II in 1955. CPP has always played an important role within AAF disaster relief owing to the history and geography of the country and the kinds of natural disaster to which it is prone, such as regular floods in the Danube river valley, where important historical cities are situated. This has also affected AAF's international missions under UN mandate since the AAF took part in the Congo mission in 1960. Nevertheless, it was not before the disaster relief mission to Calabritto (Southern Italy) in 1980 that CPP became a crucial aspect of such an Austrian disaster relief mission. Against the backdrop of these experiences the AAF Disaster Relief Unit (AFDRU) – designed exclusively for disaster relief abroad – was established in 1990 and CPP has been an integral aspect of planning ever since. Today, CPP is about to become an explicit component within AFDRU and the creation of CPPOs within the unit is planned.

BIBLIOGRAPHY AND REFERENCES

Boylan, P J, 1995 *Review of the Convention for the Protection of Cultural Property in the Event of Armed Conflict* (The Hague Convention of 1954), UNESCO Document CLT.93/WS/12, Paris

Büchel, R, 2007 Zusammenarbeit von zivilen und militärischen Stellen im schweizerischen Kulturgüterschutz (KGS), *Forum Kulturgüterschutz* 10, 4–9

Büchel, R, and Schüpbach, H (eds), 2004 *Bewahren – Sichern – Respektieren: Kulturgüterschutz in der Schweiz*, Schweizerische Eidgenossenschaft, Bern

Carcione, M, 2007 Il punto di vista delle ONG internazionali, *Forum Kulturgüterschutz* 10, 62–7

Carcione, M, and Marcheggiano, A (eds), 1997 *La protezione dei beni culturali nei conflitti armati e nelle calamita*, Milano

Chamberlain, K, 2004 *War and Cultural Heritage: An Analysis of the Hague Convention for the Protection of Cultural Property in the Event of Armed Conflict and its two Protocols*, Institute of Art & Law, Leicester

Desch, T, 1999 *Revision der Haager Konvention zum Schutz von Kulturgut bei bewaffneten Konflikten 1954 – wozu?* Österreichische Gesellschaft für Kulturgüterschutz, Vienna

Deutsches Rotes Kreuz (ed), 1988 Die Genfer Rotkreuzabkommen vom 12. August 1949 und

die Zusatzprotokolle vom 8. Juni 1977 sowie das Abkommen betreffend die Gesetze und Gebräuche des Landkrieges vom 18. Oktober 1907 und Anlage (Haager Landkriegsordnung), Bonn

Dutli, M T, Bourke Matignoni, J, and Gaundreau, J, 2002 *Protection of Cultural Property in the Event of Armed Conflict*, Report on the Meeting of Experts, 5–6 October 2000, Geneva

Eichberger, H, and Schipper, F, 2009 The Protection of Cultural Heritage in Times of Armed Conflict – a View from Civil–Military Cooperation, paper presented at the *WAC Inter-Congress in Ramallah*, 9–10 August 2009, Ramallah

Fechner, F, Oppermann, T, and Prott, L V, 1996 Prinzipien des Kulturgüterschutzes, Duncker & Humblot, Berlin

Fiedler, W, and Turner, S, 2003 *Bibliographie zum Recht des Internationalen Kulturgüterschutzes*, Walter de Gruyter, Berlin

Foramitti, H, 1970 *Kulturgüterschutz. Empfehlungen zur praktischen Durchführung*, Böhlau, Vienna

Frank, E, and Teschner, W, 2003 *Haager Konvention, Kurzkommentar zum Zweiten Protokoll sowie wichtige Annexvorschriften*, Vienna

Garcia Labajo, E, 1995 La proteccion de bienes culturales en caso deconflicto armado, *Revista Espanola de Derecho Militar* 65, 457–74

Gooren, R, 2007 Civil–Military Cooperation in Protecting Cultural Heritage, *Forum Kulturgüterschutz* 10, 50–54

Habsburg-Lothringen, K von, and Schipper, F, 2009 Archaeology in Conflict – The 'Blue Shield' Perspective, paper presented at the *WAC Inter-Congress in Ramallah*, 9–10 August 2009, Ramallah

Henckaerts, J-M, 1999 New Rules for the Protection of Cultural Property in the Event of Armed Conflict, *International Review of the Red Cross* 835, 593–620

Hladik, J, 2000 Reporting System under the 1954 Hague Convention for the Protection of Cultural Property in the Event of Armed Conflict, *International Review of the Red Cross* 840, 1001–16

Hladik, J, 2007 Aspects civils et militaires, *Forum Kulturgüterschutz* 10, 29–33

Horn, D, 2008 Militärischer Kulturgüterschutz im Österreichischen Bundesheer: Neuregelung, paper presented at the annual course for Cultural Property Protection Officers of the Austrian Armed Forces, 27 October 2008, Reichenau/Rax

Hostettler, P, 2007 KGS als Bestandteil des Kriegsvölkerrechts, *Forum Kulturgüterschutz* 10, 10–17

Kasselmann, H J, 2009 Herausforderungen für den Schutz von Kulturgut im Rahmen von Operationen der NATO, paper presented on the occasion of the re-establishment of the Austrian National Committee of the Blue Shield, 8 June 2009, Vienna

Menegazzi, C (ed), 2004 Cultural Heritage Disaster Preparedness and Response, ICOM, Paris

Micewski, E, and Sladek, G (eds), 2002 *Protection of Cultural Property in the Event of Armed Conflict: A Challenge in Peace Support Operations*, Austrian Armed Forces Printing Office, Vienna

Mihaila, M, 2007 Approche de la Societe Roumaine pour la Protection des Biens Culturels en matiere de droit international humanitaire, *Forum Kulturgüterschutz* 11, 78–83

Neuwirth, F, 1999 Changes in Legal Implementation of the Hague Convention by the Amendment to the Austrian Monument Protection Act (Federal Law Gazette I no.170/1999), unpublished paper, Vienna

Nowicki, J, and Sałaciński, K, 2004 *Cultural Heritage in the Face of Threats in War and Peace Time*, Wydawnictwo SBP, Warsaw

Pesendorfer, M, and Speckner, H, 2006 Operation 'Pallas Athena': The Protection of Cultural Property in Peace Support Operations, handbook of the *International Workshop on the Protection of Cultural Property in Peace Support Operations*, 19–23 June, Bregenz, Austrian Armed Forces, Vienna

Pesendorfer, M, and Speckner, H, 2007 Kulturgüterschutz in (friedensunterstützenden) Krisenbewältigungs-Operationen, *Forum Kulturgüterschutz* 10, 34–41

Pignatelly y Meca, F, 2001 El segundo Protocolo de la Convencion de 1954 para la proteccion de los bienes culturales en caso de conflicto armado, hecho en La Haya el 26 de marzo de 1999, *Revista Espanola de Derecho Militar* 77, 357–441

Prem, H J, 2002 *Zur Entwicklung des Kulturgüterschutzes in Österreich. Ambivalente Erfahrungen eines Kulturgüterschutzoffiziers im Österreichischen Bundesheer*, Vienna

Redl, K, and Sladek, G (eds), 1996 *Die grenzüberschreitende Verantwortung des Kulturgüterschutzes*, Bregenz – Vienna

Reichelt, G (ed), 1992 *Internationaler Kulturgüterschutz*, Vienna

Roye, I, and Blazeby, G (eds), 2001 *Implementation of International Humanitarian Law and Cultural Heritage Law*, Pretoria

Savane, Y, 2007 Pour une collaboration entre militaires et civils dans la protection des biens culturels en cas de conflit armé, *Forum Kulturgüterschutz* 10, 42–9

Schipper, F, 2009 Kulturgüterschutz darf kein Zufall sein, *Global View* 3, 28

Schuller, F, 2007 Die Rolle von NGOs im KGS am Beispiel der Österreichischen Gesellschaft für Kulturgüterschutz (ÖGKGS), *Forum Kulturgüterschutz* 10, 55–61

Schüpbach, H (ed), 2003 *Kulturgüterschutz betrifft uns alle*, Bern

Schüpbach, H, 2007 Militärische Maßnahmen und Institutionen in der Schweiz mit KGS-Bezug, *Forum Kulturgüterschutz* 10, 18–22

Sénéchaud, F (ICRC), 2007 Instruction des troupes avant des opérations internationales, *Forum Kulturgüterschutz* 10, 68–74

Sladek, G (ed), 1993 *Das kulturelle Erbe im Risiko der Modernität*, Vienna

Sladek, G (ed), 1995 *Kulturgüterschutz: Ein Aufruf zu transnationaler Aktion*, Vienna

Sladek, G (ed), 2008 *Kulturelles Erbe – Vermächtnis und Auftrag*, Klagenfurt, Vienna

Speckner, H, 2001 *Command Post Exercise (CPX) Montfort 2001*, Handbook, Austrian Armed Forces, Bregenz

Toman, J, 1996 *The Protection of Cultural Property in the Event of Armed Conflict*, UNESCO, Paris

Toman, J, 2007 La protection des biens culturels: un devoir de tous, *Forum Kulturgüterschutz* 11, 43–59

The Role of the Swiss Armed Forces in the Protection of Cultural Property

STEPHAN ZELLMEYER

INTRODUCTION

On 11 December 1961 the Swiss government, or Federal Council as it is more commonly known, issued its 'Message to the Federal Parliament concerning Swiss accession to the 1954 *Hague Convention for the Protection of Cultural Property in the Event of Armed Conflict*. An extract reads as follows:

> It would be fanciful to assume that the means exist to save with absolute certainty the entire cultural heritage of a country at war. Yet, experience has shown that it is possible to mitigate this risk. The Convention, agreed in The Hague in 1954 by many countries and inspired by the desire for greater cooperation and designed in the spirit of mutual respect, deserves our support not least because of its important moral significance. We would also be in the fortunate position of being able to invoke its provisions, were a war and its concomitant suffering to break out across our country.

In the intervening 38 years, much has changed in Switzerland with regard to the protection of cultural property. The threat from a conventional war involving combined aerial and ground attacks has largely dissipated, which is good news for both the country as a whole and its cultural property. However, new threats have emerged over the last 20 years or so. Cultural property has increasingly become the target of choice in civil and ethnic conflicts, a development which the Swiss Peace Corps has seen for itself during its mission in Kosovo. In security service circles, there is a growing concern that cultural property could be a potentially attractive target also for terrorist groups.

Nevertheless, the statement by the Federal Council is as relevant today as it was in 1961. The only difference is that the protection of cultural property, the responsibility for which is shared in Switzerland and elsewhere by the military and civilian authorities, must be adapted to these new threats and changing circumstances.

This chapter has two aims. The first is to present the Protection of Cultural Property (PCP) model adopted by the Swiss Armed Forces, and the changes it already has undergone. The second is to conjecture on the further changes that may be required in the future.

LEGAL BASES

All efforts in Switzerland to protect cultural property are based on the *Hague Convention for the Protection of Cultural Property in the Event of Armed Conflict* of

1954 and its First Protocol of 1954, as well as the Second Protocol of 1999. Switzerland ratified the Convention in 1962 and the Second Protocol in 2004. The implementation of these international provisions were subsequently included in the national legislation, resulting in the *Federal Law on the Protection of Cultural Property in the Event of Armed Conflicts* of 1966 and the *Federal Decree on the Protection of Cultural Property in the Event of Armed Conflicts* of 1984, as well as the introduction of special provisions in the Military Penal Code. In June 2005 Switzerland also passed the *Federal Law on the International Transfer of Cultural Property*. However, the latter will not be examined in detail here.

These various pieces of legislation laid the foundations for a cultural property protection system that also takes into account the country's political traditions:

1. As a general rule, the cantons (or states) are in charge of cultural property protection, the adoption of civilian protective measures and the designation of cultural property worthy of protection. This reflects the fact that the cantons are also primarily responsible for the promotion and preservation of cultural heritage, as well as for civil protection and civil defence. The cantons, therefore, are legally obliged to have a designated PCP office.

2. The cantons are not responsible for designating cultural property that should bear the Blue Shield symbol, in other words property that has full protection under international law in accordance with the 1954 Hague Convention. Instead, responsibility falls to the Federal Council to ensure that account is taken of all national defence interests. The government also runs training courses for cantonal PCP officers and subsidises the construction of PCP shelters, the creation of safeguard documentation and the microfilming of key items of movable cultural property. It also covers the cost of measures to protect cultural property in its own possession.

3. Cantonal and federal efforts to protect cultural property are chiefly a civilian matter. The cantonal PCP officer is generally a member of staff from the cantonal Office for Culture or Civil Protection. At federal level, there is a specialist PCP unit within the (civilian) Federal Office for Civil Protection. There is also the Swiss Committee for the Protection of Cultural Property which offers expert support and advice to the Federal Council and relevant government departments. Its members are drawn from the federal administration, the cantons and various professional associations.

4. Besides owners of cultural property and representatives from the relevant federal and cantonal institutions, special cultural property protection units with the Protection & Support (P&S) service (or civil defence) are involved in all PCP-related efforts. Like the Swiss army, the P&S service is compulsory for men aged between 19 and 39. Recruits who are deemed unfit for military service are assigned to the P&S service. Its role is to assist the police, the fire service and the emergency medical services so that the latter are able to sustain their long-lasting disaster and emergency relief operations. The P&S also has specially trained units that deal specifically with the protection of cultural property.

CULTURAL PROPERTY PROTECTION AND THE SWISS ARMED FORCES

Implications of PCP legislation for the Swiss army

Although the protection of cultural property in Switzerland is chiefly a civilian responsibility (civilian authorities, specialist agencies and owners), the major role played by the Swiss Armed Forces should not be overlooked. One of the most important implications of the international conventions and national legislation is the duty of all military personnel to respect cultural property. This provision is set out in more detail in Regulation 51.007/IV 'Legal provisions on the code of behaviour during military operations', which states that:

> In the event of armed conflict, cultural property of national importance shall bear the protective blue and white shield, the implications of which must be respected by all troops. The destruction or plundering of such property is strictly forbidden. Its use for military purposes should also be avoided as far as possible.
>
> Military facilities or battle zones must not be located within a 500-metre radius of such property.
>
> In cases of urgent military necessity, the sector commander must submit a request to the battalion commander for the declassification of said cultural property. The protective symbol must be removed and the property should be secured, where possible, through the introduction of additional protective measures. […]

In addition to Articles 108–111 of the Military Penal Code, which stipulate that the violation of both international conventions and the laws and usages of war, including attacks on both protected property and people, are a punishable offence, Regulation 51.007/IV legally frames the code of behaviour to be adopted by the Swiss Armed Forces and its personnel with regard to cultural property.

Additionally, Switzerland is almost the only country in the world which does not leave it to the troop commander to decide on the protective perimeter that must be observed around the protected property. The mandatory 500-metre radius was calculated by Swiss military personnel based on an evaluation of the effective radius of modern weapons.

SUBSIDIARY BACK-UP

While the Swiss Armed Forces and its personnel are legally obliged to respect cultural property at all times, they may also be deployed, in certain circumstances, to assist the civilian authorities with the implementation of 'active' PCP measures in accordance with the principle of 'subsidiarity'. This means that the Swiss army acts as a national strategic reserve force which can be deployed to assist the civilian authorities in the event of a disaster or emergency, but only if such an incident has placed civilian resources at full stretch. The army may be asked to guard at-risk cultural property or to make available its personnel, transport resources and other safety elements for the evacuation of movable cultural property. Overall responsibility during such operations still lies with the civilian authorities, with the army solely in charge of leading the deployed military units.

PCP AND THE LAW OF ARMED CONFLICT

According to the structure of the Swiss Armed Forces, legal military advisers (LEGAD) and adjutants are in charge of advising brigade, territorial region[1] and battalion commanders on all matters related to cultural property protection. The Swiss Armed Forces does not have its own designated military PCP officers, but there is a designated staff section of the Armed Forces Command, which itself is part of the Staff to the Chief of the Armed Forces. This staff section is made up of militia officers with PCP expertise.

The Swiss Armed Forces consider cultural property protection as an inextricable part of the Law of Armed Conflict (LOAC). As we shall see later, this stance has a particular bearing on LOAC training. It also affects how PCP is integrated in military training exercises and military operations in Switzerland.

By considering PCP as an integral part of the Law of Armed Conflict, the implication is that protection of and respect for cultural property is not the exclusive concern of specialist units or officers, but that it is in fact a matter for all military personnel and brigades. Given that the brigade commanders are responsible for ensuring that their units comply with the legal provisions, the protection of cultural property is an integral part of 'routine' staff activities.

This means that military personnel must receive requisite training. In addition, selective information from the Swiss Inventory of Cultural Property of National Importance is featured on the Swiss Armed Forces' Command and Control Systems, thereby enabling those military units and staffs with access to the C2 systems of either the Swiss Land Forces or Swiss Air Force to plan training exercises that take account of the cultural property located in the exercise zone, and to deal with PCP issues during the course of the actual exercise. The specialist PCP section within the Federal Office for Civil Protection and military personnel have already discussed this point, and concluded that the PCP inventory should be incorporated in the military information systems as soon as it is available in GIS format (planned for summer 2010).

MILITARY PCP TRAINING

Basic PCP training

Given that the Swiss Armed Forces consider the protection of cultural property as an integral part of the Law of Armed Conflict and that compliance with the legal provisions is a responsibility of every soldier, and of every commissioned and non-commissioned officer, all Swiss military personnel receive PCP training that is specially adapted to the rank they hold.

Military personnel are expected to have knowledge of basic legal texts and receive straightforward and easy-to-follow instructions based on PCP legislation. Hence Switzerland's belief that other countries need to ratify the Hague Convention and to introduce their own legal provisions to ensure the civilian and military protection of

1 Switzerland is divided into four territorial regions. Each of these acts as a link between the army and the civilian authorities, and is in charge of commanding the military personnel deployed to assist with civilian operations in the given territory.

their cultural property. Swiss soldiers receive training in the '10 Fundamental Rules of the Law of Armed Conflict'. Rule 7 deals specifically with cultural property protection and stipulates that military personnel must recognise the PCP symbol and remember a few simple guidelines on the right and wrong behaviour to adopt with regard to cultural property that bears this symbol:

RIGHT BEHAVIOUR	WRONG BEHAVIOUR
• Cultural property, the place where it is stored, the means used to transport it, as well as property bearing the protective symbol must be protected and spared • The protective symbol should be used only by authorised parties and only for the agreed purpose	• Attacks on persons, objects or buildings wearing or carrying the symbol • Any abuse of the symbol, eg to cover up military action • Siting military targets or combatants' quarters in buildings that carry the protective symbol

A further training resource is the educational software 'Law of Armed Conflict I' (published in 12 languages), which also uses rules similar to those set out above. (For further information see www.loac.ch, the website of the LOAC section within the Staff of the Chief of the Swiss Armed Forces.)

Company commanders receive instruction on the aforementioned regulation 'Legal provisions on the code of behaviour during military operations', which they can also use as guidelines when leading their unit. At the same time, the educational software 'Law of Armed Conflict II' (see www.loac.ch), which also includes examples of cultural property protection, is used to train prospective unit commanders. At battalion and brigade level, command post exercises and exercises in command simulators also take PCP issues into consideration.

Basic PCP training for all ranks is dispensed solely by military instructors and is included in standard military training.

Supplementary technical training

Various officers, such as battalion and brigade adjutants, as well as military legal advisers, also receive supplementary training. The technical training required to exercise these functions also includes a half-day (battalion adjutants) or full-day (brigade adjutants and LEGAD) PCP training module. The instructors are civilian members of the specialist PCP section within the Federal Office for Civil Protection. Together with those in charge of military training, these civilians are responsible for designing the training module.

The advanced PCP training module focuses on the following:

• In-depth instruction on the history of cultural property protection, on civilian efforts in this regard and on the implications for the military.

- Key resources such as the Inventory of Cultural Property and data mapping/GIS tools.

- The importance of cultural property and the special measures needed to protect it; a guided tour of a monument or collection is organised for this purpose. The tour is led by a civilian expert with specialist knowledge of the given item of cultural property.

- Time permitting, a practical training exercise is held. For battalion adjutants this chiefly involves examining case studies and then planning the training that their troops will require. For brigade adjutants, the exercise entails drawing up plans, together with the civilian authorities, for the evacuation of part of the state archives in one of the Swiss cantons. The action plan, including the coordination briefing with civilian partners and on-site reconnaissance, which are performed in accordance with the military staff processes, is implemented in exactly the same way as it would be in a real-life situation. The LEGAD training module also includes an exercise based on a major incident scenario and carried out in the field. Their job is to advise the acting commander on the declassification of protected cultural property in a state of defence.

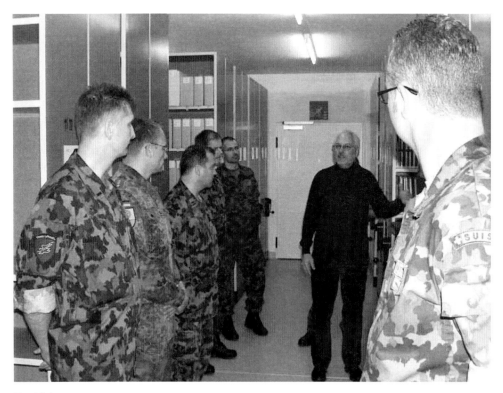

Fig 15.1
FUTURE BRIGADE ADJUTANTS OF THE SWISS AND GERMAN ARMED FORCES AT THE STATE ARCHIVES OF THE CANTON OF LUCERNE.

The civilian instructors consider these supplementary PCP training modules to be extremely useful. Judging by the reactions of participants these courses do, in fact, raise awareness of the issue as well as vividly conveying the importance of cultural property protection in modern-day conflicts. By the same token, they offer a valuable opportunity to ensure that PCP-related issues are incorporated in normal staff activities, as well as to test and refine civilian–military cooperation. The officers who receive this supplementary training go on to serve in battalions, brigades and across all territorial regions, thereby guaranteeing the dissemination of the PCP expertise they have acquired through every level of the Swiss Armed Forces.

Mission-specific training

A third area of military PCP training concerns mission-specific training, particularly for foreign missions. SWISSINT, the international command of the Swiss Armed Forces, is responsible for training all military personnel deployed in peace-keeping missions abroad. Its training courses focus on the history and culture of the country where the troops are to be deployed, and on the mission-specific rules of engagement. Particular attention is also given to the issue of the trafficking of cultural property.

Inclusion of PCP concerns in large-scale exercises

In order to consolidate and enhance existing PCP know-how, the Swiss Armed Forces endeavours to include cultural property protection concerns in its large-scale exercises, such as the 'Partnership for Peace' VIKING 05 and VIKING 08 training exercises. Organised in the main by the Swedish Armed Forces, these computer-assisted and decentralised command post exercises aimed to test civilian–military cooperation, though the Swiss brigade staff also had to contend with incidents involving cultural property.

PCP AND SWISS ARMY MISSIONS ABROAD

Internationally, the most hotly debated topic in relation to PCP is the protection of cultural property during foreign missions, a subject which was raised briefly above. Two points must be made.

First, the Swiss Armed Forces are equipped primarily to defend the country and to assist the civilian authorities with operations at home. Although peace-keeping is one of its strategic duties, the Swiss army is currently deployed in only one foreign mission, KFOR in Kosovo, where it has a troop contingent of approximately 220. Individual members of the Swiss Armed Forces are also deployed as military observers, as mine-clearers or in an unarmed capacity in missions throughout the world. National legislation stipulates that Switzerland can only participate in peace-keeping, not peace-enforcing, missions. Given their relatively small presence abroad, the Swiss army has rarely had to deal with the problem of actively protecting cultural property.

Second, it is clear that if Switzerland were to step up its involvement in foreign missions, changes with regard to cultural property protection training would have to

be made. For example, the place where the Peace Corps is deployed may not have the necessary civilian authorities who can determine the property at risk and in need of protection and assist the troops in drawing up plans for the introduction of protective measures. In such instances the basic rule which Swiss military officers are taught in relation to PCP, namely to obtain detailed information from the civilian authorities first on the importance and the risk faced by items of cultural property, would cease to apply. The question therefore arises as to whether the Swiss Armed Forces should develop their own military-specific PCP expertise.

Given that the Swiss army is chiefly a militia army, it would be conceivable to create a staff comprising cultural experts who are still subject to compulsory military service, ie archivists, museum specialists, librarians, specialists from the cantonal preservation of historic monuments offices, architects and archaeologists. It would then be the job of this staff to draw up an inventory of important and at-risk property located in the mission zone to help prepare troops for their deployment. The staff would also plan and coordinate the necessary protective measures during the mission itself.

The design of the Swiss army would also make it possible to create this type of military unit made up of civilian cultural experts, regardless of whether Switzerland steps up its involvement in foreign missions or not. This unit could then be mobilised should a foreign mission mandated by either the UN or the 'Organisation for Security and Cooperation in Europe' require it. In this way, Switzerland would be able to make a valuable contribution to peace-keeping missions, but without committing major personnel and financial resources. By the same token, this unit could take advantage of two particular strengths of the Swiss Armed Forces, namely the excellent civilian know-how of its militia and the relative impartiality that most countries grant Switzerland.

CONCLUSION

Switzerland undoubtedly has a highly developed system in place to provide every soldier, as well as every commissioned and non-commissioned officer in the Swiss Armed Forces, with special PCP training. Consequently, all army personnel consider cultural property protection as part and parcel of their military duty, and not as the exclusive domain of a special military unit or taskforce.

The fact that the Swiss Armed Forces consider cultural property protection as an integral part of the Law on Armed Conflict means that the obligations of all army personnel in this regard are legally framed. The scope for interpretation is therefore minimised, and guidelines on the code of behaviour to be adopted by each rank can be developed and trained.

Although cultural property protection in Switzerland is primarily a civilian matter, there are opportunities to expand the contribution which the Swiss Armed Forces can make to PCP during their missions abroad. By creating a militia staff made up of civilian PCP experts, Switzerland would be in a position to provide not only special PCP-related support to Swiss troops before and during their foreign missions, but also to share this important and much sought-after expertise for international peace-keeping missions, regardless of Swiss military involvement.

Preserving Global Heritage from Space in Times of War

SARAH PARCAK

Conflict and the rise of ancient states have always gone hand in hand, along with the subjugation of peoples and their cultures. Countless examples of this activity exist in the historical and archaeological records. Each past victor has dealt with the suppression of peoples in differing manners: some have slaughtered entire towns, some have captured large numbers of individuals for use as slaves, while others allowed groups and cultures to survive, putting a governor or puppet ruler in place. In each case, the manner in which 'culture' survived was more a result of circumstance than anything else. For example, with the great Diaspora of Jewish peoples following the Babylonian destruction of Jerusalem, the Torah became standardised, making polytheistic practices far less common and thus solidifying Jewish culture. In other cases, widescale destruction of cultural memory took place as a result of slavery, imprisonment or total annihilation of past peoples. Children surviving such incidents would be absorbed into other groups. In ancient Egypt, for instance, children of controlled groups in Syro-Palestine would be raised at the state court in Luxor, learning ancient Egyptian hieroglyphs, religion and cultural practices (Bresciani 1990). Archaeologists have uncovered such past cultures only via carefully controlled archaeological survey and excavation.

Modern groups have faced and continue to face similar challenges. While photographs, video, digital audio and the internet (including such social media as Facebook and Twitter) record modern moments in time instantaneously for the world to see, collective memory is much more difficult to capture and transmit. This is especially difficult as village or town elders (more often than not local or regional cultural repositories) do not have access to such media to record their memories owing to low incomes or a lack of education and social norms that encourage its usage. In times of war these elders are under great threat, as they may lack general mobility or might be too frail to survive in a refugee camp. Musicians, artists and scientists might be specifically targeted by invading groups, as such creative people represent the essence of a targeted group's identity, but in many cases these people can be the first to escape a country in a time of war, as they may have better access to international connections to aid their escape. Although they might want to return to their homes it could be years, decades or even generations before it is possible for them or their families to return.

In times of war much is clearly at stake, the heart of which is human culture. Without our culture, there is simply little left worth living for. Our language, music, art and dance vary significantly across time and space, yet all speak to the very sameness of the human condition. No one wishes for brave young male and female

soldiers to be harmed or killed (on either side) during times of war, and yet it is unavoidable. No one wishes for innocent bystanders to be affected, or for people to be forced to leave their homes, but these are the consequences of any local-international conflict, and such conflicts will remain a part of our world for the foreseeable future. Understanding the full ramifications of conflict across the spectrum of potential human suffering is, ironically, the key to preventing future suffering. At the end of a war or conflict, if a group's culture is still intact, then that group can rebuild. If war destroys a group's past and related cultural memory, even in part, then the loss is often felt across the globe.

This chapter discusses how archaeologists can use varying forms of technology (especially satellite remote sensing) and related media to communicate the importance of preserving such past cultural memory and archaeological sites in times of conflict. It argues that the key to preserving the past is carefully built partnerships between individuals and groups such as the US Department of Defense (DoD). There is no one right way to protect the past in times of war, as everything will be determined by local geography, access to resources and the needs of the partnering organisations. This is not a blueprint for such partnerships – indeed, this type of work is organic in nature, and will stretch to fit changing mission goals for diverse missions. Rather, it is a reflection of how an individual's (or a group of individuals') areas of expertise can be merged with the military's changing goals, and how beneficial such work can be to everyone involved. Ultimately, at any given point anywhere in the world, multiple entities will be in conflict, whether it is a set of skirmishes, a battle or an extended war. It is up to the experts as to whether they wish to make a lasting contribution in protecting global heritage. The time is clearly right to expand on opportunities with globally minded officials who understand all too well what is at stake, and what can be done using state-of-the-art spatial technology.

LOST VERSUS LOSS IN TIMES OF WAR

Loss of culture needs to be made distinct from a 'lost' culture during times of conflict. 'To the victor go the spoils' is not a phrase appropriate for a 21st-century world; yet to whom the 'spoils' of war have gone has changed. In the past, victorious groups would have sacked a city, stealing valuables from temples or churches and from wealthy citizens. Today, war and conflict create chaos, allowing for looting of an entirely different sort. Libraries and cultural repositories can be burned or museums ransacked (as in the case of the Iraq National Museum, see Bogdanos 2005). Closely related is what can take place under the rule of a despot: they can order museums to be closed or archaeological site guards to be fired, thus giving thieves an opportunity to steal or loot. Now, it is seemingly more unlikely that an entire culture will be 'lost', but even the most advanced technology is having difficulty saving hundreds of languages across the globe that will cease to be spoken over the next few decades, along with the associated cultural memories of those groups (Abley 2005). As young men and women leave villages for city jobs, their children may or may not be taught local dialects. Who will make the trek to the Smithsonian Institute to hear these recorded lost languages aside from a handful of anthropologists? Action to save culture must be both preventative and sustaining, and

in the case of culture under threat during times of war significant forethought is required to predict cultural ramifications.

Standing by and doing nothing in such situations is no longer an option, as is well-recognised by US government officials. The world knew well in advance that the Taliban were planning to destroy the Bamiyan Buddhas; petitions were signed across the globe in an attempt to stop them. And archaeologists predicted that many of Iraq's archaeological sites would be looted without protective measures in place during the time of conflict. Unfortunately, war only highlights the illegal actions taking place within a particular country or region. Archaeological looting is a major problem across the globe, and only appears to be getting worse over time with globalisation, rising poverty levels and the increasing involvement of international crime cartels. With enough advance planning and use of technology it is possible to safeguard a country's antiquities (and thus related cultural heritage) in wartime, and potentially offer a protection plan that can continue to function in times of peace.

What, then, is truly at stake? If archaeologists and cultural resource managers do not even know an archaeological site exists, is it even worth protecting? Iraq, the home of some of the world's first great cities, is a case in point. McAdams' monumental survey efforts in Iraq in the 1960s reshaped the way that archaeologists thought about past landscapes and settlement pattern changes, and ultimately launched the field of landscape archaeology in Ancient Near Eastern studies (McAdams 1981). His work influences many scholars outside Ancient Near Eastern studies today. McAdams recorded hundreds of archaeological sites and features not previously known and put well-known archaeological sites in more regional contexts. His work cannot, at present, be repeated in Iraq, but the stabilisation of the country may allow for survey work to resume in the next few decades. There are clearly many hundreds, if not thousands, of additional archaeological sites and features to be discovered in Iraq, with broad-scale survey, alongside excavation work, being the main way that such sites and features will be discovered. Such discoveries will undoubtedly reshape scholarly thinking about the history of Mesopotamia and the start of civilisation. If looting destroys these sites, then that potential discovery and reshaping cannot take place.

Looting of archaeological sites goes beyond the destruction of history, and actually contributes to the destruction of local economies. Archaeologists often spend 5–10 years or longer excavating sites, and once they retire or move to another site students often take over excavation work. Local workers tend to be well-paid for excavation work, and take great pride in knowing that ancient archaeological remains can contribute to their family's well-being in a substantial and long-term way. In Egypt, an archaeologist spent so long working at one site that the villagers were able to get electricity, televisions and radios in many homes, and were able to send their children to better schools. At the site of Tell Tebilla, in the eastern Egyptian Delta, the Survey and Excavation Projects in Egypt (SEPE) has undertaken archaeological excavation work (for which this author is a co-director, see www.deltasinai.com) for nearly 10 years. When we started work at Tell Tebilla in 2000, a young and very shy girl worked as my basket girl, aiding in the transportation of loose earth from our excavation square. Over time, the shy and retiring young girl from a tiny village has become a

confident young woman, heading to Cairo University to study Egyptology. I know that our archaeological project had a major part to play in her decision, and that she will be a successful member of Egypt's Supreme Council for Antiquities (SCA). The empowering of future decision makers is an important goal of the work aimed at halting archaeological site looting, but is only one of many ways in which looting may be combated everywhere, and may not be a practical solution during times of war.

While the looting of previously unknown archaeological sites poses potential problems, the looting of known sites is presenting real problems in Iraq and elsewhere. In her seminal article on the looting of archaeological sites in Iraq, Elizabeth Stone noted that looting had affected an area of 15.75 km^2 of archaeological sites across southern Iraq – a massive total area. She compared the looting using different datasets of Quickbird high resolution satellite imagery, being especially careful to note potential past looting activities versus ones that took place during the Iraq war (Stone 2008). With the collapse of Saddam Hussein's regime, economic, social and political problems flourished, and insurgents gained in power. In order to finance their work, the insurgents seem to have turned to archaeological site looting: a lack of site guards and general site protection made this an attractive option. Local Iraqis, many without work or consistent pay, have similarly turned to illegal excavation to help feed their families. This should not earn a moral judgment from Western scholars: who would not do the same thing to feed their families in a time of crisis? While the Italian Carabinieri and others are aiding the Iraqi government in the protection of archaeological sites (Garen 2004), their resources are limited, and they cannot guard every known site in Iraq.

Thousands of archaeological sites and many other unknown sites and features add up to a seemingly insurmountable problem in Iraq. Military officials and members of the public might argue that protecting archaeological sites is not why the US first went to Iraq in 2003, and is not the main purpose of the mission today. Part of creating and maintaining a democracy, however, is creating the infrastructure to respect and safeguard cultural heritage. If an Iraqi knew that protecting an archaeological site close to their home would mean lifelong employment as an archaeological site guard or seasoned excavation assistant they might think twice about looting, yet more pressing daily problems prevent them from thinking in the long term. The related issue of an ongoing insurgency funded by looting makes it crucial to adopt new strategies for archaeological site detection in the Middle East and other regions of the world.

New DoD installations in culturally sensitive areas require additional strategies for cultural monitoring, including such areas as the new DoD regional headquarters, called AFRICOM (United States African Command, see www.africom.mil/), similar issues abound regarding the protection of archaeological sites in places where soldiers will be stationed. The work of NASA archaeologist Tom Sever in Central America, Brazil and south-east Asia (Sever 1995; Saturno et al 2007; pers comm) has shown that there are tens of thousands of previously unknown archaeological sites in rainforest regions, while satellite work by the present author has shown that archaeological remains in Egypt are denser than previously assumed (Parcak 2009). If this is true for Egypt, rainforest areas and large parts of the Middle East (shown by ongoing survey work in Syria, Turkey, and Jordan), then it is likely that similarly

concentrated areas of previously unknown archaeological remains exist across the world. Archaeologists need to reconceptualise the past density of human occupation in many cultures and regions. Urbanisation, deforestation and looting affect these remains far more than we presently appreciate, and satellite remote sensing appears to be the only way to locate them and so prevent further damage (Parcak 2009).

THE ETHICS OF PARTNERING WITH THE MILITARY

Over the past few years many debates have ensued in both academic and popular presses over the issue of embedding anthropologists within the military (Shweder 2007); or additional discussion has occurred over the issue of academics partnering with the military in any form. As far as the anthropological issue is concerned, in times of conflict, a misunderstanding of cultural norms and cultural propriety can actually be a greater threat to soldiers than the actual war. One might argue that the DoD might have avoided many issues and problems if a greater understanding of Iraqi culture had existed in 2003. At the time, officials placed a greater priority on a highly focused mission. However, priorities change, and military officials now realise the importance of respecting culture and the overall good this can do for the mission. There are countless instances of soldiers in Iraq and Afghanistan who have raised money or used their personal funds to build schools, playgrounds, recreation centres and education facilities for affected cities and villages. The goodwill surrounding such efforts is in fact an unsung hero in the overall success of the missions in these places. Anthropologists and archaeologists thus all have to make their own choices on a deeply personal level. Aiding the military can help protect the lives of young men and women in the US, as well as people abroad, in addition to cultural heritage. The keys to this success are planning and good communication.

Additional issues to consider involve the actual training of military members and a respect for the differences between academic and military cultures. Academia has long been portrayed as being out of touch with global realities, but that is changing as a result of the increasing need to connect with broader agencies for funding and collaboration. The major conference 'Sustaining Military Readiness', held each year in the USA and including participation by hundreds of scholars, highlights just how important scientific research is in keeping the military mission ready. The Legacy funding programme also provides major support for cultural and natural research projects that aid DoD priorities. Scientists can provide outside-the-box thinking to aid the military in saving money and preserving resources, while the military can extend opportunities for experimental science not always available with traditional funding programmes, yet with the same opportunities for publication.

So are there any ethical issues over aiding military officials in the identification of archaeological sites using spatial technologies? The DoD already has significant expertise in the processing of satellite imagery. This imagery, including data collected from unmanned flight missions, has a far greater resolution than even the highest resolution commercial satellites. The military trains its imagery acquisition and processing teams for highly focused missions, whether it is to provide base control for ground missions, analyse terrain prior to operations or detect specific features that

require further investigation (eg foreign air bases that may be preparing a missile launch). Archaeologists cannot and should not provide any information that may cause harm to other humans, which is the main ethical issue I have heard expressed by other experts; yet this is not really the issue. I have not received appropriate training in specific military satellite imagery processing protocol, and thus any remotely sensed archaeological information that I might provide to the DoD that is subsequently used for any purposes outside my area of expertise could possibly (ironically) cause harm.

Military planners are not experts in the detection of cultural remains, understandably, given the full range of requirements to conduct successful missions. Training for military operations has a tight timetable, and any reconnaissance work for archaeological sites should be conducted beforehand to aid in planning. Is it unethical to help the DoD locate archaeological sites so that bases are not built on top of them? This enables them to conduct training missions outside areas with important archaeological remains. It becomes unethical when the data is used and abused for the purposes of personal material gain. With the 1954 Hague Convention, which stipulates that archaeological and cultural remains should be protected in times of war, recently passed by the US Government (UNESCO 1954) many doors are now open for collaboration and data sharing that will only help to end the insurgency faster, via archaeological site protection that will help to stop site looting.

HOW TO BUILD A PARTNERSHIP

Partnerships with major government entities evolve slowly, and require significant time to build trust and a working relationship. My own involvement with the DoD is a case in point. In June 2007 I received an unexpected email from Dr Laurie Rush, a cultural resource manager at Fort Drum, New York. She was planning a trip to Egypt with representatives from the DoD, and was seeking additional information about the archaeology of the area as well as about travel. She had found my name online and contacted me. My initial reaction was typical for most archaeologists: I was suspicious, and wondered why, out of the dozens of well-known archaeologists across the US, Dr Rush had chosen me. At the time I was in my first year of a tenure-track position at my university, with a background in the use of satellite imagery to locate archaeological sites in Egypt. While I was completing my PhD numerous individuals had warned me that at some point, given my subject area, the 'men in dark sunglasses' would show up – mysterious unnamed individuals from the US government who would demand my services for covert activities. Getting an email from a US military representative was tantamount, to me, to the 'men in dark sunglasses', especially following the significant negative press the US activities in Iraq had received.

How naive I was. At the time, I knew only a small amount about the playing cards Dr Rush had developed for US soldiers in Iraq. Having recently read Matthew Bogdanos' *The Thieves of Baghdad*, however, I knew the issues surrounding the looting of the Iraq National Museum were not black and white, but many shades of grey. I was nevertheless fighting against my bias; I had not supported the war in Iraq, and felt the problems with widescale looting across Iraq could be blamed on a lack of

understanding on the part of the US government. I felt very keenly for the young men and women serving honourably in Iraq and Afghanistan (some of whom were my students), and wanted them home safely. When Dr Rush had requested my help in planning a trip to Egypt as part of the Bright Star exercises, I had to fight my initial reaction and see the bigger picture. Here was a PhD archaeologist with many years of experience who had rededicated her career to finding out how to help with the ongoing looting problem in Iraq. She was open to thinking creatively about the problem, and recognised the importance in reaching out to a larger group of scholars.

I had to respect that willingness to reach out, and I recognised that it would be possible for me to make a difference even though I was not an expert in the archaeology of Iraq or Afghanistan. With my work in Egypt, I saw just how threatened archaeological sites were across the country. For example, over the course of one year I saw a large area of a previously unknown (and largely buried) Coptic monastery site removed. Many temple sites in places like Luxor are threatened by rising groundwater and pollution levels, which cause temple carvings to flake off (Brand 2001). The Karnak Temple groundwater lowering project, which is nearing completion, should have a positive effect on preserving the temple, but it is only one temple of many across Egypt. Increasing population numbers and urbanisation will have long-term effects on archaeological sites that are difficult to predict. If population numbers remain consistent in the Delta it is likely that most archaeological sites will be lost within 50 years (Parcak 2007). I had identified many techniques to locate archaeological sites from space in Egypt, with success rates ranging from 93 per cent to 98 per cent (confirmed with ground truthing, see Parcak 2008), and realised that these techniques could be applied in similar floodplain and desert environments across the Middle East – especially in Iraq and Afghanistan, where the need to identify and protect archaeological sites has only increased in recent years.

Saving and protecting archaeological sites requires multiple approaches, and we needed to see if the potential DoD partnership would be a good fit. After the success of the playing cards in Iraq, the DoD team led by Dr Rush had requested similar playing cards for soldiers travelling to Egypt for the Bright Star exercises. Together with colleagues who had access to thousands of images (many digital) taken from years of working in Egypt and a deep understanding of modern Egyptian culture, we therefore worked with Dr Rush in designing cards that would both be fun to use and contain pertinent archaeological information. We had to strike a balance between showing well-known archaeological treasures such as the King Tutankhamen mask with lesser-known artefacts like broken pottery on top of ancient settlement sites. Soldiers had to learn that the archaeology of Egypt could not be defined simply by the gold or jewellery on display in the Cairo Museum. Putting an emphasis on Islamic culture, via photographs of mosques, monuments and the famous Khan el-Khalili market, was also important. Though DoD officials have only recently printed the final version of the cards, initial reactions appear to be positive.

Additional Bright Star activities allowed the testing of archaeological and cultural resource data sharing. Although the exact location of the Bright Star exercises was classified, the general location in the Western Desert could be shared. This enabled the project archaeologists to see if any archaeological remains might be threatened by

military activities. Initial analysis using satellite imagery and detailed archaeological maps showed the area of interest to be devoid of known archaeological remains. Given the many routes, forts and related remains located close by, it was decided to produce a detailed PowerPoint presentation and an accompanying booklet describing the full range of archaeological remains that military activities might encounter. This included forts, roads, rock inscriptions, hut circles, pottery caches and pottery scatters. Officers reviewing the texts and PowerPoint presentation noted that it was easy to follow and well illustrated, and said that it would aid the military in preventing destruction of ancient remains. Future guides to prevention of site destruction will be placed on DoD websites for easy access in the field.

A further key issue in many countries is the market in archaeological artefacts, which is frequently a criminal one. Most tourists do not think twice about taking home a piece of the pyramids (albeit a very small piece), or a tiny object found while wandering across sites in Italy, Turkey or Greece. It is telling that guards at the Acropolis in Athens spread out marble chips around the site early each morning; by the end of the day many of the chips are gone, having been taken by tourists. Other tourists are not aware of archaeological site etiquette, touching paintings in tombs in the Valley of the Kings, Egypt, leaving behind sweat and oils that cause the paintings to degrade over time. Still others leave their names carved on monuments, following the poor example of many early travellers to the Mediterranean. In Egypt, many tourists are offered the opportunity to purchase ancient pieces of pottery, jewellery or coins, the majority of which are actually faked in workshops in Luxor or elsewhere. In a few cases, the objects are real. The issue is not just being able to tell the difference (and even experts can be fooled), but how to know what is safe to buy and where. This information is rarely, if ever, included in typical tourist guides, making all travellers vulnerable.

Military personnel travelling to a country like Egypt are subject to the same laws as other Americans, but the consequences are greater. A 'typical' tourist might be able to claim that they did not know any better, but DoD personnel know they will face prison for knowingly (or unknowingly) importing illegal antiquities. Guides might inform general tourist groups, while DoD personnel might be travelling in smaller groups without guides. Servicemen and women are also expected to set an example, which includes their behaviour around archaeological sites. Even the most conscientious officer might unknowingly do something inappropriate.

The main issue is being able to provide supporting documentation that is easy to follow, in a standardised format and helpful for all service personnel who, if they are lucky enough to have a free day, want to purchase safe items for loved ones at home or visit an ancient site. Such documentation was achieved in the form of a 'safe shopping' brochure, which also had information about archaeological site-visiting etiquette. The author liaised with Dr Rush about the general issues involved for the DoD personnel involved with the Bright Star operations. Based on my own extensive experience working in Egypt and leading tours for organisations such as the Smithsonian, I produced a well-illustrated guide to shopping 'dos and don'ts', as well as general advice on how to avoid the illegal purchase of antiquities. The double-sided brochure included key phrases for shopping and bargaining, and suggestions for the best places to buy high-quality local goods in Cairo and Luxor. The guide was well

received by DoD personnel, and additional guides were recommended in future for Iraq, Afghanistan and other regions.

One of the eventual goals of the DoD partnership was to produce a well-illustrated guide for military planners on how to use satellite imagery and related techniques to detect and protect areas of cultural interest. This grew out of my deeper understanding of the goals of the DoD, especially relating to the recently ratified 1954 Hague Convention and the future plans for DoD cultural protection activities. I realised that my scholarly focus on satellite archaeology in Egypt and my teaching experience could be applied to teaching DoD satellite specialists how to detect remains. This guide, in progress at the time of writing, is structured for non-archaeology specialists with an expertise in remote sensing. It describes the range of techniques and image types that archaeologists have already used to great effect in areas of the world with similar landscape types to Iraq and Afghanistan (eg desert, floodplain, mountainous, urban), and provides a plan of action for any mission planning based on the landscape types to be encountered. It then walks the users through a wide range of archaeological site types that might be encountered in each country (eg tells, cemeteries, roads, forts, structures) and shows how each feature is apparent on satellite imagery. The guide then describes the varying techniques that remote sensing specialists can use to detect archaeological sites.

Once DoD planners know how to detect different types of ancient remains they can plan their missions in order to least affect sites. For example, if planners know how to detect a major multi-period settlement site, and they had multiple potential locations, including the settlement site, for a ground base, they could eliminate that site as a location for the base in order to protect it. Finding sites in this way would allow planners to enter them into a database to be maintained by partner archaeologists at universities in the US and Europe, and the partners could aid the planners in tracking site looting, especially in areas known to have close connections to insurgents illegally selling the objects in exchange for guns or other supplies. DoD planners could work with other DoD personnel in assessing other employment options for local peoples who have been displaced and lost their jobs due to war activity. This is not as simple as it sounds, and requires much more forethought before actualising these approaches, but it is recognised that looting is only the end result of a series of complex issues related to war.

Ultimately, while looters do not need any additional technical assistance to locate archaeological sites in their home countries, DoD officials need every tool to prevent such looting. Archaeological site destruction can easily be viewed on the ground, but longer-term changes to the sites can be difficult to view without regular visits, which may be impossible during times of war. The satellite imagery allows archaeologists and specialists to pinpoint exact areas being looted. Is it possible to protect everything archaeological in a given country, or to target the most archaeologically important places? This raises many debates outside the scope of this chapter (ie what constitutes the 'most important' sites). What we can say is that satellite remote sensing has not yet been utilised by military planners in the detection and protection of ancient sites in times of conflict, and that it has the potential to impact future missions in a positive way.

The future of our global heritage is at stake everywhere: it is threatened not just by conflicts but also by globalisation, urbanisation and climate change. It is difficult to

predict exactly how much our heritage will be affected over the next 25 years, but what is evident is that forming new archaeological partnerships between organisations like the DoD and academic institutions allows for more creative approaches. These approaches may end up benefiting the field of archaeology in general as new satellite technology emerges (probably from DoD developments). Military satellite specialists, once trained in the detection of archaeological sites, may have new ideas and new techniques to offer to archaeology. With many hundreds of previously unknown sites and known sites potentially safeguarded against looters, insurgents may lose one of their main sources of procuring funding, thus protecting the lives of soldiers. Time will tell how effective this new approach will be, but if technical archaeology can potentially be used as a tool to save the lives of soldiers, then it is worth trying.

BIBLIOGRAPHY AND REFERENCES

Abley, M, 2005 *Spoken Here: Travels Among Threatened Languages*, Houghton Mifflin, New York

Bogdanos, M, 2005 The Casualties of War: The Truth about the Iraq Museum, *American Journal of Archaeology* 109, 477–526

Bogdanos, M, with Patrick, W, 2005 *Thieves of Baghdad*, Bloomsbury, New York

Brand, P, 2001 Rescue Epigraphy in the Hypostyle Hall, A Postscript to 'A forest of columns: the Karnak Great Hypostyle Hall Project' by William J Murnane, *KMT: A Modern Journal of Ancient Egypt* 12 (3), 59

Bresciani, E, 1990 Foreigners, in *The Egyptians* (ed S Donadoni), University of Chicago Press, Chicago, MI, 221–54

Garen, M, 2004 War Within the War, *Archaeology* 57 (4), 28–31

McAdams, R, 1981 *Heartland of Cities: Surveys of Ancient Settlement and Land Use on the Central Floodplain of the Euphrates*, University of Chicago Press, Chicago, MI

Parcak, S, 2007 Going, Going, Gone: Towards a Satellite Remote Sensing Methodology for Monitoring Archaeological Tell Sites Under Threat in the Middle East, *Journal of Field Archaeology* 42, 61–83

Parcak, S, 2008 Survey in Egyptology, in *Egyptology Today* (ed R Wilkinson), Cambridge University Press, Cambridge, 41–65

Parcak, S, 2009 *Satellite Remote Sensing For Archaeology*, Routledge, London

Saturno, W, Sever, T, Irwin, D, Howell, B, and Garrison, T, 2007 Putting us on the Map: Remote Sensing Investigation of the Ancient Maya Landscape, in *Remote Sensing in Archaeology* (eds J Wiseman and F El-Baz), Interdisciplinary Contributions to Archaeology book series, Springer, New York

Sever, T, 1995 Remote Sensing, *American Journal of Archaeology* 99, 83–4

Shweder, R, 2007 A True Culture War, *The New York Times*, 27 October, available from http://www.nytimes.com/2007/10/27/opinion/27shweder.html?_r=1&scp=1&sq=A%20true%20culture%20war%20%20%20Shweder&st=cse [accessed 1 October 2009]

Stone, E, 2008 Patterns of Looting in Southern Iraq, *Antiquity* 82 (315), 125–38

UNESCO, 1954 *Hague Convention for the Protection of Cultural Property in the Event of Armed Conflict*, available from http://unesdoc.unesco.org/images/0008/000824/082464mb.pdf [accessed 1 October 2009]

Appendix 1

1954 Hague Convention and its two Protocols

CONVENTION FOR THE PROTECTION OF CULTURAL PROPERTY IN THE EVENT
OF ARMED CONFLICT WITH REGULATIONS FOR THE EXECUTION
OF THE CONVENTION 1954

The High Contracting Parties,

Recognizing that cultural property has suffered grave damage during recent armed conflicts and that, by reason of the developments in the technique of warfare, it is in increasing danger of destruction;

Being convinced that damage to cultural property belonging to any people whatsoever means damage to the cultural heritage of all mankind, since each people makes its contribution to the culture of the world;

Considering that the preservation of the cultural heritage is of great importance for all peoples of the world and that it is important that this heritage should receive international protection;

Guided by the principles concerning the protection of cultural property during armed conflict, as established in the Conventions of The Hague of 1899 and of 1907 and in the Washington Pact of 15 April, 1935;

Being of the opinion that such protection cannot be effective unless both national and international measures have been taken to organize it in time of peace;

Being determined to take all possible steps to protect cultural property;

Have agreed upon the following provisions:

CHAPTER I. GENERAL PROVISIONS REGARDING PROTECTION

Article 1. Definition of cultural property

For the purposes of the present Convention, the term 'cultural property' shall cover, irrespective of origin or ownership:

(a) movable or immovable property of great importance to the cultural heritage of every people, such as monuments of architecture, art or history, whether religious or secular; archaeological sites; groups of buildings which, as a whole, are of historical or artistic interest; works of art; manuscripts, books and other objects of artistic, historical or archaeological interest; as well as scientific collections and important collections of books or archives or of reproductions of the property defined above;

(b) buildings whose main and effective purpose is to preserve or exhibit the movable cultural property defined in sub-paragraph (a)

such as museums, large libraries and depositories of archives, and refuges intended to shelter, in the event of armed conflict, the movable cultural property defined in sub-paragraph (a);

(c) centers containing a large amount of cultural property as defined in sub-paragraphs (a) and (b), to be known as 'centers containing monuments'.

Article 2. Protection of cultural property

For the purposes of the present Convention, the protection of cultural property shall comprise the safeguarding of and respect for such property.

Article 3. Safeguarding of cultural property

The High Contracting Parties undertake to prepare in time of peace for the safeguarding of

cultural property situated within their own territory against the foreseeable effects of an armed conflict, by taking such measures as they consider appropriate.

Article 4. Respect for cultural property

1. The High Contracting Parties undertake to respect cultural property situated within their own territory as well as within the territory of other High Contracting Parties by refraining from any use of the property and its immediate surroundings or of the appliances in use for its protection for purposes which are likely to expose it to destruction or damage in the event of armed conflict; and by refraining from any act of hostility, directed against such property.

2. The obligations mentioned in paragraph 1 of the present Article may be waived only in cases where military necessity imperatively requires such a waiver.

3. The High Contracting Parties further undertake to prohibit, prevent and, if necessary, put a stop to any form of theft, pillage or misappropriation of, and any acts of vandalism directed against, cultural property. They shall refrain from requisitioning movable cultural property situated in the territory of another High Contracting Party.

4. They shall refrain from any act directed by way of reprisals against cultural property.

5. No High Contracting Party may evade the obligations incumbent upon it under the present Article, in respect of another High Contracting Party, by reason of the fact that the latter has not applied the measures of safeguard referred to in Article 3.

Article 5. Occupation

1. Any High Contracting Party in occupation of the whole or part of the territory of another High Contracting Party shall as far as possible support the competent national authorities of the occupied country in safeguarding and preserving its cultural property.

2. Should it prove necessary to take measures to preserve cultural property situated in occupied territory and damaged by military operations, and should the competent national authorities be unable to take such measures, the Occupying Power shall, as far as possible, and in close co-operation with such authorities, take the most necessary measures of preservation.

3. Any High Contracting Party whose government is considered their legitimate government by members of a resistance movement, shall, if possible, draw their attention to the obligation to comply with those provisions of the Convention dealing with respect for cultural property.

Article 6. Distinctive marking of cultural property

In accordance with the provisions of Article 16, cultural property may bear a distinctive emblem so as to facilitate its recognition.

Article 7. Military measures

1. The High Contracting Parties undertake to introduce in time of peace into their military regulations or instructions such provisions as may ensure observance of the present Convention, and to foster in the members of their armed forces a spirit of respect for the culture and cultural property of all peoples.

2. The High Contracting Parties undertake to plan or establish in peace-time, within their armed forces, services or specialist personnel whose purpose will be to secure respect for cultural property and to co-operate with the civilian authorities responsible for safeguarding it.

CHAPTER II. SPECIAL PROTECTION

Article 8. Granting of special protection

1. There may be placed under special protection a limited number of refuges intended to shelter movable cultural property in the event of armed conflict, of centers containing monuments and other immovable cultural property of very great importance, provided that they:

(a) are situated at an adequate distance from any large industrial center or from any important military objective constituting a vulnerable point, such as, for example, an aerodrome, broadcasting station, establishment engaged upon work of national defense, a port or railway station of relative importance or a main line of communication;

(b) are not used for military purposes.

2. A refuge for movable cultural property may also be placed under special protection, whatever its location, if it is so constructed that, in all probability, it will not be damaged by bombs.

3. A center containing monuments shall be deemed to be used for military purposes whenever it is used for the movement of military personnel or material, even in transit. The same shall apply whenever activities directly connected with military operations, the stationing of military personnel, or the production of war material are carried on within the center.

4. The guarding of cultural property mentioned in paragraph I above by armed custodians specially empowered to do so, or the presence, in the vicinity of such cultural property, of police forces normally responsible for the maintenance of public order shall not be deemed to be used for military purposes.

5. If any cultural property mentioned in paragraph 1 of the present Article is situated near an important military objective as defined in the said paragraph, it may nevertheless be placed under special protection if the High Contracting Party asking for that protection undertakes, in the event of armed conflict, to make no use of the objective and particularly, in the case of a port, railway station or aerodrome, to divert all traffic there from. In that event, such diversion shall be prepared in time of peace.

6. Special protection is granted to cultural property by its entry in the 'Inter-national Register of Cultural Property under Special Protection'. This entry shall only be made, in accordance with the provisions of the present Convention and under the conditions provided for in the Regulations for the execution of the Convention.

Article 9. Immunity of cultural property under special protection

The High Contracting Parties undertake to ensure the immunity of cultural property under special protection by refraining, from the time of entry in the International Register, from any act of hostility directed against such property and, except for the cases provided for in paragraph 5 of Article 8, from any use of such property or its surroundings for military purposes.

Article 10. Identification and control

During an armed conflict, cultural property under special protection shall be marked with the distinctive emblem described in Article 16, and shall be open to international control as provided for in the Regulations for the execution of the Convention.

Article 11. Withdrawal of immunity

1. If one of the High Contracting Parties commits, in respect of any item of cultural property under special protection, a violation of the obligations under Article 9, the opposing Party shall, so long as this violation persists, be released from the obligation to ensure the immunity of the property concerned. Nevertheless, whenever possible, the latter Party shall first request the cessation of such violation within a reasonable time.

2. Apart from the case provided for in paragraph 1 of the present Article, immunity shall be withdrawn from cultural property under special protection only in exceptional cases of unavoidable military necessity, and only for such time as that necessity continues. Such necessity can be established only by the officer commanding a force the equivalent of a division in size or larger. Whenever circumstances permit, the opposing Party shall be notified, a reasonable time in advance, of the decision to withdraw immunity.

3. The Party withdrawing immunity shall, as soon as possible, so inform the Commissioner-General for cultural property provided for in the Regulations for the execution of the Convention, in writing, stating the reasons.

CHAPTER III. TRANSPORT OF CULTURAL PROPERTY

Article 12. Transport under special protection

1. Transport exclusively engaged in the transfer of cultural property, whether within a territory or to another territory, may, at the request of the High Contracting Party concerned, take place under special protection in accordance with the conditions specified in the Regulations for the execution of the Convention.

2. Transport under special protection shall take place under the international supervision provided for in the aforesaid Regulations and shall display the distinctive emblem described in Article 16.

3. The High Contracting Parties shall refrain from any act of hostility directed against transport under special protection.

Article 13. Transport in urgent cases

1. If a High Contracting Party considers that the safety of certain cultural property requires its transfer and that the matter is of such urgency that the procedure laid down in Article 12 cannot be followed, especially at the beginning of an armed conflict, the transport may display the distinctive emblem described in Article 16, provided that an application for immunity referred to in Article 12 has not already been made and refused. As far as possible, notification of transfer should be made to the opposing Parties. Nevertheless, transport conveying cultural property to the territory of another country may not display the distinctive emblem unless immunity has been expressly granted to it.

2. The High Contracting Parties shall take, so far as possible, the necessary precautions to avoid acts of hostility directed against the transport described in paragraph 1 of the present Article and displaying the distinctive emblem.

Article 14. Immunity from seizure, capture and prize

1. Immunity from seizure, placing in prize, or capture shall be granted to:

(a) cultural property enjoying the protection provided for in Article 12 or that provided for in Article 13;

(b) the means of transport exclusively engaged in the transfer of such cultural property.

2. Nothing in the present Article shall limit the right of visit and search.

CHAPTER IV. PERSONNEL

Article 15. Personnel

As far as is consistent with the interests of security, personnel engaged in the protection of cultural property shall, in the interests of such property, be respected and, if they fall into the hands of the opposing Party, shall be allowed to continue to carry out their duties whenever the cultural property for which they are responsible has also fallen into the hands of the opposing Party.

CHAPTER V. THE DISTINCTIVE EMBLEM

Article 16. Emblem of the convention

1. The distinctive emblem of the Convention shall take the form of a shield, pointed below, per saltire blue and white (a shield consisting of a royal-blue square, one of the angles of which forms the point of the shield, and of a royal-blue triangle above the square, the space on either side being taken up by a white triangle).

2. The emblem shall be used alone, or repeated three times in a triangular formation (one shield below), under the conditions provided for in Article 17.

Article 17. Use of the emblem

1. The distinctive emblem repeated three times may be used only as a means of identification of:

(a) immovable cultural property under special protection;

(b) the transport of cultural property under the conditions provided for in Articles 12 and 13;

(c) improvised refuges, under the conditions provided for in the Regulations for the execution of the Convention.

2. The distinctive emblem may be used alone only as a means of identification of:

(a) cultural property not under special protection;

(b) the persons responsible for the duties of control in accordance with the Regulations for the execution of the Convention;

(c) the personnel engaged in the protection of cultural property;

(d) the identity cards mentioned in the Regulations for the execution of the Convention.

3. During an armed conflict, the use of the distinctive emblem in any other cases than those mentioned in the preceding paragraphs of the present Article, and the use for any purpose whatever of a sign resembling the distinctive emblem, shall be forbidden.

4. The distinctive emblem may not be placed on any immovable cultural property unless at the same time there is displayed an authorization duly dated and signed by the competent authority of the High Contracting Party.

CHAPTER VI. SCOPE OF APPLICATION OF THE CONVENTION

Article 18. Application of the Convention

1. Apart from the provisions which shall take effect in time of peace, the present Convention shall apply in the event of declared war or of any other armed conflict which may arise between two or more of the High Contracting Parties, even if the state of war is not recognized by, one or more of them.

2. The Convention shall also apply to all cases of partial or total occupation of the territory of a High Contracting Party, even if the said occupation meets with no armed resistance.

3. If one of the Powers in conflict is not a Party to the present Convention, the Powers which are Parties thereto shall nevertheless remain bound by it in their mutual relations. They shall furthermore be bound by the Convention, in relation to the said Power, if the latter has declared, that it accepts the provisions thereof and so long as it applies them.

Article 19. Conflicts not of an international character

1. In the event of an armed conflict not of an international character occurring within the territory of one of the High Contracting Parties, each party to the conflict shall be bound to apply, as, a minimum, the provisions of the present Convention which relate to respect for cultural property.

2. The parties to the conflict shall endeavour to bring into force, by means of special agreements, all or part of the other provisions of the present Convention.

3. The United Nations Educational, Scientific and Cultural Organization may offer its services to the parties to the conflict.

4. The application of the preceding provisions shall not affect the legal status of the parties to the conflict.

CHAPTER VII. EXECUTION OF THE CONVENTION

Article 20. Regulations for the execution of the Convention

The procedure by which the present Convention is to be applied is defined in the Regulations for its execution, which constitute an integral part thereof.

Article 21. Protecting powers

The present Convention and the Regulations for its execution shall be applied with the co-operation of the Protecting Powers responsible for safeguarding the interests of the Parties to the conflict.

Article 22. Conciliation procedure

1. The Protecting Powers shall lend their good offices in all cases where they may deem it useful in the interests of cultural property, particularly if there is disagreement between the Parties to the conflict as to the application or interpretation of the provisions of the present Convention or the Regulations for its execution.

2. For this purpose, each of the Protecting Powers may, either at the invitation of one Party, of the Director-General of the United Nations Educational, Scientific and Cultural Organization, or on its own initiative, propose to the Parties to the conflict a meeting of their representatives, and in particular of the authorities responsible for the protection of cultural property, if considered appropriate on suitably chosen neutral territory. The Parties to the conflict shall be bound to give effect to the proposals for meeting made to them.

The Protecting Powers shall propose for approval by the Parties to the conflict a person belonging to a neutral Power or a person presented by the Director General of the United Nations Educational, Scientific and Cultural Organization, which person shall be invited to take part in such a meeting in the capacity of Chairman.

Article 23. Assistance of UNESCO

1. The High Contracting Parties may call upon the United Nations Educational, Scientific and Cultural Organization for technical assistance in organizing the protection of their cultural property, or in connexion with any other problem arising out of the application of the present Convention or the Regulations for its execution. The Organization shall accord such assistance within the limits fixed by its programme and by its resources.

2. The Organization is authorized to make, on its own initiative, proposals on this matter to the High Contracting Parties.

Article 24. Special agreements

1. The High Contracting Parties may conclude special agreements for all matters concerning which they deem it suitable to make separate provision.

2. No special agreement may be concluded which would diminish the protection afforded by the present Convention to cultural property and to the personnel engaged in its protection.

Article 25. Dissemination of the Convention

The High Contracting Parties undertake, in time of peace as in time of armed conflict, to disseminate the text of the present Convention and the Regulations for its execution as widely as possible in their respective countries. They undertake, in particular, to include the study thereof in their programmes of military and, if possible, civilian training, so that its principles are made known to the whole population, especially the armed forces and personnel engaged in the protection of cultural property.

Article 26. Translations reports

1. The High Contracting Parties shall communicate to one another, through the Director-General of the United Nations Educational, Scientific and Cultural Organization, the official translations of the present Convention and of the Regulations for its execution.

2. Furthermore, at least once every four years, they shall forward to the Director-General a report giving whatever information they think suitable concerning any measures being taken, prepared or contemplated by their respective administrations in fulfilment of the present Convention and of the Regulations for its execution.

Article 27. Meetings

1. The Director-General of the United Nations Educational, Scientific and Cultural Organization may, with the approval of the Executive Board, convene meetings of representatives of the High Contracting Parties. He must convene such a meeting if at least one-fifth of the High Contracting Parties so request.

2. Without prejudice to any other functions which have been conferred on it by the present Convention or the Regulations for its execution, the purpose of the meeting will be to study problems concerning the application of the Convention and of the Regulations for its execution, and to formulate recommendations in respect thereof.

3. The meeting may further undertake a revision of the Convention or the Regulations for its execution if the majority of the High Contracting Parties are represented, and in accordance with the provisions of Article 39.

Article 28. Sanctions

The High Contracting Parties undertake to take, within the framework of their ordinary criminal jurisdiction, all necessary steps to prosecute and impose penal or disciplinary sanctions upon those persons, of whatever nationality, who commit or order to be committed a breach of the present Convention.

Final provisions

Article 29. Languages

1. The present Convention is drawn up in English, French, Russian and Spanish, the four texts being equally authoritative.

2. The United Nations Educational, Scientific and Cultural Organization shall arrange for translations of the Convention into the other official languages of its General Conference.

Article 30. Signature

The present Convention shall bear the date of 14 May, 1954 and, until the date of 31 December, 1954, shall remain open for signature by all States invited to the Conference which met at The Hague from 21 April, 1954 to 14 May, 1954.

Article 31. Ratification

1. The present Convention shall be subject to ratification by signatory States in accordance with their respective constitutional procedures.

2. The instruments of ratification shall be deposited with the Director-General of the United Nations Educational, Scientific and Cultural Organization.

Article 32. Accession

From the date of its entry into force, the present Convention shall be open for accession by all States mentioned in Article 30 which have not signed it, as well as any other State invited to accede by the Executive Board of the United Nations Educational, Scientific and Cultural Organization. Accession shall be effected by the deposit of an instrument of accession with the Director-General of the United Nations Educational, Scientific and Cultural Organization.

Article 33. Entry into force

1. The present Convention shall enter into force three months after five instruments of ratification have been deposited.

2. Thereafter, it shall enter into force, for each High Contracting Party, three months after the deposit of its instrument of ratification or accession.

3. The situations referred to in Articles 18 and 19 shall give immediate effect to ratifications or

accessions deposited by the Parties to the conflict either before or after the beginning of hostilities or occupation. In such cases the Director-General of the United Nations Educational, Scientific and Cultural Organization shall transmit the communications referred to in Article 38 by the speediest method.

Article 34. Effective application

1. Each State Party to the Convention on the date of its entry into force shall take all necessary measures to ensure its effective application within a period of six months after such entry into force.

2. This period shall be six months from the date of deposit of the instruments of ratification or accession for any State which deposits its instrument of ratification or accession after the date of the entry into force of the Convention.

Article 35. Territorial extension of the Convention

Any High Contracting Party may, at the time of ratification or accession, or at any time thereafter, declare by notification addressed to the Director-General of the United Nations Educational, Scientific and Cultural Organization, that the present Convention shall extend to all or any of the territories for whose international relations it is responsible. The said notification shall take effect three months after the date of its receipt.

Article 36. Relation to previous conventions

1. In the relations between Powers which are bound by the Conventions of The Hague concerning the Laws and Customs of War on Land (IV) and concerning Naval Bombardment in Time of War (IX), whether those of 29 July, 1899 or those of 18 October, 1907, and which are Parties to the present Convention, this last Convention shall be supplementary to the aforementioned Convention (IX) and to the Regulations annexed to the aforementioned Convention (IV) and shall substitute for the emblem described in Article 5 of the aforementioned Convention (IX) the emblem described in Article 16 of the present Convention, in cases in which the present Convention and the Regulations for its execution provide for the use of this distinctive emblem.

2. In the relations between Powers which are bound by the Washington Pact of 15 April, 1935 for the Protection of Artistic and Scientific Institutions and of Historic Monuments (Roerich Pact) and which are Parties to the present Convention, the latter Convention shall be supplementary to the Roerich Pact and shall substitute for the distinguishing flag described in Article III of the Pact the emblem defined in Article 16 of the present Convention, in cases in which the present Convention and the Regulations for its execution provide for the use of this distinctive emblem.

Article 37. Denunciation

1. Each High Contracting Party may denounce the present Convention, on its own behalf, or on behalf of any territory for whose international relations it is responsible.

2. The denunciation shall be notified by an instrument in writing, deposited with the Director-General of the United Nations Educational, Scientific and Cultural Organization.

3. The denunciation shall take effect one year after the receipt of the instrument of denunciation. However, if, on the expiry of this period, the denouncing Party is involved in an armed conflict, the denunciation shall not take effect until the end of hostilities, or until the operations of repatriating cultural property are completed, whichever is the later.

Article 38. Notifications

The Director-General of the United Nations Educational, Scientific and Cultural Organization shall inform the States referred to in Articles 30 and 32, as well as the United Nations, of the deposit of all the instruments of ratification, accession or acceptance provided for in Articles 31, 32 and 39 and of the notifications and denunciations provided for respectively in Articles 35, 37 and 39.

Article 39. Revision of the Convention and of the Regulations for its execution

1. Any High Contracting Party may propose amendments to the present Convention or the Regulations for its execution. The text of any proposed amendment shall be communicated to the Director-General of the United Nations Educational, Scientific and Cultural Organization who shall transmit it to each High Contracting Party with the request that such Party reply within four months stating whether it:

(a) desires that a Conference be convened to consider the proposed amendment;

(b) favours the acceptance of the proposed amendment without a Conference; or

(c) favours the rejection of the proposed amendment without a Conference.

2. The Director-General shall transmit the replies, received under paragraph 1 of the present Article, to all High Contracting Parties.

3. If all the High Contracting Parties which have, within the prescribed time-limit, stated their views to the Director-General of the United Nations Educational, Scientific and Cultural Organization, pursuant to paragraph 1(b) of this Article, inform him that they favour acceptance of the amendment without a Conference, notification of their decision shall be made by the Director-General in accordance with Article 38. The amendment shall become effective for all the High Contracting Parties on the expiry of ninety days from the date of such notification.

4. The Director-General shall convene a Conference of the High Contracting Parties to consider the proposed amendment if requested to do so by more than one-third of the High Contracting Parties.

5. Amendments to the Convention or to the Regulations for its execution, dealt with under the provisions of the preceding paragraph, shall enter into force only after they have been unanimously adopted by the High Contracting Parties represented at the Conference and accepted by each of the High Contracting Parties.

6. Acceptance by the High Contracting Parties of amendments to, the Convention or to the Regulations for its execution, which have been adopted by the Conference mentioned in paragraphs 4 and 5, shall be effected by the deposit of a formal instrument with the Director-General of the United Nations Educational, Scientific and Cultural Organization.

7. After the entry into force of amendments to the present Convention or to the Regulations for its execution, only the text of the Convention or of the Regulations for its execution thus amended shall remain open for ratification or accession.

Article 40. Registration

In accordance with Article 102 of the Charter of the United Nations, the present Convention shall be registered with the Secretariat of the United Nations at the request of the Director-General of the United Nations Educational, Scientific and Cultural Organization.

IN FAITH WHEREOF the undersigned, duly authorized, have signed the present Convention.

Done at The Hague, this fourteenth day of May, 1954, in a single copy which shall be deposited in the archives of the United Nations Educational, Scientific and Cultural Organization, and certified true copies of which shall be delivered to all the States referred to in Articles 30 and 32 as well as to the United Nations.

REGULATIONS FOR THE EXECUTION OF THE CONVENTION FOR THE PROTECTION OF CULTURAL PROPERTY IN THE EVENT OF ARMED CONFLICT

CHAPTER I. CONTROL

Article 1. International list of persons

On the entry into force of the Convention, the Director-General of the United Nations Educational, Scientific and Cultural Organization shall compile an international list consisting of all persons nominated by the High Contracting Parties as qualified to carry out the functions of Commissioner-General for Cultural Property. On the initiative of the Director-General of the United Nations Educational, Scientific and Cultural Organization, this list shall be periodically revised on the basis of requests formulated by the High Contracting Parties.

Article 2. Organization of control

As soon as any High Contracting Party is engaged in an armed conflict to which Article 18 of the Convention applies:

(a) It shall appoint a representative for cultural property situated in its territory; if it is in occupation of another territory, it shall appoint a special representative for cultural property situated in that territory;

(b) The Protecting Power acting for each of the Parties in conflict with such High Contracting Party shall appoint delegates accredited to the latter in conformity with Article 3 below;

(c) A Commissioner-General for Cultural Property shall be appointed to such High Contracting Party in accordance with Article 4.

Article 3. Appointment of delegates of Protecting Powers

The Protecting Power shall appoint its delegates from among the members of its diplomatic or consular staff or, with the approval of the Party to which they will be accredited, from among other persons.

Article 4. Appointment of 'Commissioner-General

1. The Commissioner-General for Cultural Property shall be chosen from the international list of persons by joint agreement between the Party to which he will be accredited and the Protecting Powers acting on behalf of the opposing Parties.

2. Should the Parties fail to reach agreement within three weeks from the beginning of their discussions on this point, they shall request the President of the International Court of Justice to appoint the Commissioner-General, who shall not take up his duties until the Party to which he is accredited has approved his appointment.

Article 5. Functions of delegates

The delegates of the Protecting Powers shall take note of violations of the Convention, investigate, with the approval of the Party to which they are accredited, the circumstances in which they have occurred, make representations locally to secure their cessation and, if necessary, notify the Commissioner-General of such violations. They shall keep him informed of their activities.

Article 6. Functions of the Commissioner-General

1. The Commissioner-General for Cultural Property shall deal with all matters referred to him in connexion with the application of the Convention, in conjunction with the representative of the Party to which he is accredited and with the delegates concerned.

2. He shall have powers of decision and appointment in the cases specified in the present Regulations.

3. With the agreement of the Party to which he is accredited, he shall have the right to order an investigation or to, conduct it himself.

4. He shall make any representations to the Parties to the conflict or to their Protecting Powers which he deems useful for the application of the Convention.

5. He shall draw up such reports as may be necessary on the application of the Convention and communicate them to the Parties concerned and to their Protecting Powers. He shall send copies to the Director-General of the United Nations Educational, Scientific and Cultural Organization, who may make use only of their technical contents.

6. If there is no Protecting Power, the Commissioner-General shall exercise the functions of the Protecting Power as laid down in Articles 21 and 22 of the Convention.

Article 7. Inspectors and experts

1. Whenever the Commissioner-General for Cultural Property considers it necessary, either at the request of the delegates concerned or after consultation with them, he shall propose, for the approval of the Party to which he is accredited, an inspector of cultural property to be charged with a specific mission. An inspector shall be responsible only to the Commissioner-General.

2. The Commissioner-General, delegates and inspectors may have recourse to the services of experts, who will also be proposed for the approval of the Party mentioned in the preceding paragraph.

Article 8. Discharge of the mission of control

The Commissioners-General for Cultural Property, delegates of the Protecting Powers, inspectors and experts shall in no case exceed their mandates. In particular, they shall take account of the security needs of the High Contracting Party to which they are accredited and shall in all circumstances act in accordance with the requirements of the military situation as communicated to them by that High Contracting Party.

Article 9. Substitutes for Protecting Powers

If a Party to the conflict does not benefit or ceases to benefit from the activities of a Protecting Power, a neutral State may be asked to undertake those functions of a -Protecting Power which concern the appointment of a Commissioner-General for Cultural Property in accordance with the procedure laid down in Article 4 above. The Commissioner-General thus appointed shall, if need be, entrust to inspectors the functions of delegates of Protecting Powers as specified in the present Regulations.

Article 10. Expenses

The remuneration and expenses of the Commissioner-General for Cultural Property, inspectors and experts shall be met by the Party to which they are accredited. Remuneration and expenses of delegates of the Protecting Powers shall be subject to agreement between those Powers and the States whose interests they are safeguarding.

CHAPTER II. SPECIAL PROTECTION

Article 11. Improvised refuges

1. If, during an armed conflict, any High Contracting Party is induced by unforeseen circumstances to set up an improvised refuge and desires that it should be placed under special protection, it shall communicate this fact forthwith to the Commissioner-General accredited to that Party.

2. If the Commissioner-General considers that such a measure is justified by the circumstances and by the importance of the cultural property sheltered in' this improvised refuge, he may authorize the High Contracting Party to display on such refuge the distinctive emblem defined in Article 16 of the Convention. He shall communicate his decision without delay to the delegates

of the Protecting Powers who are concerned, each of whom may, within a time limit of 30 days, order the immediate withdrawal of the emblem.

3. As soon as such delegates have signified their agreement or if the time limit of 30 days has passed without any of the delegates concerned having made an objection, and if, in the view of the Commissioner-General, the refuge fulfils the conditions laid down in Article 8 of the Convention, the Commissioner-General shall request the Director-General of the United Nations Educational, Scientific and Cultural Organization to enter the refuge in the Register of Cultural Property under Special Protection.

Article 12. International Register of Cultural Property under Special Protection

1. An 'International Register of Cultural Property under Special Protection' shall be prepared.

2. The Director-General of the United Nations Educational, Scientific and Cultural Organization shall maintain this Register. He shall furnish copies to the Secretary-General of the United Nations and to the High Contracting Parties.

3. The Register shall be divided into sections, each in the name of a High Contracting Party. Each section shall be subdivided into three paragraphs, headed: Refuges, Centers containing Monuments, Other Immovable Cultural Property. The Director-General shall determine what details each section shall contain.

Article 13. Requests for registration

1. Any High Contracting Party may submit to the Director-General of the United Nations Educational, Scientific and Cultural Organization an application for the entry in the Register of certain refuges, centers containing monuments or other immovable cultural property situated within its territory. Such application shall contain a description of the location of such property and shall certify that the property complies with the provisions of Article 8 of the Convention.

2. In the event of occupation, the Occupying Power shall be competent to make such application.

3. The Director-General of the United Nations Educational, Scientific and Cultural Organization shall, without delay, send copies of applications for registration to each of the High Contracting Parties.

Article 14. Objections

1. Any High Contracting Party may, by letter addressed to the Director-General of the United Nations Educational, Scientific and Cultural Organization, lodge an objection to the registration of cultural property. This letter must be received by him within four months of the day on which he sent a copy of the application for registration.

2. Such objection shall state the reasons giving rise to it, the only, valid grounds being that:

(a) the property is not cultural property;

(b) the property does not comply with the conditions mentioned in Article 8 of the Convention.

3. The Director-General shall send a copy of the letter of objection to the High Contracting Parties without delay. He shall, if necessary, seek the advice of the International Committee on Monuments, Artistic and Historical Sites and Archaeological Excavations and also, if he thinks fit, of any other competent organization or person.

4. The Director-General, or the High Contracting Party requesting registration, may make whatever representations they deem necessary to the High Contracting Parties which lodged the objection, with a view to causing the objection to be withdrawn.

5. If a High Contracting Party which has made an application for registration in time of peace becomes involved in an armed conflict before the entry has been made, the cultural property concerned shall at once be provisionally entered in the Register, by the Director-General, pending the confirmation, withdrawal or cancellation of any objection that may be, or may have been, made.

6. If, within a period of six months from the date of receipt of the letter of objection, the Director-General has not received from the High Contracting Party lodging the objection a

communication stating that it has been withdrawn, the High Contracting Party applying for registration may request arbitration in accordance with the procedure in the following paragraph.

7. The request for arbitration shall not be made more than one year after the date of receipt by the Director-General of the letter of objection. Each of the two Parties to the dispute shall appoint an arbitrator. When more than one objection has been lodged against an application for registration, the High Contracting Parties which have lodged the objections shall, by common consent, appoint a single arbitrator. These two arbitrators shall select a chief arbitrator from the international list mentioned in Article 1 of the present Regulations. If such arbitrators cannot agree upon their choice, they shall ask the President of the International Court of Justice to appoint a chief arbitrator who need not necessarily be chosen from the international list. The arbitral tribunal thus constituted shall fix its own procedure. There shall be no appeal from its decisions.

8. Each of the High Contracting Parties may declare, whenever a dispute to which it is a Party arises, that it does not wish to apply the arbitration procedure provided for in the preceding paragraph. In such cases, the objection to an application for registration shall be submitted by the Director-General to the High Contracting Parties. The objection will be confirmed only if the High Contracting Parties so decide by a two-third majority of the High Contracting Parties voting. The vote shall be taken by correspondence, unless the Directory-General of the United Nations Educational, Scientific and Cultural Organization deems it essential to convene a meeting under the powers conferred upon him by Article 27 of the Convention. If the Director-General decides to proceed with the vote by correspondence, he shall invite the High Contracting Parties to transmit their votes by sealed letter within six months from the day on which they were invited to do so.

Article 15. Registration

1. The Director-General of the United Nations Educational, Scientific and Cultural Organization shall cause to be entered in the Register, under a serial number, each item of property for which application for registration is made, provided that he has not received an objection within the time-limit prescribed in paragraph 1 of Article 14.

2. If an objection has been lodged, and without prejudice to the provision of paragraph 5 of Article 14, the Director-General shall enter property in the Register only if the objection has been withdrawn or has failed to be confirmed following the procedures laid down in either paragraph 7 or paragraph 8 of Article 14.

3. Whenever paragraph 3 of Article 11 applies, the Director-General shall enter property in the Register if so requested by the Commissioner-General for Cultural Property.

4. The Director-General shall send without delay to the Secretary-General of the United Nations, to the High Contracting Parties, and, at the request of the Party applying for registration, to all other States referred to in Articles 30 and 32 of the Convention, a certified copy of each entry in the Register. Entries shall become effective thirty days after despatch of such copies.

Article 16. Cancellation

1. The Director-General of the United Nations Educational, Scientific and Cultural Organization shall cause the registration of any property to be cancelled:

(a) at the request of the High Contracting Party within whose territory the cultural property is situated;

(b) if the High Contracting Party which requested registration has denounced the Convention, and when that denunciation has taken effect;

(c) in the special case provided for in Article 14, paragraph 5, when an objection has been confirmed following the procedures mentioned either in paragraph 7 or in paragraph 8 or Article 14.

2. The Director-General shall send without delay, to the Secretary-General of the United Nations and to all States which received a copy of the entry in the Register, a certified copy of its cancellation. Cancellation shall take effect thirty days after the despatch of such copies.

Article 17. Procedure to obtain immunity

1. The request mentioned in paragraph I of Article 12 of the Convention shall be addressed to the Commissioner-General for Cultural Property. It shall mention the reasons on which it is based and specify the approximate number and the importance of the objects-to be transferred, their present location, the location now envisaged, the means of transport to be used, the route to be followed, the date proposed for the transfer, and any other relevant information.

2. If the Commissioner-General, after taking such opinions as he deems fit, considers that such transfer is justified, he shall consult those delegates of the Protecting Powers who are concerned, on the measures proposed for carrying it out. Following such consultation, he shall notify the Parties to the conflict concerned of the transfer, including in such notification all useful information.

3. The Commissioner-General shall appoint one or more inspectors, who shall satisfy themselves that only the property stated in the request is to be transferred and that the transport is to be by the approved methods and bears the distinctive emblem. The inspector or inspectors shall accompany the property to its destination.

Article 18. Transport abroad

Where the transfer under special protection is to the territory of another country, it shall be governed not only by Article 12 of the Convention and by Article 17 of the present Regulations, but by the following further provisions:

(a) while the cultural property remains on the territory of another State, that State shall be its depositary and shall extend to it as great a measure of care as that which it bestows upon its own cultural property of comparable importance;

(b) the depositary State shall return the property only on the cessation of the conflict; such return shall be effected within six months from the date on which it was requested;

(c) during the various transfer operations, and while it remains on the territory of another State, the cultural property shall be exempt from confiscation and may not be disposed of either by the depositor or by the depositary. Nevertheless, when the safety of the property requires it, the depositary may, with the assent of the depositor, have the property transported to the territory of a third country, under the conditions laid down in the present article;

(d) the request for special protection shall indicate that the State to whose territory the property is to be transferred accepts the provisions of the present Article.

Article 19. Occupied territory

Whenever a High Contracting Party occupying territory of another High Contracting Party transfers cultural property to a refuge situated elsewhere in that territory, without being able to follow the procedure provided for in Article 17 of the Regulations, the transfer in question shall not be regarded as misappropriation within the meaning of Article 4 of the Convention, provided that the Commissioner-General for Cultural Property certifies in writing, after having consulted the usual custodians, that such transfer was rendered necessary by circumstances.

Article 20. Affixing of the emblem

1. The placing of the distinctive emblem and its degree of visibility shall be left to the discretion of the competent authorities of each High Contracting Party. It may be displayed on flags or armlets; it may be painted on an object or represented in any other appropriate form.

2. However, without prejudice to any possible fuller markings, the emblem shall, in the event of armed conflict and in the cases mentioned in Articles 12 and 13 of the Convention, be placed on the vehicles of transport so as to be clearly visible in daylight from the air as well as from the ground. The emblem shall be visible from the ground:

(a) at regular intervals sufficient to indicate clearly the perimeter of a centre containing monuments under special protection;

(b) at the entrance to other immovable cultural property under special protection.

Article 21. Identification of persons

1. The persons mentioned in Article 17, paragraph 2(b) and (c) of the Convention may wear an armlet bearing the distinctive emblem, issued and stamped by the competent authorities.

2. Such persons shall carry a special identity card bearing the distinctive emblem. This card shall mention at least the surname and first names, the date of birth, the title or rank, and the function of the holder. The card shall bear the photograph of the holder as well as his signature or his fingerprints, or both. It shall bear the embossed stamp of the competent authorities.

3. Each High Contracting Party shall make out its own type of identity card, guided by the model annexed, by way of example, to the present Regulations. The High Contracting Parties shall transmit to each other a specimen of the model they are using. Identity cards shall be made out, if possible, at least in duplicate, one copy being kept by the issuing Power.

4. The said persons may not, without legitimate reason, be deprived of their identity card or of the right to wear the armlet.

Depositary:
UNESCO

Opened for Signature:
From 14 May to 31 December 1954.

The Convention has been signed by the following States:

Andorra (see note 1)	14 May 1954	Italy	14 May 1954
Australia	14 May 1954	Japan	6 September 1954
Austria	31 December 1954	Jordan	22 December 1954
Belgium	14 May 1954	Lebanon	25 May 1954
Brazil	31 December 1954	Libyan Arab Jamahiriya	14 May 1954
Burma	31 December 1954	Luxembourg	14 May 1954
Byelorussian Soviet		Mexico	29 December 1954
Socialist Republic	30 December 1954	Monaco	14 May 1954
[China] (see note 2)	14 May 1954	Nicaragua	14 May 1954
Cuba	14 May 1954	Norway	14 May 1954
Czechoslovakia	18 October 1954	New Zealand	20 December 1954
Democratic Kampuchea	17 December 1954	Netherlands	14 May 1954
Denmark	18 October 1954	Philippines	14 May 1954
Ecuador	30 December 1954	Poland	14 May 1954
Egypt	30 December 1954	Portugal	14 May 1954
El Salvador	14 May 1954	Romania	14 May 1954
France	14 May 1954	San Marino	14 May 1954
Germany (Federal		Spain	14 May 1954
Republic of)	14 May 1954	Syrian Arab Republic	14 May 1954
Greece	14 May 1954	Ukrainian Soviet	
Hungary	14 May 1954	Socialist Republic	14 May 1954
India	14 May 1954	United Kingdom	30 December 1954
Indonesia	24 December 1954	United States of	
Iran	14 May 1954	America	14 May 1954
Iraq	14 May 1954	Uruguay	14 May 1954
Ireland	14 May 1954	Yugoslavia	14 May 1954
Israel	14 May 1954		

Entry into force:
7 August 1956, in accordance with Article 33

Authoritative texts:
English, French, Russian and Spanish

Registration at the UN:
4 September 1956, No. 3511

States Parties:

CONVENTION FOR THE PROTECTION OF CULTURAL PROPERTY IN THE EVENT OF ARMED CONFLICT WITH REGULATIONS FOR THE EXECUTION OF THE CONVENTION. THE HAGUE, 14 MAY 1954.[1]

	States	Date of deposit of instrument	Type of instrument
1	Albania	20/12/1960	Accession
2	Argentina	22/03/1989	Accession
3	Armenia	05/09/1993	Notification of succession
4	Australia	19/09/1984	Ratification
5	Austria	25/03/1964	Ratification
6	Azerbaijan	20/09/1993	Accession
7	Bahrain	26/08/2008	Accession
8	Bangladesh	23/06/2006	Accession
9	Barbados	09/04/2002	Accession
10	Belarus	07/05/1957	Ratification
11	Belgium	16/09/1960	Ratification
12	Bolivia (Plurinational State of)	17/11/2004	Accession
13	Bosnia and Herzegovina	12/07/1993	Notification of succession
14	Botswana	03/01/2002	Accession
15	Brazil	12/09/1958	Ratification
16	Bulgaria	07/08/1956	Accession
17	Burkina Faso	18/12/1969	Accession
18	Cambodia	04/04/1962	Ratification
19	Cameroon	12/10/1961	Accession
20	Canada	11/12/1998	Accession
21	Chad	17/06/2008	Accession
22	Chile	11/09/2008	Accession
23	China	05/01/2000	Accession
24	Colombia	18/06/1998	Accession
25	Costa Rica	03/06/1998	Accession
26	Côte d'Ivoire	24/01/1980	Ratification
27	Croatia	06/07/1992	Notification of succession
28	Cuba	26/11/1957	Ratification
29	Cyprus	09/09/1964	Accession
30	Czech Republic	26/03/1993	Notification of succession
31	Democratic Republic of the Congo	18/04/1961	Accession
32	Denmark	26/03/2003	Ratification
33	Dominican Republic	05/01/1960	Accession
34	Ecuador	02/10/1956	Ratification

1 This Convention entered into force on 7 August 1956. It subsequently entered into force for each State three months after the date of deposit of that State's instrument, except in cases of notifications of succession, where the entry into force occurred on the date on which the State assumed responsibility for conducting its international relations.

35	Egypt	17/08/1955	Ratification
36	El Salvador	19/07/2001	Ratification
37	Equatorial Guinea	19/11/2003	Accession
38	Eritrea	06/08/2004	Accession
39	Estonia	04/04/1995	Accession
40	Finland	16/09/1994	Accession
41	France	07/06/1957	Ratification
42	Gabon	04/12/1961	Accession
43	Georgia	04/11/1992	Notification of succession
44	Germany	11/08/1967	Ratification
45	Ghana	25/07/1960	Accession
46	Greece	09/02/1981	Ratification
47	Guatemala	02/10/1985	Accession
48	Guinea	20/09/1960	Accession
49	Holy See	24/02/1958	Accession
50	Honduras	25/10/2002	Accession
51	Hungary	17/05/1956	Ratification
52	India	16/06/1958	Ratification
53	Indonesia	10/01/1967	Ratification
54	Iran (Islamic Republic of)	22/06/1959	Ratification
55	Iraq	21/12/1967	Ratification
56	Israel	03/10/1957	Ratification
57	Italy	09/05/1958	Ratification
58	Japan	10/09/2007	Ratification
59	Jordan	02/10/1957	Ratification
60	Kazakhstan	14/03/1997	Notification of succession
61	Kuwait	06/06/1969	Accession
62	Kyrgyzstan	03/07/1995	Accession
63	Latvia	19/12/2003	Accession
64	Lebanon	01/06/1960	Ratification
65	Libyan Arab Jamahiriya	19/11/1957	Ratification
66	Liechtenstein	28/04/1960	Accession
67	Lithuania	27/07/1998	Accession
68	Luxembourg	29/09/1961	Ratification
69	Madagascar	03/11/1961	Accession
70	Malaysia	12/12/1960	Accession
71	Mali	18/05/1961	Accession
72	Mauritius	22/09/2006	Accession
73	Mexico	07/05/1956	Ratification
74	Monaco	10/12/1957	Ratification
75	Mongolia	04/11/1964	Accession
76	Montenegro	26/04/2007	Notification of succession
77	Morocco	30/08/1968	Accession
78	Myanmar	10/02/1956	Ratification
79	Netherlands	14/10/1958	Ratification
80	New Zealand	24/07/2008	Ratification
81	Nicaragua	25/11/1959	Ratification
82	Niger	06/12/1976	Accession
83	Nigeria	05/06/1961	Accession
84	Norway	19/09/1961	Ratification
85	Oman	26/10/1977	Accession
86	Pakistan	27/03/1959	Accession
87	Panama	17/07/1962	Accession
88	Paraguay	09/11/2004	Accession
89	Peru	21/07/1989	Accession

90	Poland	06/08/1956	Ratification
91	Portugal	04/08/2000	Ratification
92	Qatar	31/07/1973	Accession
93	Republic of Moldova	09/12/1999	Accession
94	Romania	21/03/1958	Ratification
95	Russian Federation	04/01/1957	Ratification
96	Rwanda	28/12/2000	Accession
97	San Marino	09/02/1956	Ratification
98	Saudi Arabia	20/01/1971	Accession
99	Senegal	17/06/1987	Accession
100	Serbia	11/09/2001	Notification of succession
101	Seychelles	08/10/2003	Accession
102	Slovakia	31/03/1993	Notification of succession
103	Slovenia	05/11/1992	Notification of succession
104	South Africa	18/12/2003	Accession
105	Spain	07/07/1960	Ratification
106	Sri Lanka	11/05/2004	Accession
107	Sudan	23/07/1970	Accession
108	Sweden	22/01/1985	Accession
109	Switzerland	15/05/1962	Accession
110	Syrian Arab Republic	06/03/1958	Ratification
111	Tajikistan	28/08/1992	Notification of succession
112	Thailand	02/05/1958	Accession
113	The former Yugoslav Republic of Macedonia	30/04/1997	Notification of succession
114	Tunisia	28/01/1981	Accession
115	Turkey	15/12/1965	Accession
116	Ukraine	06/02/1957	Ratification
117	United Republic of Tanzania	23/09/1971	Accession
118	United States of America	13/03/2009	Ratification
119	Uruguay	24/09/1999	Ratification
120	Uzbekistan	21/02/1996	Accession
121	Venezuela (Bolivarian Republic of)	09/05/2005	Accession
122	Yemen	06/02/1970	Accession
123	Zimbabwe	09/06/1998	Accession

Declarations and Reservations:

Byelorussian Soviet Socialist Republic [at signature of the Convention]
The representative of the Byelorussian Soviet Socialist Republic noted that 'various provisions included in the Convention and Regulations weaken these agreements with regard to the conservation and defence of cultural property in the event of armed conflict and that, for that reason, he could not express his satisfaction' (See Acts of the Hague Conference, Records, para. 2215). Similar declarations were made at the same time by the Ukrainian Soviet Socialist Republic and the Union of the Soviet Socialist Republics (ibid., paras 2216-17).

Germany [Federal Republic of]
'As, however…ratification will take some time, owing to the federal character of the Federal Republic of Germany… in accordance with Article 18(3) of the above-mentioned Convention…the Federal Republic of Germany accepts and applies the provisions of the said Convention…accordingly, under the above-mentioned Article 18(3), all other Parties to the said Convention are thereby bound in relation to the Federal Republic of Germany'. (See letter ODG/SJ/2/467 of 2 May 1962.)

Norway (see note 3)
(Translation) '...the restitution of cultural property, in accordance with the terms of Sections I and II of the Protocol, can be demanded only after the expiration of a period of 20 years, after the date on which the property in question came into the possession of a good-faith holder'. (See letter CL/1522 of 30 October 1961.)

New Zealand
"AND DECLARES that, consistent with the constitutional status of Tokelau and taking into account the commitment of the Government of New Zealand to the development of self-government for Tokelau through an act of self-determination under the Charter of the United Nations, this ratification shall not extend to Tokelau unless and until a Declaration to this effect is lodged by the Government of New Zealand with the Depository on the basis of appropriate consultation with that territory;"

Sudan
'In view of the fact that it considers that the Royal Government of the National Union of Cambodia, of Samdeck Norodom Sihanouk is the only Government empowered to represent the Kingdom of Cambodia, it follows that the Government of the Democratic Republic of Sudan does not recognize the right of the Phnom-Penh regime to enter into international obligations on behalf of the Kingdom of Cambodia.' (See letter CL/2236 of 18 October 1972.)

United States of America :
The instrument contained the following declarations:
"(1) It is the understanding of the United States of America that "special protection", as defined in Chapter II of the Convention, codifies customary international law in that it, first, prohibits the use of any cultural property to shield any legitimate military targets from attack and, second, allows all property to be attacked using any lawful and proportionate means, if required by military necessity and notwithstanding possible collateral damage to such property.
(2) It is the understanding of the United States of America that any decision by any military commander, military personnel, or any other person responsible for planning, authorizing, or executing military action or other activities covered by this Convention shall only be judged on the basis of that person's assessment of the information reasonably available to the person at the time the person planned, authorized, or executed the action under review, and shall not be judged on the basis of information that comes to light after the action under review was taken.
(3) It is the understanding of the United States of America that the rules established by the Convention apply only to conventional weapons, and are without prejudice to the rules of international law governing other types of weapons, including nuclear weapons.
(4) It is the understanding of the United States of America that, as is true for all civilian objects, the primary responsibility for the protection of cultural objects rests with the Party controlling that property, to ensure that it is properly identified and that it is not used for unlawful purposes."
The letter of transmission of this instrument contained the following request:
"The United States of America requests that this instrument of ratification be given immediate effect in accordance with the relevant provisions of Article 33(3) of that Convention."

Territorial Application:

Notification by	Date of reception of notification	Extension to
Mauritius	22 September 2006	Island of Mauritius, Rodrigues, Agalega, Tromelin, Cargados Carajos and the Chagos Archipelago including Diego Garcia, and any other island comprised in the State of Mauritius

Notes:

(1) Signed on behalf of the Bishop of Urgel, co-prince of Andorra. The French Minister of Foreign Affairs by the communication dated 5 August 1954, made it known that the President of the French Republic, co-prince of Andorra, considered that signature as null and void, the French State alone being empowered to represent the Andorran interests on an international level (See letter CL/996 of 22 October 1954). The Bishop of Urgel, by letter of 6 December 1954, replied to this communication, calling attention to his position as a sovereign co-prince (See letter CL/1026 of 22 February 1955).

(2) Signed on behalf of China by its representatives to the United Nations and UNESCO at the time of signature.
China is an original Member of the United Nations, the Charter having been signed and ratified in its name, on 26 and 28 September 1945, respectively, by the Government of the Republic of China, which continuously represented China in the United Nations until 25 October 1971. China is likewise an original Member of UNESCO, the Constitution having been signed and accepted in its name by the Government of the Republic of China which continuously represented China in UNESCO until 29 October 1971.
On 25 October 1971, the General Assembly of the United Nations adopted Resolution 2758(XXVI), which reads as follows:
''The General Assembly,
'Recalling the principles of the Charter of the United Nations,
'Considering that the restoration of the lawful rights of the People's Republic of China is essential both for the protection of the Charter of the United Nations and for the cause that the United Nations must serve under the Charter,
'Recognizing that the representatives of the Government of the People's Republic of China are the only lawful representatives of China to the United Nations and that the People's Republic of China is one of the rive permanent members of the Security Council,
'Decides to restore all its rights to the People's Republic of China and to recognize the representatives of its Government as the only legitimate representatives of China to the United Nations, and to expel forthwith the representatives of Chiang Kai-chek from the place which they unlawfully occupy at the United Nations and in all the organizations related to it.'
The establishing of the Government of the People's Republic of China, occurring on 1 October 1949, was made known to the United Nations on 18 November 1949. Various proposals were formulated between that date and that of the adoption of the above-quoted resolution with a view to changing the representation of China at the United Nations, but these proposals were not adopted.
On 29 October 1971, the Executive Board of UNESCO, at its 88th session, adopted the following decision (88 EX/Decision 9):
'The Executive Board,
Taking into account the resolution adopted by the United Nations General Assembly on 25 October 1971, whereby the representatives of the People's Republic of China were recognized as the only lawful representatives of China to the United Nations,
Recalling resolution 396 adopted by the United Nations General Assembly at its fifth regular session on 14 December 1950 recommending that "the attitude adopted by the General Assembly" on the question of the representation of a Member State "should be taken into account in other organs of the United
Nations and in the Specialized Agencies".
Decides that, from today onwards, the Government of the People's Republic of China is the only legitimate representative of China in UNESCO and invites the ' Director-General to act accordingly.'
On 29 September 1972 the Secretary-General of the United Nations received the following communication from the Minister of Foreign Affairs of the People's Republic of China (translation):
As concerns the multilateral treaties which the defunct Chinese Government signed, ratified or

acceded to before the establishing of the Government of the People's Republic of China, my government will examine their terms before deciding, in the light of circumstances, whether they should or not be recognized.

As from 1 October 1949; day of the founding of the People's Republic of China, the Chiang Kai-chek clique has no right to represent China. Its signing and ratifying of any multilateral treaty, or its acceding to any multilateral treaty, by usurping the name of "China", are all illegal and void. My government will study these multilateral treaties before deciding, in the light of circumstances, whether it is or is not appropriate to accede to them.'

On depositing the instrument of acceptance of the Agreement, the Government of Romania stated that it considered the above-mentioned signature as null and void, inasmuch as the only Government competent to assume obligations on behalf of China and to represent China at the international level is the Government of the People's Republic of China.

In a letter addressed to the Secretary-General in regard to the above-mentioned declaration, the Permanent Representative of the Republic of China to the United Nations stated: 'The Republic of China, a sovereign State and member of the United Nations, attended the Fifth Session of the General Conference of the United Nations Educational, Scientific and Cultural Organization, contributed to the formulation of the Agreement on the Importation of Educational, Scientific and Cultural Materials and duly signed the said Agreement on 22 November 1950 at the Interim Headquarters of the United Nations at Lake Success. Any statement relating to the said Agreement that is incompatible with or derogatory to the legitimate position of the Government of the Republic of China shall in no way affect the rights and obligations of the Republic of China as a signatory of the said Agreement.'

(3) Bulgaria, Byelorussian Soviet Socialist Republic, Chad, Czechoslovakia, India, Italy, Madagascar, Mexico, Netherlands, Poland, Romania, San Marino, Spain, United Arab Republic and Union of Soviet Socialist Republics issued observations as regards this reservation (see letters CL/1606 of 27 November 1962 and CL/2351 Add. of 14 August 1974). By a note verbale dated 3 October 1973, Norway announced its decision, effective 24 August 1979, to withdraw that reservation (See letter LA/Depositary/1979/23 of 6 December 1979).

PROTOCOL TO THE CONVENTION FOR THE PROTECTION OF CULTURAL PROPERTY IN THE EVENT OF ARMED CONFLICT 1954

The High Contracting Parties are agreed as follows:

I.

1. Each High Contracting Party undertakes to prevent the exportation, from a territory occupied by it during an armed conflict, of cultural property as defined in Article 1 of the Convention for the Protection of Cultural Property in the Event of Armed Conflict, signed at The Hague on 14 May, 1954.

2. Each High Contracting Party undertakes to take into its custody cultural property imported into its territory either directly or indirectly from any oc-cupied territory. This shall either be effected automatically upon the importation of the property or, failing this, at the request of the authorities of that territory.

3. Each High Contracting Party undertakes to return, at the close of hostilities, to the competent authorities of the territory previously occupied, cultural property which is in its territory, if such property has been exported in contravention of the principle laid down in the first paragraph. Such property shall never be retained as war reparations.

4. The High Contracting Party whose obligation it was to prevent the exportation of cultural property from the territory occupied by it, shall pay an indemnity to the holders in good faith of any cultural property which has to be returned in accordance with the preceding paragraph.

II

5. Cultural property coming from the territory of a High Contracting Party and deposited by it in the territory of another High Contracting Party for the purpose of protecting such property against the dangers of an armed conflict, shall be returned by the latter, at the end of hostilities, to the competent authorities of the territory from which it came.

III

6. The present Protocol shall bear the date of 14 May, 1954 and, until the date of 31 December, 1954, shall remain open for signature by all States invited to the Conference which met at The Hague from 21 April, 1954 to 14 May, 1954.

7. (a) The present Protocol shall be subject to ratification by signatory States in accordance with their respective constitutional procedures.

(b) The instruments of ratification shall be deposited with the Director General of the United Nations Educational, Scientific and Cultural Organization.

8. From the date of its entry into force, the present Protocol shall be open for accession by all States mentioned in paragraph 6 which have not signed it as well as any other State invited to accede by the Executive Board of the United Nations Educational, Scientific and Cultural Organization. Accession shall be effected by the deposit of an instrument of accession with the Director-General of the United Nations Educational, Scientific and Cultural Organization.

9. The States referred to in paragraphs 6 and 8 may declare, at the time of signature, ratification or accession, that they will not be bound by the provisions of Section I or by those of Section II of the present Protocol.

10. (a) The present Protocol shall enter into force three months after five instruments of ratification have been deposited.

(b) Thereafter, it shall enter into force, for each High Contracting Party, three months after the deposit of its instrument of ratification or accession.

(c) The situations referred to in Articles 18 and 19 of the Convention for the Protection of Cultural Property in the Event of Armed Conflict, signed at The Hague on 14 May, 1954, shall give immediate effect to ratifications and accessions deposited by the Parties to the conflict either before or after the beginning of hostilities or occupation. In such cases, the Director-General of the United Nations Educational, Scientific and Cultural Organization shall transmit the communications' referred to in paragraph 14 by the speediest method.

11. (a) Each State Party to the Protocol on the date of its entry into force shall take all necessary measures to ensure its effective application within a period of six months after such entry into force.

(b) This period shall be six months from the date of deposit of the instruments of ratification or accession for any State which deposits its instrument of ratification or accession after the date of the entry into force of the Protocol.

12. Any High Contracting Party may, at the time of ratification or accession, or at any time thereafter, declare by notification addressed to the Director General of the United Nations Educational, Scientific and Cultural Organization, that the present Protocol shall extend to all or any of the territories for whose international relations it is responsible. The said notification shall take effect three months after the date of its receipt.

13. (a) Each High Contracting Party may denounce the present Protocol, on its own behalf, or on behalf of any territory for whose international relations it is responsible.

(b) The denunciation shall be notified by an instrument in writing, deposited with the Director-General of the United Nations Educational, Scientific and Cultural Organization.

(c) The denunciation shall take effect one year after receipt of the instrument of denunciation.

However, if, on the expiry of this period, the denouncing Party is involved in an armed conflict, the denunciation shall not take effect until the end of hostilities, or until the operations of repatriating cultural property are completed, whichever is the later.

14. The Director-General of the United Nations Educational, Scientific and Cultural Organization shall inform the States referred to in paragraphs 6 and 8, as well as the United Nations, of the deposit of all the instruments of ratification, accession or acceptance provided for in paragraphs 7, 8 and 15 and the notifications and denunciations provided for respectively in paragraphs 12 and 13.

15. (a) The present Protocol may be revised if revision is requested by more than one-third of the High Contracting Parties.

(b) The Director-General of the United Nations Educational, Scientific and Cultural Organization shall convene a Conference for this purpose.

c) Amendments to the present Protocol shall enter into force only after they have been unanimously adopted by the High Contracting Parties represented at the Conference and accepted by each of the High Contracting Parties.

(d) Acceptance by the High Contracting Parties of amendments to the present Protocol, which have been adopted by the Conference mentioned in sub-paragraphs (b) and (c), shall be effected by the deposit of a formal instrument with the Director-General of the United Nations Educational, Scientific and Cultural Organization.

(e) After the entry into force of amendments to the present Protocol, only the text of the said Protocol thus amended shall remain open for ratification or accession.

In accordance with Article 102 of the Charter of the United Nations, the present Protocol shall be registered with the Secretariat of the United Nations at the request of the Director-General of the United Nations Educational, Scientific and Cultural Organization.

IN FAITH WHEREOF the undersigned, duly authorized, have signed the present Protocol.

Done at The Hague, this fourteenth day of May, 1954, in English, French, Russian and Spanish, the four texts being equally authoritative, in a single copy which shall be deposited in the archives of the United Nations Educational, Scientific and Cultural Organization, and certified true copies of which shall be delivered to all the States referred to in paragraphs 6 and 8 as well as to the United Nations.

Depositary:
UNESCO

Opened for Signature:
From 14 May to 31 December 1954.

The Protocol has been signed by the following States:

Austria	31 December 1954	Ecuador	30 December 1954
Belgium	14 May 1954	Egypt	30 December 1954
Brazil	31 December 1954	El Salvador	14 May 1954
Burma	31 December 1954	France	14 May 1954
Byelorussian Soviet		Germany (Federal	
Socialist Republic	30 December 1954	Republic of)	14 May 1954
[China] (see note 1)	14 May 1954	Greece	14 May 1954
Cuba	14 May 1954	India	14 May 1954
Czechoslovakia	18 October 1954	Indonesia	24 December 1954
Democratic		Iran	14 May 1954
Kampuchea	17 December 1954	Iraq	14 May 1954
Denmark	18 October 1954	Italy	14 May 1954

Japan	6 September 1954	Netherlands	14 May 1954
Jordan	22 December 1954	Philippines	14 May 1954
Lebanon	25 May 1954	Poland	14 May 1954
Libyan Arab		San Marino	14 May 1954
Jamahiriya	14 May 1954	Spain	14 May 1954
Luxembourg	14 May 1954	Syrian Arab Republic	14 May 1954
Mexico	29 December 1954	Ukrainian Soviet	
Monaco	14 May 1954	Socialist Republic	14 May 1954
Nicaragua	14 May 1954	Uruguay	14 May 1954
Norway	14 May 1954	Yugoslavia	14 May 1954

Entry into force:
7 August 1956, in accordance with Article 33

Authoritative texts:
English, French, Russian and Spanish

Registration at the UN:
4 September 1956, No. 3511

States Parties

PROTOCOL TO THE CONVENTION FOR THE PROTECTION OF CULTURAL PROPERTY IN THE EVENT OF ARMED CONFLICT. THE HAGUE, 14 MAY 1954.[1]

	States	Date of deposit of instrument	Type of instrument
1	Albania	20/12/1960	Accession
2	Argentina	10/05/2007	Accession
3	Armenia	05/09/1993	Notification of succession
4	Austria	25/03/1964	Ratification
5	Azerbaijan	20/09/1993	Accession
6	Bahrain	26/08/2008	Accession
7	Bangladesh	23/06/2006	Accession
8	Barbados	02/10/2008	Accession
9	Belarus	07/05/1957	Ratification
10	Belgium	16/09/1960	Ratification
11	Bosnia and Herzegovina	12/07/1993	Notification of succession
12	Brazil	12/09/1958	Ratification
13	Bulgaria	09/10/1958	Accession
14	Burkina Faso	04/02/1987	Accession
15	Cambodia	04/04/1962	Accession
16	Cameroon	12/10/1961	Accession
17	Canada	29/11/2005	Accession
18	Chile	11/09/2008	Accession
19	China	05/01/2000	Accession
20	Colombia	18/06/1998	Accession
21	Costa Rica	03/06/1998	Accession
22	Croatia	06/07/1992	Notification of succession
23	Cuba	26/11/1957	Ratification
24	Cyprus	09/09/1964	Accession
25	Czech Republic	26/03/1993	Notification of succession

1 This Protocol entered into force on 7 August 1956. It subsequently entered into force for each State three months after the date of deposit of that State's instrument, except in cases of notifications of succession, where the entry into force occurred on the date on which the State assumed responsibility for conducting its international relations.

26	Democratic Republic of the Congo	18/04/1961	Accession
27	Denmark	26/03/2003	Ratification
28	Dominican Republic	21/03/2002	Accession
29	Ecuador	08/02/1961	Ratification
30	Egypt	17/08/1955	Ratification
31	El Salvador	27/03/2002	Accession
32	Estonia	17/01/2005	Accession
33	Finland	16/09/1994	Accession
34	France	07/06/1957	Ratification
35	Gabon	04/12/1961	Accession
36	Georgia	04/11/1992	Notification of succession
37	Germany	11/08/1967	Ratification
38	Ghana	25/07/1960	Accession
39	Greece	09/02/1981	Ratification
40	Guatemala	19/05/1994	Accession
41	Guinea	11/12/1961	Accession
42	Holy See	24/02/1958	Accession
43	Honduras	25/10/2002	Accession
44	Hungary	16/08/1956	Accession
45	India	16/06/1958	Ratification
46	Indonesia	26/07/1967	Ratification
47	Iran (Islamic Republic of)	22/06/1959	Ratification
48	Iraq	21/12/1967	Ratification
49	Israel	01/04/1958	Accession
50	Italy	09/05/1958	Ratification
51	Japan	10/09/2007	Ratification
52	Jordan	02/10/1957	Ratification
53	Kazakhstan	14/03/1997	Notification of succession
54	Kuwait	17/02/1970	Accession
55	Latvia	19/12/2003	Accession
56	Lebanon	01/06/1960	Ratification
57	Libyan Arab Jamahiriya	19/11/1957	Ratification
58	Liechtenstein	28/04/1960	Accession
59	Lithuania	27/07/1998	Accession
60	Luxembourg	29/09/1961	Ratification
61	Madagascar	03/11/1961	Accession
62	Malaysia	12/12/1960	Accession
63	Mali	18/05/1961	Accession
64	Mexico	07/05/1956	Ratification
65	Monaco	10/12/1957	Ratification
66	Montenegro	26/04/2007	Notification of succession
67	Morocco	30/08/1968	Accession
68	Myanmar	10/02/1956	Ratification
69	Netherlands	14/10/1958	Ratification
70	Nicaragua	25/11/1959	Ratification
71	Niger	06/12/1976	Accession
72	Nigeria	05/06/1961	Accession
73	Norway	19/09/1961	Ratification
74	Pakistan	27/03/1959	Accession
75	Panama	08/03/2001	Accession
76	Paraguay	09/11/2004	Accession
77	Peru	21/07/1989	Accession
78	Poland	06/08/1956	Ratification
79	Portugal	18/02/2005	Accession
80	Republic of Moldova	09/12/1999	Accession

81	Romania	21/03/1958	Ratification
82	Russian Federation	04/01/1957	Ratification
83	San Marino	09/02/1956	Ratification
84	Saudi Arabia	06/11/2007	Accession
85	Senegal	17/06/1987	Accession
86	Serbia	11/09/2001	Notification of succession
87	Slovakia	31/03/1993	Notification of succession
88	Slovenia	05/11/1992	Notification of succession
89	Spain	26/06/1992	Accession
90	Sweden	22/01/1985	Accession
91	Switzerland	15/05/1962	Accession
92	Syrian Arab Republic	06/03/1958	Ratification
93	Tajikistan	28/08/1992	Notification of succession
94	Thailand	02/05/1958	Accession
95	The former Yugoslav Republic of Macedonia	30/04/1997	Notification of succession
96	Tunisia	28/01/1981	Accession
97	Turkey	15/12/1965	Accession
98	Ukraine	06/02/1957	Ratification
99	Uruguay	24/09/1999	Ratification
100	Yemen	06/02/1970	Accession

Declarations and Reservations:

Japan

"In applying the provisions of paragraph 3 of I of the Protocol, Japan will fulfill the obligation under those provisions in a manner consistent with its domestic laws including the civil code. Japan will be, therefore, bound by the provisions of Section I of the Protocol to the extent that their fulfillment is compatible with the above-mentioned domestic laws." [Original: english]

Notes:

(1) Signed on behalf of China by its representatives to the United Nations and UNESCO at the time of signature.

China is an original Member of the United Nations, the Charter having been signed and ratified in its name, on 26 and 28 September 1945, respectively, by the Government of the Republic of China, which continuously represented China in the United Nations until 25 October 1971. China is likewise an original Member of UNESCO, the Constitution having been signed and accepted in its name by the Government of the Republic of China which continuously represented China in UNESCO until 29 October 1971.

On 25 October 1971, the General Assembly of the United Nations adopted Resolution 2758(XXVI), which reads as follows:

''The General Assembly,

'Recalling the principles of the Charter of the United Nations,

'Considering that the restoration of the lawful rights of the People's Republic of China is essential both for the protection of the Charter of the United Nations and for the cause that the United Nations must serve under the Charter,

'Recognizing that the representatives of the Government of the People's Republic of China are the only lawful representatives of China to the United Nations and that the People's Republic of China is one of the rive permanent members of the Security Council,

'Decides to restore all its rights to the People's Republic of China and to recognize the representatives of its Government as the only legitimate representatives of China to the United Nations, and to expel forthwith the representatives of Chiang Kai-chek from the place which they unlawfully occupy at the United Nations On 29 October 1971, the Executive Board of UNESCO, at its 88th session, adopted the following decision (88 EX/Decision 9):

'The Executive Board,

Taking into account the resolution adopted by the United Nations General Assembly on 25 October 1971, whereby the representatives of the People's Republic of China were recognized as the only lawful representatives of China to the United Nations,

Recalling resolution 396 adopted by the United Nations General Assembly at its fifth regular session on 14 December 1950 recommending that "the attitude adopted by the General Assembly" on the question of the representation of a Member State "should be taken into account in other organs of the United

Nations and in the Specialized Agencies".

Decides that, from today onwards, the Government of the People's Republic of China is the only legitimate representative of China in UNESCO and invites the ' Director-General to act accordingly.'

On 29 September 1972 the Secretary-General of the United Nations received the following communication from the Minister of Foreign Affairs of the People's Republic of China (translation):

As concerns the multilateral treaties which the defunct Chinese Government signed, ratified or acceded to before the establishing of the Government of the People's Republic of China, my government will examine their terms before deciding, in the light of circumstances, whether they should or not be recognized.

As from 1 October 1949; day of the founding of the People's Republic of China, the Chiang Kai-chek clique has no right to represent China. Its signing and ratifying of any multilateral treaty, or its acceding to any multilateral treaty, by usurping the name of "China", are all illegal and void. My government will study these multilateral treaties before deciding, in the light of circumstances, .whether it is or is not appropriate to accede to them.'

On depositing the instrument of acceptance of the Agreement, the Government of Romania stated that it considered the above-mentioned signature as null and void, inasmuch as the only Government competent to assume obligations on behalf of China and to represent China at the international level is the Government of the People's Republic of China.

In a letter addressed to the Secretary-General in regard to the above-mentioned declaration, the Permanent Representative of the Republic of China to the United Nations stated: 'The Republic of China, a sovereign State and member of the United Nations, attended the Fifth Session of the General Conference of the United Nations Educational, Scientific and Cultural Organization, contributed to the formulation of the Agreement on the Importation of Educational, Scientific and Cultural Materials and duly signed the said Agreement on 22 November 1950 at the Interim Headquarters of the United Nations at Lake Success. Any statement relating to the said Agreement that is incompatible with or derogatory to the legitimate position of the Government of the Republic of China shall in no way affect the rights and obligations of the Republic of China as a signatory of the said Agreement.'

SECOND PROTOCOL TO THE HAGUE CONVENTION OF 1954 FOR THE PROTECTION OF CULTURAL PROPERTY IN THE EVENT OF ARMED CONFLICT 1999

The Parties,

Conscious of the need to improve the protection of cultural property in the event of armed conflict and to establish an enhanced system of protection for specifically designated cultural property;

Reaffirming the importance of the provisions of the Convention for the Protection of Cultural Property in the Event of Armed Conflict, done at the Hague on 14 May 1954, and emphasizing the necessity to supplement these provisions through measures to reinforce their implementation;

Desiring to provide the High Contracting Parties to the Convention with a means of being more closely involved in the protection of cultural property in the event of armed conflict by establishing appropriate procedures therefore;

Considering that the rules governing the protection of cultural property in the event of armed conflict should reflect developments in international law;

Affirming that the rules of customary international law will continue to govern questions not regulated by the provisions of this Protocol;

Have agreed as follows:

CHAPTER 1 INTRODUCTION

Article 1 Definitions

For the purposes of this Protocol:

a. "Party" means a State Party to this Protocol;

b. "cultural property" means cultural property as defined in Article 1 of the Convention;

c. "Convention" means the Convention for the Protection of Cultural Property in the Event of Armed Conflict, done at The Hague on 14 May 1954;

d. "High Contracting Party" means a State Party to the Convention;

e. "enhanced protection" means the system of enhanced protection established by Articles 10 and 11;

f. "military objective" means an object which by its nature, location, purpose, or use makes an effective contribution to military action and whose total or partial destruction, capture or neutralisation, in the circumstances ruling at the time, offers a definite military advantage;

g. "illicit" means under compulsion or otherwise in violation of the applicable rules of the domestic law of the occupied territory or of international law.

h. "List" means the International List of Cultural Property under Enhanced Protection established in accordance with Article 27, sub-paragraph 1(b);

i. "Director-General" means the Director-General of UNESCO;

j. "UNESCO" means the United Nations Educational, Scientific and Cultural Organization;

k. "First Protocol" means the Protocol for the Protection of Cultural Property in the Event of Armed Conflict done at The Hague on 14 May 1954;

Article 2 Relation to the Convention

This Protocol supplements the Convention in relations between the Parties.

Article 3 Scope of application

1. In addition to the provisions which shall apply in time of peace, this Protocol shall apply in situations referred to in Article 18 paragraphs 1 and 2 of the Convention and in Article 22 paragraph 1.

2. When one of the parties to an armed conflict is not bound by this Protocol, the Parties to this Protocol shall remain bound by it in their mutual relations. They shall furthermore be bound by this Protocol in relation to a State party to the conflict which is not bound by it, if the latter accepts the provisions of this Protocol and so long as it applies them.

Article 4 Relationship between Chapter 3 and other provisions of the Convention and this Protocol

The application of the provisions of Chapter 3 of this Protocol is without prejudice to:

a. the application of the provisions of Chapter I of the Convention and of Chapter 2 of this Protocol;

b. the application of the provisions of Chapter II of the Convention save that, as between Parties to this Protocol or as between a Party and a State which accepts and applies this Protocol in accordance with Article 3 paragraph 2, where cultural property has been granted both special protection and enhanced protection, only the provisions of enhanced protection shall apply.

CHAPTER 2 GENERAL PROVISIONS REGARDING PROTECTION

Article 5 Safeguarding of cultural property

Preparatory measures taken in time of peace for the safeguarding of cultural property against the foreseeable effects of an armed conflict pursuant to Article 3 of the Convention shall include, as appropriate, the preparation of inventories, the planning of emergency measures for protection against fire or structural collapse, the preparation for the removal of movable cultural property or the provision for adequate in situ protection of such property, and the designation of competent authorities responsible for the safeguarding of cultural property.

Article 6 Respect for cultural property

With the goal of ensuring respect for cultural property in accordance with Article 4 of the Convention:

a. a waiver on the basis of imperative military necessity pursuant to Article 4 paragraph 2 of the Convention may only be invoked to direct an act of hostility against cultural property when and for as long as:

i. that cultural property has, by its function, been made into a military objective; and

ii. there is no feasible alternative available to obtain a similar military advantage to that offered by directing an act of hostility against that objective;

b. a waiver on the basis of imperative military necessity pursuant to Article 4 paragraph 2 of the Convention may only be invoked to use cultural property for purposes which are likely to expose it to destruction or damage when and for as long as no choice is possible between such use of the cultural property and another feasible method for obtaining a similar military advantage;

c. the decision to invoke imperative military necessity shall only be taken by an officer commanding a force the equivalent of a battalion in size or larger, or a force smaller in size where circumstances do not permit otherwise;

d. in case of an attack based on a decision taken in accordance with sub-paragraph (a), an effective advance warning shall be given whenever circumstances permit.

Article 7 Precautions in attack

Without prejudice to other precautions required by international humanitarian law in the conduct of military operations, each Party to the conflict shall:

a. do everything feasible to verify that the objectives to be attacked are not cultural property protected under Article 4 of the Convention;

b. take all feasible precautions in the choice of means and methods of attack with a view to avoiding, and in any event to minimizing, incidental damage to cultural property protected under Article 4 of the Convention;

c. refrain from deciding to launch any attack which may be expected to cause incidental damage to cultural property protected under Article 4 of the Convention which would be excessive in relation to the concrete and direct military advantage anticipated; and

d. cancel or suspend an attack if it becomes apparent:

i. that the objective is cultural property protected under Article 4 of the Convention;

ii. that the attack may be expected to cause incidental damage to cultural property protected under Article 4 of the Convention which would be excessive in relation to the concrete and direct military advantage anticipated.

Article 8 Precautions against the effects of hostilities

The Parties to the conflict shall, to the maximum extent feasible:

a. remove movable cultural property from the vicinity of military objectives or provide for adequate in situ protection;

b. avoid locating military objectives near cultural property.

Article 9 Protection of cultural property in occupied territory

1. Without prejudice to the provisions of Articles 4 and 5 of the Convention, a Party in occupation of the whole or part of the territory of another Party shall prohibit and prevent in relation to the occupied territory:

a. any illicit export, other removal or transfer of ownership of cultural property;

b. any archaeological excavation, save where this is strictly required to safeguard, record or preserve cultural property;

c. any alteration to, or change of use of, cultural property which is intended to conceal or destroy cultural, historical or scientific evidence.

2. Any archaeological excavation of, alteration to, or change of use of, cultural property in occupied territory shall, unless circumstances do not permit, be carried out in close co-operation with the competent national authorities of the occupied territory.

CHAPTER 3 ENHANCED PROTECTION

Article 10 Enhanced protection

Cultural property may be placed under enhanced protection provided that it meets the following three conditions:

a. it is cultural heritage of the greatest importance for humanity;

b. it is protected by adequate domestic legal and administrative measures recognising its exceptional cultural and historic value and ensuring the highest level of protection;

c. it is not used for military purposes or to shield military sites and a declaration has been made by the Party which has control over the cultural property, confirming that it will not be so used.

Article 11 The granting of enhanced protection

1. Each Party should submit to the Committee a list of cultural property for which it intends to request the granting of enhanced protection.

2. The Party which has jurisdiction or control over the cultural property may request that it be included in the List to be established in accordance with Article 27 sub-paragraph 1(b). This request shall include all necessary information related to the criteria mentioned in Article 10. The Committee may invite a Party to request that cultural property be included in the List.

3. Other Parties, the International Committee of the Blue Shield and other non-governmental organisations with relevant expertise may recommend specific cultural property to the Committee. In such cases, the Committee may decide to invite a Party to request inclusion of that cultural property in the List.

4. Neither the request for inclusion of cultural property situated in a territory, sovereignty or jurisdiction over which is claimed by more than one State, nor its inclusion, shall in any way prejudice the rights of the parties to the dispute.

5. Upon receipt of a request for inclusion in the List, the Committee shall inform all Parties of the request. Parties may submit representations regarding such a request to the Committee within sixty days. These representations shall be made only on the basis of the criteria mentioned in Article 10. They shall be specific and related to facts. The Committee shall consider the representations, providing the Party requesting inclusion with a reasonable opportunity to respond before taking the decision. When such representations are before the Committee, decisions for inclusion in the List shall be taken, notwithstanding Article 26, by a majority of four-fifths of its members present and voting.

6. In deciding upon a request, the Committee should ask the advice of governmental and non-governmental organisations, as well as of individual experts.

7. A decision to grant or deny enhanced protection may only be made on the basis of the criteria mentioned in Article 10.

8. In exceptional cases, when the Committee has concluded that the Party requesting inclusion of cultural property in the List cannot fulfil the criteria of Article 10 sub-paragraph (b), the

Committee may decide to grant enhanced protection, provided that the requesting Party submits a request for international assistance under Article 32.

9.Upon the outbreak of hostilities, a Party to the conflict may request, on an emergency basis, enhanced protection of cultural property under its jurisdiction or control by communicating this request to the Committee. The Committee shall transmit this request immediately to all Parties to the conflict. In such cases the Committee will consider representations from the Parties concerned on an expedited basis. The decision to grant provisional enhanced protection shall be taken as soon as possible and, notwithstanding Article 26, by a majority of four-fifths of its members present and voting. Provisional enhanced protection may be granted by the Committee pending the outcome of the regular procedure for the granting of enhanced protection, provided that the provisions of Article 10 sub-paragraphs (a) and (c) are met.

10. Enhanced protection shall be granted to cultural property by the Committee from the moment of its entry in the List.

11. The Director-General shall, without delay, send to the Secretary-General of the United Nations and to all Parties notification of any decision of the Committee to include cultural property on the List.

Article 12 Immunity of cultural property under enhanced protection

The Parties to a conflict shall ensure the immunity of cultural property under enhanced protection by refraining from making such property the object of attack or from any use of the property or its immediate surroundings in support of military action.

Article 13 Loss of enhanced protection

1. Cultural property under enhanced protection shall only lose such protection:

a. if such protection is suspended or cancelled in accordance with Article 14; or

b. if, and for as long as, the property has, by its use, become a military objective.

2. In the circumstances of sub-paragraph 1(b), such property may only be the object of attack if:

a. the attack is the only feasible means of terminating the use of the property referred to in sub-paragraph 1(b);

b. all feasible precautions are taken in the choice of means and methods of attack, with a view to terminating such use and avoiding, or in any event minimising, damage to the cultural property;

c. unless circumstances do not permit, due to requirements of immediate self-defence:

i. the attack is ordered at the highest operational level of command;

ii. effective advance warning is issued to the opposing forces requiring the termination of the use referred to in sub-paragraph 1(b); and

iii. Reasonable time is given to the opposing forces to redress the situation.

Article 14 Suspension and cancellation of enhanced protection

1. Where cultural property no longer meets any one of the criteria in Article 10 of this Protocol, the Committee may suspend its enhanced protection status or cancel that status by removing that cultural property from the List.

2. In the case of a serious violation of Article 12 in relation to cultural property under enhanced protection arising from its use in support of military action, the Committee may suspend its enhanced protection status. Where such violations are continuous, the Committee may exceptionally cancel the enhanced protection status by removing the cultural property from the List.

3. The Director-General shall, without delay, send to the Secretary-General of the United Nations and to all Parties to this Protocol notification of any decision of the Committee to suspend or cancel the enhanced protection of cultural property.

4. Before taking such a decision, the Committee shall afford an opportunity to the Parties to make their views known.

CHAPTER 4 CRIMINAL RESPONSIBILITY AND JURISDICTION

Article 15 Serious violations of this Protocol

1. Any person commits an offence within the meaning of this Protocol if that person intentionally and in violation of the Convention or this Protocol commits any of the following acts:

a. making cultural property under enhanced protection the object of attack;

b. using cultural property under enhanced protection or its immediate surroundings in support of military action;

c. extensive destruction or appropriation of cultural property protected under the Convention and this Protocol;

d. making cultural property protected under the Convention and this Protocol the object of attack;

e. theft, pillage or misappropriation of, or acts of vandalism directed against cultural property protected under the Convention.

2. Each Party shall adopt such measures as may be necessary to establish as criminal offences under its domestic law the offences set forth in this Article and to make such offences punishable by appropriate penalties. When doing so, Parties shall comply with general principles of law and international law, including the rules extending individual criminal responsibility to persons other than those who directly commit the act.

Article 16 Jurisdiction

1. Without prejudice to paragraph 2, each Party shall take the necessary legislative measures to establish its jurisdiction over offences set forth in Article 15 in the following cases:

a. when such an offence is committed in the territory of that State;

b. when the alleged offender is a national of that State;

c. in the case of offences set forth in Article 15 sub-paragraphs (a) to (c), when the alleged offender is present in its territory.

2. With respect to the exercise of jurisdiction and without prejudice to Article 28 of the Convention:

a. this Protocol does not preclude the incurring of individual criminal responsibility or the exercise of jurisdiction under national and international law that may be applicable, or affect the exercise of jurisdiction under customary international law;

b. except in so far as a State which is not Party to this Protocol may accept and apply its provisions in accordance with Article 3 paragraph 2, members of the armed forces and nationals of a State which is not Party to this Protocol, except for those nationals serving in the armed forces of a State which is a Party to this Protocol, do not incur individual criminal responsibility by virtue of this Protocol, nor does this Protocol impose an obligation to establish jurisdiction over such persons or to extradite them.

Article 17 Prosecution

1. The Party in whose territory the alleged offender of an offence set forth in Article 15 sub-paragraphs 1 (a) to (c) is found to be present shall, if it does not extradite that person, submit, without exception whatsoever and without undue delay, the case to its competent authorities, for the purpose of prosecution, through proceedings in accordance with its domestic law or with, if applicable, the relevant rules of international law.

2. Without prejudice to, if applicable, the relevant rules of international law, any person regarding whom proceedings are being carried out in connection with the Convention or this Protocol shall be guaranteed fair treatment and a fair trial in accordance with domestic law and international law at all stages of the proceedings, and in no cases shall be provided guarantees less favorable to such person than those provided by international law.

Article 18 Extradition

1. The offences set forth in Article 15 sub-paragraphs 1 (a) to (c) shall be deemed to be included

as extraditable offences in any extradition treaty existing between any of the Parties before the entry into force of this Protocol. Parties undertake to include such offences in every extradition treaty to be subsequently concluded between them.

2. When a Party which makes extradition conditional on the existence of a treaty receives a request for extradition from another Party with which it has no extradition treaty, the requested Party may, at its option, consider the present Protocol as the legal basis for extradition in respect of offences as set forth in Article 15 sub-paragraphs 1 (a) to (c).

3. Parties which do not make extradition conditional on the existence of a treaty shall recognise the offences set forth in Article 15 sub-paragraphs 1 (a) to (c) as extraditable offences between them, subject to the conditions provided by the law of the requested Party.

4. If necessary, offences set forth in Article 15 sub-paragraphs 1 (a) to (c) shall be treated, for the purposes of extradition between Parties, as if they had been committed not only in the place in which they occurred but also in the territory of the Parties that have established jurisdiction in accordance with Article 16 paragraph 1.

Article 19 Mutual legal assistance

1. Parties shall afford one another the greatest measure of assistance in connection with investigations or criminal or extradition proceedings brought in respect of the offences set forth in Article 15, including assistance in obtaining evidence at their disposal necessary for the proceedings.

2. Parties shall carry out their obligations under paragraph 1 in conformity with any treaties or other arrangements on mutual legal assistance that may exist between them. In the absence of such treaties or arrangements, Parties shall afford one another assistance in accordance with their domestic law.

Article 20 Grounds for refusal

1. For the purpose of extradition, offences set forth in Article 15 sub-paragraphs 1 (a) to (c), and for the purpose of mutual legal assistance, offences set forth in Article 15 shall not be regarded as political offences nor as offences connected with political offences nor as offences inspired by political motives. Accordingly, a request for extradition or for mutual legal assistance based on such offences may not be refused on the sole ground that it concerns a political offence or an offence connected with a political offence or an offence inspired by political motives.

2. Nothing in this Protocol shall be interpreted as imposing an obligation to extradite or to afford mutual legal assistance if the requested Party has substantial grounds for believing that the request for extradition for offences set forth in Article 15 sub-paragraphs 1 (a) to (c) or for mutual legal assistance with respect to offences set forth in Article 15 has been made for the purpose of prosecuting or punishing a person on account of that person's race, religion, nationality, ethnic origin or political opinion or that compliance with the request would cause prejudice to that person's position for any of these reasons.

Article 21 Measures regarding other violations

Without prejudice to Article 28 of the Convention, each Party shall adopt such legislative, administrative or disciplinary measures as may be necessary to suppress the following acts when committed intentionally:

a. any use of cultural property in violation of the Convention or this Protocol;

b. any illicit export, other removal or transfer of ownership of cultural property from occupied territory in violation of the Convention or this Protocol.

CHAPTER 5 THE PROTECTION OF CULTURAL PROPERTY IN ARMED CONFLICTS NOT OF AN INTERNATIONAL CHARACTER

Article 22 Armed conflicts not of an international character

1. This Protocol shall apply in the event of an armed conflict not of an international character, occurring within the territory of one of the Parties.

2. This Protocol shall not apply to situations of internal disturbances and tensions, such as riots, isolated and sporadic acts of violence and other acts of a similar nature.

3. Nothing in this Protocol shall be invoked for the purpose of affecting the sovereignty of a State or the responsibility of the government, by all legitimate means, to maintain or re-establish law and order in the State or to defend the national unity and territorial integrity of the State.

4. Nothing in this Protocol shall prejudice the primary jurisdiction of a Party in whose territory an armed conflict not of an international character occurs over the violations set forth in Article 15.

5. Nothing in this Protocol shall be invoked as a justification for intervening, directly or indirectly, for any reason whatever, in the armed conflict or in the internal or external affairs of the Party in the territory of which that conflict occurs.

6. The application of this Protocol to the situation referred to in paragraph 1 shall not affect the legal status of the parties to the conflict.

7. UNESCO may offer its services to the parties to the conflict.

CHAPTER 6 INSTITUTIONAL ISSUES

Article 23 Meeting of the Parties

1. The Meeting of the Parties shall be convened at the same time as the General Conference of UNESCO, and in co-ordination with the Meeting of the High Contracting Parties, if such a meeting has been called by the Director-General.

2. The Meeting of the Parties shall adopt its Rules of Procedure.

3. The Meeting of the Parties shall have the following functions:

(a) to elect the Members of the Committee, in accordance with Article 24 paragraph 1;

(b) to endorse the Guidelines developed by the Committee in accordance with Article 27 sub-paragraph 1(a);

(c) to provide guidelines for, and to supervise the use of the Fund by the Committee;

(d) to consider the report submitted by the Committee in accordance with Article 27 sub-paragraph 1(d);

(e) to discuss any problem related to the application of this Protocol, and to make recommendations, as appropriate.

4. At the request of at least one-fifth of the Parties, the Director-General shall convene an Extraordinary Meeting of the Parties.

Article 24 Committee for the Protection of Cultural Property in the Event of Armed Conflict

1. The Committee for the Protection of Cultural Property in the Event of Armed Conflict is hereby established. It shall be composed of twelve Parties which shall be elected by the Meeting of the Parties.

2. The Committee shall meet once a year in ordinary session and in extra-ordinary sessions whenever it deems necessary.

3. In determining membership of the Committee, Parties shall seek to ensure an equitable representation of the different regions and cultures of the world.

4. Parties members of the Committee shall choose as their representatives persons qualified in the fields of cultural heritage, defence or international law, and they shall endeavour, in consultation with one another, to ensure that the Committee as a whole contains adequate expertise in all these fields.

Article 25 Term of office

1. A Party shall be elected to the Committee for four years and shall be eligible for immediate re-election only once.

2. Notwithstanding the provisions of paragraph 1, the term of office of half of the members

chosen at the time of the first election shall cease at the end of the first ordinary session of the Meeting of the Parties following that at which they were elected. These members shall be chosen by lot by the President of this Meeting after the first election.

Article 26 Rules of procedure

1. The Committee shall adopt its Rules of Procedure.

2. A majority of the members shall constitute a quorum. Decisions of the Committee shall be taken by a majority of two-thirds of its members voting.

3. Members shall not participate in the voting on any decisions relating to cultural property affected by an armed conflict to which they are parties.

Article 27 Functions

1. The Committee shall have the following functions:

a. to develop Guidelines for the implementation of this Protocol;

b. to grant, suspend or cancel enhanced protection for cultural property and to establish, maintain and promote the List of Cultural Property under Enhanced Protection;

c. to monitor and supervise the implementation of this Protocol and promote the identification of cultural property under enhanced protection;

d. to consider and comment on reports of the Parties, to seek clarifications as required, and prepare its own report on the implementation of this Protocol for the Meeting of the Parties;

e. to receive and consider requests for international assistance under Article 32;

f. to determine the use of the Fund;

g. to perform any other function which may be assigned to it by the Meeting of the Parties.

2. The functions of the Committee shall be performed in co-operation with the Director-General.

3. The Committee shall co-operate with international and national governmental and non-governmental organizations having objectives similar to those of the Convention, its First Protocol and this Protocol. To assist in the implementation of its functions, the Committee may invite to its meetings, in an advisory capacity, eminent professional organizations such as those which have formal relations with UNESCO, including the International Committee of the Blue Shield (ICBS) and its constituent bodies. Representatives of the International Centre for the Study of the Preservation and Restoration of Cultural Property (Rome Centre) (ICCROM) and of the International Committee of the Red Cross (ICRC) may also be invited to attend in an advisory capacity.

Article 28 Secretariat

The Committee shall be assisted by the Secretariat of UNESCO which shall prepare the Committee's documentation and the agenda for its meetings and shall have the responsibility for the implementation of its decisions.

Article 29 The Fund for the Protection of Cultural Property in the Event of Armed Conflict

1. A Fund is hereby established for the following purposes:

a. to provide financial or other assistance in support of preparatory or other measures to be taken in peacetime in accordance with, inter alia, Article 5, Article 10 sub-paragraph (b) and Article 30; and

b. to provide financial or other assistance in relation to emergency, provisional or other measures to be taken in order to protect cultural property during periods of armed conflict or of immediate recovery after the end of hostilities in accordance with, inter alia, Article 8 sub-paragraph (a).

2. The Fund shall constitute a trust fund, in conformity with the provisions of the financial regulations of UNESCO.

3. Disbursements from the Fund shall be used only for such purposes as the Committee shall decide in accordance with the guidelines as defined in Article 23 sub-paragraph 3(c). The Committee may

accept contributions to be used only for a certain programme or project, provided that the Committee shall have decided on the implementation of such programme or project.

4. The resources of the Fund shall consist of:

(a) voluntary contributions made by the Parties;

(b) contributions, gifts or bequests made by:

(i) other States;

(ii) UNESCO or other organizations of the United Nations system;

(iii) other intergovernmental or non-governmental organizations; and

(iv) public or private bodies or individuals;

(c) any interest accruing on the Fund;

(d) funds raised by collections and receipts from events organized for the benefit of the Fund; and

(e) all other resources authorized by the guidelines applicable to the Fund.

CHAPTER 7 DISSEMINATION OF INFORMATION AND INTERNATIONAL ASSISTANCE

Article 30 Dissemination

1. The Parties shall endeavour by appropriate means, and in particular by educational and information programmes, to strengthen appreciation and respect for cultural property by their entire population.

2. The Parties shall disseminate this Protocol as widely as possible, both in time of peace and in time of armed conflict.

3. Any military or civilian authorities who, in time of armed conflict, assume responsibilities with respect to the application of this Protocol, shall be fully acquainted with the text thereof. To this end the Parties shall, as appropriate:

(a) incorporate guidelines and instructions on the protection of cultural property in their military regulations;

(b) develop and implement, in cooperation with UNESCO and relevant governmental and non-governmental organizations, peacetime training and educational programmes;

(c) communicate to one another, through the Director-General, information on the laws, administrative provisions and measures taken under sub-paragraphs (a) and (b);

(d) communicate to one another, as soon as possible, through the Director-General, the laws and administrative provisions which they may adopt to ensure the application of this Protocol.

Article 31 International cooperation

In situations of serious violations of this Protocol, the Parties undertake to act, jointly through the Committee, or individually, in cooperation with UNESCO and the United Nations and in conformity with the Charter of the United Nations.

Article 32 International assistance

1. A Party may request from the Committee international assistance for cultural property under enhanced protection as well as assistance with respect to the preparation, development or implementation of the laws, administrative provisions and measures referred to in Article 10.

2. A party to the conflict, which is not a Party to this Protocol but which accepts and applies provisions in accordance with Article 3, paragraph 2, may request appropriate international assistance from the Committee.

3. The Committee shall adopt rules for the submission of requests for international assistance and shall define the forms the international assistance may take.

4. Parties are encouraged to give technical assistance of all kinds, through the Committee, to those Parties or parties to the conflict who request it.

Article 33 Assistance of UNESCO

1. A Party may call upon UNESCO for technical assistance in organizing the protection of its cultural property, such as preparatory action to safeguard cultural property, preventive and organizational measures for emergency situations and compilation of national inventories of cultural property, or in connection with any other problem arising out of the application of this Protocol. UNESCO shall accord such assistance within the limits fixed by its programme and by its resources.

2. Parties are encouraged to provide technical assistance at bilateral or multilateral level.

3. UNESCO is authorized to make, on its own initiative, proposals on these matters to the Parties.

CHAPTER 8 EXECUTION OF THIS PROTOCOL

Article 34 Protecting Powers

This Protocol shall be applied with the co-operation of the Protecting Powers responsible for safeguarding the interests of the Parties to the conflict.

Article 35 Conciliation procedure

1. The Protecting Powers shall lend their good offices in all cases where they may deem it useful in the interests of cultural property, particularly if there is disagreement between the Parties to the conflict as to the application or interpretation of the provisions of this Protocol.

2. For this purpose, each of the Protecting Powers may, either at the invitation of one Party, of the Director-General, or on its own initiative, propose to the Parties to the conflict a meeting of their representatives, and in particular of the authorities responsible for the protection of cultural property, if considered appropriate, on the territory of a State not party to the conflict. The Parties to the conflict shall be bound to give effect to the proposals for meeting made to them. The Protecting Powers shall propose for approval by the Parties to the conflict a person belonging to a State not party to the conflict or a person presented by the Director-General, which person shall be invited to take part in such a meeting in the capacity of Chairman.

Article 36 Conciliation in absence of Protecting Powers

1. In a conflict where no Protecting Powers are appointed the Director-General may lend good offices or act by any other form of conciliation or mediation, with a view to settling the disagreement.

2. At the invitation of one Party or of the Director-General, the Chairman of the Committee may propose to the Parties to the conflict a meeting of their representatives, and in particular of the authorities responsible for the protection of cultural property, if considered appropriate, on the territory of a State not party to the conflict.

Article 37 Translations and reports

1. The Parties shall translate this Protocol into their official languages and shall communicate these official translations to the Director-General.

2. The Parties shall submit to the Committee, every four years, a report on the implementation of this Protocol.

Article 38 State responsibility

No provision in this Protocol relating to individual criminal responsibility shall affect the responsibility of States under international law, including the duty to provide reparation.

CHAPTER 9 FINAL CLAUSES

Article 39 Languages

This Protocol is drawn up in Arabic, Chinese, English, French, Russian and Spanish, the six texts being equally authentic.

Article 40 Signature

This Protocol shall bear the date of 26 March 1999. It shall be opened for signature by all High Contracting Parties at The Hague from 17 May 1999 until 31 December 1999.

Article 41 Ratification, acceptance or approval

1. This Protocol shall be subject to ratification, acceptance or approval by High Contracting Parties which have signed this Protocol, in accordance with their respective constitutional procedures.

2. The instruments of ratification, acceptance or approval shall be deposited with the Director-General.

Article 42 Accession

1. This Protocol shall be open for accession by other High Contracting Parties from 1 January 2000.

2. Accession shall be effected by the deposit of an instrument of accession with the Director-General.

Article 43 Entry into force

1. This Protocol shall enter into force three months after twenty instruments of ratification, acceptance, approval or accession have been deposited.

2. Thereafter, it shall enter into force, for each Party, three months after the deposit of its instrument of ratification, acceptance, approval or accession.

Article 44 Entry into force in situations of armed conflict

The situations referred to in Articles 18 and 19 of the Convention shall give immediate effect to ratifications, acceptances or approvals of or accessions to this Protocol deposited by the parties to the conflict either before or after the beginning of hostilities or occupation. In such cases the Director-General shall transmit the communications referred to in Article 46 by the speediest method.

Article 45 Denunciation

1. Each Party may denounce this Protocol.

2. The denunciation shall be notified by an instrument in writing, deposited with the Director-General.

3. The denunciation shall take effect one year after the receipt of the instrument of denunciation. However, if, on the expiry of this period, the denouncing Party is involved in an armed conflict, the denunciation shall not take effect until the end of hostilities, or until the operations of repatriating cultural property are completed, whichever is the later.

Article 46 Notifications

The Director-General shall inform all High Contracting Parties as well as the United Nations, of the deposit of all the instruments of ratification, acceptance, approval or accession provided for in Articles 41 and 42 and of denunciations provided for Article 45.

Article 47 Registration with the United Nations

In conformity with Article 102 of the Charter of the United Nations, this Protocol shall be registered with the Secretariat of the United Nations at the request of the Director-General.

IN FAITH WHEREOF the undersigned, duly authorized, have signed the present Protocol.

DONE at The Hague, this twenty-sixth day of March 1999, in a single copy which shall be deposited in the archives of the UNESCO, and certified true copies of which shall be delivered to all the High Contracting Parties.

Depositary :
UNESCO

Opened for Signature :
From 17 May to 31 December 1999.

The Protocol has been signed by the following States:

Albania	26 March 1999	Hungary	26 March 1999
Armenia	22 October 1999	Indonesia	26 March 1999
Austria	26 March 1999	Italy	26 March 1999
Belarus	26 March 1999	Luxembourg	26 March 1999
Belgium	26 March 1999	Madagascar	26 March 1999
Bulgaria	15 September 1999	Morocco	21 December 1999
Cambodia	26 March 1999	Netherlands	26 March 1999
Colombia	31 December 1999	Nigeria	26 March 1999
Côte d'Ivoire	26 March 1999	Oman	30 June 1999
Croatia	26 March 1999	Pakistan	26 March 1999
Cyprus	19 August 1999	Peru	13 July 1999
Ecuador	29 December 1999	Qatar	26 March 1999
Egypt	9 October 1999	Romania	8 November 1999
Estonia	26 March 1999	Slovak Republic	22 December 1999
Finland	26 March 1999	Spain	26 March 1999
Germany	26 March 1999	Sweden	26 March 1999
Ghana	26 March 1999	Switzerland	26 March 1999
Greece	26 March 1999	Syria	26 March 1999
Holy See	26 March 1999	Yemen	26 March 1999

Entry into force:
9 March 2004, in accordance with Article 43.1
Authoritative texts:
Arabic, Chinese, English, French, Russian and Spanish
Registration at the UN:
5 May 2004, No. 3511

States Parties

SECOND PROTOCOL TO THE HAGUE CONVENTION OF 1954 FOR THE PROTECTION OF CULTURAL PROPERTY IN THE EVENT OF ARMED CONFLICT. THE HAGUE, 26 MARCH 1999.[1]

	States	Date of deposit of instrument	Type of instrument
1	Argentina	07/01/2002	Accession
2	Armenia	18/05/2006	Ratification
3	Austria	01/03/2002	Ratification
4	Azerbaijan	17/04/2001	Ratification
5	Bahrain	26/08/2008	Accession
6	Barbados	02/10/2008	Accession
7	Belarus	13/12/2000	Ratification
8	Bosnia and Herzegovina	22/05/2009	Accession
9	Brazil	23/09/2005	Accession
10	Bulgaria	14/06/2000	Ratification
11	Canada	29/11/2005	Accession
12	Chile	11/09/2008	Accession
13	Costa Rica	09/12/2003	Accession
14	Croatia	08/02/2006	Ratification

1 This Protocol entered into force on 9 March 2004. It subsequently will entered into force for each State three months after the date of deposit of that State's instrument, except in cases of notifications of succession, where the entry into force occurred on the date on which the State assumed responsibility for conducting its international relations.

15	Cyprus	16/05/2001	Ratification
16	Czech Republic	08/06/2007	Accession
17	Dominican Republic	03/03/2009	Accession
18	Ecuador	02/08/2004	Ratification
19	Egypt	03/08/2005	Ratification
20	El Salvador	27/03/2002	Accession
21	Equatorial Guinea	19/11/2003	Accession
22	Estonia	17/01/2005	Approval
23	Finland	27/08/2004	Acceptance
24	Gabon	29/08/2003	Accession
25	Greece	20/04/2005	Ratification
26	Guatemala	04/02/2005	Accession
27	Honduras	26/01/2003	Accession
28	Hungary	26/10/2005	Ratification
29	Iran (Islamic Republic of)	24/05/2005	Accession
30	Italy	10/07/2009	Ratification
31	Japan	10/09/2007	Accession
32	Jordan	05/05/2009	Accession
33	Libyan Arab Jamahiriya	20/07/2001	Accession
34	Lithuania	13/03/2002	Accession
35	Luxembourg	30/06/2005	Ratification
36	Mexico	07/10/2003	Accession
37	Montenegro	26/04/2007	Notification of succession
38	Netherlands	30/01/2007	Acceptance
39	Nicaragua	01/06/2001	Accession
40	Niger	16/06/2006	Accession
41	Nigeria	21/10/2005	Ratification
42	Panama	08/03/2001	Accession
43	Paraguay	09/11/2004	Accession
44	Peru	24/05/2005	Ratification
45	Qatar	04/09/2000	Ratification
46	Romania	07/08/2006	Ratification
47	Saudi Arabia	06/11/2007	Accession
48	Serbia	02/09/2002	Accession
49	Slovakia	11/02/2004	Ratification
50	Slovenia	13/04/2004	Accession
51	Spain	06/07/2001	Ratification
52	Switzerland	09/07/2004	Ratification
53	Tajikistan	21/02/2006	Accession
54	The former Yugoslav Republic of Macedonia	19/04/2002	Accession
55	Uruguay	03/01/2007	Accession

Declarations and Reservations:

Iran
"Accession of the Islamic Republic of Iran to this Protocol shall not mean the recognition of any country it does not recognize, neither shall it give rise to any commitment toward such states or governments"
Annexed to the instrument was the following explanatory declaration:
"Considering the special importance of protecting cultural heritage of nations against damages caused by war,
Bearing in mind the fact that cultural heritage of nations is deemed as part of cultural heritage of humanity,

Considering that full protect of cultural heritage against damages caused by armed conflicts needs the protections more than that which is provided for in the present Protocol,

The Islamic Republic of Iran regards the conclusion of bilateral and multilateral supplementary agreements to the present Protocol as necessary and states its readiness to conclude such agreements. These agreements shall entail the granting of privileges and providing more possibilities for protection of cultural heritage of nations and shall also articulate the rules stipulated in the Protocol including customary rules of international law, in a way that solely include the rules that are not protested by the Government of the Islamic Republic of Iran and as well as explain more clearly the modality for the implementation of provisions of section 4 of this Protocol."

Canada

The statement of understanding reproduced below was annexed to the instrument of accession :
"STATEMENT OF UNDERSTANDING

1. It is the understanding of the Government of Canada that the definition of a military objective in Article 2(f) is to be interpreted the same way as Article 52(2) of Additional Protocol I to the Geneva Conventions of 1949.

2. It is the understanding of the Government of Canada that in relation to Article 6(a)(ii), 6(b), 7(a), 7(b), 8, 13(2)(a) and 13(2)(b) the word "feasible" means that which is practicable or practically possible, taking into account all circumstances ruling at the time, including humanitarian and military considerations.

3. It is the understanding of the Government of Canada that in relation to Article 6(a)(ii), 6(b), 7(c) and 7(d)(ii) that the military advantage anticipated from an attack is intended to refer to the advantage anticipated from the attack considered as a whole and not from isolated or particular parts of the attack.

4. It is the understanding of the Government of Canada that any cultural property that becomes a military objective may be attacked in accordance with a waiver of imperative military necessity pursuant 10 Article 4(2) of the Convention.

5. It is the understanding of the Government of Canada that a decision to invoke imperative military necessity pursuant to Article 6(c) of this Protocol may be taken by an officer commanding a force smaller than the equivalent of a battalion in size in circumstances where the cultural property becomes a military objective and the circumstances ruling at the time relating to force protection are such that it is not feasible to require the decision to be made by an officer commanding a force the equivalent of a battalion in size or larger.

6. It is the understanding of the Government of Canada that under Article 6(a)(i), cultural property can be made into a military objective because of its nature, location, purpose or use."

Appendix 2

Author Biographies

Martin Brown is a professional archaeologist employed by the UK's Defence Estates, where he is part of the Historic Environment Team responsible for the stewardship of the cultural heritage in Ministry of Defence or Armed Forces possession. Martin has worked for both local and national government in heritage protection roles and has also been very much involved in promoting public engagement with archaeological sites and landscapes. His recent research and teaching have primarily been on conflict archaeology and the Great War 1914–1918 but he continues to work in the wider field of historical archaeology and material culture, as recent work on the archaeology of television demonstrates.

Hugo Clarke was commissioned into the Scots Guards in 1990. He served in the First Gulf War and Northern Ireland, for which he was awarded the Queen's Commendation for Bravery. He left the army in 1995 and worked for the HALO Trust, a humanitarian mine clearance charity, leading teams in Afghanistan and Angola. Rejoining the Scots Guards in 2002, he organised training exercises in Africa, the Caribbean and Asia. In 2007 he was posted to Headquarters 3rd (United Kingdom) Division and worked as the Military Assistant to the General Officer Commanding British Forces in Basra. During this time he worked closely with the British Museum on Operation Heritage, a project designed to assess the condition of archaeological sites in southern Iraq and build a museum in Basra. He is currently working as a Company Commander with 1st Battalion Scots Guards.

Cpt Arch Holger Eichberger studied constructional engineering in Vienna. He is a board member of the Austrian Society for the Protection of Cultural Property and of the Austrian National Committee of the Blue Shield. As a reserve (militia) officer in the Austrian Armed Forces he served as an engineering officer for the UN mission on the Golan Heights. He is a trained Cultural Property Protection Officer, currently serving at the Austrian Ministry of Defence and teaching cultural property protection at the Austrian Military Academy at Wiener Neustadt. He is working on his PhD thesis on cultural property protection and preventative measures in the event of natural disasters.

Lt Col Dr Erich Frank is a judge at the Administrative District Court of Vienna. He was trained as a Cultural Property Protection Officer in the Austrian Armed Forces. Following his promotion to Lieutenant Colonel he was transferred to the Armed Forces Territorial Command of Lower Austria, where he now serves as a Cultural Property Protection Officer. He studied law with a focus on international, constitutional and administrative law. His expertise covers the 1954 Hague Convention and its two Protocols and in particular the 1972 UNESCO Convention.

BrigGen Norbert Fürstenhofer is NBC Defense Chief Officer of the Austrian Armed Forces, Commanding Officer of the Austrian NBC Defense School Lise Meitner (in Korneuburg, Lower Austria) and Commanding Officer of the Austrian Armed Forces Disaster Relief Unit (AFDRU). During his military career he has been involved in several military assignments, which from the beginning have focused on NBC defence and both national and international disaster management. As a senior expert in these fields he is a founding member of the International Search and Rescue Advisory Group (INSARAG), a global network of urban search and rescue specialists, and the UN project 'On the use of military and civil defence assets in disaster relief operations (MCDA-Project)', both of which come under the umbrella

of the United Nations Office for the Coordination of Humanitarian Affairs (UN-OCHA). Among other roles, he is a member of the Scientific Advisory Board of the Austrian Research Center in Seibersdorf, the Austrian Standardization Committee and the Scientific Commission of the Austrian Ministry of Defence. He is president of the Austrian Society for the Protection of Cultural Property and a board member of the Austrian National Committee of the Blue Shield.

Patty Gerstenblith is Distinguished Research Professor of Law at DePaul University and Director of its Center for Art, Museum and Cultural Heritage Law. She was a public representative on the President's Cultural Property Advisory Committee in the US Department of State (2000–2003) and is founding President of the Lawyers' Committee for Cultural Heritage Preservation. Her most recent publications include the second edition of *Art, Cultural Heritage and the Law*, and her article, 'Protecting Cultural Heritage in Armed Conflict: Looking Back, Looking Forward' 7 *Cardozo Public Law, Policy & Ethics Journal*. She received her JD from Northwestern University and PhD in Art History and Anthropology from Harvard University.

Paul R Green is Cultural Resources Program Manager for the US Air Force, Headquarters Air Combat Command, Langley Air Force Base, Virginia. His doctorate, in Anthropology, is from the University of North Carolina-Chapel Hill. He is also an Adjunct Associate Professor in the Department of Sociology and Criminal Justice at Old Dominion University. Dr Green is a member of the CENTCOM Historical/Cultural Advisory Group, formed in 2008, and the International Military Cultural Resources Working Group.

Cpt Karl von Habsburg-Lothringen is a former member of the European Parliament and current president of the Association of the National Committees of the Blue Shield (ANCBS). ANCBS, founded in December 2008, coordinates and strengthens international efforts to protect cultural property at risk of destruction in armed conflicts or natural disasters, and has its headquarters in The Hague. Karl von Habsburg-Lothringen was trained as a pilot in the Austrian Air Force, flying several types of aircraft. After his promotion to Captain he was finally transferred to the Armed Forces High Command, where he now serves as a Cultural Property Protection Officer. He has studied business and law with a focus on international law. His expertise covers the 1954 Hague Convention and its two Protocols and in particular the 2003 UNESCO Convention.

Joris D Kila is a reserve Lieutenant Colonel in the Dutch army and holds degrees in art history and classical archaeology from Leiden University. He was network manager and acting chairman of Cultural Affairs at the Civil–Military Co-operation (CIMIC) Group North in the Netherlands. In that capacity he undertook cultural rescue missions in Macedonia and Iraq. In addition, he is a board member with the World Association for the Protection of Tangible and Intangible Cultural Heritage in Times of Armed Conflict (WATCH) in Rome, a member of the Research Forum on the Law of Armed Conflict and Peace Operations in The Netherlands, an affiliated researcher and lecturer at the Netherlands Defence Academy, Leiden University, NATO School Oberammergau, an affiliated researcher at the University of Amsterdam, a Community Fellow at the Cultural Policy Center at the University of Chicago, adviser for Cultural Property Protection to the MoD of the Netherlands, member of the International Military Cultural Resources Working Group (IMCuRWG) and international adviser of the CENTCOM Historical, Cultural, Technical Working Group. He is author and co-author of several publications on cultural property protection in times of armed conflict. Currently he is carrying out research for a book on CPP in times of conflict from the military perspective.

Sarah Parcak (BA Yale, MPhil/PhD Cambridge) is an Archaeologist in the Dept of Anthropology and the founding Director of the Laboratory for Global Health Observation at the University of Alabama at Birmingham. She directs the Middle Egypt Survey Project, and co-directs RESCUE (for Remote Sensing and Coring of Uncharted Egyptian Sites), with her husband, Dr Greg Mumford. Dr Parcak has written *Satellite Remote Sensing for Archaeology* (Routledge 2009) and a number of articles. Her work has appeared on the Discovery Channel and in *The Economist, The Times, Popular Science, National Geographic News* and internet-based news channels such as LiveScience, Nasa.gov, Google, AOL, Yahoo and MSNBC.

Darrell Pinckney has been digging professionally for CRM firms since 1995 and has been a conservator since 2001. His aim as a conservation scientist is to halt decay and prevent further decomposition of objects, whether they are of inorganic or organic origin. Most recently he discussed the current conditions of archaeological sites located in Kirkuk, Iraq, in 'Time not on my Side', which he presented at the World Archaeological Conference in Dublin, Ireland, in 2008. He hopes his efforts will bring greater awareness to the archaeological community, military forces and scholars who share an interest in existing sites in Iraq. He also assists the CENTCOM Historical/Cultural Advisory Group, which is a committee of professionals concerned with issues of cultural heritage and historic sites that have been impacted or are threatened in wartime environments. Darrell currently teaches conservation courses at Schenectady County Community College in New York for the Community Archaeology Program (CAP).

Colonel (retd) Julian Radcliffe OBE QVRM TD FSA is Chairman of the Art Loss Register, the central database of stolen art and antiques for the art trade, insurers and police. The database searches 500,000 items a year to recover those stolen or looted. He was a Colonel in the UK Army Reserves and was closely involved in the UK Ministry of Defence for the mobilisation of Reserves for Afghanistan and Iraq. He wrote the report for the UK Government on how to better use the civilian skills of Reservists for tasks such as the protection of cultural property.

Laurie Rush is an Anthropologist and Archaeologist who has served 11 years managing Cultural Resources at Fort Drum, NY. Since 2006, she has also been directing the Office of the Secretary of Defense Legacy Project called 'In Theater Heritage Training for Deploying Personnel'. She has a BA from Indiana University Bloomington and an MA and PhD from Northwestern University. She has won numerous Army and Department of Defense Awards and her Fort Drum program and team were selected as best in the DoD for 2007 and 2009. At the request of MG Oates and the US State Department, Dr Rush was the military liaison for return of the Mesopotamian City of Ur to the Iraqi People in the spring of 2009. She also represented Central Command and shared the podium with the Director General of Afghan Heritage, Mr Abdul Wasey Ferauzi, at an Environmental Shura in Kabul, Afghanistan, in February 2010. Dr Rush has been invited to speak internationally on the subject of partnering with the military to achieve preservation stewardship in conflict areas, including the 2009 Hague Conference on Cultural Preservation sponsored by the Netherlands Ministry of Defense. Dr Rush has been recognised by her peers with the Register of Professional Archaeologists Special Achievement Award and with the Chairman's Award for Federal Achievement in Historic Preservation.

Friedrich Schipper studied archaeology at the University of Vienna, where he currently teaches the archaeology of Syro-Palestine. He has conducted archaeological field research in Israel and Iraq, specialising in issues of cultural property protection in the conflict-torn region of the Near East and on issues of civil and military cooperation in regard to the

protection of cultural heritage in the event of armed conflict. He is general secretary of the Austrian National Committee of the Blue Shield and a board member of the Austrian Society for the Protection of Cultural Property.

Col Dr Franz Schuller studied international commerce, trade and business administration at the Vienna University of Economics and Business Administration and economic history and art history at the University of Vienna. He is general secretary of the Austrian Society for the Protection of Cultural Property and a board member of the Austrian National Committee of the Blue Shield. He is a trained Cultural Property Protection Officer and as such he is an adviser to the Austrian Ministry of Defence. He also serves as a military expert in the protection of cultural property for the ICRC and UNESCO.

Diane Siebrandt has been the Cultural Heritage Liaison Officer for the US Embassy in Baghdad since December 2006. One aspect of her work is to facilitate understanding and dialogue between the US military and Iraqi antiquities authorities. Her chapter focuses on the support provided by US armed forces that has allowed her to concentrate on cultural heritage preservation and awareness issues. She has worked on archaeological and paleontological sites since 1992 in Israel, the United Kingdom and south-western United States. Her prior experience includes working with the Denver Museum of Nature and Science and the York Archaeological Trust. Diane has a BA in Anthropology and an MSc in Zooarchaeology.

Krysia Spirydowicz is Director of the Art Conservation Program at Queen's University and holds a BA honours and MA in classical languages and archaeology from the University of Alberta, Edmonton, and a Master's in Art Conservation from Queen's University, Kingston, Canada. As a specialist in artefact conservation she has participated in many archaeological excavations and international conservation projects in Turkey, Italy, Israel, the Sudan and Iran. Her research interests also include the rescue and preservation of cultural property during wartime. She is preparing a book on the activities and accomplishments of the Monuments, Fine Arts and Archives Section of the Allied Expeditionary Force in Europe during World War II.

Corine Wegener is an Associate Curator in the department of Decorative Arts, Textiles, and Sculpture at the Minneapolis Institute of Arts and a retired Army Civil Affairs Officer. Her last assignment prior to retirement was as the Arts, Monuments and Archives Officer for the 352d Civil Affairs Command, where she worked as military liaison to the Iraqi Ministry of Culture and the Iraq National Museum in 2003–4. She is also founder and president of the US Committee of the Blue Shield.

James Zeidler is Associate Director for Cultural Resources and a Senior Research Scientist in the Center for Environmental Management of Military Lands in the Warner College of Natural Resources, Colorado State University. He is a Registered Professional Archaeologist and also holds adjunct faculty appointments in the CSU Departments of Anthropology and Forestry/Range/Watershed Sciences. He received his PhD in Anthropology from the University of Illinois and has over 35 years of experience as a practising archaeologist in North and South America. He has been involved in Federal cultural resource management since 1992, with recent emphasis on global Cultural Property Protection issues.

Stephan Zellmeyer holds a PhD from the University of Basel and is a member of the Policy Division of the Federal Office for Civil Protection, which is also the national authority for the Protection of Cultural Property (PCP). He is also a specialist adviser to the Staff of the Chief of the Swiss Armed Forces on PCP matters.

Index